THE HIPLIFE IN GHANA

THE HIPLIFE IN GHANA

WEST AFRICAN INDIGENIZATION OF HIP-HOP

HALIFU OSUMARE

palgrave
macmillan

THE HIPLIFE IN GHANA
Copyright © Halifu Osumare, 2012.

First published in 2012 by
PALGRAVE MACMILLAN®
in the United States—a division of St. Martin's Press LLC,
175 Fifth Avenue, New York, NY 10010.

Where this book is distributed in the UK, Europe and the rest of the world,
this is by Palgrave Macmillan, a division of Macmillan Publishers Limited,
registered in England, company number 785998, of Houndmills,
Basingstoke, Hampshire RG21 6XS.

Palgrave Macmillan is the global academic imprint of the above companies
and has companies and representatives throughout the world.

Palgrave® and Macmillan® are registered trademarks in the United States,
the United Kingdom, Europe and other countries.

ISBN: 978–1–137–02164–9

Library of Congress Cataloging-in-Publication Data is available from the
Library of Congress.

A catalogue record of the book is available from the British Library.

Design by Newgen Imaging Systems (P) Ltd., Chennai, India.

First edition: September 2012

10 9 8 7 6 5 4 3 2 1

Printed in the United States of America.

To
my ancestors who paved the way and speak through me
Ochosi and Oya for your unfailing wise counsel
and Gene Howell, my rock

CONTENTS

FIGURES

ACKNOWLEDGMENTS

JUST AS NO ONE GETS THROUGH THIS LIFE BY ONESELF, so too is no book written alone. A sole-authored book, although a solitary endeavor, in the final process is a collaborative effort that includes the knowledge and generosity of numerous people and institutions. I would like to acknowledge a few in the writing of *The Hiplife in Ghana*. First, the Fulbright Scholars Program should be thanked for my 2008 teaching/research fellowship that formed the basis of this research. The Fulbright Program and the Institute of International Education are invaluable institutions that quietly build bridges between the United States and the rest of the world on a people-to-people basis. I also thank the office of the Dean of Humanities, Arts, and Cultural Studies (HArCS) at the University of California, Davis, where I teach, for their financial support with a publication grant. In addition, two institutions of the University of Ghana, Legon buttressed the fieldwork and initial presentations: The Department of Dance Studies, headed by Professor Oh! Nii Sowah, located in the School of Performing Arts, headed by Dr. Awo Mana Asiedu; and the Institute of African Studies headed by Dr. Akosua Adomako Ampofo. Esteemed ethnomusicologist Professor Emeritus Kwabena Nketia, whom I first met and worked with in the late 1970s in Ghana, was always supportive of my hiplife research.

During my fieldwork in Ghana, many people generously gave of their time and knowledge of hiplife music and culture. I thank my fiancé Gene Howell for providing general research assistance, photography, moral support, and security. Terry Ofosu, as my research assistant, was invaluable in helping me establish initial contact with artists, providing translation and interpretation of hiplife lyrics, and cultural deciphering of much locally encoded material. Terry always believed in this project, and I truly benefitted from his support. Others helped in various ways: Andrea King tallied my survey data, Adia Whitaker provided moral support as another American in Ghana at the time, Jenny Fatou M'Baye provided needed French translations for my interviews in Burkina Faso , and Andrews K. Agyemfra-Tettey assisted my work with Professor Nketia. My Ghanaian "family" of Christian Village,

the Ahadji family headed by Kudjo Ahadji, was personally very supportive. I would also like to thank hiplife filmmaker Eli Jacobs-Fantauzzi for his encouragement and supplementary information back in the United States.

Lastly, I need to acknowledge the many producers and artists in Ghana's hiplife culture. Among the artists explored in this book, several culture bearers particularly need to be singled out. Reggie Rockstone, as the acknowledged founder of hiplife music, was particularly helpful, always willing to talk to me and provide the background to understand the culture. Panji Anoff, producer of several artists and the High Vibes Festival, was also very accommodating and gave me numerous interviews and astute insights into Ghanaian and hiplife cultures. Iso Paley, producer at TV3, was also particularly helpful and charitable. Several other artists were particularly generous in giving me multiple interviews, such as Okyeame Kwame and Blitz the Ambassador. Hiplife, as a hybrid music that has established itself as a unique pop music genre in Africa is an important contribution to world culture, and it is my hope that through all our efforts, we helped put it further on the world's cultural map.

INTRODUCTION: "EVERY HOOD HAS ITS OWN STYLE"

THE SOUNDS OF POPULAR MUSIC ACROSS THE CONTINENT of Africa are distinctive yet intertwined. From mid-twentieth-century Kenyan *benga* music to *juju* and Afrobeat in Nigeria, from contemporary *bongo flava* in Tanzania to *kwaito* in South Africa, and from the influential Congo *soukous* to Ghana's distinctive hiplife music, the popular secular rhythms of Africa are riveting, inspiring, and always danceable. Radio programs such as "African Beat" on the veteran Voice of America network and "Zane's Jammin' Africa" on the newer Radio Express, Inc. broadcast the latest African pop artists singing everything from reggae to African contemporary to hip-hop, often juxtaposed with their latest American counterparts. Radio shows, such as these, broadcast across the continent of Africa to youth audiences that increasingly negotiate their contemporary identities between global musical influences and local indigenous sounds and rhythms, which are often, in turn, revisions of previous African generations' Western musical influences.

The circle of musical and dance influences from Africa to its diaspora and back again, represented by these rhythmic musical genres from all regions of the African continent, is what I call an *arc of mutual inspiration* that has existed since the Atlantic slave trade. When one multiplies Saidiya Hartman's "[n]ine slave routes [that] traversed Ghana...following the trail of captives from the hinterland to the Atlantic coast"[1] by the many West and Central African countries involved in the transatlantic slave trade, we recognize that many resulting cultural and historical influences merged to constitute a complex arc of music and dance that would evolve into a core of today's African diaspora. Hiplife music in Ghana tells the latest saga of this arc of musical inspiration across time and space, African approaches to rhythm and call-and-response performance styles reinvented in the diaspora and then reformulated back in the motherland. As one of the newer musical

genres to come out of West Africa, hiplife music developed out of the fusion of Ghana's own twentieth-century popular highlife music with contemporary hip-hop beats and style that first swept the continent in the 1980s. As the subject of this book, hiplife's story is one revealing tension between globalization and localization, neocolonialism in today's "borderless" transnational capitalism, and hip-hop's youth agency that facilitates young Ghanaians finding their voice within a traditional society beyond music to many realms of sociopolitical discourse.

I have been traveling to Ghana since 1976, just at the time or before most of my hiplife culture bearers were born. It was during my first "searching for my roots" trip as an African American enrolled as an auditor in the School of Music, Dance, and Drama, under the revered ethnomusicologist Dr. Kwabena Nketia and the dance ethnologist Albert Opoku, that I became familiar with the major ethnic groups and their musical and dance traditions. Unlike S. Hartman (2007), for whom "neither blood nor belonging accounted for my presence in Ghana only the path of strangers impelled toward the sea,"[2] I *did* come searching for "belonging," but neither for "blood" nor the slavery connection. I had little interest in tracing my specific bloodline, but *cultural* belonging is something that I discovered through Ghanaian dance and music.

The famed dancer-anthropologist Katherine Dunham has said that dance and the body is one of the most "tenacious cultural traits to survive the ravages of slavery." So, is that why back in 1976 the Queen Mother in the Ashanti village of Kaasi, near Kumasi, asked, "How can that white woman know how to dance like that?" when I humbly, and reluctantly, danced the signature Ashanti dance *adowa* that day during the funeral celebration that I had come to witness. Yet, the translation of her "royal" question, by my Ashanti male escort who had brought me to the funeral in 1976, had the dreaded word, "*Obruni*" (white stranger), which was again hurled at me by a Ghanaian woman as I entered Elmina Castle during this 2008 research trip some 30 years later. And again, unlike Hartman, I did not "learn to accept it" because as I told the bold Ghanaian woman with whom I had the chance encounter entering Elmina Castle, "no matter my skin color, my grandmother looks just like you," and "if you don't want to call me 'African' then you have to find another word for me other than *Obruni*, because I am not white and I am connected to you." As I had learned in the interim 32 years between my fieldwork in Ghana, the body both linked us through expressive culture and offered appearances of discrete difference.

I had returned with the confidence that my previous experience, decades earlier, had given me through dance and music. I was able to hold my own in the dance circle, and have Ghanaians marvel at my ability to perform

adowa, agbadza, gahu, and other dances that said I spoke "the language" with all its subtle syntactical and rhythmical movement nuances that had been translated in my bodily muscles and cultural memory across all this time and space. I had not returned with the pain of the memory of slavery, but with the celebration of our mutual dance and music speech, and part of that legacy was now being repatriated from *my* culture back to theirs through hip-hop. The abhorred tragedy that it was, slavery becomes a complex symbol, as well as the point of historical contact that allowed for *the mutual arc of inspiration* that I am now exploring. Africa's historical connection as the "motherland" for African Americans allowed me to explore not the "path of strangers," but a path of mutual cultural inspiration found in what Westerners call "art." However, in 2008, my search was no longer some romantic Afrocentric journey for my lost mother, but an investigation of the "connective marginality" stories that we tell ourselves in the continuing saga of the mutual arc of inspiration now being fueled by twenty-first-century capitalism.

The actuality of what I am calling the "mutual arc of inspiration" does not always mitigate the disconnections that exist between Africa and its diaspora. Particularly in rural Ghana, outside of the major urban areas, such as Accra and Kumasi, ignorance of African diasporic links, and more specifically the view of hip-hop as foreign and deleterious to traditional values of discrete ethnic groups is also present. Hartman's and my "obruni" experiences, as black American females, are indicative of the extant disconnects of Ghanaians (and Africans in general) with African descendants from the diaspora. As hip-hop globalizes, the moral issues accompanying it engenders resistance to the influences of Western pop youth music, as well as the argument of my arc of mutual inspiration. Anthropologist Jesse Shipley's 2005 Black History Month music touring experience in Ghana testifies to this cultural disconnect.

> In the course of my research and the making of my documentary film *Living the Hiplife,* several hiplife artists and I were sponsored by the US Cultural Attaché to tour Ghana as a part of the American promotion of 2005 Black History Month. Much to the confusion of US government officials the music was not seen as positive marker of America but rather among audiences outside of Accra as a flashpoint for debates about the deleterious effect of foreign influence, the nature or racial connection and disconnection, and ethnographic insight into the strangeness of urban Accra for remote rural communities. (These multiple appropriations produce and contest community affiliation and origin in the language of Black diasporic music).[3]

Indeed, hip-hop creates issues of moral standards in the United States let alone in rural, marginally literate areas of Africa, making the academic arguments

about African diasporic cultural links incongruent with rural communities disengaged from the urban area of cities such as Accra. African metropolitan areas are viewed as a morass of battling local and foreign exigencies. This rural-based cultural suspicion eventually reflects what Shipley calls "national anxieties about cultural integrity in the face of foreign intervention,"[4] at the basis of arguments against the global neoliberal marketplace adversely effecting small poor countries such as Ghana (Chapter 3).

However, my long-term familiarity with Ghanaian culture provided me a perspective to assess Ghana's cultural changes over time through its current youth generation's involvement with hiplife music. This account of the pop music scene in the capital city of Accra is based on my six-month Fulbright-funded fieldtrip in 2008 and a follow-up one-month visit in 2010.[5] Both of these latter trips to Ghana afforded me interviews and social encounters with artists, producers, academics, and cultural critics, as well as attendance at concerts and impromptu performances in the burgeoning hiplife scene in Accra.

Yet, in tandem with music phenomena in Africa there are a plethora of social issues with which one must grapple and grasp: the generational divide, continuing ethnic and cultural rivalries, traditional gender roles and the place of today's female artists in West Africa, the impact of global capital and technology, unstable political climates, and poor infrastructure's impact on pop culture industries. Just as in the structure of hip-hop music itself, an all-important "hook"—organizing melodic phrase linking often-dense rapped verses—was needed to center multiple social, economic, and cultural dimensions of Ghanaian hiplife subculture.

THE ARC OF MUTUAL INSPIRATION AND LOCAL STYLE

My "hook" came to me one day, when I was riding in a taxi going through Madina, a small market town near the University of Ghana, Legon's campus, 15 kilometers (9 miles) north of Accra. We drove by a contemporary clothing store that featured hip-hop gear. The name of the store was a revelation: "Every Hood Has Its Own Style." Surrounded by dusty dirt roads, women dressed in colorful African fabric carrying their head loads, bustling cars careening carelessly with no road rules right along side goats rambling sluggishly down the same street, the name on the sign above this small Madina clothing store was the trope that allowed me to understand hiplife music and its youth culture, 3,000 miles away from hip-hop's so-called origins in New York. *Every Hood Has Its Own Style* sells hip-hop inflected American sport jerseys and faded jeans, as well as contemporary African designs. The name of this store captured a simple, but profound

hip-hop concept: "Rep your hood"—represent where you come from in all its complexity.

"Rep your hood" has become a mantra in contemporary hip-hop to the point where pop culture scholars write entire chapters and books to explain the intricate dimensions of the meaning of "representing." Murray Forman's classic *The Hood Comes First: Race, Space, and Place in Rap and Hip-Hop* (2002) eloquently articulated hip-hop's emphasis on space and identity in the United States; but how is that phenomenon augmented exponentially in what writers are now calling the "Global Hip-Hop Nation (GHHN)"? How does this globally exported American popular culture capture an essential aspect of the human need to establish one's own uniqueness within one's own local circumstances in a completely different cultural framework outside of the United States?

S. Craig Watkins opens his *Representing: Hip Hop Culture and the Production of Black Cinema* (1998) with, "Black youth are not the passive victims of history but are instead actively involved in its making."[6] What I discovered in Ghana is that hiplife youth are definitively creating their own history interactively with their own cultural past, and the key to understanding how they are making their history with hiplife music was to explore how they are doing so through a complex interface with the global cultural influence of hip-hop. The concept that "every hood has its own style" implicitly challenges the theoretical perspective of the one-way street of local cultural appropriation of American popular culture. Particularly in Africa, the *origins* of hip-hop aesthetics are under debate. As I explored extensively in *The Africanist Aesthetic in Global Hip-Hop: Power Moves* (2007), the performance principles at the basis of hip-hop culture, with its antiphonal improvisatory process-over-product focus, has its basis in ubiquitous African performance practices across the continent. One definition of cultural appropriation is "the taking—from a culture that is not one's own—of intellectual property, cultural expressions or artifacts, history and ways of knowledge."[7] But within this definition, "culture" itself, given the arc of mutual inspiration of Africa and its diaspora, is complex because "cultural expressions" that *discreetly* belong to any particular part of the black Atlantic are difficult to ferret out. In dealing with cultural appropriation, usually the important questions are "the political ones." Ziff and Rao explain the political aspects of appropriation by delineating particular global examples:

> When white writers appropriate the images of Blacks, a political event has occurred. The same is true when commercial interests exploit African folklore or indigenous knowledge from South America. These are events that teach us about power relationships and, in part, about how the law seeks to respond to appropriation.[8]

But how do these political dimensions play out when examining the borrowing that takes place across the Black Atlantic among African and African diasporic artists?

Part of the answer—for Ghana in particular—lies in the history of its relationship historically with African Americans. In elucidating hiplife music and culture in Ghana, the question of who influenced whom in the cultural flow of hip-hop across the Black Atlantic is thoroughly explored in this book. But crucial to understanding hip-hop's origins regarding Africa, and Ghana in particular, one must have a sense of Ghana's history and the interrelations of Ghanaians and African Americans over time. Within Ghana's history, hiplife music and culture become the current phase of a complex relationship between the two groups in the arena of popular culture—the arc of mutual inspiration.

GHANAIAN HISTORY AND AFRICAN AMERICANS

With a population of approximately 24 million, Ghana is a small country (2,470 sq. mi.) in Western Africa, a little smaller than the state of Oregon. As a West African coastal country, it borders the Gulf of Guinea between Cote d'Ivoire and Togo, with Burkina Faso to the north. As a nation, Ghana was forged from the British colony of the Gold Coast and the Togoland trust territory in 1957, as the first sub-Saharan country in colonial Africa to gain its independence. It did so through nonviolent protests and boycotts, lead by it's first prime minister, the eminent pan-Africanist Kwame Nkrumah under his Convention's Peoples Party (CPP). Just as Barack Obama's January 20, 2009, inauguration as the forty-fourth president of the United States meant so much to so many throughout the black world, so too was Kwame Nkrumah's first speech as president of the new Republic of Ghana on March 5, 1957. As the Union Jack was lowered, and Ghana's red, black, and yellow flag with the lone black star rose, the symbolism of the onset of a series of independent African countries was invoked. The British colony of the Gold Coast becoming independent Ghana was *the* sign of African empowerment and the emblematic end of a long history of direct European colonial exploitation,[9] and Ghana's interest in and involvement with African Americans began with Nkrumah.

That March 1957 day was informed by decades of Nkrumah having lived in the United States in the 1930s and 1940s. He graduated with a BA in 1939 in economics and sociology from Lincoln University, the oldest of the Historically Black Colleges and Universities (HBCU),[10] witnessing discrimination and exploitation of African Americans in the Jim Crow South first hand. Cognizing the world oppression of black people led him to his bond with W. E. B. Du Bois of the United States and George Padmore and C. L. R. James from Trinidad to conceive and implement the concept of

Pan-Africanism on the African continent. With that charge, his famous speech at the United Nations in 1960 called for African freedom in very definite terms.

But Nkrumah's inauguration speech in Ghana's historic 1957 Independence celebration that contained the famous statement, "Independence of Ghana is meaningless unless linked up with the total liberation of the African continent," was the symbolic cry of Pan-Africanism that included not only the continent but also the diaspora. Ghana became the leader of worldwide Pan-Africanism that would ironically create an aura of contention within Ghana itself, and particularly its leader who began to be perceived as focusing too much on international issues. As Jesse Shipley states:

> Ghana supported liberation movements around Africa, civil rights movements in the US, and the establishment of an African American community in Accra. The tensions between national interest and Black internationalism, in fact, contributed to growing public criticism of Nkrumah and eventual Western involvement in his overthrow in 1966.[11]

The debate around Nkrumah and whether he reached too far too fast in his establishment of Ghana within global black independence, which was implicated in the 1960s Cold War conflict, exits even today. Even though he has been restored to a revered Founding Father status in Ghana, complete with Nkrumah Memorial Park in Accra's metropolitan center, a Kwame Nkrumah Centenary Celebration in 2009, and an annual national holiday in his honor, the controversy about his political tactics and his true meaning to the country continues to rage publicly. Throughout this book, I will refer to this Nkrumah debate in Ghana as the myth of Nkrumah.

Yet another "myth" regarding the concept of Pan-Africanism itself must be addressed as well. Ghanaian-British philosopher and cultural critic Kwame Anthony Appiah has long been one of the most articulate about the construction of Pan-Africanism and black solidarity as being partially mired in the mystifications of "race" itself.

> The problem, of course, is that group identity seems to work only—or, at least, to work best—when it is seen by its members as natural; as "real." Pan-Africanism, black solidarity can be an important force with real political benefits, but it doesn't work without its attendant mystifications…"Race" disables us because it proposes as a basis for common action the illusion that black (and white and yellow) people are fundamentally allied by nature and thus, without effort; it leaves us unprepared, therefore, to handle the "intraracial" conflicts that arise from the very different situations of black (and white and yellow) people in different parts of the economy and of the world.[12]

The logic underpinning these thoughts are obvious; for there are probably more differences between people of African descent than there are similarities. However, the one common experience that binds Africans and African descendants is the victimization of racism and colonialism that spurred the *need* for social movements of common solidarity. Europe did not quibble over their national differences at the 1884–1885 Berlin Conference when the dividing of Africa into its current jigsaw puzzle configuration of national polities was created. The Portuguese, French, English, German, Danish, and Dutch, cooperated in their self-interest to divide the rich resources of the African continent among themselves as Europeans. They did not relapse into a philosophical discussion about their perceived common identity or lack thereof. "European" against "African" became the common theme and modern Africa was born. Similarly, self-interest and future survival, as well as my argument of cultural resonances, can be the basis for a twenty-first-century Pan-Africanism as a solid foundation on which black cohesion, as opposed to spurious racial identity, can be forged.

The celebratory symbolism of Ghana as the first independent African country, the importance of the Gold Coast becoming Ghana (named after an ancient African Kingdom) is a perfect example of such a *politically based* black solidarity at the turning point in European colonialism in Africa. Ghana's independence was supremely significant to the leaders of the Civil Rights Movement in the United States. Along with other civil rights leaders and prominent African Americans, the Rev. Dr. Martin Luther King attended the momentous March 1957 event. Yet the civil rights leaders were not the official US delegation; lead by none other than the vice-president under Eisenhower, Richard Nixon, who made a major blunder at the celebration. The following account of Nixon's revealing mistake at Ghana's independence celebration appears in Kevin K. Gaines' *American Africans in Ghana*:

> During the official festivities, Nixon reportedly asked several bystanders, "How does it feel to be free?," only to be taken aback at their response: "We wouldn't know. We're from Alabama." While the story of Nixon's faux pas captures the bittersweet meaning of the occasion for African Americans, it also suggests the impossibility of confining the problem of racial oppression to the Untied States. On Ghanaian soil, Nixon was compelled to meet with King, who had vainly sought to engage an apathetic Eisenhower administration on the issue of civil rights. The story of Nixon's failed attempt at small talk with African Americans he had mistaken for Ghanaians points to the transformative significance Ghana's independence held for black Americans.[13]

Indeed, upon returning to the United States, Reverend King delivered an important speech at Dexter Avenue Baptist Church in Montgomery,

Alabama, called "The Birth of a New Nation." Dr. King's speech was a definitive address on the meaning of African freedom to African American freedom, with Ghana as its sign. Nixon's blunder demonstrated how intertwined African Americans' and Ghanaians' histories are. The recognition of black Americans by Ghana, during Ghana's independence under Nkrumah, and the historical relationship of Ghana to African America have symbolized the historical oppression of the black world across the black Atlantic.

Nkrumah was overthrown by a *coup d'état* in February 1966, but during the nine years of his presidency, he accomplished great infrastructure feats, such as the Akosombo Dam that harnessed electrical power from Africa's largest man-made lake; built Tema Harbor to initiate industrialization in Ghana; as well as the Tema Motorway, Ghana's first highway, bridging the capital city of Accra and Tema, a city he had constructed around the harbor (See Map of Ghana in Figure 0.1). Unfortunately, Ghana suffered a series of

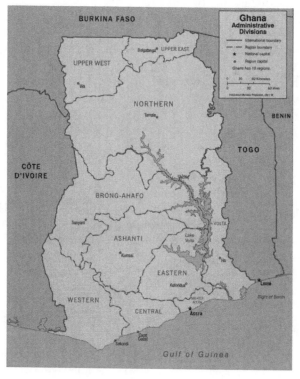

Figure 0. 1 Map of Ghana (Courtesy of the Library of Congress).

coups until Lt. Jerry Rawlings took power with his own government over-
throw in 1981 that hastily banned political parties. The national curfews
that ensued in the 1980s affected youth expression and shaped early aspects
of the hiplife music scene (Chapter 1).

Rawlings did, however, create a new constitution and reinstitute a mul-
tiparty system in 1992, the year he was elected president and then again
in 1996 under the National Democratic Congress (NDC). John Kufuor of
the rival New Patriotic Party (NPP) succeeded Rawlings in 2000 and was
reelected in 2004. It was during elections between the NPP ad NDC in
2008 that I did my initial hiplife research, and these elections figured prom-
inently into the hiplife music scene, which will be discussed in Chapter 4.
Eventually John Atta Mills of the NDC won in a close runoff election in
2008, and is the current president at this writing.[14] As becomes apparent in
this book, Ghanaian political history figures prominently in the story of
hiplife; and culturally, like many African society, music and dance has been
a part of Ghana's collective identity, with musicians and artists often becom-
ing pawns in political bids for power.

Ghana, today, is very interested in African Americans economically
as a tourist source. A 2004 survey by Ghana's Tourism and Diaspora
Relations Bureau reports that a little less that half of the tourists from
the United States were African Americans, and there were over a 1,000
black Americans living and working in Accra alone.[15] During my initial
2008 research, I lived and worked among African Americans who own
land and businesses, individually and in conjunction with Ghanaians.
Although there can be significant bureaucratic obstacles to foreign small
business owners, many blacks have transversed the red tape and become
major entrepreneurs, leaders of nongovernmental organizations (NGO),
and permanent residents of Ghana.

Tourism generated by the slave castles in Ghana (32 of the 45 old colonial
forts built by Europeans on the West Coast of Africa) continue to be one of
the major attractions for African Americans. When President Obama visited
the famous Cape Coast Castle on July 11, 2009, he spoke for millions of
Africans who had been enslaved in the Americas:

> As Americans, and as African Americans, obviously there's a special sense
> that on the one hand this place was a place of profound sadness; on the other
> hand, it is here where the journey of much of the African American experi-
> ence began. And symbolically, to be able to come back with my family, with
> Michelle and our children, and see the portal through which the diaspora
> began, but also to be able to come back here in celebration with the people
> of Ghana of the extraordinary progress that we've made because of the cour-
> age of so many, black and white, to abolish slavery and ultimately win civil

rights for all people, I think is a source of hope. It reminds us that as bad as history can be, it's also possible to overcome.[16]

The idea of overcoming this "bad history" has also prompted Ghana's "Right to Abode" congressional bill, first inaugurated by former President Jerry Rawlings in the early 1990s to recognize African diasporans as a special Ghanaian constituency that could have dual citizenship with special privileges. Even as this bill remains bogged down in Ghana's legislature, if passed it could eliminate the need to renew visas for people of African descent moving to Ghana to live and work.

New York-based Ghanaian musician Blitz the Ambassador perceives the need for reeducation of African Americans and Ghanaians about each other. Blitz, born Samuel Bazawula in northern Ghana, recognizes an important connection between the past Atlantic slave trade and today's overrepresentation of black males in "the prison industrial complex" in the United States. This perception is represented on his track "Ghetto Plantation" on his album *Stereotype*.

> I feel the Prison Industrial Complex that's global is repetitious of the Atlantic slave trade, and slavery in general. A lot of people do not make that connection—a parallel of what they think could never happen again. These parallels make you look closer, and not much has changed.
>
> I'm very in tune to what's happening with my brothers and sisters here, as well as my people back home. In Ghana they get a misconstrued picture of what African Americans here are. They think they are lazy and don't take advantage of the opportunities that they think are in the U.S. for them. They end up blaming the victim. There is miseducation on both ends of the spectrum [about each other]. My goal is cross-education.[17]

Blitz's connections between history and the sociopolitical situation of African Americans today in relationship to Ghana are at the crux of reeducation about the Black Atlantic continuing links.

Obama chose Ghana as his first African country to visit because of its relatively stable political and economic climate. Even though most Ghanaians live below the poverty line by US standards (the average Ghanaian makes less than US$4 a day), it has a GDP of US$9.4 billion and a US$420 per capita, ranking below most Asian countries, yet above the majority of African countries. In February 2006, The World Bank named Ghana the friendliest country in West Africa to do business.[18] This distinguishes Ghana within a continent wrought with political violence, famine, and poor technological infrastructure. These statistics and Ghana's long-term position within Black Atlantic history constitutes the context for the ongoing

cultural and artistic exchange, in which the hiplife movement is but another link in a long historical chain.

EARLY HISTORY OF HIP-HOP MUSIC
AND CULTURE IN ACCRA

It is within this reciprocity of Ghanaian–African American history that we find hip-hop entering the Ghanaian cultural lexicon in the mid-1980s. The early importation of the US street culture, like in most international locations before the ubiquity of the Internet, was through broadcasts in rap music on international radio stations, and the dance and cultural style of Hollywood movies such as *Beat Street* (1984) and *Breakin' 2: Electric Boogaloo* (1984) shown in movie theaters and eventually on video tapes around the world. A particular street style, social rebellion, and the hip-hop tenant of "flippin' the script" were first lodged among a group of young Ghanaian males known to sport a "sakura" style while living in the upper-middle-class Cantonment district of Accra. The implicit generational divide wherever hip-hop migrates arose almost immediately, as they wore baggy pants and boots, and were known for their baldheads, hence the term "sakura."[19] However, Ghana's particular hip-hop transference through ubiquitous American pop culture industries was augmented by Ghana's history with African Americans, and the older generation's negative reactions were mitigated by the musical arc of mutual inspiration.

Besides the generational divide working against hip-hop, initial hip-hop inroads into Ghana represented a class divide as well. The fact that these *sakura* youth grew out of a middle-class district of Ghana's capital, as opposed to the poorer sections of Accra that are closer to hip-hop's US ghetto signifier, reveals a complex class dimension to hiplife in Ghana. As Shipley notes, "Rappers such as Run DMC and Public Enemy first became popular with DJs, and at schools and universities among elite Ghanaians with access to travel, technology, and English language idioms."[20] Contrary to "ghettocentricity" that is partially constructed around hip-hop's commercialization, as well as to the real-life exigencies of the ghetto that some US rappers represented, hip-hop's importation into Africa initially demanded access to education, technology, and English language facility, both standard and ebonics. Hence, not only was hip-hop first adopted by college students with access to these resources, but many of the first-recorded Ghanaian rap groups were also formed in and around university campuses. The middle-class dimension of Ghanaian hip-hop complicates its more simplistic ghetto representation within in the United States.

Like most global localities outside the United States, early Ghanaian hip-hop was aesthetically an imitation with direct quotes from American raps, with Accra youth "spitting" Eric B. & Rakim, Big Daddy Kane, and

Public Enemy lyrics over recorded tracks. According to John Collins, noted pop music historian of West Africa, imitation of English-language rap over recorded hip-hop beat tracks was definitively the beginning of hip-hop in Ghana in the late 1980s and early 1990s, preceding the eventual development of their own hip-hop music that reflected a unique, if inchoate, Ghanaian sound dubbed "hiplife."[21]

However, these early-middle-class inroads of hip-hop eventually shifted to the poorer youth in Accra and Kumasi.

> Quickly these trends spread from elite youth with access to foreign idioms to non-English-speaking, uneducated youth...Hip hop bodily and musical aesthetics no longer symbolized African American rebellion but rather marked a form of cosmopolitanism and elite status through identification with Black Diasporic capitalist accumulation and global movement.[22]

In Shipley's analysis, we witness the adoption of the American rags-to-riches myth that attends the international adoption of US aesthetic idioms, with poorer urban youth in Ghana assuming the capitalist external symbols of hip-hop—baggy jeans, athletic shoes, and Timberland boots often second-hand from Nigeria. In an increasingly privatizing economy, the potential for appropriation of hip-hop was transferred to the larger sector of Ghana's poor as a part of the values of a globalizing cosmopolitan lifestyle (Chapter 3).

Another dimension of the early imitative hip-hop period in Ghana was openness to all forms of hip-hop music, not inheriting the growing divisions within US hip-hop about what is "the real" hip-hop. Blitz the Ambassador acknowledges a broad vision of hip-hop music culled from the early imitative days in Accra that tended not to categorize hip-hop.

> My hip-hop schooling in Ghana was very critical, and I had a particular vision of it. I came up in a good time, because we listened to everything without breaking it into commercial and underground. We listened to Talib Kweli and Company Flow just like we listened to Jay-Z.
>
> When you're trying to get here [to the US origins] you have a certain vision. I expected to find equality here also. Instead I found opposition and separation. The hip-hop that I grew to love had taken a back burner here in the States. I understood improvisation, and sampling jazz from what I listened to back home. For example, there were Coltrane samples in Tribe Called Quest. When I came here I had to outgrow hip-hop. People here (due to the commercialism of hip hop) treated the art with no regard. In my quest to find the real music I had to go to the source of hip-hop.[23]

Again, the cultural links between Ghana and African America are concretized, and when young musician such as Blitz found stagnation at one point

on the arc of mutual inspiration, they located other points in the historical cultural continuum to advance their musical development.

However, early hip-hop dance, which did not require verbal language for cultural transference, became the initial hip-hop element that originally surpassed rap in making institutional inroads into Ghanaian society. Like in other international sites, the different branches of the dance—breaking, popping, and locking—became important aspects of configuring this new African American culture in Accra. Legitimate and bootleg copies of music videos made their way to Ghana and were viewed in what were called "video centers," like Freedom Video Center in Accra, where youths could pay to view the latest dances. The school-age youths of the 1980s and early 1990s were able to experience the so-called modern dances with rhythmic torso isolations and fast-syncopated footwork, which were essentially reinvented African dance forms from the diaspora. Today hiplife music videos have become the dominant youth culture on Ghanaian television, with only occasional Jay-Z, Lil Wayne, and Nicki Minaj videos, which can be viewed on MTV Africa and Channel O out of South Africa for those with a satellite dish.

Before there were broadcasts of hip-hop or hiplife music on the radios in Ghana, and before today's televised hiplife videos on special youth-oriented programs, there were formal dance contests at local *highlife* dances under the auspices of the Ghana Arts Council in Accra. According to dancer-choreographer-producer Terry Bright Ofosu, "These dances included 'the robot,' 'break,' 'body pop,' and 'electric' dances. Competitions in these dances are now organized under a common heading [called] 'freestyle.'"[24] Hip-hop dance aficionados can place these styles into the "b-boying" [breakdance] and "popping" categories, the latter of which includes the robot and electric *boogaloo*. These direct imitations of American styles of hip-hop dances, although having origins in specific dances of particular African ethnic groups, were not traditional Ghanaian dance forms per se, and were therefore called "foreign dances." They were the visual dance counterparts to the imitative rap music emerging in Accra at the same time, but the music had no industry infrastructure at that point. But in the hip-hop dance scene in the mid-1980s, due to the nationally organized "Embassy Double-Do" competitions, the dancers began making some money,[25] while the musicians remained at the level of the street-sold mixed tapes. Hip-hop culture was imported in all its elements, including rap, breaking, deejaying, and even graffiti art; but the hip-hop expressive language of the body was the easiest element to transfer and develop locally, particularly because many moves could easily be recognized in traditional Ghanaian dances.

It was during this early imitative period that particular skilled dance personalities, such as Slim Busterr and Reggie Rockstone, emerged, with the latter eventually earning the title of Godfather, or "Granpapa," of Hiplife. While Slim Busterr continued to dance in the 2000s, teaching and performing the continually morphing hip-hop dance moves to the current generation of Ghanaian dancers, Reggie Rockstone, like many b-boys, eventually graduated into the more lucrative rap business.[26] Through his use of indigenous language, he helped to usher Ghana out of the imitation phase into the adaptation and indigenization phases that I explore below and in Chapter 1.

REGGIE ROCKSTONE: "THE GODFATHER OF HIPLIFE"

A thorough examination of Reggie Rockstone's background is necessary to fully understand the development of hiplife in Ghana, as well as the complex global-local problematic that underpins hip-hop outside the United States. Rockstone was born Reginald Asante Ossei to Ghanaian parents, father from the Akyem and mother from Ashanti ethnic groups, both a part of the Akan clan. He was born in London, and taken back to Ghana at one-year old, remaining there through the mid-1980s. As a young adult, he also moved to the United States with his father, living in the hip-hop centers of New York and Los Angeles, and settling in London by the late 1980s. His father was an internationally recognized fashion designer, exposing Rockstone to many high-powered celebrities in the emerging hip-hop scenes between the United States and England. After his parents divorced, his father married an African American woman, crowning Rockstone with the "authentic" credentials to become the Ghanaian with direct American hip-hop roots, while still being local.

> Because of my background, I was exposed to a lot of information. My father lived in Crenshaw [black community of Los Angeles—home of Ice-T] for many years doing fashion. And of course, my [step]mother was a model. It's a collage, and with the traveling [back and forth] it was a lot of information.[27]

Following his father's profession, his first foray into hip-hop was actually in fashion, buying "authentic" hip-hop gear in New York from the famous Dapper Dan in Harlem and then selling them in London. "These were the fly days—with the rope chains and the four finger rings. Yeah man, it was great times in hip-hop, and I was there."[28]

Indeed, Rockstone's London, New York, and LA Crenshaw district experiences maps him onto some of the seminal events and personalities that

shaped hip-hop in the United States and in the United Kingdom. As a youth living in Great Britain, he started a London–New York hip-hop clothing "corridor," selling hip-hop gear and pimp/playa wear made by Dapper Dan on 125th street in Harlem, in London.

> When I was in England, after I came back in my teenage years, and after going to secondary school in Ghana, I would always go get New York clothes and sell them in London. They love the hip-hop gear. And there is a brother called Dapper Dan, right there in Harlem on 125th, who is a Ghanaian; not too many people knew that; but I don't know if he came back [to Ghana].
>
> My hustle worked because in London they always do the retro, they always do the old school. I would sell my clothes I got from Dan to General George's in London. But Dapper Dan used to fake the Gucci. 'Cause I seen Jadakiss rocking it and all of them. I remember seeing Big Daddy Kane in a goose down Louie Vittan jacket, and I know Louie didn't make that. He had the hat to match and everything.[29]

Rockstone's early transatlantic hip-hop life did indeed put him at the center of the development of not only the music and dance, but also the style and "floss" of the developing culture that he helped facilitate. In fact, the Dapper Dan–Reggie Rockstone connection, as Ghanaians, is a testament to the Ghanaian–African American connection that underscores the mutual cultural histories.

When he returned again to Ghana in 1994, his direct hip-hop experience abroad allowed Rockstone credentials to position him as a cultural broker for Ghanaian youths precisely because he knew Ghana and his father's Twi language. He was literally mapped by his lived experience of hip-hop both in its US origins and in its diaspora of England, Ghana's colonial mother country. He had created his own kind of contemporary "triangular trade" between Ghana, England, and the United States that continued to inform his persona, as well as how he is perceived in Ghana to this day.

Language has always been at the heart of the authenticity debate within hip-hop. Ghanaian highlife musicians forged a cultural fusion that constituted *that* popular music genre since the 1920s. As a Ghanaian musical precursor to hiplife, highlife developed out of early US jazz and Caribbean calypso with Ghanaian rhythms and melodies, usually sung in pidgin English of Accra, but interspersed with indigenous languages. Early Ghanaian hip-hoppers, trying to follow the "keeping it real" tenet while rapping in English, needed "permission" to find their own voice by using their own languages and pidgin slang. Reggie Rockstone became the "permission giver" for local

Ghanaian youths with his first attempt to rap in Twi, revealing his father's central place in his rise to fame, as well as the place of language in the institutionalization of new forms of pop music in Africa.

> My father was making clothes for all the famous highlife stars. He was making clothes for one of the biggest artists by the name of Kojo Antwi. He came over to my father's to get his new outfit for his show that night at the new National Theatre (about 1994), and he said that my father had told him that I was a rapper. He told me if I came to his show that night, he would give me a shot. I remember turning up late with some short pants and Timberland boots on with this African American girlfriend of mine who had been living in Ghana longer than I had at the time. K.K.D. was the emcee, and he announced me as "The Son of St. Ossei," which is what they called my father. I did the first sixteen bars of a Twi rap, and everyone was silent, and then I repeated it verbatim, and they went crazy applauding. I guess they couldn't believe their ears the first time. Kojo Antwi invited me for three more shows after that.[30]

Twi is the lingua franca of Ghana, as the language of the Ashanti, the largest ethnic group in the country. Even though today Ghanaian hiplife music is sung in the other major languages such as Ga, Ewe, and Hausa, Twi is the language that allows all Ghanaians to speak in an indigenous language to each other. As Ghana's lingua franca, Rockstone's popularizing of early hiplife music in Twi was significant.

A brief recounting of Rockstone's family lineage in relation to Ghana's history situates hiplife music strategically in the larger Ghanaian narrative. His late father's name was Ricci Evans Osei. He changed the spelling of the family name to Ossei, and his first name from Evans to Ricky, but spelled it "Ricci," after the Italian. Ricci Ossei was born in a small mining village called Akwatia, in the Eastern Region of Ghana west of the Atewa mountain range in the Birim River Basin. During the colonial Gold Coast era, diamonds were discovered near the village, which brought British administrators to reside in Akwatia.[31] Rockstone remembers one of the primary family stories that changed his father's life path forever.

> The first President, Kwame Nkrumah, came to our town, riding on a platform in his special car and wearing his kente cloth, as he was famous for. All the people of Akwatia came out to greet him. My father, a very creative young boy, had made a toy replica of Nkrumah riding in his platform car, complete with the kente and everything. Someone held up my father, and he, in turn, held up his toy above his head that was a replica of Nkrumah in his car waving to the people. Nkrumah saw it and called this small boy to be brought to him. Nkrumah was very impressed.[32]

Rockstone's father's creativity had so impressed Nkrumah that he later sent a representative of his administration to have Evans Osei (to become Ricci Ossei) brought to him in Accra. Nkrumah gave him a scholarship to middle and secondary school and eventually to a college in London. Rockstone assesses the importance of this phenomenal story that changed his entire family's life, including his own.

> Nkrumah used to do this for a lot of people. So, it was due to my father's creativity and Nkrumah's generosity that my father ended up in London. He met my Ashanti mother Anna, a nurse, and I was born in London. My father always had his own style, and he knew how to hustle. As a university student he eventually got into gambling at high-end West End clubs in London. He got in easily because of his unique style of dress and charisma. When the coup that overthrew Nkrumah happened, all students who had been sent abroad for schooling by his administration were called back to Ghana. Instead of returning to Ghana, my father went to the U.S. and took me with him. And by the way, he was always a Pan-Africanist like Nkrumah.[33]

Through Rockstone's personal story, we see Nkrumah's plans early on for an educated Ghanaian elite, as well as how the United States and Pan-Africanism figured prominently into the history of Ghana during the pre-hiplife period.

The Ossei family's history is intertwined with the events that shaped Ghana's first nine years as Africa's first independent nation under Nkrumah. This linked personal and national history serendipitously positioned Reggie Rockstone (Reginald Ossei) for his multiple cultural influences that allowed a particular "collage" of global and local intersections so seminal to the hiplife generation of Ghanaian youths. The "authenticity" accorded Rockstone's US- and UK-perceived experiences melded old school hip-hop musical influences with Ghana's twenty-first-century highlife pop music. He validates his early hip-hop sources abroad: "My influences were James Brown, Blow Fly, Grandmaster Flash, Cold Crush Crew, Funky-Four + One, and then in Ghana there was Gyedu-Blay Ambolley."[34] The latter artist's influence is an important link between the highlife sound and the developing hiplife approach growing out of the initial imitative Ghanaian hip-hop phase; Ambolley is explored in Chapter 1. The "street cred" that Rockstone's life abroad provided him was the all-important ingredient, in the eyes of Ghanaian youths, to spark a revitalizing phase of hip-hop adaptation that countered the mimesis of inferior English-language rhymes over rudimentary hip-hop beats.

Rockstone's transition from fashion to performance—to becoming an emcee—also happened in London before he returned to Ghana in the

early 1990s. He met a Sierra Leonean rapper Freddie Funkstone and they teamed up with a well-known London deejay, DJ Pogo, to form a hip-hop group called Party á la Mason, or PLZ (Parables, Linguistics, and Zlang).

> Funkstone was the one who was rapping. He convinced me to try to "fake the funk," but I was always feeling like I didn't know what I was doing, because "I didn't."[35] Freddie knew a legend in London, and convinced him to check out a demo we made, and that's how we got started. But even before that, I first joined the Gravity Rockers, a B-boy group. My b-boy name was R2D2 from *Star Wars*, and then I changed it to Reggie Rockstone, to match Funstone's chosen name.

PLZ would be Rockstone's novice attempt at rap in the artistic vein of the L. L. Cool J–Whoodini—Mr. Magic era of early rap.

His early lack of rhyming skills belied his London period as training for what was to become his true calling: after returning back to Ghana, his "collage" life experiences allowed him to put Ghanaian hip-hop on the map by using his mother tongue. My first Twi rap was in London at Panji's [Panji Anoff—Ghanaian sound engineer-producer] first wife's house. "I created two verses, but I didn't do anything with them at that time." Everything was leading to Rockstone's return to Ghana for his fateful meeting with a new form of Ghanaian music.

> The Jungle Brothers were appearing at a London Club, and my deejay, DJ Pogo, was playing for them, and even Moni Love was there. They are the ones who told me that there was a festival starting in Ghana called Panifest. I just thought that would be the venue to return and do my thing. I called my father [who was now back in Ghana] and told him, "I wanna come home."[36]

It was appropriate that a festival celebrating Ghana and the African diaspora, Panifest, would be the venue to bring Reginald Ossei, having now become Reggie Rockstone, back to his roots to facilitate an entirely new contemporary musical sound. After his chance performance at the National Theatre in Kojo Antwi's highlife show, Reggie's performance at one of the early Panifest performances became his larger exposure for his new Twi raps. He was destined to instigate a whole new form of music in Ghana, with which he will forever be associated. (Figure 0.2 is a photo of Reggie Rockstone wearing an appropriate "I Am Hip-Life" T-shirt during one of our interviews.) A summary of hiplife's history will provide a background to understand the issues generated by Reggie Rockstone's revolutionary act and the development of hiplife music in Ghana.

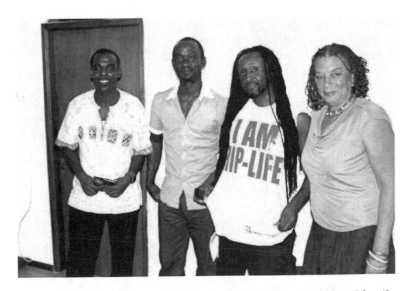

Figure 0.2 Reggie Rockstone, wearing his "I Am Hip-Life" T-Shirt with Terry Ofosu (far left), an assistant to Rockstone, and the author (far right) (photo courtesy of Gene Howell).

HIPLIFE'S BEGINNINGS IN ACCRA

Many other emcees and producers percolating in the cauldron of Ghanaian imitative hip-hop also helped develop the next stage of the new sound as the first generation of hiplife music. Producers such as Panji Anoff, Abraham Ohene Djan, and Michael Cook, all of whom started in London with Rockstone, along with Rab Bakari, Zapp Mallet, Talking Drum, NFL, and Adinkra Clan, contributed different aspects to hardcore hip-hop beats and local highlife rhythms that developed into Ghanaian hiplife. Anoff started Talking Drum, consisting of Kwaku-T and Abeeku The Witch Doctor, and produced a song called "Aden?." During the same time Michael Cook wrote "Tsoo Boi" (Heave Ho) for Rockstone, using the term "hiplife" in the second verse, becoming the first recorded rap in Twi. Ohene Djan, owner of one of the oldest music and video studio in Accra, OM Studios, remembers these two songs as the beginning of recorded hiplife music:

> Really, if we had to date hiplife from a specific point, I would say it would be Reggie's "Tsoo Boi" and Talking Drum's "Aden?." It's those two songs that really were the first hip-hop videos. And "Aden?" used an Osibisa sample; so Mac Tontoh [late highly respected highlife artist] was working on it, and basically it was his music, so they were using it to do hip-hop. He was very much into trying to help them create something more authentic, much more localized if you'd like.

Initial hiplife music was developed by creative experimentalists, with the emerging inchoate "new" genre grounded in the "old" established pop sound of highlife that Ghanaians already understood and that was grounded in solid musicianship. Mac Tontoh of Osibisa helped put highlife music on the international circuit. Tontoh died in 2010 during my fieldwork, and well-known highlife and hiplife musicians alike headlined his memorial concert. Musicians of both generations paid tribute to him as a Ghanaian musical genius. Just as James Brown, Chic, Kool and the Gang, and Parliament Funkadelics were the typical samples from soul, R&B, and funk music genres in the United States, young Ghanaian musicians began to use Mac Tontoh and Osibisa samples at the beginning of the development of the new hiplife sound.

Yet the media support of the new hiplife sound was sparse because it was initially viewed as a poor imitation at best and a foreign invasion at worse. In addition, hiplife came to the public's attention during the time of martial law under the first Rawlings regime, with its street curfew that was enforced from 6:00 p.m. to 6:00 a.m. Therefore, there was increased pressure on media to showcase all Ghanaian music, because live shows were at a premium. GTV (Ghana Television as the state-run TV channel) was one of the few television stations in the early 1990s, because many of the channels broadcasting out of Nigeria and South Africa today had not yet established themselves in Ghana. Early pop-formatted radio stations like Vibe-FM and shows such as B. B. Menson's "The Night Train" on Radio Gold, began functioning during the mid-1990s, and would occasionally take a chance with the new hiplife sound.

Ghanaian radio, like most international sites, played Tupac and Biggie Smalls during the mid-1990s, even if the people didn't understand all the English lyrics, especially hip-hop slang. "People were like, 'Who'd wanna listen to this?' The majority of what was being played on the radio was foreign—it was about 98% foreign music. Occasionally on GBC [Ghana Broadcasting Corporation] you'd hear local highlife."[37] American pop culture dominating the international airwaves was hegemonically all-pervasive, creating an environment that rendered local music as illogically noncommercial. When Rockstone's first album *Maaka Maka* (If I said so, I said It) "dropped" in 1997, there was little hiplife music being played on the radio and certainly few music videos on television, but it was his fearless bravado that caught the youths' and media attention; and it was important for the media to broadcast this new kind of individual bravado for hiplife's development. Metro TV (originally called Media 1) was the first independent television station in Ghana to welcome freelance producers like Panji Anoff and Abraham Ohene Djan to produce hiplife videos on their new "Smash TV" program, inherited from GTV. It was through this show's exposure

of beginning hiplife videos that the new local style began to penetrate Ghanaian culture.

I argue that two more generations of emcees emerged as hiplife progressed, representing the "adaptation phase" of hiplife, eventually evolving into the current "indigenous phase." Joining immediately with Reggie Rockstone in the early days of hiplife were emcees such as Lord Kenya and the group VIP or Vision in Progress (Lazzy—Abdul Hamidu Ibrahim, Prodical—Joseph Nana Ofori, and Promzy—Emmauel Promzy Ababio). VIP is a perfect example of a group of young rappers emerging out of Nima, one of the poorer districts of Accra, and forming their own record company, Boogie Down Nima (after KRS-One's Boogie Down Productions in the Bronx, NY). They implicitly challenged the upper-middle-class dimension of hiplife that produced young emcees emerging from the small, educated middle class of Accra. VIP showed the majority of poor youth in Accra that hip-hop/hiplife was actually an economic way out of poverty, as well as an exposure to a larger world. Lord Kenya reinforces one of the primary concepts of hip-hop in relation to Africa, viewing the continent as the actual source of the youth culture.

> I'm a true African boy who knows how to *make an African out of the computer.* I wouldn't say I've been influenced by Hip Hop, because we have structures here in Ghana. To me what I'm doing is not something I borrowed. I am doing something indigenous. Everybody samples. At the end of the day I listen to Busta Rhymes [Put Ya Hands Where My Eyes Can See] and I know its indigenous African music. It's evolution.[38]

Issues such as class and the origins of the hip-hop aesthetic arose as early hiplife music developed, advancing savvy emcees' individual artistic identities and general musical creativity as it became a new form of entrepreneurship and youth agency.

One of my major arguments in this text is how these mid-to-late-1990s artists represented a turning point in the development of hip-hop in Ghana as the first generation. They experimented musically to set themselves apart in the increasingly international big business of hip-hop by rapping in various indigenous languages, yet continued hip-hop synthesized tracks. This bold, but necessary, development in Ghanaian hip-hop represents the "adaptation phase" of hiplife music: from approximately 1995 to 2000 the adaptation of Ghanaian languages, such as Twi, Ga (the language of the majority ethnic group of Accra), Ewe (spoken in southeast Volta region), and Hausa (primarily spoken in the north), was used in raps accompanied by hip-hop looped beats. This culturally empowering phase alluding more indigenous rhythmic phrasing and play on words and metaphors alluding to familiar Ghanaian myths, national social incidents and campaigns, as well as local imagery that

localized the new music. Hiplife lyric content began to contextualize local issues in the discrete Ghanaian experience and even particularized Accra neighborhood's braggadocio. Original issues promoted by the imitation phase, such as flaunting one's formal education, facility with English, and the money to imitate faux Gucci, Fendi, FUBU, and Addidas brand names became less of a priority. The utilization of local languages automatically modified class issues that were a part of the transference of American hip-hop, and simultaneously empowered Ghanaian youths to represent their local lived experience, while continuing to be "fly" and hip-hop. Tony Mitchell has theorized this adaptive process as hip-hop globalized.

> Hip-hop and rap cannot be viewed simply as an expression of African American culture; it has become a vehicle for global youth affiliations and a tool for reworking local identities all over the world. Even as a universally recognized popular musical idiom, rap continues to provoke attention to local specificities. Rap and hip-hop outside the US reveal the workings of popular music as culture industry driven as much by local artists and their fans as by the demands of local capitalism and U.S. cultural domination.[39]

As hiplife musicians and their developing fan base "rework[ed] their local identities," the more a new music genre that transcended imported hip-hop began to emerge.

Since about 2002, the second hiplife generation developed a wide variety of styles that began what I call the "indigenous phase" of the genre by moving it beyond the mere shift in language. More corporate infrastructure also aided this new process, particularly the Ghana Music Awards that started in 2000 and came of age with the development of hiplife music (Chapter 3). Second-generation hiplifers began to represent a wider aesthetic range as they concentrated on indigenizing the rhythms and melodies in various individualized methods. Contemporary hiplife artists such as Kwaw Kese, Tinny, Tic Tac, and Obrafuor began to embolden the hiplife sound with catchy highlife melodies and fast-paced raps that often included Jamaican dub music.

As the Caribbean/Jamaican reggae-dancehall and calypso sounds merged with the Ghanaian developing hiplife sound, musicians who privilege those genres are often categorized in the hiplife genre. The Ghanaian dancehall musicians represent what Collins calls the "raga" Caribbeanized sound that has Jamaican ragamuffin influence. One of the main award-winning artists in this category is Batman Samini from Dansoman City, a suburb of Accra. Sporting dreadlocks, often with head wraps, this musician has his own multicultural style blending hip-hop and reggae that has garnered him a large fan base and several African music nominations and awards. Okyeame Kwame,

from Kumasi, has been recognized across the entire continent, often with his strong emphasis in the United States South-based crunk rhythm, which he theorizes has strong Ashanti influences (Chapter 2). There were also early female emcees, such as Abiriwa Nana and Mary Agyapong, the latter giving Samini his start by featuring him on her second album. The result of the individuation of the inherited hiplife sound by the second generation was an increasingly localized approach that often sounded closer to the parallel genre of *contemporary* highlife than hip-hop, pushing the genre to a new level of popularity that began to appeal even to the older highlife generation of Ghana.

This collage-like indigenizing process developed hiplife artists who began to sound not like received globalized hip-hop, but artists creating a unique Ghanaian musical sound that set it apart in pop music across the continent. It also allowed individual musicians to establish their own entrepreneurial brands. One such artist is King Ayisoba, who has evolved a "roots man" persona that utilizes his Upper Region Frafra language, along with particular trademark primal guttural sounds, while often performing in nothing by a loincloth (Chapter 2).[40] There are also consciously political hiplife emcees, such as Obour, who has centered many of his raps on Ghanaian social issues, such as promoting peaceful elections in 2008, a celebrated accomplishment for Ghana (Chapter 4).

Twenty-something hiplife emcees abound as today's third generation of hiplife has emerged, solidifying the indigenization of Ghanian-style hip-hop. Contemporary hiplifers of the second decade of the twenty-first century have a much stronger industry infrastructure in radio, television, and the Ghana Music Awards, as well as several African music awards continentally, in which to compete. Many of them have won numerous awards in the increasingly prestigious Ghana Music Awards for "Artiste of the Year," "Song of the Year," and "Hiplife Artiste of the Year." Increased technology, through ringtones and social media, and networking on the Internet, has enhanced their international profiles. In 2010, artists such as Sarkodie, Edem, Asem, Richie, Trigmatic, Iwan, D-Black, and Wanlov Kuborlor, as well as young female artists such as Mzbel, Mimi, and Eazzy, all vied for various audiences globally as the hiplife genre splinters into styles that have been labeled, Gh-Rap, Afro-Pop, Twi-Pop and others.

At this writing, hiplife music and culture have evolved over a 15-year period, progressing with predictable attendant issues of representation of African identity and cultural hybridity, hip-hop origins myths, corporatization, and globalization and cultural hegemony. Three generations of hiplife artists form an indigenizing continuum in Ghana, from an African roots imaging to urban pidgin hybridity to the much-imitated pimp/playa image familiar in the United States. There is even a "back-pack outcast" image in

Ghana as well, especially on the many university campuses. The indigenization process of received hip-hop evolving into local hiplife created key central issues explored in this text, such as the following: (1) local identity as negotiated by young Ghanaian hiplife artists, (2) hiplife artists changing Ghanaian society through the marginality of youth, (3) global transnational corporate power driving the economics of Ghanaian popular culture, and (4) hiplife artists' counter-hegemonic projects operating in the context of the government's neoliberal economic strategies.

BREAKING IT DOWN: THE CHAPTERS

Chapter 1, "'Making An African Out of the Computer': Globalization and Indigenization in Hiplife," engages theories that emphasize locality in the globalization of American pop music, while examining hiplife's equal origins in twentieth-century Ghanaian highlife music. I explore hiplife music from its highlife origins as a whole new form of world music, highlighting highlife artists from E. T. Mensah in the post–World War II era to today's highlife artists such as Gyedu-Blay Ambolley. I also interrogate the origins myth of hip-hop's beginnings in the Bronx that African hip-hop implicitly challenges. Many contemporary African emcees emphasize hip-hop's aesthetic origins in Africa, pointing to their own traditional local practices that underpin the artistic principles, disputing hip-hop's US-origins in the Bronx, while "flippin' the script" on the notion of African hip-hop imitation of the United States. This chapter provides detailed accounts of some influential contemporary hiplife artists, allowing me the opportunity to analyze their stories of place, class, gender, and individual artistic choices, as well as close readings of lyrics from influential hiplife songs over the last decade. In so doing, I demonstrate the complex global-local dimensions of the new contemporary contribution to world music called "hiplife."

"Empowering the Young: Hiplife's Youth Agency," as Chapter 2, investigates an important dimension of Ghana's new music genre that is generated from the marginality of youth. I continue my exploration of "youth" as a construct that represents a distinct marginal status in most societies, introduced in *The Africanist Aesthetic in Global Hip-Hop*. This ethnography of hiplife's impact on Ghana necessitates an investigation of the influential power generated from its youth proponents who live in a society that traditionally had few avenues sociopolitically for allowing youths to express themselves. I utilize Cultural Studies' subculture theory, initiated out of England's Birmingham School, to deconstruct the symbols and significations that have been generated both from received hip-hop culture and Ghanaian semiotics since its independence from colonial rule. It becomes clear that Ghana, as a typical African society that reveres eldership, has been

greatly affected by hiplife as a youth-dominated culture emerging in the mid-1990s. During my fieldwork, I also traveled to an important regional hip-hop festival in Ouagadougou, Burkina Faso, allowing me a comparison of Francophone and Anglophone hip-hop that places Ghana's hiplife in a larger West African context. In the process, I analyze two important hiplife artists, King Ayisoba (who appeared at the Ouagadougou festival), and Okyeame Kwame.

Chapter 3 shifts to the decidedly economic and sociopolitical context in which hiplife music is situated. "'Society of the Spectacle': Hiplife and Corporate Recolonization" examines neoliberalism as the global free market agenda that often acts as a new form of colonialism. Ghana's ubiquitous telecommunications companies, which are integrally involved with marketing hiplife music artists, are investigated as multinational corporations representing late capitalism. The telecoms' central involvement with Ghana's economy today is further contextualized within the much-touted Structural Adjustment Programs (SAPs) of the World Bank and International Monetary Fund (IMF), examined from a Ghanaian historical perspective. In addition, I investigate an increasing interest in Africa as a pop music market, as well as African musicians' potential for increased global exposure, through more local business involvement, such as the Charter House's Ghana Music Awards. Hiplife's economic potential is becoming a prime profit motive for American pop culture giants such as Viacom's MTV Base Africa and South Africa's Channel O. Therefore, hiplife music is situated in the global free enterprise market that is casting a wide net over the African continent, creating both opportunities and threats for hiplife music artists.

In Chapter 4— "'The Game': Hiplife's Counter-Hegemonic Discourse," using Cultural Studies theory, I define and explore the counter-hegemonic projects of hiplife music particularly through the artist-activist Obour. As an artist who exposes the threats to hiplife and Ghanaian society in general, he has become recognized for his social campaigns that tackle long-standing African social issues. His hiplife music and his sociopolitical activism form a counter-hegemonic story to illustrate how what started as imported American popular youth music in Ghana was not consumed wholesale, but was instead transformed for its own local needs through the indigenization process. Obour and Okyeame Kwame's song, "The Game" becomes a trope for necessary self-reflection about hiplife music having come of age and the attendant dilemma that its maturation process has engendered at the beginning of the second decade of the twenty-first century.

The Hiplife in Ghana: West African Indigenization of Hip-Hop is quintessentially an ethnography of Ghana's hip-hop scene that becomes another example of the youth culture's internationalization. In the process, corporate

neocolonial forces interacting with youth agency through popular music is illuminated as a contemporary global dynamic in the postmodern era of late capitalism. Hiplife has distinguished itself within African popular music by indigenizing a received American pop music form, and in the process transforming it into an entirely *new* world music genre. Hiplife in Ghana becomes another youth music revolution that fundamentally challenges African traditional social order while allowing a new generation of young Ghanaians to find their voice that speaks to African realities and dreams in the twenty-first century.

"MAKING AN AFRICAN OUT OF THE COMPUTER": GLOBALIZATION AND INDIGENIZATION IN HIPLIFE

ARE YOUNG HIPLIFE ARTISTS IN ACCRA MERE IMITATIONS of Jay-Z, Snoop Dogg, Kanye West, Eve, and Nicki Minaj? Are contemporary Ghanaian musicians and their fans trying to replicate American hip-hop wholesale? Perhaps the larger question is, are local cultures in Africa subsumed by a global cosmopolitanism constituting a new brand of colonialism that engenders a "foreign" identity among the local youth generation intent on being "modern" and "hip?" The answers to these questions are both simple and complex, representing convoluted realities of how culture travels, encounters both complicity and resistance, and reconstitutes itself in various hybrid forms.

Hiplife is not the first Ghanaian performance to receive scrutiny as to its cultural authenticity in relation to the United States. Catherine Cole interrogates the colonial era's Ghanaian concert party as a theatrical form that utilized inferences of American minstrelsy, including controversial blackface, which supposedly countered the concert party's "indigenous roots in storytelling traditions known as *anansesem*."[1] Using Roach (1996), she rightly analyzes that "concert parties partake in a process of displaced propagation in which historic practices adapt to changing conditions and new locales."[2] Indeed, hiplife partakes in the same indigenous Akan *ananse* spider tales that have been historically ubiquitous in Ghanaian culture, as well as incorporates circulating twenty-first-century fictive identities such

as the pimp/play and street-thug roles situated in US hip-hop that become acclimatized to local needs in today's Accra. These two hybrid Ghanaian performances, some 70 years apart, both utilize globally circulating stereotypes generated by American racializing imaginaries. Both performance modes—concert party and hiplife music and culture—engage hybridity through imported black stereotypes, as well as through long-standing local cultural traditions.

Indeed, similar postcolonial performance processes such as Ghanaian hiplife circulate throughout the African continent. Michael Wanguhu's 2007 film documentary on Kenyan hip-hop, *Hip-Hop Colony*, offers a challenging example of hip-hop culture as "a new breed of colonialization." He analyzes, "In the vein of colonialism, [hip-hop] is dictating the choice of attire, language and lifestyle in general." But, he concludes about this new brand of foreign invasion, "unlike the [British] colonialists its presence is welcome and wildly embraced by the majority [of youth]." Wanguhu's film subtitle says it all: "The Revolution That Can't be Ignored."[3] Back in Ghana, just as concert parties contained ideologies and characters representing the shifting social structure of colonialism, including the "Fante 'gentleman,' the anglicized African 'lady,' the domestic worker from Liberia, the Muslim malam, the urban good time girl, the traditional Ghanaian 'cloth woman,' and the city slicker young man,"[4] so too do today's hiplife youth "perform" the sagging baggy-jean hipster, the stiletto-heels-wearing third-wave empowered African feminist, and the mobile phone tech junkie. Globalized performances are filtered through local identities, while era dictates specificity.

African *political* colonialism ushered in by European military dominance in the late nineteenth century has now been replaced by a willing twenty-first-century *cultural* colonialization that some perceive as no less sinister in its hegemony and ubiquity. It is precisely hip-hop's welcomed presence by worldwide youths that has implications for the very nature of twenty-first-century global cultural transference. Simultaneously, hip-hop's international embrace by youth carries with it questions about hip-hop aesthetics' exact origins, particularly when examining its presence in Africa. This chapter explores how the local and global intersect in increasingly intricate ways viewed through the phenomenon of hiplife in Ghana.

GHANAIAN HIPLIFE, GLOBALIZATION THEORY, AND "THE BOOMERANG HYPOTHESIS"

Ronald Robertson's concept of the "glocal" that conflates global influences and local practices—what Bourdieu calls *habitus*—encompasses the story of hiplife in Ghana.[5] Theories of the relation of the global and local as

polar opposites are not only simplistic, but are also ultimately not useful in deducing the complexity of how groups mediate the inevitable social phenomenon of foreign cultural influences. "Glocal" is a concept that captures hip-hop's circulation quite succinctly, with youth in discrete locations increasingly comfortable with creating a cultural "mash up" as their collective identity. Hip-hop youths in Africa signify the intricacy of the global and local simply and naturally, allowing local practices and received Western influences to connect organically as their own subjectivities. Bourdieu explains habitus as "a subjective but not individual system of internalized structures, schemes of perception, conception, and action common to all members of the same group or class . . ."[6] This schematic of agreed-upon cultural conceptions allows a culture or subculture to recognize itself, and it is precisely this recognition of "internalized structures" that has allowed hiplife to go through several phases of indigenization on its journey to becoming a society-wide accepted new genre of music in Ghana.

The evolution of Ghana's hiplife music is situated within the arguments of the social, cultural, and economic explanations about how global cultural forces intersect with local realities. Therefore, before I explore how hiplife artists in Ghana represent this hybridity, I first theoretically investigate the global-local problematic. I have discussed various theoretical frames extensively in the previous book, and here I allow those arguments to dialogue with more recent analyses. Indeed, today's hip-hop scholars, such as Pennycook and Mitchell, are challenging the notion that the global is hegemonic and imperialistic in the global-local equation:

> While this perspective captures several important points—Hip Hop is indeed a globally marketed phenomenon, and American Hip Hop is dominant, particularly in English-language media—it fails to engage with the different circuits of flow through which Hip Hop circulates globally, the diversity of local appropriations of Hip Hop, or the coevalness of origins and the roles of mimicry and enactment.[7]

In analyzing Ghanaian hiplife, for example, it becomes clear that Western musical influences were already present in Ghanaian pop music. Ghanaian hip-hop can be perceived in reality as a revision of Ghana's own local popular sounds, language, and cultural propensities that existed throughout the twentieth century. As Gilroy (1993) and others have made clear, circuits of cultural flow have been a part of black Atlantic cultures for centuries, and are not superficially traceable to the ubiquity of today's twenty-first-century usage of the Internet, or even global media generated from the United States initiated by late twentieth-century capitalism.

It is obvious that contradictory messages and symbols of globalized hip-hop emanate from African American culture in the United States. South African hip-hop scholar Zine Magubane records this ambivalent core of "dual tendencies with respect to Western modernity" when she explores African American hip-hop culture that celebrates both materialism *and* community as it circulates throughout Africa.

> On the one hand, rap music celebrates individualism, racial chauvinism, consumerism, capitalism, and sexual dominance—core values that have shaped the trajectory of modernity and its bitter fruits, particularly for people of color...On the other hand, rap music has also provided a powerful critique of Western modernity. The rap music produced by artists like Mos Def and KRS-One offers an alternative worldview that eschews violence and market values while promoting respect for the community and reverence for the historical struggles undertaken by communities of color around the globe.[8]

These perceived contradictory dynamics of US-globalized rap music are a part of today's international cosmopolitan lifestyle, revealing itself as sexist individualized materialism encountering a resistive counter-hegemonic communalism in the twenty-first century. Magubane suggests, "As a result, when it is 'indigenized' both elements become available for interpretation and incorporation."[9] Indigenization, thus, becomes both a part of the antidote to hegemonic individualized consumerism, and simultaneously the means by which the entire process is promulgated. The latter part of this chapter illuminates these dual elements in several Ghanaian hiplife artists' aesthetic motivations and careers.

Today's African youths do not accept hip-hop uncritically. Their critique of American hip-hop represents a healthy resistance along with their complicity with it. For example, opposition to predominant American hip-hop *narratives*, often antithetical to contemporary African realities, also prevails.

> We should care more about our hunger problems...we live in a country where we have poverty, power, race...you know ethnic wars and stuff like that. So we couldn't afford to go like Americans, talking about "Bling Bling," calling our pretty women "Hoes" or stuff like that. So we couldn't afford that.[10]

This critique by Senegal's Daara J, quoted in Pennycook and Mitchell (2009), echoes sentiments throughout Africa and regions of the diaspora, such as Brazil, where the "keeping it real" tenet of hip-hop forces them to challenge deleterious American hip-hop representations. The superficial adoption of hip-hop's American commercial trappings during its inevitable initial imitation phase eventually is not adequate for local needs, and an internalizing of hip-hop practices eventually necessitates a self-reflexive stance in relation to

one's own sociocultural circumstances. Reaching this point, Daara J reveals, "So that's why we went out at a point where we began to realize...you know...that rap music was about the reality and therefore we went back to our background..."[11] African emcees ultimately arrive at their own "background" stance as the foundation for adaptation, which, in turn, can lead to the eventual indigenizing of hip-hop where a *new* musical culture evolves.

The question of hip-hop's *origins* compounds the contradictory hegemonic and counter-hegemonic elements of global hip-hop in Africa. If hip-hop performance patterns are African in nature, did the culture originate in the South Bronx or on the continent? Many African hip-hopers argue for hip-hop as a received US aesthetic, the source of which was *already* present traditionally among the West African Ashanti, Ewe, and Dagomba in Ghana; the Wolof in Senegal; and the Yoruba in Nigeria or the Central African Bakongo, Bakuba, or Bateke.[12] Lord Kenya's perception of his hiplife music mentioned in the Introduction—that it is "not something I borrowed,...[but] something indigenous"—resonates with Daara J's similar sentiments: "...but this music is ours. It is a part of our culture."[13] This viewpoint among African emcees is evidence of what Tope Omoniyi terms "The Boomerang Hypothesis," with rap as "a long-standing African oral tradition that was only transplanted to North America through the Middle Passage."[14] According to *this* argument hip-hop aesthetics has only "boomeranged" back to the African continent from its diaspora.

When African emcees internalize the often-ambivalent hip-hop philosophy of "keeping it real" they set into motion the other important tenet of "flippin' the script." Pennycook and Mitchell define a hip-hop "dusty foot philosophy" that emerges from hip-hop emcees once they are truly "grounded in the local and the real, and capable of articulating a broader sense of what life is about."[15] Indigenized new forms emerging out of hip-hop's globalization develop when emcees begin to situate their perceptions firmly within their own locality, rather than merely adapting that which has been received from the global mediascape. Moving beyond mimesis to adaptation, hip-hop "heads" must eventually cultivate indigenization, resulting in a whole new musical genre steeped in local identities and realities.

Today's globalization of hip-hop has created a black Atlantic dialogue among emcees and hip-hop practitioners that challenges the very foundation of hip-hop's origination. The transatlantic dialogic discourse supports one of the primary points in *The Africanist Aesthetic in Global Hip-Hop*: hip-hop outside the United States is steeped in an Africanist aesthetic that can be traced to African cultures throughout the continent.[16] Today's African emcees are fiercely claiming this mantle rather than accepting the "imitation model" like other geographical locations on the globe. As Lord Kenya analyzes, he and his contemporaries are "creating Africans out of the

computer," because many of the aesthetic principles used in this digital age, such as sampling, looping, and rhythmic repetition with critical difference, are based in performance patterns originating in Africa. An ancient improvisatory African aesthetic has now been disseminated through technological sampling in the twenty-first century. The resulting indigenization of hip-hop in Ghana is but one example of the arc of mutual inspiration occurring in Africa and its diaspora.

Rap outside the United States, and Africa in particular, can no longer be seen as a simplistic imitation of US hip-hop, and I argue for the deep aesthetic connection between African American and African musical and dance forms and sensibilities. Hip-hop in African countries, as opposed to many other parts of the world, represents what I have called a "connective marginality of culture" that allows an even deeper connection to received hip-hop aesthetics.[17] Therefore, the argument of origins is ultimately a false one because it represents the "chicken and the egg" analogy that can never be solved—one cannot have one without the other. Hip-hop in Africa is an engagement of the aesthetics already present within the cultural matrix circulating between Africa and its diaspora that has become what I call throughout this book "the arc of mutual inspiration." Ultimately, the question of origins is one entangled in arguments of "authenticity"—what and who is real hip-hop? These authenticity debates are themselves mired in the complexities of culture, individual subjectivities, and the construction of race. Enough has been explored on that topic, so I feel no need to rehash those discussions.[18]

In the case of hiplife in Ghana, it becomes apparent that local pop music figures centrally in its construction and the entire indigenization process. The overlapping phases of highlife and hiplife music, as a part of the indigenization of hip-hop in Ghana, was clarified by Obour, one of Ghana's most visible hiplife emcees (see Chapter 4). He identified five distinct hiplife phases since the mid-1990s (Figure 1.1) that correspond to my delineation of three distinct hiplife generations in the Introduction:

1) strictly hip-hop rhythm with a local dialect [beginning era of Reggie Rockstone]
2) hip-hop mixed with local beats and local dialect [First Generation Hiplife]
3) extremely traditional rhythms with traditional lyrics on it, which is highlife by production and instrumentation, with Twi or any other local dialect [Second Generation Hiplife]
4) English on the local beat
5) gradually going back to the hip-hop beat with a fusion of hip-hop English language and minor Twi.[19] [Current Third Generation Hiplife/Hip-Hop]

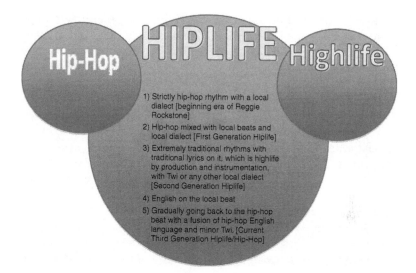

Figure 1.1 Diagram of hiplife's five stages of intersections of hip-hop and highlife.

Obour's designated first phase is obviously what Reggie Rockstone introduced and represents the transition from the imitation phase into the adaptation phase of hip-hop turning into hiplife's first generation ["hip-hop mixed with local beats and local dialects"]. Obour's third phase is what I call "the indigenizing phase" that solidified hiplife as a completely different genre of music from hip-hop. As the music continually evolves, the current third generation of hiplife musicians are recapturing some of the original hip-hop "flava" as new splinter genres known as GH Rap and Afro-Pop.

Once commercial incorporation becomes the dominant process, the counter-hegemonic agenda of hip-hop as a subculture emerges to counter mainstreaming procedures with which it has been complicit (Chapter 4). Reggie Rockstone summarizes the continual evolution of hiplife music, emphasizing the continuing hip-hop *raison d'être* as counter-hegemonic: "The good thing about all of this is that like most movements, it'll evolve. It's [about] transitions...Today, it's actually turned back again. The kids now want to go back to the hip-hop beats, 'cause hiplife music started being like tourist attraction music, man."[20] One reading of today's GH Rap and Afro-Pop genres is as a counter-hegemonic strategy to keep hiplife "real" by continually "flippin' the script" as a counter-narrative to social expectations. Hence, indigenization and implicit hip-hop youth rebellion interact to promote a continually evolving artistic process. The contemporary hiplife trend at the end of 2010 for some third-generation

hiplifers, to which both Obour and Rockstone refer, was a return to an original hardcore hip-hop sound. Hiplife music, in reality, will continue to oscillate within the hip-hop-hiplife-highlife continuum as branches of the polyrhythmic social commentary that is presentative of the Africanist aesthetic (Figure 1.1).

Communications scholar James Lull has articulated the cultural indigenization process as "reterritorialization," where local consumers never entirely adopt hegemonic American pop culture. Obvious embracing of Western values and subjectivities is mitigated by reterritorialization—what I am calling "indigenization"—as an equally powerful tendency in the globalization procedure. Popular music scholar Andy Bennett reveals, "Far from destroying local differences between national and regional cultures, globalization may in fact work to enhance such differences."[21] The *beginning* process of "reterritorialization" is what I call "adaptation," eventually transmuting into the final stage of "indigenization," where a broad continuum of local traditions and global contemporary aesthetics merge within exigencies of the local social context. The process can evolve to a new musical tradition that is much greater than the sum of its merging constituent parts. Hiplife music in Ghana is one example on the African continent of this phenomenon (Figure 1.1). Detailed dimensions of the developmental stages in hiplife, along with global economic forces that arrive with Western pop culture, will become apparent in this and subsequent chapters.

The indigenization process also includes sociolinguistic practices that include the comingling of hip-hop slang as a new "universal language"[22] among youths, with African American Vernacular English (AAVE) or Ebonics used generally among African Americans of all generations. Black linguistics are transferred throughout the world in rap lyrics and mixed with local pidgin languages that contain their own slang, along with local formal languages. These global-local linguistics intermingle in today's African rap, and hiplife music is no exception. Contemporary scholars of African hip-hop explore intricate analyses of "trilingual codeswitching," representing deep linguistic structures in many African raps, which toggles back and forth between these various dimensions of hip-hop languaging.[23] For example, Magubane found this linguistic tendency with an emphasis on youth street slang in South African rap and *kwaito* forms. In quoting Dellios, she says, "Zulu may be the proud language of their parents, but it is proficiency in kwaito lingo, used in the new black kwaito dance music, that puts urban youths on the cutting edge. Most Sowetans speak five or six languages, but there's more pride being able to speak this street language."[24] The indigenization process in Ghanaian hiplife contains similar codeswitching with strong use of pidgin English and traditional proverbial allusions contained in Twi.

Sampling, so prevalent in hip-hop music, mirrors similar processes in the flow of culture itself through various processes of physical and virtual interaction. Hip-hop, lodged in the Africanist aesthetic, has taken its principle of improvisation to a point where digitally quoting and revising the past has become a form of ancestor reverence—honoring past musical classics and producers who have gone before. Cultural transference *within* specific African cultures, such as Ghana's hiplife generation sampling the previous highlife generation's music, often allows smooth translations of Bourdieu's *habitus* across the generations from the familiar (highlife) to the less familiar (hiplife) through artistic explorations by creative music artists. Bourdieu explains habitus thusly:

> Everyone can recognize himself in his practices, and, as such, there is no need to posit a self-transparent, deliberating consciousness. Moreover, *habitus*— the system of internalized structures—is formed through education and socialization, both in the memorization of explicit wisdom that reinforces the group's ethos, and in the education of the body in behavioral schemes.[25]

Hiplifers inherited internalized structures of highlife music by virtue of their very socialization as Ghanaians, as well as specific Akan oral traditions of *anansesem* proverbs and stories, reinforcing the social collective's worldview. However, global influence (in Bourdieu's terms, the "field") necessitates a cultural transference, where the receiving culture creates new subjectivities and self-perceptions. The hiplife generation in Ghana mediates these two social dynamics, the local and the global.

In Ghana, changing social and individual perceptions, resulting from Western music's influence, did not start with Ghana's hiplife generation, but was a process occurring as early as the nineteenth century. The early Brass Bands and Orchestras of Ghana, as the precursors to highlife, are prime examples. In the 1880s, brass band music called "adaha" became very popular in the Fante region of Ghana, around the towns of Secondi and Takoradi. "Within a short time the whole of the south of Ghana was swinging to this music, and every town of note wanted to have its own brass-band. When local musicians couldn't afford to buy expensive imported instruments, they made do with drums, voices, and plenty of fancy dress."[26] The flow of Western culture into Africa's coastal areas, including changing styles of music, song, and dress, was facilitated by African cultures' ability to improvise and adapt, creating shifting subjectivities within inevitable cultural change. The current generation of hiplifers in Ghana continues this same procedure in the twenty-first century.

The local articulation of Ghanaian identities is what the best of hiplife is about, not the wholesale replication of American gangstas and pimp/playas

with a local twist. Panji Anoff, as one of the early producers of hiplife in Ghana, is very explicit in his critique of the original effect of hip-hop on Ghanaian musicians and its initial impediment to musicianship in the process of localization.

> Hip-Hop lowered the entry point for people entering the art of music. It made music cheap. Somebody can wake up today and say I'm a rapper. It doesn't require discipline. It's also propagated the concept that to be a musician you don't need to study music. Ghana is barely ten to fifteen years into its own innovations. It's only been about the last five years where those transitions are happening towards real originality. I am very proud of indigenous Ghanaian hiplife. If you have a sound where no one can get it anywhere else, then you've got something. The British artists, for example, produced jungle instead of replicating hip-hop.[27]

Part of Panji's observations about originality alludes to the different approach to live performance of hiplife and the basic tenet of improvisation. Interestingly enough, a Ghanaian hiplife concert has less to do with innovative improvisatory practices than does an African American rap concert in the United States. "Hiplife concerts are not sites of improvisation," notes Shipley, "but are important as they reference the baptismal origin of the music in its electronic production. Contrary to the logic of creative public speech culture, these concerts are primarily references to electronically mediated circulation rather than recordings being references to live music."[28] The electronic mediated sound becomes the *reference point* in the expectations for Ghanaian hiplife fans. In contrast, a US hip-hop concert is not successful if the emcee and deejay don't recreate and improvise upon the original recording, allowing an instantaneous remix with audience participation. In a country whose technological infrastructure is still growing, "the lack of live instruments and the fetishization of technology [became] central to the genre."[29]

Hiplife artists experiment(ed) with various musical elements and language—trilingual codeswitching—to achieve a unique localized indigenous sound that "no one can get anywhere else." Artists succeeding Reggie Rockstone experimented with various permutations of Ghanaian highlife and hip-hop, adding Twi, Ewe, and Ga, with certain artists becoming known for hiplife in particular Ghanaian dialects. Edem, for example, became popular among the Ewe people because of his Ewe raps. Hiplife musicians continue to experiment with various modes of sampling, revising, and covering highlife music's melodic and rhythmic phrasings, allowing them to arrive at a sound that is no longer hip-hop, but uniquely Ghanaian. Hiplife, as a completely new style of contemporary African music, set Ghana apart on the continent, progressing it beyond mere adaptation to a new form of music that musically identifies Ghana, just as highlife does.

HIGHLIFE AS THE FOUNDATION OF HIPLIFE

Highlife, as the worldwide-acknowledged Ghanaian pop music, is central to the birthing of the three generations of hiplifers. Ghanaians had already mastered the indigenization of Western music through a hundred years of highlife music and its precursors. The glocalization process was honed throughout the decades of the twentieth century as highlife music evolved from the late nineteenth-century European-ballroom orchestra-oriented sound to the smaller mid-twentieth-century highlife rhythmic combos of E. T. Mensah and others. The British might have brought their pompous upper-class "high life" style displayed in waltzes, foxtrots, ragtimes, and ballroom dance music, but it was the adapted African diaspora rhythms of Caribbean calypso and US jazz that ultimately intrigued Ghanaians to evolve the rhythmic emphasis, along with lyrics of social commentary that would eventually become known as "highlife music."[30] Hence, even during the World War II era the indigenization process was occurring through the incorporation of earlier guitar-inflected palm-wine bands popular in the rural areas, coupled with the calypso sounds of the diaspora that filtered through London. Highlife's own indigenization process created the musical mix that resonated with early twentieth-century Ghanaians and became *the* popular music circulating throughout West Africa.

Ghana was then the early innovator in West African popular music because of its flexibility to engage its own local indigenous ("lower class") music that defied the established cultural hierarchy during colonialism in Anglophone and Francophone Africa.

> In Nigeria, highlife music like konkomba, juju, and palm-wine was left to the rural and low-class urban nightspots. High-class clubs featured dance-bands like Bobby Benson's, Sammy Akpabot's, and the Empire Hotel Band, which played only swing and ballroom music. E. T. [Mensah]'s style of highlife soon began to influence them and created a whole new generation of Nigerian dance-band musicians...During the 1950s, the Tempos toured West African countries where there was no highlife dance-bands. In Sierra Leone there were local palm-wine music and meringue (or maringa), but this was never played by the dance-bands there. So E. T.'s music was an instant success.[31]

In this quote by West African pop music scholar John Collins, he establishes Ghana's E. T. Mensah as the seminal innovator for highlife music beginning in the post–World War II era for the whole region. "It was during the 1950s that E.T. was acclaimed the king of highlife throughout West Africa, for although the palm-wine variety of highlife was popular in the rural areas of West Africa, ballroom music and colonial-type orchestras still dominated the urban dance scene."[32] Hence, Ghana was the first to promote a regional

acculturated pop music that blended European, African, and Caribbean musical techniques.

Mensah chanced his social standing, defying the cultural order simply by finding innovative ways of incorporating African-derived sounds into the dance music during the colonial Gold Coast period. In so doing, he not only helped develop a new form of popular music but also inadvertently made a sociopolitical statement in the process: local African approaches to music, along with local languages and social concerns, are laudably credible and, more importantly, they are what inspire African people.[33] Mensah's extension of the African-based urban highlife sound defied the marginality of African cultural practices established by a Eurocentric social order that had invaded not only politically, but also *culturally* throughout twentieth century colonial Africa. Ostensibly, I am arguing that highlife music partly became a musical form of anticolonialism, even as it incorporated European elements.

The meaning that Collins attributes to Mensah in early highlife music I bestow on Reggie Rockstone in hiplife music some 60 years later. In the same way, hiplife music today, utilizing Twi, Ga, Ewe, and Hausa languages sung over established Ghanaian (West African) highlife indigenous sound-scapes, defies the indiscriminate adoption of American hip-hop. However, hip-hop, perceived as African in its very foundation, transcends the class hierarchy constituted by early twentieth-century colonial European dance music of the British and the French. Hence, in the era of hiplife, what I am calling "the arc of mutual inspiration," at the center of Africa's relationship with its diaspora, creates a welcomed, though ambivalent, colonialization. True to the colonial project, this new twenty-first-century black pop music is even more implicated in hegemonic transnational capitalism (Chapter 3). This music comparison across time carries with a "recolonization or renaissance" economic question that Pádraig Carmody asks in *Globalization in Africa* (2010), because contemporary music and lifestyle products are now embedded together in multinational corporate influence in Africa.

Historically, the arc of mutual inspiration is responsible for recurring appropriations and reinventions of musical influences from the diaspora into Africa. From nineteenth-century Caribbean influences of calypso music, through maritime trade and actual British drafting of West Indian soldiers to fight against the Ashanti Kingdom, to ragtime jazz and vaudeville influences in the Gold Coast concert party theatre (see Introduction), diasporic musical authority weighs heavily in the development of Ghanaian popular music. Diasporic musical influences extended into the seminal 1960s and 1970s as recorded by Shipley:

> In the 1960s and 1970s high life incorporated African American gospel, soul, and rhythm and blues music. Groups such as the Jaguar Jokers began to dress in sequined jump suits and covered songs like James Brown's "I'm black

and I'm Proud." Highlife demonstrates a pattern of popular influence later followed by hiplife music in which African Diasporic music combines with local popular traditions. It was at first understood as foreign but over time was accepted as a local tradition.[34]

During my 2008 fieldwork, TV3 sponsored a reality talent show called "Gang Starz" whose premise was like "American Idol" adapted to finding talented young singing *groups* in Ghana. I visited a live taping of the talent show in September of that year, and the particular theme of the elimination episode that I observed was 1970s and 1980s American R&B. All-male and all-female groups competed with songs such as Kool and the Gang's "Celebration" and "Get Down on It," as well as Al Green's "Love and Happiness" often in Ghanaian-accented English. The competing groups executed their songs with funky African American choreographic moves and period costuming like platform shoes and padded-shoulder polyester shirts. The arc of musical inspiration has obviously been a part of Ghana's history, from early British coastal contact to the soul and funk era, as well as today's globally circulating black popular music of R&B and hip-hop.

Gold Coast slave history in relation to its inevitable New World diaspora, in fact, established this eventual unintended circulatory cultural influence through music and dance. As Hartman reflects, "As it turned out, the slave was the only one expected to discount her past. Why would those who had lost the most be inclined or likely to forget?"[35] In fact, cultural memory had been encoded in the specific rhythms and movements, as well as approaches to sonic organization and choreographic structure in relation to sociality.[36] Music and dance generated modes of remembering—methods of cultural memory—even when drumming was banned throughout the Americas due to perceived potential for generating slave rebellions.[37] Musical and dance resonances were created between Africa and its diaspora in every decade of the colonial and postcolonial eras.

In the era just before the introduction of hip-hop into urban Ghana, hiplife artists point to one major transitional highlife artist, Gyedu-Blay Ambolley. Just as US hip-hop historians credit artistic precursors to rap music, such as the Last Poets and the late Gil-Scott Heron using spoken word in melodic form to their own musical compositions, so too does Ambolley serve a similar role in the development of the hiplife sound in Ghana. As a highlife and jazz musician, Ambolley spent over 20 years in the United States making highlife music popular abroad and developing his Afro-Jazz sound. Ambolley told me in a 2008 interview at Accra's Golden Tulip Hotel, "My music has become an indelible stamp,"[38] and the hiplife artists that I interviewed all validated his assessment of his "simi-gwa-do" sound of Fante and English as an important influence on the development of hiplife. He chanted texts along with his melodic sung phrasings to comment on male-female relationships, as well as community social conditions.

Music video producer and former radio deejay B. B. Menson assessed Ambolley's role:

> It [hiplife] started with Gyedu-Blay Ambolley, back in the day. He had been around, and then run out of town, and then came back. He had all that [old school] rap: bla-to-the-bla-to-the-bla. But then he fused it up with indigenous language—with the Fante language. Where he comes from, the Fantes have their way of blending the local language with English. It sounds a little slang-ish; it sounds a little artistic in a way. Seriously, you first think they're speaking English, but if you listen carefully, they're speaking the Fante language. You can't get one straight line out of the Fante language without English in it. It's like Pidgin in a way; and I think it comes as a package: style of living, style of eating. Ask anybody about the Fantes; they're the closest to outside [foreigners] than anybody else. They're supposed to be like the prim and proper.[39]

Here Menson sources Ambolley's influential highlife style in his Fante language and lifestyle resulting from that ethnic group's early precolonial contact with Europeans. Menson also reminds us of the influence of language as central to establishing indigenization in music.

The Fante, as coastal people in the southwest region of Cape Coast, Secondi and Takoradi, had initial contact with several European groups as early as the fifteenth century. The Fante's hybrid language, to which Menson refers, is a constituent of Ghana's coastal history and the Fante's central role in the Gold Coast slave trade. The Portuguese had been trading with the Fante since 1452, building Elmina Castle in 1482 that eventually served as one of the oldest slave forts of West Africa. Fante identity was established upon what Bayo Holsey calls "the image of the 'Anglo-Fante'" character that "encapsulates urban coastal cosmopolitanism."[40] As a coastal elite class grew, due to their interaction with European slavers and their facilitation of the enslavement of ethnic groups from the north (Hausa, Dagomba, Frafra, etc.), the privileged coastal people harbored ideas of "the dangers of their misrecognition as enslavable subjects." Therefore emphasizing ethnic differences, "coastal residents [like the Fante] stressed their identity as urban, cosmopolitan individuals" unlike the so-called uncouth African groups of the north.[41] Class differences began to be based on their ability to assimilate to the new coastal social order by adopting European dress, "residential segregation," "membership in religious and secular organizations," "use of European imported goods," and of course the adoption of the English language as the British became the prominent colonials.[42] The latter class trait of incorporating English with local coastal dialects such as Twi, Fante, and Ga became the basis of Pidgin in today's Ghana.

Ambolley's "simigwa-do" style is based in pidgin English slang, prevalent as a cultural marker in today's hiplife tracks in Ghana, and in Nigerian

hip-hop as well. For example, Ambolley's song "Abrentsie" blends typical calypso/soca-like rhythms with melodic highlife horn riffs in the hook that frames the rhythmically sung verses.[43] But in his third verse, instead of singing, he breaks into rhythmic poetic phrasings that strongly punctuate the basic beat underpinning the entire song. Ambolley's simigwa-do rap-chanting makes obvious the indigenous African roots of rap music, situating Ghanaian youths' creation of hiplife music in another spoken-word style other than US rap. His sound that he coined, "simigwa-do," alludes to his studied and stately, regal demeanor: "The name of my dance and music likens me to a king sitting on my throne. I become the climax of everything." Even though he has collaborated with hiplife artists such as Asem, his perception of hiplife musicians, however, is a typical old-school view: "They just want to get rich quick; most have not paid their dues by learning music itself."[44]

Several highlife musicians, besides Ambolley, play centrally into the story of hiplife. Groups such as Osibisa and icons such as Mac Tontoh and Queen Asabea Cropper were influential in the development of the hiplife sound. Daddy Lumba (Charles Kwadwo Fosuh), along with Nana Acheampong and guitarist George Darko, helped to usher in a new highlife sound known as "Burger Highlife." Created from Ghanaians living in Hamburg, Germany, Burger Highlife became another kind of "triangular trade" in musical cross-fertilization between Europe, the United States, and Africa. Hamburg's major US military base had many black G.I.s who played funk music, and who directly influenced the Ghanaian musicians living in Germany. Once those Ghanaians returned home, the addition of the rhythmic funk sound was dubbed "burger" highlife by Ghanaians to distinguish the new foreign influence from Ghanaian ex-patriots in Hamburg.[45]

Since highlife was the established musical genre, it behooved early hiplife artists to record with their predecessors as an introduction to local audiences. But, often working with highlife musicians was viewed as "selling out" to the commercial music scene. Hip-hop's cultural tenets travel with the music, and Rockstone admits his early dilemma:

> There's a fine line between not totally giving it all out for the commercial, and maintaining your consistency, you know what I mean. It's deep! But you gotta eat, and at the same time you still gotta mix. I know how to make a quick fix [if my record sales are slumping]. I should have made a song with Daddy Lumba real quick. But it was never the case, man. I just stuck to my guns, like this is how we're gonna do it.[46]

Hybrid musical forms always have multiple allegiances. Here, Rockstone shows his hip-hop roots to which he wanted to adhere; but highlife was the

music of the locals and the indigenization process was inevitable. Before the hiplife sound was fully established, there were choices to be made about the amount of local popular music to be incorporated. Accompanying the shift from highlife to hiplife, according to Collins, as he told Shipley, was the "valorization of individual star performers, especially with the lack of bands the focus is on the celebrity."[47] This was certainly the case with Reggie Rockstone, whose celebrity was built upon sampled recorded tracks. "Over the course of a few years, perceptions of hiplife shifted from seeing it as imitation of foreign practices to debating its importance within localized cultural traditions."[48] Shipley's observations about the transition from the popularity of highlife to hiplife reflect hip-hop's ability to instigate seminal sociocultural changes wherever it lodges.

Although the tension between the locally familiar and the globally inherited continues in today's generation, hiplife music strives to resolve it. Over time, confidence in their own original sound grew and cultural allegiance shifted from being "true hip-hop" to being uniquely "Ghanaian hiplife." Even Rockstone now celebrates highlife as his roots. In 2010, he recorded "Ese Woara" featuring Batman Samini as a tribute to Agyeman Opanbour, one of the older highlife artists from the 1970s. Now thoroughly into Ghanaian music, Rockstone reveals his motivations for "Ese Woara": "This was to reinforce our music roots in Ghana, least the younger generation forgets."

The video of "Ese Woara" opens with Samini deejaying at a backyard party populated by older Ghanaians. When he initially plays contemporary hiplife, the old-timers reject the music; but when he switches to "Ese Woara" filled with Opanbour samples, they begin to party furiously, and the tension is resolved. Rockstone portrays the generational conflict as it is reflected in music, and at the same time vividly illustrates how it has been resolved in his contemporary hiplife music.

> I got to meet Opanbour's wife. So throughout the video, you see us holding up his record. It says, "Opanbour, that's him." That whole beginning sample, that's all him. So, right now, we kinda like reinforcing hiplife, as far as being highlife authentic with the hip-hop together. Because I can't, you know, run away from that.

Indeed, as Producer Panji Anoff analyzes: "The generational gap is considerably smaller in Ghana. The older people like the younger people's music, especially because they use highlife."[49]

Hiplife music has become the contemporary music of today's twenty-first-century Ghana across generations, just as highlife music was for the twentieth century. Exploring three generations of the most influential

hiplife artists since Reggie Rockstone further explicates the process of hip-life's journey to its current popularity. The following artists' stories of place, class, and artistic choices reveal the dynamic complexity of this contemporary music genre.

HIPLIFE PROFILES: DIVERSITY AND CONTINUITY

The personal stories of hiplife musicians allow a more in-depth study of the hip-hop indigenization process, in relation to received aesthetic and social tenets, as they unfolded in Ghana. The following profiles of various hiplife artists represent some of the more popular musicians in Ghana today, but are by no means exhaustive. These musicians epitomize some of the most celebrated music awardees, both nationally within Ghana and continentally in several of Africa's annual music competitions in Nigeria and South Africa. Although my choices are subjective, the contextual frames that I construct represent important realities for many hiplife practitioners and fans alike. Having already extensively discussed Reggie Rockstone as hiplife's founder and quoted Lord Kenya, I concentrate below on their contemporaries and the next generations of contributors to hiplife music.

VIP (VISION IN PROGRESS)

VIP, or Vision in Progress, is a hiplife trio of emcees who started as street-level artists simultaneous to Reggie Rockstone, and who evolved out of the youthful imitation phase of early Ghanaian hip-hop. Rockstone's media attention in the mid-1990s gave them the inspiration to develop their already-established hip-hop experimentations to a commercial level. Emerging from Accra's Nima ghetto as young saggy-pants hip-hop teens, their first album *Biibiibo* (Something is Coming) "dropped" in 1998. As one of the few still-surviving early hiplife *groups*, VIP consists of Lazzy (Abdul Hamidu Ibrahim), Promzy (Emmauel Ababio), and Prodical (Joseph Nana Ofori). By Ghanaian standards, many hiplife emcees actually come from relatively privileged backgrounds, including Reggie Rockstone, and are well educated. The members of VIP, however, have "branded" their story as replicating the familiar rags-to-riches and fame tales of many American emcees such as KRS-One, Nas, Wu Tang Clan, and Tupac Shakur. Ghanaian television interviews emphasize their humble beginnings and neighborhood roots, allowing current-day Accra ghetto dwellers a sense of self-respect. I interviewed Lazzy and Prodical in Berkeley, California, during their December 2008 California tour, just days after I had returned from my first Ghanaian hiplife fieldtrip. Lazzy articulated

my concept of "the arc of mutual inspiration" in his own way, illuminating hiplife evolving out of hip-hop in Accra.

> Black American culture has a big affect on us in Africa. We love the culture; so back then we practiced the culture: the way they dress, the way they move. At the same time, we don't want to loose our culture. So when you hear our songs, we have the Africa beat, the highlife beat together with the hip-hop beat.

VIP makes it clear that both sides of the global-local equation were important in the early evolving dimensions of hiplife.

As one of the early hiplife groups to achieve success, they clarified the place of Reggie Rockstone and the evolution of the commercial hiplife industry developing out of the imitative hip-hop street culture in Accra. Lazzy captures the initial imitation phase of Ghanaian youths' relationship with American rap, and the role of the media in taking Accra's neighborhood culture to a commercial level.

> We used to rap over other hip-hop artists from America. We used to rap over their songs. Some of our models were Ice Cube, NWA, Wu Tang Clan, Wu Syndicate, and the Killa Army. Those are the people I can remember, Scarface, all these people; we used to listen to their songs, and rap over their songs because we wanted to get into it.
>
> We used some of their instrumentals before Reggie came up in '95, '96. He came out with an album rapping in Twi, and he came on TV. Everybody was like whose this guy rapping in Twi. But then we had already been doing it, but it was not out [in the media]. You know what I mean? So they [the public] didn't know about it. So when he put it on TV, everybody felt like, "Wow, we can do it. Let's just take it out there." And then we decided to do ours in Hausa. So we came out with the first album that was in Hausa and it was a big hit, because we were the first people to start rapping in Hausa in Ghana, and so it blew up. That's it!

VIP's story also illustrates the power of language in a multilingual society such as Ghana to empower identity and locality. Twelve years later their latest album *Progress* (2010) pushes the current hiplife sound and approach, blending highlife and hip-hop with three languages, and winning the coveted Artiste of the Year in the 2011 Ghana Music Awards. On VIP's album, tracks such as "Away" have strong highlife harmonized vocals as hooks, along with hip-hop beats sampled within danceable highlife musical phrasings. Hiplife is no longer a sound imitative of American hip-hop, but has become another mature contribution to world music advanced by artists such as VIP who started in the streets of Nima.

Eli Jacob-Fantauzzi's film documentary on the group's evolution from street rappers to internationally touring artists over ten years, *Home*

Grown: Hiplife in Ghana (2008), documents VIP's first visit to the Bronx, the often-touted US "home of hip-hop." Promzy's first reaction walking down a Bronx street was "This is just like Nima—Ghetto."[50] In fact, the name of their production company, Boogie Down Nima, pays homage to KRS-One's now-world-famous Boogie Down Productions located in the Bronx. Their very name, Vision in Progress, signifies their collective sense of emerging from humble beginnings, transcending poverty and poor education, and becoming "black stars" of Ghana who still represent their hood. Their local celebrity was evident when they became the headliners of Happy 98.9 FM Radio's massive street jam held at the Nima Highway on September 19, 2010, commemorating *Salah* as the end of *Ramadan*, the Muslim fasting period. VIP, now synonymous with Nima, were joined by other artists representing nearby Accra neighborhoods where many Muslim residents live, such as New Town, Pig Farm, Mallam Attah, and Circle.[51] Because hiplife music is based in youth culture, and simultaneously cuts across the generations, radio stations such as Happy 98.9 FM utilize hiplife festivals such as this one to boost their ratings and listenership. VIP members are prime artists for such events because of their strong Accra ghetto identity.

Although many of the neighborhoods of Accra may represent a specific ethnicity, Nima is actually very mixed, and the three emcees represent that ethnic diversity. Lazzy is the only actual Muslim and often raps in Hausa, the *langua franca* of predominantly Islamic northern Ghana, as opposed to southern Ghana, which is overwhelmingly Christian. Muslims (colloquially known as "Zongos") are therefore often marginalized in Accra, and festivals such as the one headlined by VIP become important events of inclusion. Promzy is Ewe and Prodical is Ga and Akan, the latter of whom actually grew up in the neighboring Asylum Down district. VIP represents Ghana's relatively stable ethnic relations; even though tensions between ethnic groups still exist, often erupting during election times when candidates associated with particular ethnic groups vie for power.

Besides Hausa, VIP raps in Twi, the most prevalent indigenous language in the country, and also in the Ga language of the predominant ethnic group of Greater Accra. Their multilingual approach signifies not only Ghana's relative ethnic harmony, but also hip-hop culture's Global Hip-Hop Nation (GHHN) construct of youth across the globe finding common cultural ground through the subculture. Lazzy alludes to this sense of using hiplife for ethnic unity on their freshman album.

> The first album was the first hiplife album in Hausa, but it wasn't all in Hausa. We also rap in Twi and Ga. The other nigga, Promzy; Oh, sorry to say "nigga." I'm not supposed to say that. The other Brother, Promzy, was rapping in Twi. I was rapping in Hausa. Everybody was rapping in English too,

at the same time. And then we had Bon [a former VIP member] rapping in French. All these languages were on [the first album] *Biibiibo*, which means something is coming.

Lazzy continues to interpret the meaning behind diverse language usage in VIP's music.

The album has everything on it. When a Ga man listens to the album, it would be something for the Ga people. If a Twi man listens to the album, he understands what we saying. Hausa man listens, French, English. I think we should try rapping in Chinese too. (laughter).

Prodical further contextualizes:

The album is basically like a fight together album, where we trying to bring different kinds of people with different languages together. Fight your battles in Ghana. The album is basically like that, where we can put, like, everybody together—all Ghana's regions together on one album. We now have artists even rapping in Ewe.

Thus, VIP stresses ethnic unity and cooperation through their hiplife music, a long-standing tenet of globalized hip-hop that implicitly unites youths across national borders, as well as ethnic divides within discrete nation-states such as Ghana. The hip-hop subcultural principle of "love, peace, unity, and having fun," which started as a visionary refrain by Afrika Bambaataa during the early Bronx-neighborhood phase of US hip-hop, remains in VIP's methodology within hiplife music, three decades later and thousands of miles away in Ghana. A not-so-quiet revolution is taking place with the GHNN.

VIP has had several international tours and has won many of Ghana's and some of Africa's top awards. Their 2011 Ghana Music Awards was a "come-back" since their first validation in 2004, when they amassed "Artiste of Year," "Song of the Year," "Hiplife Artiste of the Year," and "Hiplife Album of the Year." Representing Ghana in the same year, they also won the esteemed "Artiste of the Year" award from the All African Kora Awards of South Africa, performing alongside Malian musician Salif Keita, one of the continent's biggest music celebrities. They have represented Ghana as international ambassadors for the 2004 Olympic Games in Athens, Greece, as well as United Nations representatives in Sierra Leone's and Liberia's Peace and Reconciliation Concerts. The artistic efforts of VIP toward peace in West Africa won them a 2005 appreciation award, "Best Group in Africa" from the United Nations and the government of Sierra Leone.[52] These VIP African music awards outside of Ghana symbolize hiplife's recognition as a

West African music form, while facilitating social healing necessary after the ethnic and regional wars plaguing many African countries. They serve as an African example of what Michael Eric Dyson calls, "these unlikely bearers of a noble verbal tradition...for whom rhetoric becomes the sound of a social reveille."[53] VIP's place in hiplife's evolving discursive narrative parallels the rise of the music genre from street culture to the international music arena.

OBRAFUOR (KWABENA OKYERE DARKO)

Obrafuor is another early pioneer of first generation hiplife, developing out of Rockstone's commercialization of the music. He was born into an Akan family in the Kwawu Eastern Region of Ghana in 1978, but moved to Accra as a child with his parents. His mother, Gladys Agyapomma, was a church singer who encouraged him as a child to sing in the choir. This early gospel experience established his Christian sensibility running throughout his thematic approach to hiplife, particularly on his gospel rap song, the first ever in Ghana, called "Enyeɛ Nyame a" and recorded on his second album *Asem Sebe* (2001). "Enyeɛ Nyame a" caused a dilemma for Ghanaian deejays who didn't know whether to include it on the gospel or hiplife playlists.[54] Although his hiplife name of Obrafuor, meaning "Executioner," follows an American gangsta trope, he is also known as "The Rap Sofo," or "Rap Priest," denoting his social moralizing tendency, admonishing Ghanaians to do "the right thing."

Inspired by Rockstone's *Makaa Maka* as the first hiplife album, as well as by emerging artists such as Ex Doe, Chicago, and the group Akyeame, Obrafuor soon turned to rapping in Twi. At an outdoor concert at Secaps Hotel in Accra, B. B. Menson, as emcee for the event, was the first in Ghana's evolving music industry to take note of Obrafuor. But it was Hammer (Edward Nana Poku Osei), emerging as one of the best hiplife studio producers, who helped Obrafuor create his particular sound. The evolving industry of independent, privately owned radio stations, engineering studios such as Abraham Ohene Djan's OM Studio, and raw street talent all converged to create Obrafuor's 2000 award-winning first hit album, *Pae Mu Ka*, capturing the first "New Artist of the Year Award" in the newly established Ghana Music Awards. Obrafuor's hiplife narrative presents the development of Ghana's hiplife music industry as a confluence between street artistry, technical infrastructure, media criticism, and recognition through industry awards at the beginning of the twenty-first century.

On *Pae Mu Ka*, Obrafuor achieved another first by creating a resounding tribute to Ghana's first prime minister with his song "Kwame Nkrumah."

As explicated in the Introduction, Kwame Nkrumah had a great impact on Ghana and Africa as a whole; but after his overthrow, he fell out of public favor, with many of his political abuses being accentuated over his accomplishments. The premier of Obrafuor's "Kwame Nkrumah," 35 years after his overthrow, revealed how hiplife as social commentary could resurrect Nkrumah's image for a new generation. The rap and video "Kwame Nkrumah" complimented the erection of the Kwame Nkrumah Memorial Park, Tomb, and Museum in the middle of Accra, which the government had recently dedicated to Nkrumah's legacy. In the Twi lyrics to "Kwame Nkrumah," Obrafuor introduces himself to the Founder of modern Ghana, while honoring him for his good deeds:

> Menie, Obrafuor me wɔ fawohodie.
> Mamo mo mɔdenbɔ dwuma die ne mpomudie,
> efiri sɛ yɛn ara ya asaase ni, ɛyɛ aboɔdenden ma yɛn,
> mogya na Nananom hwie gu nyinaa de to hɔ ma yɛn dom yɛn boa yɛn,
> gye yɛn, eduru mɛnɛ wo soso sɛ yɛnso yɛ bɛ ye bi atoaso muemoaso,
> kataso, oman yi mu deɛ ɛmmaso
> This is me, Obrafuor I have my freedom.
> I congratulate you for your good works, hard work, and good health.
> Because this is our land,
> the blood that our forefathers shed and placed down for us,
> gave us grace, helped us, and rescued us.
> It is now our time to continue the good works.
> Cover-ups and stifling would not be tolerated in our land.

Obrafuor, the lyricist, positions Osagyefo (Nkrumah's honorific title meaning "redeemer") as the reason for his own personal freedom in contemporary Ghana, and honors him as the supreme ancestor among all the forefathers who "rescued us" from British tyranny. But he warns of government corruption by current-day leaders in his admonishment of dishonesty through "cover-ups," as well as the "stifling" of truths that emcees like himself are dedicated to uncovering.

Traditionally, African youth have not had a voice of power. Early on in the hiplife movement, Obrafuor and other emcees perceived of themselves as seizing discursive power (Chapter 2), just as anthropologist Mwenda Ntarangwi analyzes for their East African counterparts through the use of "music as a way to exercise power to reconfigure national culture and identity."[55] At the beginning of the twenty-first century, Ghana needed reinforcement of Nkrumah's meaning to the nation, and Obrafuor offered a positive reading with his lyrics and video imagery that conflate the past and present. Obrafuor uses hiplife to invoke Ghanaian historical memory as a means to shape the contemporary national discourse.[56]

Hiplife emcees often position themselves as new linguists, or *akyeame* (plural of the singular *okyeame*), who do not merely speak for the elite chiefs and queen mothers of Ghana as in traditional Akan society, but today are New Age *akyeame*, speaking for the people, the masses:

> Yɛ kɔ gyina baabi na sɛ yɛ frɛ moa nyɛ sɛ ade bɔni.
> Ghana man yi mu yɛ wɔ, yɛdeɛ yɛpɛ nkwantrenee,
> nsɛnkyerɛnee, kyerɛsɛ
> Ghana man mu yɛnpɛ nsɛm bɔne.
> Kofi babɔnee yɛnkɔ kɔ gyano bɔne.
> Okyerɛma Asante bɔ twenee kyerɛsɛ Ghana man no ntie.
> When we stand somewhere in public and call on you,
> it is not a bad initiative.
> In Ghana we prefer the right path and right signs and wonders,
> which mean we hate bad news.
> Kofi the bad child should not be left with bad ideas.
> The master drummer of Ashanti plays the drum,
> this means that people of Ghana listen.

The collective "we" positions Obrafuor within a hiplife social movement with a public agenda that speaks to the nation-state as subject. The news that they (hiplifers) bring is not negative but actually positive, having the means to reverse the "bad" child because hiplife *is* the language of the younger generation. The youths listen to hiplife like older Ghanaians listened to the master drummers of Ashanti in bygone days. He also reminds the people of Ghana's image as a peace-loving country in Christian terms when he invokes "right path, signs, and wonders" from God. Obrafuor's moral message is central to his place within secular hiplife, viewing himself as a spiritual town crier who bears a needed redeeming message.

Obrafuor presents an important moral subjectivity, using rap to challenge perceived lapses in imagined national morality and unity. Hiplife becomes a commercial form of what Shipley calls "…a Black aesthetic [that] speaks of both moral criticism and personal aspiration." Yet Shipley places this personal morality into a larger historical context: "Hiplife reconfigures Pan-Africanism as an entrepreneurial project epitomized by the rap artist, invoking established structures of racialization…" Indeed, Obrafuor does invoke a twenty-first-century Pan-Africanism by reminding the Ghanaian populous about the virtues of Nkrumahisms through the lucrative business of hiplife music. But does his methodology utilize "structures of racialization?" The project of hiplife's repatterning of Pan-Africanism (discussed further in Chapter 3), is particularly prevalent in Obrafuor's aesthetic, a methodology of "the arc of mutual inspiration" between African nations and their diaspora. "Racialization" as a construct invokes spurious and purposeful

construction of imagined relationships between humans for flawed agendas. Hiplife artists as entrepreneurs are engaged in a form of youthful agency in transnational global commerce, as well as in national and continental hierarchies, resulting often in a rethinking of Nkrumah's aims in the era of the cessation of formal colonialism. This process is not creating imagined, nonexistent diasporic relationships, but rather attempting to focus national and international attention on local and global needs for unity-based *political* positions.

Just as VIP does through their use of Ghana's diverse languages, Obrafuor uses a moral plea to Ghanaians for ethnic unity in his tribute to Nkrumah:

> Mesee me srɛ omanfoɔ mo nyinaa monyɛ baako, efri sɛ yɛ te faako,
> prayɛ wɔhoe sɛ woyi baakoa na ebu wo ka bomua emmu.
> Krobea Asante Kotoko wo kum apim a, apim bɛba is the motto,
> yɛnfa ɛnkɔto lotto, moma yɛn moa mmɔfrano.
> Yɛsee monya ntoboaseɛ ne ahobraseɛ, mondi nidie na monkoto,
> bible kyerɛ sɛ di woagya ne wɔ nna ni, na wonkwa aware wɔ asaase
> so, nti monyɛ brɛbrɛ.
> Ghana yɛ mene wɔ dea.
> I plead with all citizens to be one because we occupy one land.
> It is easy to break a single broom but not the bunch.
> Krobea Asante Kotoko, if you kill a thousand, a thousand more will
> come. We won't stake the lottery with it (gamble with it)
> Let's help the children. You need patience and humility.
> With respect, just bow. Bible says honor thy father and mother,
> so that your days will be long on this earth, so take it easy.
> Ghana is for me and you.

In quoting an Akan proverb that alludes to the broom that cleans the living quarters or compound, Obrafuor invokes traditional wisdom to promote national unity. At the same time, Ashantis are known for their persistence in war (being the last group to be conquered by the British), and even after their defeat, the Asante Kotoko Club was established to provide their own self-government under British rule. Unity, according to Obrafuor, is an attribute that is priceless, and therefore is not one with which to gamble. And again the sociopolitical Ghana mother/fatherland is situated within biblical scripture of honoring "thy father and mother."

Hiplife has become a new mode of claiming active citizenship by using youth agency as power to gain participation in the public discourse from the political to the personal. South African media scholar Adam Haupt sees this same dynamic happening in South African hip-hop. "Hip-hop continues to be a significant vehicle through which subjects are able to position themselves as citizens in post-apartheid South Africa." Hip-hop then becomes,

as he analyzes, "an expression of dissent and empowerment in relation to debates about global capital and concepts of citizenships…"[57] Obrafuor promotes a moral criticism through his hiplife rhymes and beats while furthering his personal ambitions as artiste.

In Obrafuor's third verse, he demonstrates how Ghanaian hiplife allows its artists to enter the public sphere of discursive debate, as he places Nkrumah on a historical pedestal as the beginning of Ghana's salvation. He praises Nkrumah for his audacity to confront the British, as well as his intelligence acknowledged by all of Africa:

> Hwɛ gyina nkyɛn, okofoɔ ntwenee, megyina ha ma Ghana me frɛ Osagyefo Kwame Nkrumah.
> Yɛ bɔ wodin, wɔ deɛ woyɛ ntini, wode wo nyansa no gyee Ghana to hɔ bɛyɛ ohene.
> Owim yɛ dinn, brɔfo kuma bɔɔ brim efirisɛ wohunuu sɛ wo akokoduro mpo dɔɔso te sɛ nwii.
> Doctor Kwame Nkrumah, wodeɛ wonyansa tesɛ nsoroma, Africa man nyinaa yɛ gyedi sɛ wonim nnwoma.
> Look, stand aside for the fighters drum, I stand here for Ghana to call Kwame Nkrumah.
> We call your name, you are the root. You used your brains to rescue Ghana to become king.
> The atmosphere was silent; the white man's heart seized, because they saw your bravado was as numerous as the beads.
> Dr. Kwame Nkrumah, your wisdom is like the stars.
> The whole of Africa believes you are a scholar.

In African spiritual traditions, oral invocation brings a thing or person into being. "Kwame Nkrumah" invokes the spirit of Ghana's founder by using the hip-hop rap genre, which itself is steeped in that ancient tradition of orality. Obrafuor at once uses his Akan culture's traditional wisdom within the newfound artistic context of his generation.

Obrafuor has continued to stay at the forefront of the hiplife movement in Ghana, becoming an elder statesman of the genre by his early thirties with several more albums, while also helping to produce the next generation of hiplife musicians. His 2002 single "Maame" was a tribute to his mother that featured the hiplife artist Tic Tac, and has become a favorite throughout Ghana on Mother's Day. The year 2003 was prolific with two albums: *Time Out for Adhesion (TOFA)*, another admonition of the need for unity, and *Nteteɛ Pa*, with its hit "Be Disciplined" that received much radio airtime. Obrafuor followed many American rapper-entrepreneurs by establishing his own record label, Execution Entertainment, which produced his last three albums while introducing new hiplife talent. In 2004, he produced

his fifth album, *Execution Diary*, which featured relatively new artists such as Kwaw Kese and Dogo and promoted his peers Tinny, Okyeame Kwame, 4X4, and others. Obrafuor continues his promotion of the next generation with younger popular artists such as Sarkodie, whom I explore below. Obrafuor represents hiplife as moral criticism that inserts his generation in the national public discourse as neo-Pan-Africanism.

KWAW KESE (EMMANUEL ABROMPAH BOTCHWEY)

Seemingly just the opposite from Obrafuor in public persona, Kwaw Kese also calls himself "Abodam," or "The Menace." He is the "bad boy" of the hiplife scene who revels in speaking his mind and creating controversy. His "abodam" tag has become a slang word in Ghana and throughout West Africa. Emmanuel Botchwey was born in Agona Swedru and attended Winneba Secondary School. As Ghana has no universal free education beyond middle school, the majority of hiplife artists come from families who can afford to send them to high school and to the university, or a tertiary-level of education. Hence, as I have intimated earlier, by Ghanaian standards most hiplife artists come from the middle class, and Kwaw Kese is no exception.

The young Botchwey was singing and rapping as early as his middle-school days, activities that motivated him to hang around Hush Hush Studios, one of Accra's top recording studios where he was eventually used on several of the studio's hiplife compilation albums. Kwaw Kese was first heard on Obrafuor's 2004 *Execution Diary* compilation with his single "Oye Nonsense" that was an immediate hit with the growing hiplife audience. That first recording established his penchant for controversial subjects such as cheating love partners, as well as reportedly inaugurating one of Ghana's first "diss" records that created acrimony with a fellow hiplife artist. Along with imported hip-hop music comes the notorious propensity for competitive battling with its potential for disrespect (dissing) and ultimately confrontation (beef).

Unlike gang warfare and the penchant for violent public confrontation associated with US hip-hop, Ghana's hiplife scene has reproduced only a minimal degree of that level of controversy. Yet even the level of violence that has been generated is disturbing to many hiplife producers. When I queried television producer and music manager Iso Paley of Ghana's TV3 about hiplife's influence on youth violence in Ghana, he didn't hesitate to expose it.

> Hell yeah there's been violence! There has been beef from those from the Westside of Accra against those from the Eastside of Accra. There would be accusations and counter-accusations in their music. Someone would say something about somebody, and that somebody would definitely reply on his next album. It has happened a few times.[58]

He also didn't hesitate to chastise hiplife artists for not living up to hiplife's fullest potential as a Ghanaian youth movement.

> But I was disappointed. Because of the foundation on which hiplife was built, I didn't think that sort of thing could happen. Because it was all about brotherhood, all about young people expressing themselves. Because Africa has been too long waiting for young people to be able to speak.[59]

Iso locates hiplife music's original intent in youth agency and collective self-expression that was not always traditionally sanctioned in many African cultures (a subject fully explored in Chapter 2). His frustration was with Ghanaian hiplifers' inability to overcome perceived inherited US disunity, which groups such as VIP and Obrafuor attempt to ameliorate. These two opposing tendencies by hiplife artists—competitive rap battling potentially leading to real violence *and* promoting cooperation and unity through rap—represents the dilemma of the global-local problematic in hip-hop, further complicating the argument about rap's supposed deleterious effects in the United States. Hip-hop scholar Tricia Rose articulates the issue thusly: "...hip hop advocates and thus causes violence...that listening to violent stories or consuming violent images directly encourages violent behavior." But then Rose challenges us to not fall prey to simplistic casual arguments as she maps hip-hop within the larger context of a violent world.

> High saturation levels of violent imagery and action (in our simulated wars and fights in sports, film, music, and television but also, more significantly, in our real wars in the Middle East) clearly do not support patient, peaceful, cooperative actions and responses in our everyday lives. However, the argument for one-to-one causal linking among storytelling, consumption, and individual action should be questioned, given the limited evidence to support this claim.[60]

No matter what is the real cause of youth violence, tension between the global import and local realities outside the United States often reveals itself through inherited and unwanted by-products of US pop culture. Furthermore, this US inheritance is often in collusion with a particular localities' own sociocultural problems. African countries have only become national polities in the last 50 years, and therefore have a monumental task of forging a unified national consciousness out of precolonial ethnic, regional, and religious divisions. Youth rivalry, derived from received Western popular culture, becomes another unwelcomed layer of local division, and Kwaw Kese is often viewed as fueling these social dynamics.

Between 2004 and 2007, Kwaw Kese's career became well established with another single and several albums, solidifying his often spectacularized and contrived "bad boy" persona. His second single track at Hush Hush Studios was "Kwakwa," produced on Hammer's *Sounds of the Time* compilation, and in 2005, he created his second album *Na Ya Tal* with its hit title tract. Like many other hiplifers, he has created his own label known as "Abodam Records," as well as his own NGO called "Music 4 Help Foundation." His philanthropic efforts results in free music concerts for orphanages throughout Ghana. He also has not forgotten his roots in the Central Region, establishing a productive farm to feed the people in his town of Agona Swedru.[61] Like most hiplife artists, Kwaw Kese is complex, with several sides to his private and public personas.

Batman Samini (Emmanuel Samini)

Batman Samini, whom I mentioned earlier as a part of Reggie Rockstone's "Ese Woara" video, is considered a hiplife/reggae musician, in the equally popular "raga" style in Ghana. Previous to the hip-hop wave, reggae music enjoyed a significant following from the 1980s throughout Africa. With the arrival of hip-hop as a viable commercial genre in the 1990s, there have been various artists merging the two into what Ghanaians call "raga," and Samini has become synonymous with the genre. His marketing label for his music is "African dancehall," a mixture of highlife, dancehall, reggae, and hip-hop.

Emmanuel Samini was born in Wa in the Upper West Region of Ghana to parents of the Wala ethnic group, but grew up in the Dansoman suburb of Accra since the age of nine. His family's move from the rural Upper Region to the urban South represents a continuing migration pattern that perceives Accra as the economic "Mecca." His artistry was discovered at the age of 18 by hiplife artist Mary Agyapong, one of Ghana's early female hiplife artists who featured him on her albums. During the early Agyapong period, he began using the hiplife tag "Batman," and due to his prolific freestyle lyricism, he quickly became one of the most sought-after musical collaborators by other hiplife artists. In 2004, he released his first album, *Dankwansere*, with his hit tract "Linda" that launched his award-winning career.

Sporting dreadlocks, often with head wraps, this musician in his early 30s has earned a large fan base of Ghanaians and West Africans, along with international music nominations and awards. His second album, *Samini*, released in 2006 was responsible for four awards in the 2006 Ghana Music Awards, while being named "Best African Act" at the 11th annual Music of Black Origin (MOBO) awards in England. All of these accolades culminated in 2008, when he won "The Best African Artist" at the Hip-Hop World

Awards in Nigeria, as well as international performances with Caribbean artists such as Sean Paul, Shaggy, Chaka Demus and Pliers, Damien Marley, and Bennie Man, as well as US hip-hop artists such as Jay-Z.[62]

Yet international fame in the context of a country with rampant poverty often breeds local realities of professional jealousies in the context of infrastructure corruption with which artists such as Samini must contend. In Ghana, as in many other African countries, payola—the bribing of radio deejays to play one's records—is legal, producing rampant injustice and animosity among artists. Samini has been particularly vocal about payola.

> Payola is not helping us at all! There is this DJ at Peace FM, some **** guy who wouldn't play a very popular music of mine because my manager would not give him payola. Imagine! In fact, they should be paying us for using our music! In a sense they exploit us because musicians are so desperate. We should come together and prevent our music from being played, and then we would see who needs who![63]

Not only is payola rampant in Ghana's radio industry, but also in television. Owners of the majority of Ghana's television stations not only *charge* artists to play their music videos, but also run adverts simultaneously while the video is playing on the screen. During my fieldwork in September 2010, a major news story surfaced about Metro TV becoming the first to pay musicians' royalties for televising their videos. However, as Panji Anoff explained, "It is a smoke screen, because all they're doing is paying a small percentage of what the artists have already paid them to have their videos played on air, and Metro TV charges the most."[64] This exploitation of artists in Ghana, as well as other African countries, exists within the exigencies of a poor nation where hustling is the lifestyle from street vendors ("hawkers") to government workers and elected officials, all taking under-the-table "dashes" for performing public services that are already a part of their daily routine job.

Samini's answer to this competitive and corrupt business practice of payola surrounding Ghana's music industry, as well as the treachery among fellow artists that it generates, is his signature sound and symbol, "Kpooi," representing a gunshot. As he says, "the gunshot is meant for all the back bitters. We kill them dead."[65] This evokes Public Enemy's famous logo of a black man in the crosshairs of a sniper's rifle. Public Enemy's politically motivated meaning positioned the black man in the United States as an endangered species, who has been historically the target of America's violence. In the context of Ghana's often vicious bad-mouthing and infighting exacerbated by payola, Chuck D's symbolic design takes on a new meaning of intragroup divisiveness. Samini's "kpooi gunshot" is meant for other Ghanaians who exhibit jealousy and resentment in the wake of his fame.

The local Ghanaian socioeconomic system, already built on corruption and exploitation is taken to a global high-stakes level with the introduction of multinational corporate capital by the global pop music industry. Transnationals such as telecommunication companies that market themselves through global pop culture, up the ante of Ghana's potential for generating individual fame and therefore wealth (Chapter 3). The competition already present in a poor third world country's political economy is augmented to a greater level of marketplace hustle in which hiplife artists must compete. As Tricia Rose reveals, to blame hip-hop music itself is simplistic and "obscures profound corporate involvement in commercial hip hop and refuses to acknowledge and embrace the facets of local, enabling, and progressive hip hop."[66] Social unity and cooperation promoted by hiplife artists, such as previously mention about VIP and Obrafuor, are often obscured by the increasing greed in the industry as it expands exponentially with the rise of hiplife as an international music genre. Samini's "kpooi gunshot" is a personal reaction to the root cause of a growing parasite industry that I fully investigate in Chapter 3.

Over time, Samini began to make London his home base, moving back and forth across the Atlantic between Britain and Ghana as needed, placing him in an international music arena beyond Ghana's singular market. His fourth album *C.E.O*, released in 2010, represents a new level of entrepreneurship with a major endorsement by Mobile Telecommunications Network (MTN), one of the largest telecommunication companies on the African continent. On the CD, he collaborates with well-known Nigerian artists, as well as Ghanaian hiplife artists such as Kwaw Kese and Sonny Balli and veteran highlife artist Pat Thomas. Even as Batman Samini grows in international recognition, he continues to exhibit the trait of collectivity in hip-hop—to bring one's peers and newcomers along with one's celebrity—based in African communalism.

TIC TAC (NANA KWAKU OKYERE DUAH)

Tic Tac has been dubbed the Busta Rhymes of hiplife for his unique voice and performance antics, starting in 1997 with his teen group, Nutty Strangers, at Labone Secondary School in Accra. He hails from the Kawamo suburb of the Ashanti Region, and became a solo artist when he was featured on several established hiplife artists' tracks such as DJ Azigiza's "Woye Bia" and Slim Busterr's "Masan Aba." Performing internationally early on in his career in England and other European countries, Tic Tac's first album in 2001 was *Philomina* with the hit singles "Ye Me Bre Bre" and "Bronze." His own label T-N Records released his second album, *Masom*; but it was his

third album *Masem* that pushed him to the forefront of the hiplife scene, topping the Ghanaian charts for 22 consecutive weeks.

The first decade of the twenty-first century ushered in an expanded transnational pop culture industry into Africa on a scale that was unprecedented, and Tic Tac has benefitted greatly from this surge in market development on the continent. In 2005, MTV Base Africa was introduced and Tic Tac, as a recognized hiplife celebrity, was a part of its launching in Ghana.

In Anglophone Africa, corporate and governmental relationships with Europe, and the UK in particular, are important for technological and economic development. However, Malian film scholar Manthia Diawara critiques this seemingly commonsense phenomena when he observes that the global media "wired Africa to the West,...to the extent that Africans are isolated from nation to nation, but united in looking toward Europe and America for the latest news, politics and culture."[67] This dependence on Europe plays out in hiplife collaborations with Nigerian artists such as J Martins and 2Face Idibia. While Ghanaian and Nigerian musicians bypass some of the Western pop culture dominance artistically through their self-generated collaborations, the corporate sponsorships and increasing presence of commercial businesses such as MTV Base Africa are all ultimately controlled from outside of Africa (Chapter 3). People-to-people hip-hop connections across borders within Africa and with its diaspora do not negate implicit international pop culture industry hierarchies.

Hip-hop culture takes its place within the larger context of Africa's neo-colonialist umbilical cord, linking the continent to the Western-dominated media for news and popular taste. Although the World Wide Web has ameliorated this hierarchal dynamic to a degree by linking individuals as well as entire artistic communities, aspiring African emcees are still in competition with the hegemony of American music promoted by global pop culture multinational companies. For example, the German-based global sports clothing company Puma now has Puma Africa, and, like most multinational corporations, engages in cross-marketing as a part of its profit-making strategy. Puma produced a 2006 FIFA World Cup album that featured African and diasporan hip-hop and pop music artists, such as Akon, John Legend, Baaba Maal, The Roots, and Tic Tac representing Ghana. Hiplife artist Tic Tac participates in this Western-dominated corporate world of pop culture that links music, sport, and media, all built around the celebrity of particular individuals like him. But artists such as Tic Tac are not without their own personal agency. Just as transnational corporations are using them and their established celebrity, Tic Tac negotiates his business associations for his own agendas, such as his involvement in a campaign with the Untied Nations in Sierra Leone and Ghana raising funds for children.

Tic Tac's hit song "Kangaroo" on his fifth album, the 2006 *Accra Connection*, was made into a video by MTV Base, making him the first African to have a song on the MTV Base charts. But its global recognition was not this song's only distinction; it took on important local Ghanaian and continental African meaning as well. "Kangaroo," featuring Batman Samini, is a typical hip-hop-oriented song in terms of content that speaks to triumphing over one's detractors. Tic Tac likens himself to a kangaroo that can jump so high that his PhDs (Pull Him Downs) cannot reach him; the chorus chants, "No matter how high I go, I will never fall, cause I am son of a God, a Kangaroo." In both, the first verse by Tic Tac and the second verse by Samini, they extol their skills as rappers and their indomitable spirits as unstoppable.

Returning to the global-local paradigm, emcee braggadocio is obviously inherited from US hip-hop, where bravado is commonplace to establish oneself in the music genre. As the economic stakes are raised in the global arena, local hiplife artists are forced into these cultural tenets that have become standard fare in US hip-hop. However, Terry Ofosu explains this hip-hop inheritance from a local perspective.

> Tic Tac and most hiplife artistes, like the hip-hop musicians, see the music industry as a battlefield full of hatred and pull-him-down attitude. This antagonistic nature of these young Ghanaian rap artistes might have been picked up from their American counterparts consciously or unconsciously. Tic Tac, therefore, refers to such evil-wishers as crazy ones. He goes on to look at himself as the strong resilient Kangaroo that can jump very high but never falls.[68]

Cultural orientations, such as US hip-hop's braggadocio, have affected local representations in hiplife. However, at the same time, these inherited representations are translated into local contexts, particularly through language use. Codeswitching between English, Ghanaian pidgin, and Twi to particularize what he's communicating to his local audience can be seen in one of Tic Tac's verses.

> Tic Tac I am still gonna
> Be unbreakable, unstoppable
> Am gonna be incredible, unbeatable
> Am already invisible
> Na w ɔsesɛn, na w ɔ sesɛn
> We hu aboa kangaroo da ɔw ɔkotoku
> Sɛ ɔ de ne ba no shemu pɛ owere k ɔ
> Soro soro ɛnso ne ba no bano fre nt ɔda da
> fre tre tre, kose tre tre
> from the north to the south

Otumi jumpi jumpi
Ne bano ne bano infiri nt ɔda da
Mene a bere sɛ kobene
Tic Tac me yɛ kangaroo nti me npene hu ha! Me papa ns
 ɔont ome ntwene ha hu

Tic Tac I am still gonna
Be unshakable, unstoppable
I am gonna be incredible, unbeatable
I am already invisible
And what do you say to that
Have you seen the kangaroo
It has a pocket,
when it puts the baby in the pocket,
it jumps high up but the baby never falls.
From one end to the other,
from the north to the south, the kangaroo keeps jumping
but the baby never falls.
My eyes are red like the traditional red cloth
Tic Tac I am a kangaroo so I will never give up ha hu!

Language codeswitching becomes an obvious tool of localizing globally received music culture in the indigenization process. After the first line that establishes his unsurpassable stature, he switches to Twi to ask, "And what do you say to that?" This language switch is essential to the localization process: it establishes that he is speaking directly to his *local* "homies" who speak Twi, and not to the entire GHHN. What is inherited from the global arena becomes particularized for local consumers. The animal imagery of the kangaroo Africanizes *how* he will beat his enemies, while, at the same time, the kangaroo humanizes God as the mother protector, carrying her child (Tic Tac) in her pouch and jumping so high that he becomes unreachable. The allusion to his eyes being red like the "traditional red cloth" locates the whole process of transcending earthly obstacles into Akan terms where red (along with black) is worn to funerals where the deceased ancestor's spirit is celebrated.

What commences as imitation of US hip-hop braggadocio is translated into a specific Ghanaian framework through language and cultural context. As Omoniyi analyzes, "For the sub-Sahara African HHNL [Hip-Hop Nation Language] community, several frames of reference exist and these frames are interconnected in complex and interesting ways...The function of codeswitching is to produce appropriate alignments and stances or positionings."[69] Tic Tac uses language to realign his stance back and forth between the global and the local—between GHHN, Ghana, and specifically the Akan people in just a few deft lines.

What is even more significant about this particular quirky Tic Tac song is that it found several social functions in the arenas of Ghanaian sports and politics. The video of "Kangaroo" was released during the 2008 Championships of African Nations (CAN) soccer tournament, and Ghana's national team of footballers (soccer players), The Black Stars, used Tic Tac's "Kangaroo" dance movement whenever they scored. As Ofosu interprets, "Though the dance actually depicts the hand position of the kangaroo whenever it moves, [this movement] also signifies moving forward or making progress. Each time the players scored, they did the dance to tell the Ghanaian fans they were making progress."[70] Politically, the same dance movement was appropriated by the National Patriotic Party (NPP) during its 2008 campaign for the presidency. The NPP adopted the slogan "Moving Forward," and therefore decided to use Tic Tac's dance from his Kangaroo video to associate themselves with the Black Stars.

However, appropriation of signs and symbols as they circulate through various social arenas often loose their origin. When the general public began not associating the Kangaroo movement with Tic Tac, he wrote an article in the newspapers clarifying the use of the movement by the national soccer team, and in the process reclaimed his origination of the symbolic dance movement in his music video. The power of popular culture to create symbols that in turn become marketing tools was made clear in this interplay between music, sport, and politics. As Ofosu conjectures, "Perhaps it was this [realization] that caused the...NPP's flag bearer [presidential candidate, Nana Akuffo-Addo] to realize how powerful musicians are, causing he and his party to start a massive contracting of musicians with large fees to endorse him."[71] Young hiplife musicians in Ghana who have established international reputations, such as Tic Tac, are often appropriated at the highest levels of sports, politics, and the corporate sector, becoming a powerful and influential force in Ghanaian society.

SARKODIE (MICHAEL OWUSU-ADDO)

One way to determine a musical genre's validity is its ability to spawn newer generations of artists who extend that music's appeal; Sarkodie, as a protégé of Obrafuor, represents that reality for hiplife. He started rapping after hearing Obrafuor's first album when he was a junior at Achimota Secondary School, one of the oldest and most prestigious high schools in Ghana. Sarkodie's penchant for a rapid-fire Twi-style of rap brought a new aesthetic to hiplife and caused him to eventually record the single "In This Life" with his revered mentor: "When I am with him [Obrafuor], I am still a fan, not an equal; I will eventually get to being a [superstar] person who everyone knows; then it will be different."[72] Sarkodie's admission during my

2010 interview with the artist reveals his continued humility, even as he is perched on the precipice of worldwide celebrity since being signed earlier that year to Senegalese-US R&B singer Akon's Konvict Musik.

Sarkodie's latest career development with Konvict Musik Africa signifies how hiplife music and the current generation of pop musicians across Africa in general are being boosted by sons of Africa such as Akon, who have achieved American and European pop music clout. Akon is providing African artists such as Sarkodie with an international platform to globally popularize little known music genres from Africa such as hiplife. Akon was socialized on both sides of the black Atlantic, growing up between the United States and his father's home of Dakar, Senegal, an increasing bicultural reality for many young Africans.[73] His Konvict Musik and Kon Live Distribution have become a major music production and distribution corporation whose superstars include Lady Gaga, T-Pain, Jamaican R& B singers Brick and Lace, and the gender-bending American model-singer-songwriter Jeffree Star. Simultaneously, Konvict Musik is focused on the development of the pop music infrastructure across the African continent, which has become only a recent focus of the international pop music industry.[74] For Akon's corporation, building Africa's pop music industry (i.e., production studios, distribution networks, and high-tech money-making award ceremonies) includes the promotion of key artists in Africa's three most developed popular music markets: South Africa, Nigeria, and Ghana. Sarkodie is Babs's (president of Konvict Musik) and Akon's choice to represent Ghana on Konvict Musik Africa.

Sarkodie's rise to this potential level of international stardom reveals another way in which the global and local merge in today's GHHN. He grew up in the Community 9 ghetto district in the harbor town of Tema, and was first discovered by radio deejay Dr. Duncan (Isaac Duncan Williams) of Dom 106.3 Radio, and who manages Duncwills Entertainment. Duncan also sponsors what is known as "street carnivals," where underground hiplife rappers can battle for recognition. Sarkodie participated in those carnival events, distinguishing himself at the street level enough to earn time on Dr. Duncan's radio program "Kasahari."[75] It was Dr. Duncan who engaged the influential hiplife producer, Hammer, who had also helped Obrafuor develop his early hiplife sound, to now work with Sarkodie. One swelteringly hot afternoon in Tema, Sarkodie and I sat talking on the balcony of Vienna City, one of Sarkodie's favorite local restaurants, "where I come to be quiet and observe people." He revealed his early US hip-hop inspirations and the place Dr. Duncan played in the artist's focus of his music for local consumption.

One example of Sarkodie's hiplife indigenization process, facilitated by Hammer, can be witnessed in one of his early singles. "I really like T.I.'s 'Hurt' that featured Busta Rhyme. Hammer took my version of it and did

something Ghanaian with it, while using the crunk beat with Edem [Ewe hiplife artist]." Yet, "Hurt['s]" hardcore lyrics about gang banging ("I ain't scared of the law; I'm about to go to war"), along with video imagery of T. I. wearing a thick weapon-like chain around his neck, *is* imported "gangsta" rap with a level of violence that does not resonate altogether with Ghanaian youths' realities. Although Tema's youths might engage in occasional fights, the spectacularizing of community violence by US gangsta rap portrays an intensity that doesn't exist in the Tema ghetto from which Sarkodie comes. However, it *does* resonate with poverty and use of one's wit in the hustle to overcome social and economic marginalization. Also what binds is aesthetics: artistically, Sarkodie is drawn to Busta Rhymes's often fast-paced Jamaican patois delivery, which spurred him to develop his own rapid gunfire-like style of rap. "I always start with the rhythm like a drummer, and then I find the lyrics to fit it." Sarkodie's mind-boggling rap speed can be witnessed in his hit single inspired by the "Hurt" video, "I'm So Hood Our Way (Ghana)." A line from this track says it best: "I sacrifice my life for hiplife; we taking it local." Thus, imported global discursive practices are translated into local relatable imaginaries. Black Atlantic diasporic connections are made relevantly specific for native consumption.

Yet the gangsta image of global hip-hop continues to whole sway over the HHGN. For example, at the beginning of most Konvict Musik artists' songs there is the sound of the clank of a jail cell, followed by Akon pronouncing the word "Konvict." Symbols and signs of being an outlaw against social norms (flippin' the script) is definitely a US trait, lodged in the American myth of the "wild, wild West." These signs of gangsta rap, conflated with race and the plight of poor ghetto blacks, are exported to international youths who see themselves as members of the HHGN. No matter how much Twi he utilizes in his rap, Sarkodie's signature line in English is: "For my niggaz on the block." When I asked him about his obvious use of black hip-hop slang and the N-word, his answer was unapologetically locally situated:

> You can go someplace [in Tema] and you don't have to plead for them to become your fans, because those from your own area are your foundation, your home base. That's who I'm talking to: the people from Community 9 in Tema, and also Community 1 that is the real hood here.[76]

When global hip-hop symbols are transmitted to discrete localities (in this case Tema, Ghana), they are reinterpreted for local purposes with transposed meanings.

Sarkodie aspires globally, but he definitely focuses locally. He is entrenched in his own neighborhood of Tema as the foundation of his growing recognition. Everywhere we drove in the town, he was enthusiastically

acknowledged; after our interview he took my fiancé and me to Data Link University College in Tema for our next appointment, and his car was flooded with polite young fans that immediately recognized him. Sarkodie views his fame, which is solidly positioned for the *international* market, as founded on his local notoriety in his own community: his hood has made him who he is. When we first arrived at the upscale Peking Chinese Restaurant in Tema, as our initial meeting place for the interview, he called me and told us to wait instead at his mother's little makeshift "chop bar" that was adjacent to the restaurant. As we waited for Sarkodie to arrive, we sat among young and older Ghanaians eating and drinking at modest tables in a traditional outdoor setting. These were Sarkodie's people, and they were clearly proud of him. No matter how much celebrity he attains, the family "chop bar" and its community represent his core.

Positing his self-perception in a communal stance allows Sarkodie the solid platform from which he can take off, as his name infers, and fly to new heights of recognition (Sarkodie means "like the eagle"). Association with American rappers is often vital for international stardom, and his contract with Konvict Musik was made possible by his opportunity to perform on radio with his favorite rapper, Busta Rhymes, who frequents Africa. Their freestyle collaboration in Ghana was heard by Sway, a Ghanaian artist who represents Konvict Musik, who then brought Sarkodie to the attention of Babs and Akon. The year 2010 ended as an important one for Sarkodie, solidifying his current recognition as one of the leaders of the third generation of hiplifers: he achieved the coveted "Artiste of the Year" at the 2010 and 2012 Ghana Music Awards, and was nominated for Best Anglophone Artist category for the 2010 MAMAs in Nigeria, all generated from the debut of his 2009 album *Makye*. His first album became that year's best-selling record in Ghana, with such hits as the self-reflective "Alter" about his past wrongdoings, as well as "Borga" that chastises Ghanaians who go abroad for education, but don't return to help their country.

Sarkodie was being very calculated about the song mix on his second album, *Rapaholic*, which was scheduled for a late 2010 release. He knows that traditionally African music and dance are inseparable, and with his lyric-intensive fast-paced raps, dance is often not the main focus. Club deejays will only play tracks that they know will get Africans on the dance floor; hence, he was gauging the mix of songs on his second album very carefully.

> I'm just waiting on one more song that can be played in the clubs for dance. Right now the club deejays don't play my music because it is more about the lyrics. People will download my raps as ringtones, and then stand around and listen to the lyrics, but the deejays don't play it. So, I want one dance song that can work for the clubs on this second album.[77]

Given his studied approach, his keen observation of people, and his community-orientation, Sarkodie is poised as one of the third generation of hiplife musicians to take the genre to new arenas both aesthetically and professionally, combining the global and local in his own personal mix.

TRIGMATIC (NANA YAW)

Trigmatic is a third-generation Ga hiplife artist who grew up in the Osu district of Accra and represents another approach to the development of contemporary Ghanaian music. True to the hip-hop tenet of flippin' the script, Trigmatic challenges the very categorization of what he does as hiplife. "I wouldn't want to call it hiplife. Why? Because I'm still waiting for that solid definition of hiplife to see where it started. Then I could be a part of it, because I would then understand it."[78] Trigmatic alludes to the various permutations of different genres emerging out of hiplife music that, for him, are discrete and wrongly categorized together.

> Now when Reggie brought in the beginning era and then Hammer came in [with his beats], that was hiplife. After the Hammer regime, people were even doing "souk" and we still called it hiplife. People were doing reggae and still called it hiplife. I think that the understanding is not there. So [there's a problem] if I'm doing reggae music, and I don't know I'm doing reggae music. I mean I wanna be like Samini in Ghana, and Samini says he's doing hiplife; so then I'm doing hiplife. That's where the mistake is. For me, I would do a proper research and find out what I am doing. Am I doing hip-hop, or hiplife? Am I doing reggae or dancehall? And then I will say I'm doing this, I'm doing that.[79]

Trigmatic's critique of the lack of discernment in labeling different strains of music categorized under the term "hiplife" is a valid one.

Today there is a cacophony of categories of hiplife music that can be mind-boggling to the non-Ghanaian. I have already mentioned "jama" music representing the influence of neighboring Francophone music from Côte d'Ivoire, Benin, and most prominently Congo, as well as the "African Dancehall" sound of Samini that is categorized as "raga," which Trigmatic uses as example of hiplife artists' lack of discrimination in classifying their music.[80] In addition, new descriptive appellations discussed during my research were "Afro Pop," and "GH Rap," and even language-specific "Twi-Pop," through which today's Ghanaian artists are beginning to perceive their music, all under the larger banner of hiplife. The bewildering array of musical styles proliferating under the category of "hiplife" testifies to Trigmatic's pronouncement that "there is no solid definition for hiplife," as it continues to develop. However, viewed from the global-local paradigm,

categorizations are often marketing tools representing the inevitable artistic experimentations in the indigenization process of received global pop music. The seeming confusion often represents different youth factions trying to establish their unique generational identities through the admixtures of the musically prolific African continent with Western pop music.

Trigmatic also blames language in the indigenization process for the "mash up" convoluting how artists perceive their music, in turn leading to the industry's confusing branding of music:

> I've been underground for a while, so I kinda know how the boys think. There was a time that if I'm not rapping in English, then it's not hip-hop. That is why I didn't really follow the whole hiplife thing, because I think it gave people a different perception about hip-hop itself. They thought if I'm rapping in English then that's hip-hop. If I'm rapping in Ga, in Twi, or in Pidgin, then I can't call it hip-hop, then you're doing hiplife. Well, they could call it hiplife as a nickname or something; but it still remains hip-hop for me.
>
> For example, at the Kano Music Awards [in South Africa] they nominated Okyeame Kwame, and I was there. He wasn't nominated for a hiplife category. He was nominated for a hip-hop category, while the same song was nominated at the GMAs in the hiplife category.

His critique of the relativity of self-perception and music industry categorization points to the often symbiotic relationship between the two, ultimately leading to the crucial late-capitalist concept of branding in the global marketplace.

There *may* be various subgenres of a particular musical style, but the music's foundation must have a clear conceptual sound that is understood by those both inside and outside of the culture—both producers and consumers. Hiplife as a musical genre can falter in its international ambitions if it does not contain strong identifying markers. This pop music quagmire is implicitly embedded in hip-hop's global proliferation, producing myriad of *sub*genres and *new* genres, such as hiplife, developing along the way of hip-hop's international journey, becoming situated in discrete localities such as Ghana. Ultimately African pop music's categorical confusion stems from the complexities implicit in the global-local problematic.

Trigmatic has gone through his own artistic permutations to reach the current stage of his career. He has been performing professionally since 2000, having started underground when he was in middle school, "trying to be another Biggie, another Pac." However, he followed his own advice and researched hip-hop's history. "Because I'm young, I didn't start from the Kool Herc era, you know. Actually, I fell in love with it from the days of Biggie, and started finding myself in about 2000."[81] He also researched

traditional Africa music, including listening to and communicating with artists in other African countries such as Kenya and South Africa. "I realized that there was something there, you know, and I could find that original African. That's when I started using [the] Ga [language], and I used some of the [traditional] instruments—some of the drums and all that. I started performing with some 'cultural' groups [traditional Ga musicians], and I started using live bands—live music."

Trigmatic's personal approach to the indigenization process of received hip-hop music represents a trend of utilizing more traditional African music. In Ghana for example, King Ayisoba, whom I explore in Chapter 2, is a traditional musician who plays his Frafra people's *Kologo* two-string instrument, and yet he has been categorized within the hiplife genre. Making live music a focal point in the hiplife sound, as opposed to solely using synthesized beats, is what producer Panji Anoff encourages with his annual High Vibes Festival in Accra, which could further distinguish and create an international "brand" for hiplife.

Yet, instead of the indigenous creativity of hiplife as a genre as I have been arguing, Trigmatic argues that Ghanaian musicians are currently emphasizing too much of the global—the British and the American sound.

> Everybody's too much TV; everybody is just confused right now. People want to look out for how "good" you sound—how foreign you sound. You need to sound British or American. [That mentality] is all over the place. It's not just Ghanaians. I went to Nigeria, and the disease is all over the place. Even in South Africa it's like that. The only difference is South Africans are very strong when it comes to their culture; you can never take it away from them. But Ghanaians, we welcome everything that comes in; [we say] let's throw away our stuff, let's welcome the new ideas.

His perception of Ghanaian musicians' overzealous acceptance of foreign musical influences is consistent with a larger critique of Ghanaians being too influenced by their British colonial masters. Rockstone mentioned in an interview that Ghanaians have the reputation throughout West Africa of being too accommodating to Europeans, and that he considers Kwame Nkrumah to be the only revolutionary that the country has produced. Rockstone concluded his class analysis of a perceived general Ghanaian accommodationist stance with how it translates into the use of language— that speaking the proper Queen's English in Ghana is the primary attribute that garners success and respect.[82]

A class argument that I have been promoting in this text is that hiplife musicians are usually from the Ghanaian middle class and unquestionably proficient in English. Although there are a few exceptions, like VIP, who

display their poorer ghetto roots proudly. Ghanaian hiplifers have tradition-
ally emerged from the educated middle class, and excel in adapting received
English-language rap lyrics. Power relations, class and Western pop culture
hegemony work in tandem to render Trigmatic's critique of contemporary
hiplife music as altogether plausible.

Trigmatic's own life reflects these class dimensions in Ghanaian highlife.
At the time of this study, he attended Central University College in Ghana,
one of the many institutions of higher learning in the country. As a proud
marketing major, he found it disheartening that many African American
hip-hop fans in the United States often drop out of their *free* high schools in
the United States, and often view becoming educated in general as "acting
white."[83] Ghana's national emphasis on education creates an environment
for self-motivated young men such as Nana Yaw, though financially diffi-
cult, to achieve their educational goals. This is true, despite higher education
being usually unavailable to youths from the poor majority who populate
Trigmatic's Osu district. But he never forgot his roots, making his purpose
to give expression to his poor community, whose voice is not always heard.

> They need a voice to speak for them, especially from where I come from; I
> didn't come form a lucky background, so I know what it feels like to be in
> the slums and in a ghetto. I know how it feels because I've been there, I've
> lived there. I understand the life. And one of my songs "My Jolie (Bernice)"
> talks about a boy in the hood. The video portrays a boy who lives in the
> ghetto, and talks to his girlfriend over the Internet, because that's something
> that's happening lately. And he misses her. It's love. But it's love based in the
> hood.[84]

Trigmatic's class background does allow him to identify with many emcees
from the ghettos of the United States, viewing his celebrity as a chance
to make the lifestyle of his hood more intelligible and recognized in the
larger Ghanaian society. This social "power move" that promotes so-called
underclass culture is a significant achievement of hip-hop culture as it is
appropriated by marginalized communities internationally.[85] In Ghana,
Trigmatic has been able to highlight his Osu district's particular lifestyle
filtered through his individual artistry and education that has provided him
an awareness of broader global dynamics impinging upon that community.
The opportunity to utilize expressive youth culture such as hip-hop is ren-
dered through the globalization of the youth culture's implicit *ghettocentric*
power move.

The venue at which Trigmatic and I met for the interview and its street
context—Frankie's tourist-oriented restaurant on Accra's Oxford Street—is
symbolic of the admixture of Western imagery and local priorities at play in

hiplife culture. Oxford is a street with a dizzying array of Ghanaian tourist shops and artisans that literally stretch out into the actual street, forcing one to walk along with the slow-moving traffic. A plethora of Western-oriented stores lining crowded Oxford Street sell the latest technological gadgetry, including all the major telecom companies (see Chapter 3), as well as haute couture fashion such as Gucci, Coach, and Louis Vuitton. In analyzing the symbolism of streets such as Oxford and "new" pop culture genres such as hiplife, Ato Quayson asks us to image "what happens when we stop seeing streets merely as geographical locations and rather interpret them as archives?"

> And if in focusing on an African street such as Oxford Street in Accra, this archive is interpreted not as static, but as providing a transcript of dynamic simultaneities...For the real task lies rather in demonstrating that the link between technology, representation, and desire is mediated through especially variegated environments, the variegations pertaining to the nexus between apparently evanescent local traditions that coalesce into increasingly syncretic new wholes and the spectral globalized processes that materialize in commodities and their attendant imagescapes.[86]

Pop culture forms such as hiplife certainly trigger and enhance these "syncretic new wholes" that streetscapes such as Oxford Street also reflect.

At the center of Trigmatic's challenge to categorization of Ghanaian pop music is this construct of "syncretic new wholes" that create nexuses of received globalized music with local African priorities. The stages necessary to establish a musical "whole," like hiplife, often create confusion as they attempt to coalesce into a coherent new sound that develops its own archives and cultural priorities. These new musical hybrids, like hiplife, inevitably fetishized new commodities—what Quayson calls "imagescapes." As Trigmatic and I sat talking about hiplife music, I peered out of Frankie's seen-and-be-seen picture windows onto Oxford Street's poor African women vendors selling groundnuts and plantains just in front of a Vodafone billboard selling its worldwide technology, both images "invoking a rich and intricate relationship between tradition and modernity."[87]

One example of a nexus between a received globalized approach filtered through African precedence can be viewed in Trigmatic's style of hiplife, or hip-hop, music. His approach can also be categorized in what in the United States has been called "emo-rap," or emotional rap, where uncharacteristic of hardcore rap the emcee is willing to reveal his personal vulnerabilities and discuss his inner life. Both Eminem and Kanye West have been placed in this category of rap, and one of Trigmatic's most famous tracts, "My Life," fits in this genre in Ghana. As I interviewed him at Frankie's, the impact of Trigmatic's personal approach on his audience was made apparent when

a Ghanaian male came over to obtain his autograph. The man, who spoke with a British accent, said he had seen Trigmatic on television and admitted that he really liked "My Life" in particular because he could really identify with it. The artist's subjectivity, created through a mass-mediated world, resonated with one of his male fans as they both engaged in revisioning the possibilities of individual actualization in today's Ghana. Shipley captures this artist-audience connection when he evaluates hiplife's local reception: "For local audiences, the moral legitimacy of an individual microphone-wielding speaker is produced and contested in their moral commentary on the authority of public figures, in the formulation of a masculine speaking subject urban youth creatively re-think possibilities for individuated action."[88]

Indeed, Trigmatic represents a Ghanaian emcee focused on moral subjectivity in relation to defining himself individually and within the game of hiplife. His appeal to his fan base is an ultimate validation of his artistic goal of using rap to process his personal growth, thereby creating a self-reflexive space for his public to engage in the same existential praxis. Trigmatic is one of the artists expanding the reach and meaning of hiplife music in Ghana in the current third generation.

MIMI (WILHEMINA ABU-ANDANI) AND GENDER ISSUES AMONG GHANAIAN FEMALE ARTISTS

Just as in US hip-hop, male hiplife musicians outnumber females, creating what Ghanaian singer Mimi calls a "male dominance," even as this fact also renders "our competition not as tough as the guys."[89] As a recognized Ghanaian hiplife artist, Mimi represents the female wing of the genre first started by Abrewa Nana and Mary Agyepong, who have ceased performing. As a calculated "business woman," Mimi projects herself beyond the borders of Ghana, positioning her career throughout the continent, performing frequently in Nigeria, Tanzania, and South Africa.

Mimi's continent-wide focus of her career is partially due to gender inequality in Africa. It is much the same in West Africa as Ntarangwi reveals for East Africa: "Many of the hip hop artistes in East Africa are male because music making happens in public space, and public space has, in most instances, been sanctioned as male space, especially in urban centers…"[90] However, public female figures of Ghana with its Queen Mothers who wield considerable power in traditional matrilineal clans, as well as the ubiquitous Ghanaian market women who exert substantial influence over the local Ghanaian street economy, are strong forces with which to be reckoned.[91] Therefore, traditionally in West Africa, public space has been an arena for the voice of *particular* women, evidenced in other genres of

Ghanaian music such as "gospel." According to Collins, there has been a "feminization of gospel music," with women constituting a large part of that genre. Moreover, he estimates that gospel music in Ghana makes up over 50 percent of the total music sales.[92] Therefore, male dominance in Ghanaian hiplife music in particular may be more attributable to the masculinization of public space as an *imported* trait accompanying the globalization of US hip-hop.

According to Mimi there were only four working young female artists in pop music at the time of my fieldwork in 2010, three in what could be considered the hiplife genre (including herself) and one in contemporary highlife. Becca (Rebecca Acheampong) is an award-winning contemporary highlife female artist. Along with Mimi, there are Mzbel—pronounced Ms. Bell—(Nana Akua Amoah) and Eazzy (Mildred Ashong), all categorized in hiplife. The latter three sing with an Afro-Pop style that includes rapped verses, and often featuring collaborations with male hiplife emcees. In addition, there are a few other *emerging* female emcees in the newer GH Rap category such as Tiffany ("I'm inspired by Nikki Minaj") and Lady-G, a hardcore rapper who performed a freestyle battle with all males on Rockstone's "BET Cipher." Another female, Sherifa Gunu, who hails from northern Ghana like Mimi, performs her own style of contemporary West African music, mixing highlife and juju, and always wearing traditional African dress and singing in her Dagbani language. These women signify different twenty-first-century approaches to Ghanaian female identity, representing the wide continuum of the global-local paradigm in which contemporary African women are positioning themselves.

Mimi's career actually began by representing Ghana on the 2008 episode of "Big Brother Africa," the African version of the imported US reality show, which is produced by Endemol International, the biggest producers of reality television in Africa (Chapter 3). This all-African platform helped her launch her singing career throughout the continent.

> Right after my 2008 Big Brother season, I released my album, which I was already working on. So, I just used my popularity advantage to release the album. It was so easy, because I was already known as a reality star all over Africa. So when the music came out, everyone was like, "Oh Wow, Mimi's now singing." And everybody wanted to go out and get the album, and get to know what is in it.[93]

Mimi demonstrates a business acumen that partially comes from her being a graduate in chemistry from the University of Cape Coast. "That's why I'm very analytical; I do a lot of experiments and comparisons, and then apply that to life."

Her scientific approach, along with her strong Ghanaian female persona, underpins her understanding of the different cultural markets to which she sells her "brand."

> I'm an African artist. That is the platform I'm on right now. Tomorrow, even I'm outta here. I'm going to South Africa, because I have a gig. So this is how I see myself. That [small Ghanaian scene for women] doesn't limit me. I give myself a wider view. That means I work harder, because there's more competition out there [across Africa]. There are very good female artists. So if I do that, I will work hard. I always think that competition brings competence. If there's no competition, then you don't strive harder.
>
> ...So I could put out a video in South Africa or Tanzania and it wouldn't be such a big deal like it is here, because they have a different way of doing their things. So now I know how they do theirs, and I do a video to suit them, and I'm getting a lot of gigs and calls because of that. I'm just not only known in Ghana; I travel all over Africa to perform. So that's how I get myself in, because I see myself like that.

Mimi represents Ghanaian female hiplife artists who see the *world* as their stage and are becoming increasingly savvy about parlaying their local fame into continental and international platforms. Mzbel was doing an American tour while I was conducting my research, and Eazzy had only been back a year from London where she had been completing her college degree. These educated and business-savvy young Ghanaian women use their hiplife music careers as a way of both "shaping...[their] subjective realities," analyzes Ntarangwi, "and as a form of gainful economic activity."[94]

Mimi was born in the Northern part of Ghana, "in Tamale, the poorest part," and raised in Kumasi. She released her first album *Music in Me* in 2008, featuring hiplife emcees 4X4 and Tinny. The album represents typical topics of "fun and love," she reflects, "trying to 'outdoor' the music in me, so that people would accept it." That purpose is translated in her hit singles "Leave Me Alone," and "Tattoo," the latter of which became a video showing her in an urban upscale domestic love relationship. In the video, she switches back and forth between a Western "glam" hair weave look and one adorned in African garb with head wrap and a *kaba* cloth wrap that exposes a bare back on which her lover's face is shown tattooed throughout the video. Globalization of US hip-hop music exports many often-unintended cultural traits such as body tattooing; however, reinscription with an African gloss turns the inherited trait into part of the indigenizing process.

The "Tattoo" video portrays all three of Tricia Rose's analysis of the central themes of black female hip-hop artists, elucidated early on in hip-hop scholarship: "1) heterosexual courtship, 2) the importance of the female voice, and 3) mastery in women's rap and black female public display of

physical and sexual freedom."[95] Although "Tattoo" features Mimi as an African R&B ballad singer, singing mostly in Twi, the inclusion of hip-life rapper Tinny on several verses legitimately positions it in the hiplife genre. The video of "Tattoo" provides Mimi with a showcase for her personal sexuality, as well as her voice on the subject of male-female relationships. It opens with her in bed as the main protagonist, accompanied by her male lover in the background caressing her back where the tattoo is to be placed. Continuing in various domestic scenes, such as a high-tech designer kitchen,[96] she serves coffee to her man who is dressed in a business suit and tie. She croons the English hook, "I cannot live without you" in between Twi verses of her professed love, placing the couple in a typical romantic scenario. The video concludes with the camera moving in for a close-up of a complete image of her lover's face tattooed on her back draped in her Ghanaian *kaba* cloth.

Even though Mimi is the music video's female protagonist, her male lover has been at the center of attention. Rose notes this ambiguous tendency of female hip-hop artists: "Works by black women rappers that place black women's bodies in the spotlight have a...contradictory effect; they affirm black female beauty and yet often preserve the logic of female sexual objectification,"[97] and as a result patriarchy is affirmed, with males remaining as the central figure. Mimi and other women of the hip-hop generation, I argue, are willing to "play" the patriarchal game, while being cunningly in charge of this imaging, as well as their own business affairs. Rose's insights about female themes in hip-hop may have been absolutely true in the early 1990s; however, I argue that today's twenty-first-century hip-hop female artists are actually highjacking patriarchy as a tool to get paid in the global pop culture industry.

Today's savvy women in hip-hop render new wrinkles to Rose's analysis in the present phase of late-capitalism and hip-hop's flirtations with third-wave feminism. For example, hiplife females such as Mimi, have no illusions about the fact that they are indeed living in a patriarchal world. Like their male US hip-hop counterparts, who *perform* race as "the nigga as performative identity,"[98] so too do hip-hop (and hiplife) females perform *gender*. They provide the male-dominated industry with the expected female sex roles, knowing all to well that their sexuality is far more saleable in a sexist patriarchal marketplace than their often-prodigious skills. Yet, in the twenty-first century pop culture market they simultaneously cultivate their own celebrity images along with establishing their own individual voices, all the while focused on improving their financial status.

Some feminist scholars often see this reading of hip-hop and hiplife female artists as contradictory to critiques of sexism in the marketplace; yet other feminists, analyzing the continually shifting dynamics of female

representation of their own sexuality in popular culture, offer a different reading. As Cheryl Keyes, for example, has noted, "Black fly girls express a growing awareness of their erotic selves by sculpting their own personas and, as folklorist Elaine Lawless (1998) puts it, 'writing their own bodies.'"[99] Hip-hop feminist journalist Joan Morgan articulates for many in the hip-hop generation what she calls "functional feminism":

> In my quest to find a functional feminism for myself and my sistas – -one that seeks empowerment on spiritual, material, physical, and emotional levels – -I draw heavily on the cultural movement that defines my generation. As Post-Civil Rights, post-feminist, post-soul children of hip-hop we have a dire need for the truth. We have little faith in inherited illusions and idealism...Love no longer presents itself wrapped in the romance of basement blue lights, lifetime commitments, or the sweet harmonies of The Stylistics and The Chi-Lites. Love for us is raw like sushi, served up on sex platters from R. Kelly and Jodeci. Even our existences can't be defined in the past's simple terms: house nigga vs. field nigga, ghettos vs. bourgie, BAP vs. boho because our lives are usually some complicated combination of all of the above, . . We need a feminism committed to "keeping it real." We need a voice like our music – -one that samples and layers many voices, injects sensibilities into the old and flips it into something new, provocative, and powerful.[100]

So-called third-wave feminism is often about trusting the choices that savvy young women make through their own agency. I offer this reading of several Ghanaian hiplife female artists who too are influenced by "functional feminism" while fighting the continuing sexist challenges present in Ghana, like in the United States.

Mzbel offers a poignant example of this third-wave feminist approach among young Ghanaian women. Known as "the saucy girl," Mzbel is seasoned in playing gender with her hiplife persona. In her "Sixteen Years" video she transforms herself into a sexy teen siren, while simultaneously warning the public against older male pedophiles who lust after young Ghanaian girls. When asked about her "saucy" image in that video during an interview on TV3's "Late Night Celebrity Show," she coyly explained her real intent in the video: "I'm not saucy. I was talking about a [young] girl, and it was a character. I am Mzbel. I'm saying, 'I'm 16; stay away from me.' It was anti-pedophile, supporting an anti-rape message." Reggie Rockstone, who was on the same talk show with her, concluded to the television audience: "So Mzbel's clarification was for those of you who misread the album."[101]

The performativity of gender is crucial in the postmodern era of late capitalism, and the most astute performers such as Mzbel and Mimi become masters of its inherent play(acting). Ntarangwi reminds us, "Gender gains meaning through performance...[and can be] regarded in the same way

Judith Butler does, not as a fixed reality of who one always is but rather what one does (perform) at a particular time."[102] In the convolutions of late capitalism's use of popular culture, resistance can come in many guises, even one that superficially appears complicit with the status quo.

Yet, even with the manipulation of patriarchal norms in Ghanaian society by savvy female pop singers, there are a group of female scholars at the University of Ghana who are trying to change the sexist status quo itself. "Changing Representation of Women in Popular Culture" is a research project that is a part of the global Pathways of Women Empowerment Initiative that was locally born out of the Center for Gender Studies and Advocacy (CEGENSA) at the University of Ghana, Legon. Drs. Akosua Adomako and Awo Mana Asiedu of CEGENSA are the project coordinators. Dr. Adomako Ampofo informed me that those in the project "would like to see more contestation" concerning the images and roles of women in Ghanaian society that are reinforced in popular culture and music specifically.[103] This contestation would challenge what is now accepted as domestic and public roles open to women, as well as challenge the objectification of women's bodies.

"The Changing Representation of Women in Popular Culture" project's first phase was a 2008 forum, "The Reflection Workshop", held at Eli King Hotel in Accra with scholars, musicians, disc jockeys, and radio presenters "to reflect on the messages encoded in popular song texts about women."[104] In attendance were women scholars from Nigeria and Egypt as well. The participants in the forum found that many Ghanaian song lyrics contained messages about women that "are often negative and tended to reinforce stereotypical societal perceptions of women." Besides the usual women-as-sexobjects message, additionally they found a "tendency to portray women as fickle-minded, unfaithful, money lovers, exploitative, competitive, gossips, submissive, jealous. etc."[105] This is unnervingly similar to the same accusations against American rap music lyrics. One is lead to wonder whether the blame lies in the negative by-products of hip-hop's globalization, or local sexism in Ghanaian patriarchy.

Two more phases of the project included a focus group to illicit concrete data and a song competition, the latter of which established a focus on "positive images of women." The focus groups included students who listen to popular music and taxi drivers who play popular music in their vehicles to attract customers. The project coordinators felt that these two populations represent large segments of Ghanaian popular music consumers. From the focus groups, the researchers found that the comments of the participants showed images of women as "lopsided and demeaning." The music competition was initiated to be the project's proactive component that could potentially create more positive images of Ghanaian women. According to Dr. Asiedu, "the lyrics—what they were actually saying—became the focus of criteria

for success." Out of the twenty-six entries, there were three winners, who happened to be all males. Compact discs of their music were produced that included their winning songs. Hip-hop globally could benefit from more proactive feminist-oriented scholarly projects such as "The Changing Representation of Women in Popular Culture" with its song competition, where feminist researchers of popular culture are engaged.

The reality of the *business* of the Ghanaian music industry, with its legalized payola, is one area where Mimi and other female hiplife artists are treated as equals with their male counterparts. As mentioned previously, in Ghana, radio stations and television stations charge artists to play their music and videos. Mimi's concentration on the business of her career and her choice to market herself across Africa, rather than solely relying on the Ghanaian market, is also fueled by these injustices in the Ghanaian pop culture industry.

> South Africa is more advanced than Ghana, and that is the truth. They do things properly. In Ghana, the industry is good, but the procedures are not proper. Royalties are messed up. If you want to play your music video on TV, you have to pay to be played. And that's crap, because you are using my video as context. You should be paying me for playing my music video. I'm being paid right now, because they're playing my song on a reality show in South Africa. They actually sent me a contract to sign to be paid for royalties. Now, this is the way to do things, because it's my song.[106]

Mimi speaks for the few women in the male-dominated hiplife scene, when she admonishes Ghana's music industry: "The producers should start believing in the women, because the men are dominating. The producers always believe they will make more money with the men than the women. But I think they should start producing more girls. That's why I say I'm an African artist; Africa is big, and there are a lot of female artists in Africa, and that makes me work harder."[107] Mimi represents African female musicians who are empowering themselves in a male-dominated business, as they take advantage of a pop culture-saturated world to project their female messages while enhancing their entrepreneurship and therefore economic status.

CONCLUSION

Globalization and indigenization are practices at the core of a shrinking world where exportation of Western economics, technology, and expressive culture are underpinned by an attendant cultural ideology that colludes and collides with local socioeconomic needs and values. Ghana's hiplife music becomes a lens through which this complex worldwide procedure is rendered

more intelligible. In this chapter, I have explored several social dynamics and personal narratives that illuminate several of late capitalism's global-local processes through Ghanaian youth's contemporary music. Ghana's hiplife music is sweeping across the African continent, perched to become a global pop music phenomenon. This West African country, with its long history of interaction with African Americans and their political and expressive culture, has traditionally utilized black-generated pop cultural forms such as ragtime, jazz, R&B, and hip-hop. But, I argue, Ghana's hiplife music is in equal part a revision of its own highlife popular music that has engaged global influences throughout the twentieth and now twenty-first centuries. British colonialization produced hybrid highlife that became one of the contemporary pop music forms of West African for the twentieth century. Therefore, highlife is the pop music with which hiplife artists had to engage in their indigenizing project. Hence, imported music and culture mix with local practices to form unique expressive statements in discrete locations. As hip-hop proliferates around the world, Ghana's hiplife music is one such example of the indigenization of globalized cultural practices from the United States.

Although hip-hop can be viewed as a new "colonialization" affecting the entire African continent, its cultural usurpation, for the most part, has been welcomed. Moreover, hip-hop music in Africa has been actually claimed as historically indigenous. This reclamation of hip-hop's basic musical approach of polyrhythmic, antiphonal social commentary, and the near-verbatim ubiquitous dance moves, has rightly challenged hip-hop's history and origin myth in the United States. Omoniyi's Boomerang Hypothesis captures the African reclamation of hip-hop's aesthetics and testifies to my argument for the *arc of mutual inspiration* at the center of the cultural relationship between African and its diaspora. Hip-hop scholarship, developing over the last 16 of the subculture's near 40-year year history, has had to become more scrutinizing due to published ethnographies of its practice in discrete local sites, resulting in the exploration of many international dimensions. *The Hiplife in Ghana: West African Indigenization of Hip-Hop* is another link in the continuing investigation of this ubiquitous youth subculture.

For my purposes, what is most important about the globalization of hip-hop music and culture is how it has provided the youth in Ghana the ability to intervene in the development of their socioeconomic lives, allowing them personal and group agency, similar to their US counterparts. As Shipley recognizes:

> It provides an Afro-cosmopolitan poetics for young Ghanaians to position themselves as viable economic and political actors. While the music focuses on local moral issues cast in formal terms of indirect speech, it provides a poetic language for accessing transnational Black agencies for youth otherwise relegated to non-speaking positions.[108]

Twenty-first-century entrepreneurial agency of hiplife artists in Ghana is a continuing example of Arjun Appadurai's evaluation of mid-1990s globalizing practices that transform "everyday subjectivities through electronic mediation and the work of imagination."[109]

Today the business acumen of many artists has created collaborations among specific artists across the black Atlantic physically and virtually, directly fueling rapidly shifting subjectivities among its youth participants. Transatlantic collaborative entrepreneurship is evidenced in the video featuring Reggie Rockstone, Nigeria's 2Face Idibia, and Jamaica's Beenie Man. Under the aegis of Beenie Man, the "King Meets King" video claims transatlantic black royalty within hip-hop/dancehall swagger, with an allusion to the Ashanti being one of the historical cultural groups forming black Jamaica. Rockstone and Beenie Man strut their assumed historic "kingship" before the camera through a contemporary black masculine subjectivity, lodged simultaneously in a ubiquitous global MTV spectacle and an ancient local Akan *durbar* festival.

Hip-hop's global aesthetic has been adjusted in varying degrees through the indigenization process. Ghana has indigenized hip-hop to the point where hiplife has become its own musical genre, demonstrating the inevitable localization process—the "reterritorialization" procedure—in the receiving of global products. Lord Kenya casually stated that as "a true African boy" he "knows how to make an African out of the computer," which I first mentioned in the Introduction and used as the title of this chapter. His assessment of the indigenization process captures the essence of how many young Ghanaians view their technologically mediated lives, increasingly at the center of their participation in the global hip-hop movement, the GHHN.

Perceptions about the indigenization process are particularly cogent through the individual artists' profiles that I have explored in this chapter across three artistic generations in Ghana. From the use of hiplife to create a sense of Ghanaian unity through rap in multiple languages by VIP and through a national moral criticism by Obrafuor to the Abodam "bad boy," but philanthropic, image of Kwaw Kese, hiplife can be proactive in its various social, cultural, and historical interventions. Simultaneously, the local and global demands of the marketplace create various defensive reactions such as Samini's "Kapooi" symbol and Sarkodie's localizing "I'm So Hood [But] Our Way." Also, Tic Tac's fun-loving, but seriously competitive, "Kangaroo" positions hiplife in the typical rap bravado, while Trigmatic challenges the entire hiplife genre of Ghanaian music to be more rigorously critical about its development.

Female hiplife and R&B singers add another dimension to the global-local problematic as they expose the strategy of performing gender, just as some US rappers perform "race." The exigencies of a patriarchal pop culture

industry forces female hiplifers to often play the objectified body while inserting their antipatriarchal messages and commanding top dollar. Artists such as Mimi and Mzbel are doing their best to negotiate the "minefields" of a male-dominated industry, while some female university academics are attempting to impact gender biases in Ghana's culture and its music industry as a whole.

Although all hiplife musicians have been influenced heavily by hip-hop from the United States and continue to follow it religiously, as Lord Kenya also stated, "we have structures here in Ghana." Indeed, the "structures" to which he alludes includes complex sonic approaches to the organization of rhythm that have influenced all of world popular music. As I explored in *The African Aesthetic in Global Hip-Hop*, one of these structures has to do with rhythmic repetition in conjunction with improvisation what, musicologist Olly Wilson calls the "fixed and variable rhythmic sections."[110] As I have said,

> These two musical dynamics in tandem establish a foundation of expectation that is circular, but at each turn contains critical difference. The surprise invoked by the variable unit, whether a holler of James Brown or the slap of a master Senegalese djimbe drummer, creates anticipated innovation within the rhythmic conformity.[111]

Indeed, James Snead has explained that "Black music sets up expectations and disturbs them at irregular intervals: that it will do this, however, is itself an expectation Without an organizing principle of repetition, true improvisation would be impossible, since an improviser relies upon the ongoing recurrence of the beat."[112] It is precisely this kind of rhythmic organization, for which Africanist music is noted, providing the aesthetic power to which humans worldwide respond and that hip-hop re-engenders.

Tricia Rose was the first to articulate similar issues of circularity and "disturbance" in hip-hop aesthetics. I said previously,

> She utilizes a concept of 'flow, layering, and ruptures in line' to explain hip-hop's use of this African aesthetic principle of repetition with breaks. While *flow* is a term used in hip-hop to denote either the rhythmic fluidity of the beat or the rhyming of an emcee, the breaks and interruptions in conjunction with flow more fully explain the energy of hip-hop aesthetics.[113]

The tonal slaps of the master drummer in traditional African music accents a movement or musical phrase, while interrupting the circular rhythmic flow of the support drums is the same process Rose analyzes that happens in hip-hop musical production: "The flow and motion of the initial bass or

drum line in rap music is abruptly ruptured by scratching (a process that highlights as it breaks the flow or the base rhythm)."[114] Flow and rupture become the foundation of the producer's technological skills or a deejay's deft mix, as in African musical organization throughout the centuries.

This understanding of African sonic organization, along with the linguistic adaptations of hiplife artists, provides a layered comprehension of the indigenization process, and further reinforces the claims of Africa being the place where hip-hop aesthetics originated. In Chapter 2, I explore other artists such as Okyeame Kwame and King Ayisoba who are using those Ghanaian musical and linguistic "structures" in their own creative ways. Ghanaian youth agency furthered through the hiplife movement and the resulting generational shift that has occurred in relation to the *sociopolitical* structures of power in Ghana are what I next explore.

EMPOWERING THE YOUNG: HIPLIFE'S YOUTH AGENCY

AN ESSENTIAL THEORETICAL CONCEPT IN *The Africanist Aesthetic in Global Hip-Hop: Power Moves* is "connective marginalities." The construct illuminates one of the primary reasons that hip-hop music and culture have become international among youths worldwide. Besides the obviously influential transnational corporate pop culture power emanating from the United States, Europe, and now Asia, I argue that there are also "extant global inequalities [that] work in tandem with the irresistible Africanist aesthetics to construct the global lure of hip-hop."[1] Ubiquitous social inequalities represent various marginalities that connect youths globally. In that text, a diagram of connective marginalities consists of four concentric circles: linking (1) culture as aesthetic hierarchy (already discussed in Chapter 1), (2) class inequalities, (3) historical oppression, and (4) youth rebellion.[2] The latter marginality of "youth rebellion" is the subject for this chapter, specifically the inequality of "youth" as a marginalized status in most societies. In conjunction with the construct of "youth," I am also interested in agency—the means of exerting power or influence—that hip-hop culture has provided for youth globally. Youth agency allows culture participants to resist expectations, offer counter-narratives, and amass sociocultural and economic power against social norms of the older generation. Indeed, "youth," perceived as an often-insignificant social ranking, particularly in traditional societies that give omniscient power to eldership, is the largest circle in my connective marginality diagram in *The Africanist Aesthetic in Global Hip-Hop*. Rebellion by youths against their assumed powerlessness occurs everywhere hip-hop has taken root.[3]

This chapter is about how Ghanaian hiplife artists and consumers utilize their local pop music to find their own voice in opposition to the

power of the adult population. In Ghana, the confrontations with power can be *general* (norms of social morality, economic and political injustice, the perceived old-school highlife generation) or *specific* (particular corrupt politicians, record label executives and corporate manipulations of hiplife, obstinate civil servants, impotent public intellectuals, a particular local antiquated custom). Hiplife music provides avenues to personal and collective agency that serves as social, political, and economic intervention in the public sphere by youths in ways that have not previously been available in Ghana. Ntarangwi found the same use for youth agency through hip-hop against perceived marginalization and powerlessness in East Africa.

> I see youth agency through hip hop as a means of retaining autonomy and the ability to act on their own behalf while influencing other people in political discourse and even economic activity in spite of the global forces of inequality and exploitation they face.[4]

Hence, hiplife music in Ghana, like hip-hop in other parts of Africa, is an important tool in shifting power and offering young people a modicum of authority in shaping their personal lives and national affairs that is unprecedented.

In Africa, even with some traditional song narratives having a notorious reputation for purposeful derisive chastisement, music empowerment has traditionally been perceived as a relatively nonthreatening acceptable means of limited agency. However, in Ghana today, with corporate executives, politicians, and regional agencies all vying for the endorsements of the most popular hiplife musicians, I will show that today these young artists have assumed an unprecedented level of influence in the public sphere. Shipley, one of a few researchers of hiplife music in Ghana, states that "while youth create new performance styles redefining public life, state, corporate, and international organizations increasingly appropriated popular culture for institutional legitimacy."[5] Shipley calls the power that young Ghanaian hiplife artists have garnered "performative agency," resulting only partially from global hip-hop.

> Hiplife music indexically links multiple forms of performative agency provided by the bodily force of creating a moral public, grounded in national myths, transnational racial imaginaries, and local genres of speaking and political consensus—that is an historically specific normative "we." Implied in this process, is a particular kind of agentive narrator and individuated "acting subject."[6]

The local habitus of any locality where hip-hop situates itself engages particularized "national myths" and "local genres of speaking," as well as a

contentious hard-won "political consensus." In Ghana's case for example, as I demonstrated in Chapter 1, the contested historical place of Kwame Nkrumah as Ghana's first leader, for example, is one such myth, while allusions to *ananse* tales [*anansesem*], Akan and Ga proverbs, and traditional drum language are all examples of Ghanaian speech acts about which scholars have written extensively, and which constitute different indigenous sources for hiplife music.

However, in Shipley's foundational index of performative agency, his concept of "transnational racial imaginaries" suggests what other hip-hop scholars, such as Tony Mitchell, have advanced as a spurious essentialized connection to African American culture as the root of global hip-hop. From this perspective the basis of my construct of "the arc of mutual inspiration" between African diasporic music and dance forms and Ghanaian ones is merely a summoning of "circular, diasporic influence...that has been invoked to justify claims that the roots of rap and hip-hop are quintessentially African American; but these roots are as culturally, eclectically, and syncretically wide ranging as they are deep."[7] Yet, as I said in my earlier book, "my global argument about hip hop is based on a cultural aesthetic, not a black racial essence."[8] Connections between African American musical construction and African ones are deeply felt resonances across time and space, which I will demonstrate later in this chapter with hiplife artist Okyeame Kwame, and represent astute observations by Ghanaian musicians, as they often claim the artistic principles of African American hip-hop. Therefore, although it would be difficult to prove, one could argue that mythical *cultural* imaginaries, rather than *racial* ones, are engaged in the indigenizing project of hiplife music. Furthermore these cultural fantasies do not dilute undeniable historical links between Africa and its diaspora, even when African elders unwittingly render these connections as "foreign."

Hence, hiplife's new sociocultural clout—collective agency claimed by the artists—extends to fans of the music, as consumers of pop culture products and also as participants in the national social discourse and local politics. As hiplife musicians become empowered entrepreneurs, the resulting artist-fandom agency creates a new kind of national constituency that provides twenty-first-century fodder for transnational corporate power. This shift in the position of youth in the social, political, and economic marketplace in Ghana and the international market results from the adoption of global, in-your-face, rebellious hip-hop culture, seen as "foreign" by elders in its original imitative form, and now localized and *generally* accepted across generations in Ghana as original Ghanaian hiplife music and culture. Hip-hop's rebellious youths persona dictates the exceptional and often "illicit," that creates a "critical public" sorting out the shifting social discourse across generations. However, in the long term, locations such as Ghana normalize

these new individualistic behaviors within the larger influence of the multi-national corporate marketplace (Chapter 3).

One way to understand this social shift toward youth empowerment is the semiotics of body language indicative of changing subjectivity. Unlike Judith Butler's (1990) use of "performativity" as a fictitiously constructed element of gender, as I have said elsewhere, "I define performativity as an often unconscious but *meaningful* series of bodily postures, gestures, and movements [often used in performance] that implicitly signify and mark a sense of social identity or identities in everyday pedestrian activity."[9] The performativity of everyday life is revealed in the body, and as such it can also reflect social change. Producer-choreographer Terry Ofosu acknowledges a shifting bodily subjectivity in relation to social identity among hiplife youth in Ghana:

> When hiplife first started to take root, it was perceived as in your face, and older Ghanaians were against it. They felt the youth weren't being humble. This was even seen in the body language. Usually when you talk to an elder, younger people hold their hands behind their backs. Now in hiplife, the youth are not putting their hands behind their backs; they are putting them in your face. They were seen as talking back to their elders, and this was an affront to traditional culture.[10]

Through music videos, hip-hop ushered in a new body language, with hard-core arrogant stances, while shaking the hands into the camera (the viewers face) for rhythmic emphasis. In Ghana, this represents new enacted youth subjectivity through an affronting bodily identity that was (is) insulting to Ghanaian traditional standards of identity representation. Something as seemingly benign as body language signals a significant shift in the way young people characterize themselves in public space. Shipley signifies this bodily appeal in its larger economic and celebrity frame: "American hip hop appealed to Ghanaians through its formal elements of stylistic persuasion, especially the defiant stances and spectacular rise to fame of your Black male artists."[11]

But the appeal of African American style was not initiated by hip-hop; there has been a long-standing black "stylistic persuasion" that has transversed the Atlantic. New York University's Malian film scholar Manthia Diawara offers cross-cultural analyses of hip-hop through his own older generation of West Africans. He captured a cross-cultural and cross-generational connection in "Homeboy Cosmopolitan," in his 1998 book *In Search of Africa*, where he explores his generation's identification with an earlier manifestation of black cultural production in collusion with America's pop culture industry: the exported 1970s Blaxploitation films. Being a Malian living in

Monrovia, Liberia in his early years, Diawara was struck by how much that West African country identified with the United States (which is not *that* surprising given its history with US slavery and the debacle of the African-American repatriation movement). Diawara reminisces:

> I saw *Superfly, Shaft*, and other Blaxploitation films in Monrovia in the early Seventies. I remember being particularly struck by the opening sequence in *Superfly*—it seemed an extraordinary cinematic event. I was...fascinated with the movies, the music, the hairstyles, the hats, and the leather jackets what were popular among black Americans...To my students [at NYU], these films are at best corny, and at worst celebrations of black men's macho, violence, and misogyny. They also find exotic the fact that although I was living so far away and in a completely different culture, I could identify with Blaxploitation films.
>
> But my students tend to overlook the elements of empowerment and pleasure and the subversive strategies that these films, and black American culture in general, make available to people oppressed because of the color of their skin.[12]

As I have said elsewhere:

> Diawara captures two important points about the trans-Atlantic style, music and cultural exchange between African Americans and Africans: 1) historically, several African generations, including the current hip-hop one, have been fascinated with black American style and cultural production as *the* world black population [that establishes] global trends from the riches country in the world, and 2) this style is a part of an Africanist aesthetic that has provided, in Diawara's words, "elements of empowerment and pleasure" for black Americans themselves, as well as for blacks throughout the world, including Africa. The process of claiming one's power of identity in the face of oppression, whether it be racial as in the U.S. or ethnic, class, or political in the case of many African countries, becomes an important process promoted by this aesthetic that has it's latest manifestation in exported hip-hop culture.[13]

From blaxplotation movies of the 1970s to twenty-first century hip-hop the Black Atlantic's arc of mutual inspiration has played an important role in the identity formation of young Africans.

Youth agency was signaled early on in the development of hiplife in Ghana. Rapper Obrafuor signaled the shift in his rap verse that alludes to the generational transfer of power regarding public attention and collective social issues. In his "Kwame Nkrumah" track in 2000 (Chapter 1), when hiplife was escalating commercially, he attempts to assuage elders' fear of this new youth culture: *When we stand somewhere in public and call on you,*

it is not a bad initiative. He wants to assure the older generation that this seemingly "foreign" culture, dominated by the youth, is not deleterious, but indeed carries an empowering message to which youths are listening: *In Ghana we prefer the right path and right signs and wonders, which mean we hate bad news. Kofi the bad child should not be left with bad ideas.* To convince his elders, he invokes the voice of authority that they respect, the master drummer: *The master drummer of Ashanti plays the drum, this means that people of Ghana listen.* Skilled hiplife emcees are positioned as the new "master drummers" who call the people to reflective action. Nkrumah was known for his public use of popular music and new cultural influences in service to what he conceptualized as "The African Personality."[14] Obrafuor's message to Ghanaian elders in authority is based on a call to reclaim respect for Osagefo Kwame Nkrumah, now a "national myth" within contentious public debate to achieve "political consensus."

Hiplife artists have ushered in a new level of recognition and income potentiality for popular music in Ghana that assumes not just sonic power, but an important socioeconomic "power move." This new kind of authority has mobilized the younger generation in a society where over 50 percent of the population is under the age of 18.[15] Where previous highlife musicians utilized their music to make political statements regarding local party affiliations and particular Ghanaian social norms, or even wider subjects like South African antiapartheid messages in the Burger Highlife music of the 1980s, hiplife's social power is exponentially greater with larger economic stakes in the era of the global multibillion dollar hip-hop industry. The larger global audience through the Internet, which generates greater social currency and influence in all spheres, makes this new status of Ghanaian popular music possible. The full impact of hiplife culture's youth agency can be further illuminated through youth subculture theory in relation to late capitalism, to which I now turn.

SUBCULTURE THEORY, CLASS, AND HIPLIFE YOUTHS

The first full-fledged study of youth cultures started with the 1964 establishment of the Centre for Contemporary Cultural Studies (CCCS) at Birmingham University in England, simply called "the Birmingham School of Cultural Studies." Their theoretical frame came from the neo-Marxian analysis of British scholars Raymond Williams, E. P. Thompson, and Richard Hoggart. Other Marxian theorists were used as well, such as Louis Althusser, Roland Barthes, and Antonio Gramsci, the latter of whom is credited with developing the concept of "cultural hegemony" as a part of his critique of Italian society. The Birmingham School theorists were able to establish a causal relationship between social ideology and emerging

cultural forms generated by various groups at different social levels within a given society. In Britain they focused particularly on

> the spectacular forms adopted by youth subcultures, mods, Teds, skinheads, punks, and so on. Their work thus turned to the distinctive "look" of these subcultures; but the primary aim was to locate them in relation to three broader cultural structures, the working class or the "parent" culture, the "dominant" culture, and mass culture.[16]

Birmingham School's Marxian-class analysis can be applied to Ghana's hiplife youth culture because the country is a postcolonial society with a long history of the overlay of British-class structure in contention with various traditional African cultures and social orders. A brief interrogation of this historic clash and its resulting postcolonial class structure in contemporary Anglophone Ghana is in order.

As explored in Chapter 1, Gold Coast coastal elites in cahoots with the first European traders adopted an assimilationist approach to distinguishing themselves from other African ethnic groups and regions (i.e., the Muslim North) that became human fodder for the transatlantic slave trade. Slavery and the constructed European discourse of the natural inferiority of the African, which eventually lead to the nineteenth-century pseudoscience of eugenics and innate racial difference, necessitated a counter-discourse. Coastal cosmopolitan African ethnic groups interacting with European traders and colonials developed the necessary counter-narrative. According to Holsey (2008), their lived experience became a "political tool among the colonized to gain freedom by throwing into question the assumed difference between colonizer and colonized."[17] By adopting European (British) dress, language, consumer goods, and so on, not only was a new Ghanaian colonial class emerging, but a new form of agency also developed, where Western "respectability was perceived as a weapon against such assumptions, since it was used to expose race relations as socially constructed rather than derived by evolutionary law or divine judgment."[18] Yet, even as a colonial elite class developed among Ghanaians as a weapon against the emerging nineteenth-century global racializing narrative, it also became a social trap, by forming a new layer to the traditional social hierarchy of royalty and commoners implicit in traditional Akan social order. The resulting layered class hierarchy, with its attendant economic inequalities, is today often attacked in hiplife music by educated, yet impoverished and unemployed, youths who are current-day victims of this historical colonial class structure.

The shift from Cape Coast to Accra as the colonial capital not only de-emphasized the Fante as central to the early European and West African interaction that created this class of Gold Coast cultural brokers, but also

privileged traditional rulers over assimilated literate elites. British indirect rule, posits Holsey, vested political power "instead in traditional rulers who the colonial government believed better represented the native population."[19] Hence, the assimilated Europeanized coastal African was pitted against traditional hinterland royal chiefs, deaccentuating African integration into British culture for a system of rule through "racial" separation.

The rural and tradition versus the urban and modern continues to be a disputed dichotomy harkening back to the complex class structure imposed by British incursion into Africa, and the English educational structure at the basis of Ghana's modern universities first established by the colonial power. One of Ghana's hiplife artists, King Ayisoba, whom I explore later in this chapter, continues to emphasize his father's and his grandfather's traditional culture in his representation of hiplife. King Ayisoba's manager-producer, Panji Anoff, represents Ayisoba's cultural choice of his tradition as the basis of his music in relation to the so-called modern cosmopolitan:

> Ayisoba is also very conscious of the ancient spirit that he represents. And it's important to understand that it is timeless... [But it does not pay when a modern hiplife artist] questions the educational system, with perhaps something as small a thing as the way his [university] teacher dressed. It is much simpler for him to dress the way his *teacher* dressed than to dress the way his *father* dressed, because he associates his power and success with his teacher, not his father.[20]

Hence class plays an integral role in the choices that contemporary hiplife artists make along the global-local continuum. Cultural hegemony results from the historical class dimension created by colonialism that defined the later twentieth century and now twenty-first century dominant culture in Ghana. However, traditional African cultures of the Akan, Ewe, Ga, Dagomba, and so on of young hiplife artists are *also* still very prevalent, creating a multidimensional interaction between those traditions and global mass culture.

Several of the Birmingham School's subculture theorists have poignant observations about youth cultures that are applicable to Ghana's hiplife movement. John Clarke et al. reveal that youth "members of a subculture may walk, talk, act, look 'different' from their parents and from some of their peers; but they belong to the same families, go to the same schools, work at much the same jobs, live down the same 'mean streets' as their peers and parents."[21] That is, subculture youths *purposely* sport the style markers, including body language, which they deem crucial to distinguishing themselves, as a unique group. These style symbols of the subculture serve as markers of rebellion against mainstream social norms. In Ghana, this can

take the form of dreadlocks (Rockstone, Samini, and Kwaw Kese), Mohawk and brightly dyed haircuts (Tic Tac and Promzy), earring-wearing males (Trigmatic), as well as the ubiquitous hip-hop gear of saggy pants, baggy t-shirts, hoodies even in hot-humid Accra, and the pimp/playa business suit, often in bright colors that are more akin to high-affect colors in traditional *kente* cloth than an African American imitation.

On a poster of a hiplife event in Tema on September 10, 2010, called "Da Squad Boys Akwaaba Party," some of these styles were quite evident. The advertisement was an example of hiplife youth style that referenced a confluence between the inherited global and indigenizing local. Variously, the "squad boys" used symbols such as the backward-turned cap, dark shades, and a distinctive scowl on the face (Smiling in a posed publicity photo in hip-hop is almost ubiquitously shunned.), all markers that situate the artists in the GHHN. Yet on the poster they also used significations of pride in being Ghanaians. Besides using the traditional Twi "Akwaaba" (Welcome) in the event title, these hardcore hip-hop dudes proudly sported the Ghanaian flag with its famous black star, which has historical allusions throughout the diaspora. The event featured Tema's current hiplife star, Sarkodie (Chapter 1), along with well-known hiplife artists R2bees, Nana Borro, D-Black, and Guru, representing the various subgenres of hiplife of Afro-Pop, Jamma, and GH Rap. The sponsors of "Da Squad Boys Akwaaba Party" were *local* Tema radio station Adom 106.3 FM and the *global* E-Jam advertising network. The semiotic style of hiplife youths becomes a part of the total subculture being promoted by the larger institutional infrastructure managed by older Ghanaians. The hiplife generation, with its rebellious youth style, forms partnerships with big business for mutual benefit, locally, continentally, and globally.

Ghanaian hiplife youths mark themselves by their dress, style, and an in-your-face body language that is exhibited on their music videos and concerts. Simultaneously, they also exist within their larger communities where many of their elders still eschew these new youth cultural symbols. Anoff confessed that in the early days

> from 1990–1997 I was into what we called sakura music, and the style of we Ghanaian hip-hop boys was baldheads, baggy pants, and [Timberland] boots, even in this hot weather—that was my uniform. Of course the older generation put us down, because Ghanaians are quite conservative.[22]

Ghanaian hiplifers can be an example of the Cultural Studies theory of "double articulation," encompassing the representation of both their global style (hip-hop) and their local allegiance (Ghanaian social networks of all generations). Just as Clark theorizes, they must continue to exist within the social context of their parents and community elders.

Dick Hebdige's classic 1979 essay "Subculture: The Meaning of Style" remains the standard bearer for articulating the meaning of youth subcultures to the overarching societies in which they exit. Analyzing the growing influence of youth punk culture in 1970s England, the essay provides theoretical frames for youth subcultures across time and space, with implications for hiplife in Ghana today. Hebidge analyzes that youth

> subcultures represent "noise" (as opposed to sound): interference in the orderly sequence, which leads from real events and phenomena to their representation in the media. We should therefore not underestimate the signifying power of the spectacular culture not only as a metaphor for potential anarchy "out there" but as an actual mechanism of semantic disorder: a kind of temporary blockage in the system of representation...Violations of the authorized codes through which the social world is organized and experienced have considerable power to provoke and disturb.[23]

Hiplife culture in Ghana, as it developed from Rockstone's beginning experimentations, was originally viewed as "a blockage in the system of representation" of Ghanaian musical culture, even as it was also embraced for its novelty of rap in the Twi language. As hip-hop youths in Accra became empowered by Rockstone's media attention and other artists began to add their hiplife "noise," such as VIP, Lord Kenya, and Obrafuor, a new spectacular youth culture emerged, the signifying power of which could not be ignored. An intrusive "noise" turned into a new indigenous sound that radio deejays began to take a chance on, spurring its gradual acceptance by older Ghanaians.

Anoff suggests that hiplifers' early experimentation with live instrumentation, as opposed to only relying on digital sampling, also aided in the new music genre's early acceptance across generations.

> Here, hip-hop has been a bit of sampling; but a lot of hiplife in Ghana has been original, going way back to fifteen to eighteen years ago. I think in part it is because *in Africa the generational gap is usually considerably smaller*, therefore it was easier for younger musicians to work with the older musicians who were actually playing instruments, and older producers, and older engineers to get what they were looking for. So, in Ghana, the material has quite a strong instrumentation [focus]. The older people liked the younger people's music, especially because they used highlife.[24]

In Panji's historical account, cultural connections across generations are emphasized in hiplife's indigenization process, often trumping the generation gap underscored in European and American cultures. Yet, even an Afrocentric perspective does not overlook the fact that, "differences in age

and generation occur along with other social differences and affect them [the youth], at times overriding them, at other times being inconsequential."[25] New social formations, such as hiplife subculture, are affected by multiple factors, with generation being only one.

The hip-hop aesthetic practice of sampling the past is another example of Hebidge's concept of subculture "noise" disrupting the normative sound of usual musical production, and by extrapolation, social discourse. South African communications scholar Adam Haupt, using Schumacher, explores this concept by highlighting the practice of hip-hop sampling that "creates noise in legal discourse because rap music and the practice of sampling change the notion of origin (the basis of copyright) to one of origins..."[26] New aesthetic practices, such as sampling, disrupt social and legal discourse through political, moral, and personal challenges to the status quo.

Hiplife youth rebellion through aesthetic sampling afforded Ghanaian youths a new agency as a part of the indigenizing of imported hip-hop. These new aesthetic practices were simultaneously implicating the subculture in the country in vital and counter-hegemonic ways. Liberian-born television producer Iso Paley views the hiplife scene in continental terms with youths finding their voice for the first time in Africa:

> It's all about young people expressing themselves. Because on the [Africa] continent its been too long waiting for young people to be able to speak. I grew up in a society where I was not allowed to speak back to older people, because its definitely disrespect. So we've been suppressed for too long a time. It [hip-hop] was an opportunity for young people to express themselves through music.[27]

Iso also reflects on the greater social and economic options that hiplife has brought to Ghanaian youth. He suggests that before the hiplife music movement, Ghanaian youths were

> concentrating on school or a trade or something else. You never had people who were eighteen and nineteen who were musicians. You know what I mean? And if you were, you were just in a band, just doing gigs in a hotel, and stuff like that. [During the exclusively highlife era] you really didn't have real artists in the younger age group. Today the [most popular] musicians in the country are young people.[28]

Hiplife music's emphasis on youth expression, therefore, changed the social dynamics in Accra, including more job opportunities for youths as well as a new potential for personal celebrity.

Over the years that hiplife has been a musical force since the mid-1990s, inevitable changes in lyric content and musical structure precipitated social

transformations in the pop music scene in Ghana, all of which reflect a concerted age factor. Iso reminisced about the "solid foundation" on which early hiplife was built before the current commercial era. In the late 1990s, "The lyrics then were really, really strong in terms of what we stand for as young people, in terms of what we needed to grow, in terms of what contribution we need to make nationally, and internationally as well. That's what they were talking about." Hiplife's development into the twenty-first century as a potentially viable international music commodity has brought inevitable focus on more superficial themes like its hip-hop cousin in the United States; however, the reshaping of Ghana's popular music industry due to hiplife cannot be denied. "The old people [highlife musicians] retired; they try to come back, but they realize this is a different world altogether. And the kind of music they were doing back then [older style highlife] is not as popular— you have to change with time."[29] The shift in Ghana toward popular music primarily produced by youths is a product of the hiplife movement

Officials at the Ghana Music Awards, which started in 2000, have had a significant influence on the popularity of hiplife music (see Chapter 3). They supported Iso Paley's perception of the age factor in the growth of the music. Nii Ayite Hammond, head of production at Charter House, the producers of the Ghana Music Awards, highlighted youth agency in hiplife's development in Ghana.

> Hiplife is a youthful genre, and a lot of young people identify with it. The traditional form of music, or highlife music, that our parents grew up with, and that we picked up has metamorphosed. I realize that my kid is more into hiplife than into highlife. And so, it [hiplife] was trying to now blend that development, because otherwise there would be no expression for the youth. They do not identify so much with the highlife; they identify with the hip-hop because that is the youthful culture. So, there needed to be a synergy so that we would be able to grow outside *our* music, which is highlife. And that is how the hiplife came about; and that is why now it is easier for it to grow, because the young people can identify with it, and they can link the highlife to the hip-hop.[30]

Hammond also emphasizes that musical innovation in Ghana happens not as a total revolution, but as a respect for tradition that creates the needed "synergy" for change. Hiplife's growth, like previous pop music genres, happened with new global sounds blending with local predispositions. "The same thing happened with jazz and the funk of earlier times influencing highlife music. So obviously the hip-hop would influence that kind of music [too]. And so, not to loose the traditional bit of it, that's why they started to fuse the highlife into it, but you have the hip-hop stronger beat." In Ghana, incorporating youth-driven hip-hop music and style created a

shifting social ideology with new meanings that shape(d) the entire music scene over time.

In Africa, youth subcultures cannot be successful in revolutionizing social norms by implementing disruptive "noise" without the incorporation of previous traditions. Change in Africa happens on the back of continuity, and hiplife's success, as Hammond suggests, emerged from its synergy with hiplife that localized the global influence of hip-hop. The agency that hip-hop provides youths across the African continent is constituted by style markers of youths' new assumed social identities, along with cultural factors such as respect for tradition that mitigate the generational gap in African cultures.

Yet, social anxiety about shifting public morals associated with hip-hop, occurring in almost every society across the globe, is also generated by hiplife music as a youth subculture in Ghana. But these anxieties over social changes brought on by youth culture often generate healthy civic discussion. Austin and Willard remind us that, "[t]he public debates surrounding 'youth' are important forums where new understandings about the past, present, and future of public life are encoded, articulated, and contested."[31] In Ghana for example, The "Changing Representation of Women in Popular Culture" research project generated out of GENSA at the University of Ghana, Legon, was a project in reaction to the mounting anxieties about the obvious social change that popular music in general, and hiplife in particular, seemed to be having on the representation of women (Chapter 1). The research project became a moment of social reflection, which, in turn, generated proactive components of intervention, such as the public song competition for female-empowering lyrics.

My own data-gathering survey on the effects of hiplife music among youth was conducted in the School of Performing Arts at the University of Ghana in the fall semester of 2008. During my Fulbright teaching fellowship in the Department of Dance Studies, I administered a questionnaire to approximately one hundred students in the school. Faculty members passed out my "Student Survey of Hip-Hop/Hiplife" to undergraduate students attending dance, music, and dramatic arts classes. Certain generalizations about Ghanaian youths' awareness and participation in hiplife culture can be culled from the responses to the survey. The majority of the students became aware of hip-hop/hiplife music between the ages of 10 and 15 years, just at the advent of puberty during preteen and early teen age groups. The majority of the respondents were very aware that hiplife music began in the mid-1990s and were cognizant of its development over several generations of artists, many of whom I explored in Chapter 1. From the responses to my question, "Who is your favorite hip-hop/hiplife music artist?" a few students mentioned American artists such as Lil Wayne, 50 Cent, Jay-Z, Wyclef Jean, Busta Rhymes, Missy Elliot, Nas, and Akon; but the vast majority preferred

their own Ghanaian hiplife artists: old-schoolers such as Reggie Rockstone, Lord Kenya, Obrafuor, Tinny, and Samini; the second generation emerging in the mid-2000s such as Okyeame Kwame, Mzbel, and Castro; as well as third-generation hiplifers such as Praye and 5Five. Several students also listed artists in the contemporary highlife genre such as Daddy Lumba and the younger Kwabena Kwabena.

It became clear that use of indigenous lyrics with local cultural allusions and social morals were far more popular than American hip-hop. Hiplife and contemporary Ghanaian music that utilize these students' indigenous languages and Ghanaian pidgin English were the overwhelming choices among the respondents, even when they are consumers of internationally recognized American hip-hop artists. Hiplife has become the indigenous youth music of Ghana, with a large following across several generations. However its predominant youth consumer base is made more evident in the many hip-hop music festivals happening throughout West Africa. The larger context of hip-hop among African youths can be explored through one of the larger annual festivals in Burkina Faso, the country just north of Ghana.

WAGA HIP HOP 8 AND KING AYISOBA

The youth factor spurring on the popularity of indigenous contemporary popular music in Ghana is part of the larger youth movement of hip-hop throughout the African continent. The annual hip-hop festival in Burkina Faso, "Waga Hip Hop," is a prime example, and I attended the last few days (October 17–18) of the 2008 festival in the capital of Ouagadougou (colloquially called "Waga"). "Waga Hip Hop" is a festival celebrating Francophone hip-hop that includes all of the elements of the culture: emceeing, deejaying, breakdance, graffiti art, and hip-hop cinema. "Waga Hip Hop 8" provided an opportunity to witness and participate in Francophone Africa's youth agency with artists representing not only Burkina Faso, but also Republic of the Congo, Sénégal, Gabon, Côte d'Ivoire, Bénin, and Niger. Represented also were youths from France and Belgium as colonial countries of Francophone Africa. Ghanaian hiplife artist King Ayisoba was the only Anglophone African performing, and I shared a bus ride across the border back to Ghana with Ayisoba and his manager Panji Anoff.

Before exploring the festival's performances and their meaning, my journey *to* Burkina Faso is worth describing, representing the realities of traveling in contemporary West Africa. Immediately after delivering one of my primary lectures during my Fulbright Fellowship at the

University of Ghana's Institute for African Studies on October 16, 2008, I had to quickly change into traveling clothes and take a short taxi ride to the Achimota STC (State Transport Corporation) bus station near the campus. Soon I was on an air-conditioned relatively comfortable bus to Kumasi, the second largest city in Ghana. However, that leg of the journey took about seven hours even though Kumasi is only 74 miles from Accra. To entertain the passengers the STC bus drivers all play Nollywood films (Nigerian soap operas) or hiplife music videos throughout the trip. Bus companies, as well as municipal taxi drivers, become a link to consumers for hiplife musicians trying to market themselves to the Ghanaian and West African public.

After traveling from Accra's Atlantic coast to the tropical rainforest of the Ashanti Region, we arrived in Kumasi about 8:00 p.m., where I had to get a second bus northward through the drier savanna of the Northern and Upper Regions and across the border to Ouagadougou. My second bus to Burkina Faso left from another station across town, and I was not clear where that was. I had to walk with my bags for about half a mile in a bustling Kumasi evening, asking directions in English, and trying to understand the polite, but often unintelligible answers (even though they were speaking English). I finally stumbled upon the right station just before the bus was about to leave. Needless to say, I slept most of the way to the border, where we had to dismount for passport checks. Arriving in Ouagadougou about 11:00 a.m. the next morning, the entire trip took nearly 24 hours for the 480-mile trip from Accra to the capital of Burkina Faso.

When I arrived at the Ran Hotel Somketa, the official festival hotel, it was the last two days of the festival. Hip-hop style young artists from throughout Africa and Europe filled the lobby, and I met Panji and got an orientation to the festival program and its several venues. He gave me an invitation to the sound check for that evening's main performance where Ayisoba was to perform with several Francophone hip-hop artists. The performance was to be one of the largest concerts of the festival, held at the nearby outdoor amphitheater Centre Culturel Français (CCF). It became immediately apparent that the emphasis of the festival's hip-hop music was definitely on *indigenization*, including rap songs in local languages and French, as well as the use of live traditional African instruments. Besides the featured turntablist, DJ Geebyss from Sénégal, and musicians on trap drums and base guitar, there was a full battery of *djembe* drums (the ubiquitous West African drum originally from the Sénégal, Guinea, and Mali region), a melodic *balaphone* (forerunner to the Western xylophone), and the *mbira* (thumb piano), representing familiar traditional Francophone African instrumentation.

Even though the security was fairly lax (unlike hip-hop concerts in the United States), it was a privilege to have a special backstage pass to observe the sound check for a concert slated to be an important collaboration between artists from several African countries, including Ghana's King Ayisoba, Freddie Massamba from Congo-Brazzaville, whom I had met at the hotel earlier that afternoon, and Burkinabè female singer Awa Sissao from Ouagadougou. Massamba's French and Bakongo rap mixed seamlessly with Sissao's French and Mooré [language of her Mossi ethnic group] melodic singing. In what has become a typical hip-hop gender mix, Massamba became the rapper-singer, while Sissao sang melodically, reminiscent of the long line of great African female singers such as Miriam Makeba and Oumou Sangare. French was the official language of the festival, becoming the colonial linguistic link between the myriad Francophone Africans participating in the festival; but indigenous languages were always invoked. Yet, Massamba's and Sissao's rhythmically infectious opening song, "Mama Africa," needed no translation.

King Ayisoba added an important indigenous element to "Mama Africa." Ayisoba's stage dress, a vastly different semiotic style marker, was in stark contrast to the contemporary hip-hop look of the other musicians on stage. His costume of a loin cloth, off-the-shoulder animal skin cape, and traditional sandals, while carrying his ubiquitous "ancestor" stick, provided a visual time warp that took the audience to an Africa that is not usually represented in contemporary African pop music. As he walked on stage after Massamba and Sissao had started the song, his image differed greatly from Sissao's glittery red jump suit with hip-hop cap and Massamba's khaki saggies with open Western shirt. King Ayisoba's persona is one of complete indigeneity without any allusions to Western culture—a "roots man" persona. His version of hiplife is one that also does not incorporate any recognizable hip-hop style of rap. Figure 2.1 is a dreadlocked Ayisoba dressed in the traditional woven smock-*batakari* of northern Ghana and carrying his ancestor stick during sound check.

Ayisoba often chants in his own personalized mysterious dialect between his verses in traditional Frafra, his language of the Upper Eastern Region of Bolgatanga, Ghana. His individual language and sounds, often called "Ayisoba lingo," can be perceived as a part of the origins that some African hip-hopers claim to be the African foundations of rap music. Ayisoba often accompanies himself on a version of the northern Ghanaian *gonje* lute, a two-string instrument known as *kologo*. Strumming the *kologo*, he intersperses some of his Ayisoba lingo into his songs, such as "siri na" (come down) and "kai, kai, kai" (I have finished speaking), phrases that he has made regionally common as part of his signature expression, to which his fans all respond. During his featured verses in "Mama

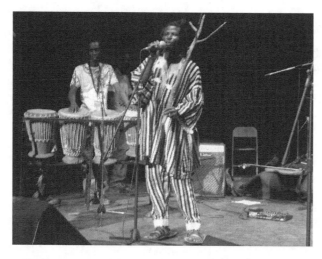

Figure 2.1 King Ayisoba during sound check at Waga Hip Hop 8 carrying his ancestor stick (Author's photo).

Africa," the audience connected to him viscerally and enthusiastically and engaged in his call-and-response Ayisoba lingo.[32] Panji revealed to me that "Ayisoba has three registers that he sings in: a whisper, low, and high. The high register is what he used to talk to the animals when he was a cow herder near Bolgatanga."[33] His fans' appreciation of Ayisoba's effective "roots man" approach to hiplife music affirms an indigenous African identity that he invokes in contemporary hip-hop. The fact that he has achieved this popular reinvocation of indigeneity within the contemporary hiplife movement reveals the Africanist power of the word, the *nommo* force.[34]

King Ayisoba (Albert Apozori) was one of 14 children, born to a Frafra father who had three wives. He has a deep reverence for his Frafra culture and carries his ancestor stick, given to him by his grandfather, everywhere he goes. He confessed to me on the journey back to Ghana that his grandfather travels with him and watches over him through the stick. Indeed, a Google search of the Frafra people on the *National Geographic* site reveals a traditional people of Northern Ghana who believe that "wealth lies in preserving a traditional lifestyle of farming and honoring the family."[35] Although Ayisoba was always involved with music in his family, it was Terry Bonchaka (Terry Adjetey), a hiplife/ragga artist who died an untimely death in 2003, who introduced him to the contemporary Ghana music scene; Panji Anoff, as his current manager, is taking him to new levels of recognition through platforms such as the Waga Hip Hop 8 festival.

Ayisoba's uncompromising style has been subsumed within hiplife as a part of its indigenization process, but Ayisoba is acutely aware of his style's antithesis to modern life in Ghana and West Africa. He recorded his critique of modernity itself in his 2006 "Modern Ghanaians" as the title track of the album that featured hiplife artists Kweku T and Kontihene. After a Twi verse by Kontihene, Ayisoba enters the song with his Frafra and pidgin second verse that deconstructs the symbols of modern Accra, which is here translated into English:

> Red, gold, green, when you see the Black Star, Black Star,
> and I hustle for my people in Accra, Accra,
> HIPIC Lane, where I live,
> not really too far, Petrol prices petrol so high,
> I am packing my car, baggy jeans, designer boots, niggers and more
> White collar suits, wearing regalia, yo.

Ghana, as a HIPC, or highly indebted poor country, was perceived as gaining more economic status under President Kuffour's administration; therefore the road that he lived on was colloquially renamed "Hipic Lane." King Ayisoba releases a scathing critique of the economic hustle of modernity that includes hip-hop symbols, while reflecting his own people's understanding of "wealth" as their cultural traditions, in opposition to a superficiality of imitating the West. He reminds his listeners that the West has its own economic problems, as well as political hypocrisy.

> Too many people ready to buy tickets to starve like in America,
> Britain,
> They sold the war, Check Check.

Ayisoba continues with a condemnation of local Ghanaian youth style that he conflates with the country's contemporary sociopolitical life, which includes the so-called sexual revolution with its ubiquitous female butt-shaking in clubs and music videos. In one deft line, he compares this youth style to obvious materialism and corrupt politicians, all revealing a perceived "modern" lifestyle in the present that is equated with progress for the future of modern Africa. He paints a picture of modernity that has become his own urban context, and to which his "roots man" persona is opposed.

> kelewele, where dey the chop bar Face the wall,
> hoping they shaking they bomchas
> I'm aware, big booty, wear they show me yo
> They don't care, the sexual revolution is going on
> Democracy, crooked politicians, singing the song rhetorical, lyrical,

make I am thinking they wrong
This is the present, the future
And I call it my home
Black, Gold Coast, West Africa, my home.

Indigenous rappers such as Ayisoba encode their social critiques with col-loquialism that only local audiences fully comprehend. His line "I'm aware, big booty, wear they show me yo" is slang for the trend where women's pants sag low enough to make their panties visible; while "black gold" is local code for the valuable resource that is African thought, a reference to Africa's brain drain through the continent's brightest and smartest emigrating to other parts of the world.[36] After Ayisoba's scathing critique of modern Ghanaian life, he ends with his traditional "kai, kai, kai"—I have spoken. Ayisoba's persona that he performed on stage in Ouagadougou that could be viewed as "primitive," in fact, reveals itself as penetratingly perceptive regarding the nonprogressive social, sexual, and political elements of modern West African life, in which hip-hop and hiplife is implicated.

The headliner for the October 18 show at CCF was Disiz La Peste (Sérgine M'Baye Dueye), a French rapper of Senegalese descent from Paris. After the Massamba-Sissao-Ayisoba indigenous warm-up act, his more straight-ahead French rap performance paled in comparison. However, he did invoke the GHHN as an international hip-hop youth movement, to which the entire festival gave credence. Like his American counterparts, Disiz La Peste reveals in his famous hit, "Jeune de Banlieue" (Youth of the Ghetto), the harsh life in the Parisian banlieues, which are in the suburbs instead of the inner city of Paris.[37] That Friday night show, as well as the following closing night at Maison du Peuple (Home of the People), with its rap battle competition, represented an imaging continuum from African indigenous to American-imitation. Waga Hip Hop 8 evidenced that there is a GHHN spurred on by youth agency, and Africa is a significant part of it.

That I was in Francophone, and not Anglophone, Africa, was made clear by the culture prevalent among the audience for Waga Hip Hop 8. The white Frenchmen mixed easily with the black Africans, blending into a seemingly comfortable French West African cultural mix. This European-African intermingling does not exist in Anglophone Africa in the same way. The only racial mixing one witnesses in Ghana, for example, is during stu-dent cultural exchanges and in the corporate business sector, and rarely en masse during personal leisure time. The audience consisted of young French teens and African youths, most of whom wore the hip-hop "uniform" of baggy pants, t-shirts, and side-turned caps. In the audience also were fami-lies of French fathers, Burkinabe mothers, and their mixed mulatto children, representing a seemingly common practice in Francophone Africa, where

interracial marriages are far more common than in Anglophone countries such as Ghana.

The obvious cultural difference just north of Ghana in Burkina Faso, as a former French colony, is the result of different forms of colonialism by the British and the French. Indirect political rule with little cultural mixing occurred in British colonies, while the French engaged in a so-called civilizing process for its colonial subjects in West and Central Africa that consisted of an emersion in its language and culture. The resulting cosmopolitan atmosphere as seen in Ouagadougou is typical for a former French colonial capital, with many Frenchmen comfortably interspersed into the culture. French Burkinabe citizens and ethnically mixed families who attended the hip-hop concert were an example of the differences between Francophone and Anglophone Africa.

On the last day of the festival I interviewed the festival's director, Ali Diallo of Umané Culture, a producing company in Ouagadougou since 1997. As he spoke only French (and my French is about middle-school level), my translator was Jenny Fatou M'baye, then a Senegalese graduate student writing her PhD on hip-hop at the London School of Economics and Political Science. Diallo told me that although the festival had been steadily increasing in attendance and international reputation, Umané Culture had not been able to procure any financial support from the government at that time. Even without governmental funding from Burkina Faso, the festival is drawing the international press from France, Belgium, Holland, and England; and Umané Culture, as Diallo revealed, has ambitions to expand the festival to encompass more Anglophone countries.

The official Waga Hip Hop 8 poster had a drawing of a black woman's head with a huge Afro coiffure, out of which the names of the festival's headliners grew. A female emcee/singer focus was unexpected for Burkina Faso's 8th annual hip-hop festival, and when I queried Diallo about the festival's emphasis he explained, "Since hip hop is so male-oriented, the past female rappers we have invited became invisible. So the only way to rectify this was to feature women, and there are a lot of female rappers throughout Africa."[38] I had discovered another example of a proactive initiative around women in African popular music and hip-hop, as a part of a major regional project.

Several of the festival's concerts featured all-female singers. In the hotel lobby, I had already met Priss'K and Nash, two female rappers from Côtd'Ivoire who had performed on the opening day, along with Ideal Black Girls from Guinea, and Naneth from Gabon. This was not a token opening gesture of the festival; the concentration on female emcees and singers continued on the third and fourth days of the festival with Alif, one of the early female hip-hop groups from Sénégal, and Youmali from Burkina Faso.

Supported by the festival deejay, DJ Geebyss, the last concert started with a rap battle of the remaining six male contestants, narrowed from an earlier 16-member contest. The winner was an emcee from Niger named Elgrintcho, who had also won the year before. Elgrintcho, the reigning champion, was anticipated to win yet again, as Niger is one of the countries with a strong *griot* tradition. His rap style was a combination of his indigenous language along with a fast Jamaican dub style; this mix of American, Jamaican, and indigenous linguistic rap styles has become standard fare throughout Africa. Elgrintcho's overt style is local-focused with his Niger robe and traditional head wrap that indicates wealth and status in his culture, uniting local African and diaspora performance skills in the indigenization process of hip-hop.

After the emcee battle, I had the opportunity to experience the women-focused part of the last night, with two female singers ending the 8th annual Waga Hip Hop festival with hip-hop inflected melodies. Sissao returned to perform as a solo act, singing like an African Sarah Vaughn in French and Mossi with a charismatic style that has won her a substantial fan base throughout Burkina Faso. The entire festival ended with Bénin artist Zeynab singing various cultural styles: from French chanson, á la Edith Piaf, to a Francophone highlife sound to a Beyoncé-like R&B flow that integrated rap, all in French. The final evening of Waga Hip Hop 8 made its central point: across the African continent there are indeed a wide variety of women hip-hop artists, from rappers to singers, who are an integral part of the continent's expressive hip-hop youth movement. Waga Hip Hop 8 reinforced the concept that young African women *and* men are making unique contributions to the globally circulating culture of hip-hop, and that "African" is located in many different cultures and languages that are a part of today's GHHN.

One question emerging from this research is whether the construct of a GHHN is becoming a new identity rivaling the constructs of race or ethnicity. This interrogation could work in tandem with Anthony Appiah's challenge as to what could replace these age-old categories: "We would need to show not that race and national history are falsehoods, but that they are useless falsehoods at best or—at worst dangerous ones: that another set of stories will build us identities through which we can make more productive alliances."[39] I submit that among global hip-hop youths, the construct of the GHHN is becoming one such "story" that provides young people, who often still identify with their cultural/tribal roots, with another identity construct that relies on their membership in the international hip-hop network. One such Ghanaian hiplife artist, Okyeame Kwame, to whom I now turn, has one foot in both imaginaries: his Ashanti roots and the GHHN.

OKYEAME KWAME, YOUTH AGENCY, AND
INDIGENIZING AESTHETICS

Returning to Ghana, I want to explore Okyeame Kwame, an artist who has made a significant impact aesthetically on hiplife music. Interviewing and observing him in concert in 2008 and 2010, I realized that his artistic impact has also enhanced the empowerment of youth in Ghana. He is a proud Ashanti who reluctantly moved from Kumasi to Accra to further his and his wife Anica's careers, both of whom have their master's degrees from Kwame Nkrumah University of Science and Technology in Kumasi. He represents the middle class of Ghana, many of whom were some of the first consumers of hip-hop.

Kwame Nsiah Appau was born in 1976 (the first year that I visited Ghana) to a middle-class Ashanti family, with his father an accountant and his mother a school tutor. He was encouraged by his literature teacher at Kumasi Anglican Secondary School to write poetry, to compliment his music that had started as early as primary school.[40] In 1995, Kwame began his hiplife career as a duo with Okyeame Quophi (Daniel Kofi Amoateng) naming the group Akyeame (plural of Okyeame), which made them one of the first-generation hiplife musicians emerging immediately after Reggie Rockstone. Akyeame became an important group in the development of hiplife with four albums in the late 1990s.

For Ghanaian youths, the venue of school becomes one of the primary breeding grounds for emerging talent, which is where Kwame and Quophi met and started their experimentations with rap music.

> Akyeame started about the same time I started rapping, I met Okyeame Quophi in '92; we used to study together in our final year in form five, so while waiting for our results after school, we were going for these rap competitions; but around this time he wasn't rapping he was only writing and in '95 we decided to come together and be on stage.[41]

Because the expressive needs of youths are inspired by hip-hop's reputation for creative youth rebellion fostering youth agency, these kinds of innocent scenes like Akyeame's are replicated in many schools all over the world in the ranks of the GHHN.

The allure of empowerment gained from finding their unique voice results from youths' challenge to "youth" as a connective marginality, and represents what Ntarangwi calls "the reconstitution of youth agency through their music."[42] Hip-hop youth agency at the entrepreneurial level usually occurs after the first local breakthrough artist, like Reggie Rockstone in Ghana. It was no different for the young Kwame Appau: "In '96 when Reggie came

out with his first album we went wild and wanted to prove to the world that we could do something, so we formed Akyeame, initially we were three, Quophi, Flash Jr. and I."[43]

For Ghana, it was the local indigenization of globalized hip-hop music that established the potential for a new music form during the initial stages of Ghanaian hip-hop turning commercial. Rockstone rapping in Twi was the impetus for the commercial viability of Ghanaian hip-hop, establishing indigeneity as the key component for achievement in the preliminary stage for young aspiring artists such as Okyeame Kwame. He remembers Akyeame's first 1995 newspaper review in Ghana's *Daily Graphic* after their first major performance at the Miss Malaika Ghana Pageant telecasted on national television. The praise they received for their use of the Twi language encouraged them to translate hip-hop's "keeping it real" tenet into their artistic priority.

> Well it was a bomb, and one journalist with the *Graphic*, Akosua Serwaa Bonsu, wrote something about us, saying we were "slanging the Twi dialect." At first we thought she was trying to defame us, but latter on we realized she was right, so we took a cue from that and started doing indigenous stuff.[44]

With the aid of London producer Andre Opoku Amankwah, in 1997, Akyeame premiered their first album, *BreBre Obaa Hemaa*. On that album, they not only included their indigenization process with Twi lyrics, but also incorporated the signature Ashanti *adowa* rhythm in several of their songs' musical structure. This was revolutionary for Ghanaian hip-hop and a major step into Ghanaian hip-hop's indigenization. "Our debut was big; it was the first hiplife song that had both highlife and rap with *adowa* fusion. What Reggie was doing then was hip pop with Twi lyrics; we sold fourteen thousand copies, which was big then."[45] The inclusion of traditional rhythms into the musical structure advanced the indigenization process of early hip-hop in Ghana, which incited the development of hiplife as a completely new genre of popular youth music emerging from West Africa.

Okyeame Kwame became a popular *solo* artist in 2006 with his first album *Bohye Ba*, but in 2008 his second album *M'awensem* (My Poetry) turned him into an *award-winning* artist. His hit single "Woso," remixed with the Ghanaian R&B singer Richie, received significant radio airtime, playing in just about every taxi that I took during my six-month 2008 fieldtrip. Okyeame Kwame's "Woso" remix was selected for the prestigious Sony Music Africa's *One Africa: African All Stars Volume 1* compilation album produced out of South Africa. Today, tagged the Rap Doctor,

Okyeame Kwame has established his One Mic Entertainment label (an obvious allusion to New York rapper Nas' famous hip-hop track) through which he produced his two albums that established his solo career. True to hip-hop's communalist culture, he brags on his Facebook page that he is "The Hiplife Artiste with the most collaborations." Indeed, he has created tracks with highlife legend Daddy Lumba, Afro-Pop star Kojo Antwi, Nigerian hip-hop artist Olu Maintain, and many hiplife artists such as Batman Samini, Ofori Amponsah, Richie, and his original partner Okyeame Quophi. At one of the major annual concerts in Accra, Joy 99.7 FM Radio's "Nite of the All-Stars," on which I report below, he became the 2008 Artiste of the Year, repeating that honor at the 2009 Ghana Music Awards. He has also performed continentally and internationally, including a 1999 Apollo Theater appearance in New York.

Besides these accomplishments and serving as an "artiste endorser" for Coca Cola and MTN, the African and Middle Eastern mobile phone company (Chapter 3), what distinguishes Okyeame Kwame is his cognition and utilization of the Africanist aesthetic that animates the entire Black Atlantic. His comprehension and creative deployment of rhythmic patterns that span Ghana and African America adeptly invokes the arc of mutual inspiration while conflating the global and local dynamics of hip-hop. His "Woso" hit, for example, utilizes US southern *crunk* beats that he perceives as rooted in his own Ashanti rhythms. Kwame analyzes, "Crunk utilizes the same rhythmic structure as Ashanti *kete* drumming. You can hear the same beats; crunk comes straight from our music. Specifically, there is a direct connection between *adowa-kete* rhythms and crunk —the 4/4 time signature and syncopations are exactly the same."[46] The creative Black Atlantic connection that Okyeame Kwame makes is fundamentally a cultural one, found in the deep rhythmic structure surviving at a historical level.

The initial crunk sound, growing out of southern cities such as Memphis and Atlanta, is high-energy club-oriented music, which was dismissed by rap aficionados as being lyrically sophomoric with simple hooks. However by the 2000s, with emcees such as the Ying Yang Twins and Lil Jon & The East Side Boyz it began to be taken seriously.[47] Okyeame Kwame allows us to comprehend the African musical roots underlying the structure of crunk, focusing on the *aesthetic* continuity that it represents. Lyric content of hip-hop and hiplife may be similar when imitating at the local level (womanizing and female body objectification), or dissimilar when indigenizing at the local level (African politics, rampant urban poverty, village life). However, when examining the continuity of cultural memory in the Black Atlantic, aesthetic musical *form* in African hip-hop becomes essential, often trumping lyric *content*.

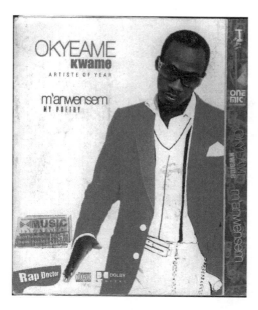

Figure 2.2 Okyeame Kwame's *M'anwenseem* album cover.

Okyeame Kwame's "playa" image in his red blazer and shades (Figure 2.2) speaks more to his calculated entrepreneurship in the pop music market-place, belying the cultural and historical orientation in his music that he imparts to his youthful audience base. On November 29, 2008, at Joy 99.7 FM Radio's "Nite of the All- Stars" hiplife concert that took place at the International Conference Center in Accra, for the first time Kwame show-cased his stage production of "Woso," dramatizing the relationship between Ashanti culture and African American hip-hop. He entered the stage as an Ashanti chief in traditional *kente* cloth wearing an Akan gold crown, while being carried on a chief's palanquin (carved boatlike conveyance reserved for high-ranking chiefs) on the shoulders of several young men in tradi-tional African draped cloth. On the opposite side of the proscenium a bat-tery of young drummers, also in traditional cloth, were seated at Ashanti kete drums. He shocked the audience at the hiplife concert with this highly unusual traditional Ghanaian cultural stage entrance, one with which the youths were quite familiar but usually associated with their royal elders.

In one deft stroke, he brought traditional Ashanti culture to the con-temporary popular culture stage. As he was lowered to the stage floor and stepped out of the palanquin, Kwame began the traditional stately and regal *fontomfrom* warrior dance along with another male dancer who was an obvious expert. The Ashanti *fontomfrom* dance with its strong rhythmic

leg kicks is embedded with meaningful hand gestures about battle strategies and prowess in war. The dance and drumming is normally performed at royal occasions at the chief's palace or during solemn ceremonies such as funerals; here Okyeame Kwame had transformed the dance's purpose to reorient young Ghanaians, many of whom eschew traditional culture in favor of Western youth pop culture. At this annual hiplife music event, Okyeame Kwame's performance had succeeded at this point in replicating a traditional Ashanti royal ceremony without any references to hiplife or hip-hop. (See Figure 2.3).

The performance continued with a demonstration of the correlation between traditional drum language and rapping. After throwing off his *kente* cloth at the end of the dance, Kwame moved to the side of the stage with the drummers and began rapping specific Twi phrases that they replicated with their *kete* rhythms. The drummers, utilizing Ashanti stick drumming technique required by the *kete* drums, played the exact rhythms Okyeame Kwame had just rapped to the audience with his microphone. This cultural call and response is exactly what occurs at Ashanti state events, with the traditional linguist, or *okyeame* [pronounced oh-chee-a-may], chanting the praises of the chief and offering proverbs to the people by which to live, accompanied by the traditional drum language.

As the tempo of Kwame's speech-drum dialogue increased to a rapid-fire pace, the deejay, stationed upstage center, began to overdub looped rhythms

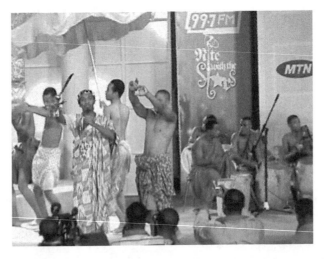

Figure 2.3 Okyeame Kwame at 2008 *Nite with the Stars* concert performing traditional Ashanti dance (Still Shot from Author's Video).

that provided a smooth segue into the synthesized looped beats of "Woso's" hiplife sound. As Shipley aptly analyzes, "In contemporary urban Ghana young rap lyricists, and by association their audiences, use proverbial indirection and humor appropriating the public authority of traditional political orators in ways previously inaccessible to them."[48] In this case, Kwame took the chance to not merely appropriate, but to replicate complete with traditional dress, the ancient drum-speech culture of Ghana for contemporary hiplife youths, clearly referencing and allowing his fans to experience one of the sources of hip-hop's aesthetics in Ghana's tradition. The traditional *kete* drumming and his own rap-chanting continued until the centrally placed deejay mixed in the rhythm of "Woso," overtaking the drumming.

Traditional Ashanti culture segued into contemporary hiplife. Male and female hip-hop dancers entered the stage performing choreography that included specific b-boying moves, the body-shaking rap dance of music videos, and the Congo soukous dance style ubiquitous throughout Africa. Witnessing this deftly executed cultural juxtaposition, the youthful crowd was enthusiastically ecstatic. Global hip-hop aesthetics of deejaying, rapping, and hip-hop dance had been dramatically connected to their parents' and grandparents' most sacred traditions. Making "the arc of mutual inspiration" clearly apparent, Okyeame Kwame had fused traditional African and contemporary pop culture aesthetics into an effective spectacle, and in so doing he created what Brenda Dixon-Gottschild terms "high-affect juxtaposition" at the root of the Africanist aesthetic.[49]

Indigeneity was utilized to fashion a particular kind of youth empowerment that had specific meaning for Ghanaians. Indeed, the localization process in hip-hop becomes the most effective form of youth agency. Okyeame Kwame's indigenized "Woso" performance was the closing act on a show that had eight other artists; yet it was his dramatically effective spectacle of traditional Ashanti-African American hip-hop juxtaposition, translated as hiplife, that won him the Artiste of the Year competition that night. An articulate mapping of "the arc of mutual inspiration" had been created, which his audience received enthusiastically because historical and cultural lucidity shone through time and space.

Another way of viewing Kwame's cultural juxtaposition that night is as a representation of what Shipley theorizes as a contemporary restructuring of Pan-Africanism. "Hiplife reconfigures Pan-Africanism as an entrepreneurial project epitomized by the rap artist, invoking established structures of racialization in which a Black aesthetic speaks of both moral criticism and personal aspiration."[50] Certainly hiplife artists such as Kwame, who have researched historical cultural connections to the African diaspora, are engaged in a kind of repositioning of *political* Pan-Africanism. Within this

era of globalized pop culture these diasporic links are emphasized through an artistic lens; but this repositioning of Pan-Africanism is far from "structures of racialization." Rather, this reworking process is recognition of undeniable *cultural* bonds that music and dance themselves have maintained. African Americans, as producers of hip-hop, are racially *mixed*, yet culturally tied to Africa in ways that many of them don't even fully recognize. Utilizing the Black Atlantic connections can create an effectively convincing performance of these cultural bonds as Kwame did that night at the Accra Conference Center.

This arc of mutual inspiration that Okyeame Kwame deftly expressed is at the heart of my argument about the indigenization phase that has rendered hiplife an original new form of music. Indigeneity in this era of transnational pop culture facilitates a cultural circularity within the Black Atlantic. This is not "racial imaginary," as Shipley would have us believe, but are in fact astutely cognized and enacted gems of the Africanist aesthetic as a Pan-African revisioning that has transcended all attempts at obliteration. However, the weight that Shipley gives the entrepreneurial aspects of this concept of revised Pan-Africanism is particularly well argued in this era of postmodernity, where capitalism and pop culture are so closely linked. Young artists on both sides of the Atlantic are desperately trying to "get paid." In Ghana, there is an acute hiplife entrepreneurship emerging from many youths' need to hustle for survival, as Shipley rightfully illuminates as one artistic strategy of exploiting "Ghana's speech culture."

> Creative word play then is not only about public critique and the pleasure of speaking, but also about economic competition in the marketplace. The affinity between salesmanship and effective lyrical performance marks how hiplife aligns with entrepreneurship.[51]

Okyeame Kwame, as a recognized celebrity in the Ashanti Region and the entire country, is able to parlay his fame in the service of his knowledge and artistic expertise in Ashanti speech culture, as well as his extensive familiarity with hip-hop and US black music. In Ghana, today this translates into the artistic skills to use "lyrics Ghanaians will remember [like "Woso"] . . . [t]o talk about daily life and the real environment people know about,"[52] as well as provide sociocultural public critique. Concomitantly, it offers the opportunity for entrepreneurial marketing savvy in the increasingly competitive national and global marketplaces.

Even his emcee title of *okyeame*, linguist, is an indigenization of the cultural dictate of renaming prevalent in hip-hop. As I have analyzed before, "Utilizing the naming process with the power of *nommo*, coupled with

the contemporary politics of persona and spectacle in popular culture," as well as "labeling and nicknaming have become ubiquitous in hip-hop culture."[53] Examples abound, from the early days of the culture (Clive Campbell as Kool DJ Herc, Joseph Saddler as Grandmaster Flash) to its beginning commercialization (Dana Owens as Queen Latifah, Richard Colon as Crazy Legs) to contemporary times (Curtis Jackson as 50 Cent, Shawn Carter as Jay-Z). So when Kwame Nsiah Appau took his artistic moniker, as he and his original partner Quophi entered the hip-hop game in the mid-1990s, he assumed the title of the "original rappers" in Akan culture: the linguist as wordsmith translating communication between the chief and his people is the *okyeame*. Kwame's title, therefore, became one of the indigenous sources to Africanist-based hip-hop culture, providing him an easy translation of hip-hop renaming to the Akan's original wordsmith, the *okyeame*.

Okyeame Kwame's personal background provides the platform for his particular focus in hiplife music. He not only grew up in Ashanti-steeped culture in Kumasi, but also majored in Akan studies, along with Sociology, in college. In our initial interview backstage before his "Nite of the All-Stars" performance, I asked whether he saw himself as a contemporary *okyeame*. He didn't hesitate to answer, "Yes, that is right. I see myself as an *okyeame* because I am the translator of the messages [that come through me] from God, *and* the messages of the people to God. It is a heavy responsibility." Beyond a royal translator as *social* mediator, he views his role as the *divine* mediator. However, this spiritual focus does not preclude his need to translate the will of the people, which for him is his *generation*—the youth of Ghana who are transforming the society. The response of his young audience at that performance verified his successful connection to his assumed role. His tools of indigenization are music (traditional Ashanti rhythms, highlife, and the crunk beat) and language (Twi linguistics), the latter of which he emphasizes in his near-scholarly approach to his craft. "I have put academics into my rap. I'm going back to school to study Linguistics, with an emphasis on the Akan language."[54] Okyeame Kwame's approach becomes one methodology of the indigenization process of hip-hop becoming hiplife.

Linguistics scholar Kwesi Yankah has written extensively on Akan oratory and the role of the *okyeame* in traditional Ashanti. In his *Speaking for the Chief: Okyeame and the Politics of Akan Royal Oratory* (1995), he reveals the power of the word that I have been calling *nommo* in indigenous cultures where oral traditions continue to hold important power.

> In cultures where writing is only a recent development...the practice of using speech intermediaries attains an added significance. This is partly due to the sociopolitical significance of oratory in such cultures, but also because of

the potency they often attach to the spoken word. Being the embodiment of acoustic energy and ordinarily enjoying co-presence of all participants in the communicative enterprise, the spoken word has an immediate impact; a capacity to make or break, a potential for instantly enhancing the sociopolitical status of its practitioner.[55]

Indeed, hip-hop and hiplife performances invoke a powerful ancient tradition of orality that continues to reenact the impact of "acoustic energy" among the younger generation, while putting the practitioner (rapper) on the line for success or failure in his/her communal context.

Yankah goes on to illuminate the *okyeame*'s particular job in Akan societies as that of "surrogate oratory" that manifests in five different forms, the fifth of which is most applicable to the role of the emcee in hiplife: "Principle [Leader] is absent from the scene of discourse; his orator speaks on his behalf." Yankah gives a contemporary example of this type of surrogate oratory as "a spokesperson speaking on behalf of a functionary or government leader in the latter's absence."[56] This model of the *okyeame* is most applicable to the role that Okyeame Kwame perceives for himself as a hiplife artiste.

> The orator here does not compete for attention on the stage, holding a virtual speaking monopoly...[A]ll five performance modes...imply a search for consensus or affirmation. For the practice of employing a surrogate, or respondent, is in part a strategy for emphasizing the objectivity of the speaker's word. Using an okyeame to repeat, confirm, or elaborate a principal's word implies that the principal's viewpoint is not subjective, but arises from shared experience.[57]

Although an obvious supposition, Okyeame Kwame's assumption of the contemporary role of an *okyeame* implicitly affords him a perceived objectivity, particularly if he feels that he is his community's voice (as do many emcees in hiplife), and his base community is the youth of Ghana. His perceived *divine* inspiration, as the source of his artistry, is a metaphor for the level of inspiration that he feels from the power of the word, the *nommo* force itself. Indeed, his Facebook page advertises the themes of his raps as "didactism, hip-hop and hiplife education, and social commentary,"[58] all of which allude to his sense of his role as *okyeame* for the youth of Ghana.

Okyeame Kwame's didactic social commentary is nowhere more evident than in his hit single, "Woso." The title means "Shake It Off," alluding to overcoming the many obstacles in life to find fulfillment. The song's intoxicating crunk beat that made it an instant club favorite belies its penetrating, insightful message about life's trials and tribulations. Similar to Jay-Z's "Dirt Off Your Shoulder" track on his 2003 *Black Album*, with its message about

removing jealous "playa haters" from one's life circumstances, "Woso" warned people in its hook, "Don't let the stress push you down." Kwame tackles many issues within the song as Ghanaian social commentary, from abusive personal love relationships to the slave-like treatment of orphans by adoptive Ghanaian families, and from basic poverty and hunger that continues to plague Ghana to racial power relations when Ghanaians try to immigrate to Europe.

> Wo bɛko Germany
> Afe yi wo bɛ gye wo shegen
> Wa danfo bi a bɔ Mmɔ den atwa wo invitation
> Wo bɛ fa Berlin,
> Hamburg, wo wie a wa Si Norway
> Wo kɔ duru German Emba
> Broni bisi no way
> Woso mmoa yi gu

> You will go to Germany
> This year you will receive your shegen (visa)
> A friend of yours has tried to send you an invitation
> You will pass through Berlin,
> Hamburg, finally you get off at Norway
> When you get to Germany embassy
> the white man says no way
> Shake this animal off.

In the very first verse, Okyeame Kwame takes on the global neocolonial hierarchy. All Africans face an often-insurmountable obstacle when trying to immigrate to the West. The process of obtaining a visa is often humiliating and degrading, demonstrating to Africans the unequal power they face as black men and women in their subservient relationship to Europe. Kwame speaks to the few successful Ghanaian who are lucky enough to receive their visas "this year," for it is usually a multiyear process before a visa to a European country is granted, even when friends abroad send letters guaranteeing accommodations and employment. He warns them that even if they finally arrive at their European destination, they are subject to harassment ("When you get to Germany embassy the white man says no way"). Kwame militantly calls these white men animals that must be shaken off. This is a message to Ghanaians, and Africans in general, to not internalize the inequality, advising them that if they can stay strong they will win in the end.

The lack of employment for young, even educated, men in an increasing privatizing, corporatizing Africa is at the center of motivation to emigrate to the West. The decreasing access of the young to employment becomes

a motivating factor for immigrating to Europe or the United States. Cameroonian philosopher and political scientist Achille Mbembe analyzes:

> The relative weakening of the socio-economic status of young men constitutes in this respect a novel phenomenon. Unemployment levels have risen significantly for this social category. The passage from adolescence to adulthood is no longer automatic, and in some countries the average age of the household heads is clearly rising... [as a results] the social distance between social seniors and juniors deepens, while the distribution of roles and resources between generations become more complex... Henceforth, for numerous young men various forms of dependence are prolonged. The only escape is to migrate or to have themselves recruited as soldiers in military formations.[59]

Okyeame Kwame's concerns about the inequities lodged in the increasing numbers of young Ghanaian males caught in the international politics of obtaining a visa to the West must be viewed within a larger context of the shifting familial and generational dynamics caused by changing economic factors resulting from transnationalization and privatization in contemporary Africa (see Chapter 3).

In the third verse of "Woso," Kwame turns to the internal social problem of abuse of orphans by so-called benevolent foster parents.

> Agyenkwa ba obi te Hɔa onfa won ye ne ba da
> NPP adaroma cytho Yɛ free ɔnfata wo nkɔ bi da
> Wobɛ si nnoɔma, adware nkwadaa,
> adedwa asan abɛ di awɔ ka, yɛ wie a bankye a sa nkwan agu ho
> ɛno na wɔdiada
> Madam Fofuo, kɔ n'ano
> Wo hwɛ n'anim dindindin
> Na wa few o na
> Woso ɔtain no gu
> Na wonso wo mmrɛ bɛ ba

> An orphan who has never been taken care of by a guardian
> would not be accepted as his/her child
> By the grace of NPP, public schools are free
> but he/she will never take you to school
> You will do the washing, bathe the kids,
> and also pound the fufu,
> but you will eat un-pounded cassava and soup for supper.
> Madam Fofua, you go before you look at her face quietly
> then you miss your grandma.
> Shake the hatred off.
> Your time will come.

Ghana's rampant poverty, along with the average life span of 57 years (as opposed to 77 years old for Germany, the country he singled out for unfair immigration policies), yields a national orphan problem.[60] As an alternative to legitimate orphanages, many families take in parentless children from their surrounding communities. But as Kwame accuses, the motive of many of these supposedly benevolent people is to use the children as nonwage labor. Besides doing all of the household chores, indigenous cultural hierarchy related to food further demonstrates inequality: even after the hours of labor that it takes to pound cassava and yam into the Ghanaian delicacy of *fufu*, the orphan children themselves have to eat "unpounded cassava" that is deemed less appetizing. This is an example of addressing local issues in the indigenization process that makes hiplife more relevant to young Ghanaians than US rap.

Kwame deftly blends the issue of the abuse of Ghanaian orphans with other aspects of his agenda. He makes public that orphan children, to extract their full daily labor, are not even allowed to attend the free schools. But, in revealing this form of child abuse, he also exposes his political affiliation by praising the NPP (New Patriotic Party) for establishing free education (through middle school). It should be noted that many Ashantis fill the NPP's ranks, and this political party was one of the main contenders during the 2008 election year when the "Woso" remix was first released. As a true hiplife Akan *okyeame*, Kwame speaks for the powerless, like orphaned children, and simultaneously shows his political/tribal allegiance. He ends the verse by telling the children to have hope, and to "shake the hatred off; your time will come." Interspersed between these social commentary verses, as well as the obligatory ones about "gold digging" girls and womanizing boys as equally abusive, he inserts hip-hop braggadocio about his prowess as the "Rap Doctor" that has resulted in his chart-topping songs. Local Ghanaian issues and aesthetics, and global hip-hop style merge into the global-local music form that hiplife has become.

The popularity of hiplife artists, such as Okyeame Kwame, with youths who represent a significant portion of the population has not gone unnoticed by the Ghanaian government. Several official agencies are using hiplife artists for social campaigns to reach the youth population with particular messages. The minister of health, for example, has made Okyeame Kwame the government's Hepatitis B ambassador. The Okyeame Kwame Foundation, established to do philanthropic work in the country, has interfaced with Ghana Health Services and together they developed a hiplife music tour called "Mind, Body, and Spirit." In 2010, Kwame noted, "Along with two doctors and thirty nurses, we are teaming with hospitals in Bolgatanga, Takoradi, Accra, and Sunyani, where I will perform. We will set up in marketplaces and town squares in those cities to give free, voluntary screenings

and counseling for hepatitis B." The Ministry of Health and Kwame's foundation are both financing the hiplife tour. Kwame states the country's health facts: "One in six Ghanaians have hepatitis B, and the government recognized my past efforts around this disease, and decided to join forces with my Foundation."[61] Youth agency through hiplife in Ghana is making a difference in long-standing problems in areas like African health issues. Hiplife artists such as Okyeame Kwame are dramatizing the importance of the youth population and the efficacy of using music to attack persistent social problems.

Project-oriented relationships between hiplife artists and the government can be forged precisely because of the social currency that hiplife music and its artists have established among the youth population. This social currency was apparent at the September 25, 2010, Milo Marathon performance at the Keep Fit Club in Dansoman, just outside of Accra proper. Ghana, as the second leading producer of cocoa (after Côte d'Ivoire), has counted Nestlé Ltd. as a part of its corporate sector for decades, producing the popular instant chocolate drink called Milo. The 24th annual Accra Milo Marathon that sponsors 15 km and 42 km races attracted throngs of youths. As a major fundraiser for the city, the race ended at Dansoman's Keep Fit Club with its large open soccer field, big enough for several outdoor stages where the day ended with hiplife music. Performing for hundreds of youths, aged from seven to twenty-seven, the performances spanned Afro-Pop with Ruff & Smooth and Eazzy and hiplife with OJ Blaq, Tinny, and Okyeame Kwame.

The power of youth and the influence that these musicians had over the entire event was made evident at the ending performances. Throngs of admiring, though polite, young fans gathered around Okyeame Kwame at the Milo Marathon performance. Hiplife musicians' popularity among Ghanaian youths gives the artists social currency on many levels from governmental to corporate, and from local to global. As Ntarangwi tell us:

> Musicians occupy certain important spaces in the communities where public discourse is often dominated by politicians or agents of development. Because of its contemporary and unbounded nature, hip hop has come to embody a specific public function, providing a forum for youth, who for a long time have lacked political or economic agency to express and assert their own presence.[62]

Agency by youths—projection of their social influence in the public sphere—becomes a way to wield power among themselves and their social context of the older generation in traditional roles of power. All the while, they advocate for their perspectives on the contemporary social issues in which they have a vital stake.

Hiplife music and its youth culture have created a new kind of agency for young people in Ghana that they have not previously enjoyed. Hiplife youths in Ghana, like youth subcultures all over the world, create identity style and performative markers that distinguish them from the older generation, which aids the establishment of possibilities of new forms of a public agency. Neo-Marxian subculture theory developed out of the Birmingham School of Cultural Studies offers some theoretical frames to identify and analyze youth subcultures like hiplife in Ghana. West African youths are creating a counter-hegemonic ideology resulting not only from their style markers, but also from the actual content of their music, as evidenced in Obrafuor's "Kwame Nkrumah" and Okyeame Kwame's "Woso."

Powerful youth agency through hip-hop is happening not only in Ghanaian hiplife, but also throughout Africa, as seen in the 2008 Waga Hip Hop 8 festival that I attended in Ouagadougou, Burkina Faso. Many forms of indigenization of hip-hop could be observed through the styles of artists from all over Francophone Africa, as well as Anglophone Africa, including the "roots man" image of Ghanaian hiplifer King Ayisoba. Focusing on youth marginality in global hip-hop, I have explored the power garnered by artists such as Okyeame Kwame, who are forging partnerships with governmental agencies in their efforts to maximize their personal agency as they take on the mantle of contemporary *akyeame* or linguists for their generation and their country. But this level of youth agency could not occur effectively without global corporate support, both from within and without the multinational pop culture industry. It is the intricacies of these capitalist-pop culture relationships on which I focus in Chapter 3.

"Society of the Spectacle": Hiplife and Corporate Recolonialization

AFTER DISCUSSING IN THE LAST TWO CHAPTERS THE evolution of the indigenization of hiplife music and culture within the global-local problematic, as well as the significant social and cultural inroads that the subculture has made generationally in Ghana, I turn now to the economic implications of hiplife—its obligatory interfacings with local and multinational corporate structures within global commerce affecting Ghana. Hiplife, as a part of the GHHN *and* Ghana's local pop music industry, is positioned both within hip-hop's global trajectory across Africa, as well as Ghana's place in Africa's development. Hip-hop music is poised centrally in the continent's economic growth because of "the arc of mutual inspiration" musically between Africa and its diaspora, as well as youth pop culture's focal point in late capitalism's spread throughout the world. Just as Katherine Cole assessed for Ghana's early theatrical form in the black American-influenced concert parties of 1930s and 1940s, so too hiplife is caught in "the cultural maelstrom where [post]colonialism and performance converge."[1] But, as opposed to the modernity of early twentieth-century capitalism, in this era of postmodernity twenty-first-century late capitalism relies heavily on pop culture that has grown exponentially since the 1980s.[2]

Capitalism's success is predicated on nation-states with reasonably stable governments and civil societies from which transnational corporations can expect to generate their goal of profit, and Ghana has proved to be the model of African nations in this regard. Akon's Konvict Entertainment, for

example, deciding to promote three emerging pop music celebrities in Africa (Chapter 1), chose Ghana as one of the three, along with Nigeria and South Africa. Ghana's close 2008 election that ended in a smooth transition in government (which hiplife played a part in promoting) was a much-watched international event. Ghana did not follow Kenya's electoral route in response to a closely contested election, but it instead peacefully transitioned from eight years of rule by Kufuor's NPP to the NDC reclaiming political power under John Atta Mills.[3] Its political stability has also helped Ghana make reasonable progress in the United Nation's Millennial Development Goals, established to give benchmarks for reducing persistent global problems such as poverty, gender inequality, HIV-AIDS, and global partnerships for development by 2015.

The latter goal in Ghana is one that is progressing at a steady pace, making it one of the primary countries through which global capitalist enterprises seek to make inroads into African markets. Ghana's relative progress is what prompted President Obama to choose Ghana as the only African country to visit on his 2009 world tour after his election (Introduction), and what prompted Victor Navasky to opine in *The New York Times* about Ghana's place in "rebranding" the continent just before Obama's visit.

> No one's leaked me a copy of the President's speech in Ghana but it's pretty clear he's going to focus not on the problems that afflict the continent, but on the opportunities of an Africa on the rise. If that's what he does, the biggest cheers will come from members of the growing African middle class, who are fed up with being patronized and hearing the song of their majestic continent in a minor key…But as the example of Ghana makes clear, that's only one chord. Amid poverty and disease are opportunities for investment and growth[4]

The rebranding of Africa is taking place through the technological revolution that includes global telecommunications companies, headquartered often in Europe and the Middle East, as well as the simultaneous spread of MTV Africa and international music and entertainment companies to the largest cosmopolitan markets in Africa. As new economic initiatives tend to be, this new "rebranding" phenomenon across Africa is both a marketing and financial enhancement to hiplife music *and* a threat to its artistic integrity. Ghana's economic growth during the Kufuor administration (2000–2008) was facilitated by a significant increase in privatization of previous public sectors with a corresponding augmentation in transnational corporate presence. In this era of late capitalism, youth and popular culture play a significant role in forging those capitalist inroads, positioning hiplife music and style as a primary tool for competing corporate interests. Youths, as primary

consumers, along with their cultural lifestyle and musical tastes, become the social bait for the advancement of what, I argue, is a form of *corporate* colonialism. Transnational corporate investment in Africa has corresponded with an attendant decentralization and overturning of previous postcolonial state ownership of many sectors of public welfare. Shipley states it this way:

> As in other locales across Africa, hip hop's rise resonated with the rapid privatization and decentralization of state institutions, and the related valorization of individuated modes of wealth accumulation that overtook state and collective ideas of progress. Ghana's 1992 constitution mandated the privatization of many state institutions including media and culture programs.[5]

Hence, the hiplife artists that I have been exploring in this book are primed as product endorsers, corporate spokespersons, and symbols of the cosmopolitan ideology and lifestyle that accompany corporate privatization that is a part of "rebranding" of Africa to sell global consumer products like never before. This chapter explores these lucrative corporate relationships that have developed with hiplife artists, preparing the hiplife music scene in Ghana to internationalize as well as to potentially follow similar commercial pitfalls as US hip-hop. Yet, these corporate-artists relationships develop in a shifting political economy that has everything to do with Africa's so-called modernization.

THE MEANING OF MODERNITY AND POLITICAL ECONOMY IN AFRICA

Although anthropologists who studied African cultures over the last one-and-a-half century have abandoned the notion of a simplistic unilinear model of sociocultural progress, those antiquated notions of social evolution of nations still linger in new forms. Europe and the West were projected as the socioeconomic pinnacle that exported its advanced cosmopolitan modernity to "undeveloped" societies mired in "tradition." Today, according to Geschiere, Meyer, and Pels, "whether and how it [modernity] can be achieved [is the only thing] that seem[s] to have changed." Adhering to the obsolete concept of a "phased progression" of social development with a singular notion of "tradition to modernity, to be achieved by the transfer of technology and political systems from the West,"[6] relies on an old-fashioned political economy analysis of society and an illusion of universal equal access to individual economic improvement.

Ideologies of neoliberalism and policies of Structural Adjustment, which will be discussed in this chapter, are a central part of the insidious looping of notions of modernity and a "progress ethos" into discussions of Africa.

Geschiere, Meyer, and Pels articulate the dilemma as it plays out in reality for contemporary Africans:

> While some present-day Africans look for access to modern life through increasingly transitional forms of seeking wealth, others seem to feel trapped in downward spirals of deprivation and despair. Even if grand narratives of modernization and development have lost credibility among Africans, as well as among those who study Africa, notions of being or becoming modern continue to wield tremendous power in everyday African life.[7]

Anyone touring or doing field research in African countries today actually realizes that the disparity between the wealthy minority and the vast poor majority has not changed even with increased infrastructure and a small rise in the middle class. Yet the dream of the possibility of economic growth and the cosmopolitan lifestyle, for those so long relegated to poverty, has become an increasingly predominate social ideology in this era of trans-nationalism. A cosmopolitan ideology is inculcated through the structures erected to transmit "the dream," including the utilization of hiplife music culture and its artists.

Noted Cameroonian philosopher and political scientist Achille Mbembe attributes the current dilemma of modernity in Africa to a "conflict between a cosmopolitan vision and a nativist vision of African identity and culture." He further summarizes the complex state of affairs in most African nations thusly:

> The dichotomy between the urban and the rural economy imploded and so did the separation between the formal and the informal economy, character-istic of the immediate post-colonial period. This was replaced by a fractured economy, composed of various closely related nodes, maintaining changing and extremely complex relations with international circuits.[8]

Hiplife's economic relations with the corporate telecommunications com-panies in Ghana, which I explore below, should make Membe's analysis clear, serving as a prime example of how economic "international circuits," promoted through popular culture, can easily enter twenty-first-century African countries with impunity, and in the process institute hegemonic, invented cosmopolitan practices that become all-pervasive.

Although Mbembe outlines several modes of cosmopolitanism that are at work in Africa today, one that is crucial for my argument is a form among African elites. He analyzes that it "is based on distancing them-selves from tradition, their main concern being the emergence of a modern and de-territorialized self," allowing a "gradual emergence of a private sphere

which borrows its symbols from global culture." Mbembe foregrounds, as I do, the realm of *popular* culture where social and personal symbols can be easily manipulated: "There are no other domains that highlight so vividly the impact of such transnationalization as those of clothing and fashion, sport and body care in general. However the same drive to open up to the world is to be found in music, dance and sexuality."[9] Certainly, Ghanaian hiplife music with its pervasive hipster-rapper trope is an obvious conduit for this transference of symbols of private ownership and imaginaries of the self at the core of the cosmopolitan lifestyle promoted by transnational corporations for profit.

Yet, there is a distinction between "globalization" and "cosmopolitanism." While globalization implies "the free movement of capital and the global (mainly Western) spread of ideas and practices, [the best of] cosmopolitanism is about reaching out across cultural differences through dialogue, aesthetic enjoyment, and respect."[10] Hiplife should be viewed in both contexts—clearly participating in what I have been calling a cosmopolitan arc mutual of inspiration with the African diaspora, while simultaneously being influenced and manipulated by neoliberal transnational capital. Anthropologist Pnina Webner discerns that "cosmopolitans insist on the human capacity to imagine the world from an Other's perspective, and to imagine the possibility of a borderless world of cultural plurality."[11] As we saw in Chapters 1 and 2, Ghanaian hiplife artists have a participatory sense of being a part of the GHHN, while being anchored in specific Ghanaian musical and oral practices entrenched in tradition. This dual hiplife allegiance is centered in the indigenization of hip-hop, creating both the exigencies of participating in "economic transnational circuits," while personally creating an enjoyable link with Ghanaian musical traditions in aesthetic dialogue with the diaspora. Webner analyzes that this kind of "cosmopolitanism attempts to theorize the complex ways in which cosmopolitans juggle particular and transcendent loyalties—morally, and inevitably also, politically."[12] Very little happens in Africa that ultimately doesn't have political implications, and in the case of hiplife popular music the personally moral definitely becomes socially political.

Germane to hiplife music, Guy Debord (1970) created a classic neo-Marxian analysis of the "commodity as spectacle" that presaged the current era of late capitalism's use of cosmopolitan symbols. He states:

> The fetishism of the commodity—the domination of society by "intangible as well as tangible things"—attains its ultimate fulfillment in the spectacle, where the real world is replaced by a selection of images which are projected above it, yet which at the same time succeed in making themselves regarded as the epitome of reality.[13]

There is no spectacle as palpably influential as the rock concert or the rap cipher. Symbols of imagined identities are transferred back and forth from stage to audience, not to speak of the commodities of clothing style and technological innovations [Facebook texting during the performance] fetishized in the popular music concert spectacle, now facilitated by YouTubing globally at the click of a computer mouse. However, the hip-hop spectacle becomes the arena where the rap artist is both complicit in this symbolic display, as well as resistant through alternative presentations of identity that is more nativist in perspective, like the kind of "society of the spectacle" performance by Okyeame Kwame in 2008 analyzed in Chapter 2.

Debord not only illuminates the beginning of late capitalism's foray into popular culture with the spectacle, but investigates why it is deleterious to the overall health of society. He speculates that the illusory world created by the spectacle is "at once present and absent" becoming "the world of the commodity dominating all living experience. The world of the commodity is thus shown for what it is, because its development is identical to people's estrangement from each other and from everything they produce."[14] In Africa, the transposition of transnational capitalism onto societies still primarily involved in small-scale farming and crafts production—where human connection is at the center of commerce—becomes a disorienting dynamic that leaves citizens struggling to find equilibrium between cosmopolitan and nativist paradigms clarified by Mbembe. Debord astutely evaluates:

> The loss of quality that is so evident at every level of spectacular language, from the objects it glorifies to the behaviour it regulates, stems from the basic nature of a production system that shuns reality. The commodity form reduces everything to quantitative equivalence.[15]

In this era of "cosmopolitan modernity" in Africa, what follows illuminates Debord's analysis about the erosion of the quality of life, through the fetishization of the commodity and regulation of behavior perpetuated by the spectacle. Hiplife music's complicity in the "complex relations with international circuits" through Ghana's telecom corporations becomes a new kind of colonization—a corporate recolonization.

GHANAIAN TELECOM COMPANIES AND HIPLIFE MUSIC

Everywhere one travels in Accra, Ghana's telecommunication companies, such as Vodafone, MTN, Tigo, Zain, and Glo loom large through ubiquitous mobile phones in the hands of the majority of Ghanaians, and on huge billboard advertisements throughout the city on major thoroughfares,

as well as minor roads. These billboards bombard one with sound bytes and slogans that demonstrate a globalized corporate hegemony in the guise of a simple and "natural" cosmopolitan lifestyle: MTN's "Live without Borders," Tigo's "Express Yourself," Zain's "Life Simplified," and Glo's "Rule Your World" are just some of their attempts at constructing a postmodern, urbane way of life in a country where the majority of the citizens make less than US$4 a day.[16] Moreover, marketing strategies that promote cosmopolitanism through mobile phones and their services are usually promoted primarily through music artist endorsers, the majority of whom are hiplife artists. English scholar Ato Quayson examines Ghanaian and transnational circuits of images and ideas that he calls "imagescapes" (see Chapter 1), part of which are advertising strategies of Ghanaian cell phone companies. "Taken together the two dimensions of inscription, billboard and slogans, hint at the arc of urban social histories, while also invoking a rich and intricate relationship between local and transnational imagescapes."[17] Indeed, Accra's telecom companies create this kind of urban imagescape through advertising a lifestyle ideology using hiplife music and culture.

Cellular phone service in Africa has allowed the majority of the population to make a technological leap from a lack of landline telephone infrastructure in most countries to having instant access to worldwide communications, and Ghana is no exception. Pádraig Carmody, quoting Castells's characterization of the African continent as a "black hole of informational capitalism," notes that the mid to late 1990s was a time when "there were more telephone landlines in Manhattan or Tokyo than in all of sub-Saharan Africa." Carmody and Castells emphasize the "technological dependency and technological underdevelopment, in a period of accelerated technological change in the rest of the world."[18] But Ghana was actually ahead of the market when cellular technology came to the country in 1992 with four major companies: Spacefon, Millicon, Ghana Telecom, and Kasapa Telecom, the latter of which still marginally operates. Usage started with approximately 19,000 people, but ballooned to 43,000 users by 1998, and by 2000 it had increased to 132,000 users.[19] One can perceive the rapid exponential increase in usage by the following statistics in the first decade of the twenty-first century: by the end of 2005, cellular use had risen to 3 million, and in 2007 it had risen to 7.5 million people in a population of 23 million.[20] Not only are Ghanaians using their mobile phones for person-to-person communication, but are also increasing faster than Americans in using cell phones for banking and entertainment. Panji Anoff explains:

> Nearly all of the mobile phones now sold in Ghana have Internet capability. And the Chinese phones now have android operating systems, which means they are fully-fledged, and that's the cheapest of all of them. What's

more, Google has made the android system for the mobile phone its operating system, which means when you log onto the Net with your phone, you'll be using a Google-derived interface, and not Microsoft Windows. It might take America or Europe five or ten years to switch from the MAC and the PC for accessing the Internet entirely. But here in Africa it will happen in three months time.[21]

Indeed, what media guru Henry Jenkins calls "convergence culture," where old media (writing, telephone communication, and television watching) and new media (Internet access, blogging, texting, downloads of television and music programming, gaming, and uploading videos on YouTube) unite, will indeed happen more rapidly in Africa because of the cost savings.[22] Cell phone usage by Ghanaians, paid for by purchasing pay-as-you-go scratch-off cards, is obviously a cheaper investment than the purchasing of a landline telephone, a television, and playstation hardware to accomplish the same activities as one cell phone.

This price accessibility is made possible by increased globalization through what Carmody calls "the new interregionalism between Asia and Africa," and to what Anoff alludes regarding "the Chinese phones." Indeed, Asian countries, particularly China and India, are investing in Ghana in various development projects.[23] Cell phones and their underpinning informational technology has changed the perception of Africa as a "black hole of informational capitalism," because today "the global technological revolution has swept over the continent through the wide-scale adoption of mobile phones." Carmody articulates the obvious: "Many of these phones are, of course, manufactured in Asia," with China now being "the world's largest producer of mobile phones" due to "its massive productive capacity, with consequent pressure on prices, [that have] made mobile phones more accessible for Africans."[24]

But, does this large cheap cell phone market that Africa represents mean that, for once, there is an economic sector in which the continent does not get exploited for its abundant natural resources? The answer is as follows:

> Africa is also integrated into the global mobile phone value chain through precious metal coltan, without which most modern information and communication technologies (ICTs) would not work. In addition to traditional resource extraction, globalization in Africa has other new axes such as "super-marketization" as South Africa supermarkets, in particular, spread throughout the continent.[25]

Coltan (columbite-tantalite) is a metallic ore comprised of niobium and tantalum, 80 percent of the world's supply of which produces metallic tantalum that stores a power electrical charge. Coltan is found mainly in the eastern

regions of the Democratic Republic of Congo.[26] Globalization's need for increasingly faster informational and communication technologies (ICTs) means that Africa, again, becomes a prime target for its exploitable abundant natural resources.

Because ICTs have become big business promoting a completely new mode of doing business, Africa has advanced several stages in communications technology usage to merge with technologically advanced societies. Jenkins, using MIT political scientist Ithiel de Sola Pool, notes:

> Freedom is fostered when the means of communication are dispersed, decentralized, and easily available...we are in an age of media transition, one marked by tactical decisions and unintended consequences, mixed signals and competing interests, and most of all, unclear directions and unpredictable outcomes.[27]

As Ghana's telecom companies scramble to compete for the country's growing cellular convergence market in a changing technological world, results can be random, thereby making the unpredictability of the marketplace more vulnerable to personal agency by young creative Ghanaians. As Panji conjectures, "If you have a mobile phone and you can put a TV, radio, and everything on it, someone who is a single person and hasn't got a TV can still have that power of choice; everything is on your mobile phone."[28]

On my last fieldtrip to Ghana in September 2010, the telecommunications market was literally changing before my eyes, with Vodafone launching what it called its "Blackberry Solutions." The majority of Ghanaians had simple cell phones that include regular keyboard texting. But Vodafone's introduction of the Blackberry represented a relatively affordable advancement in the availability of smart phones to the average lower-middle-class citizen. Their postmodern marketing strategy, "Power to You," was intended to engage the concept of "participatory culture," where each consumer is a unique individual that supposedly has the power to shape his or her life with the BlackBerry, which has access to the web, personal banking, and "lifestyle applications" including Facebook and MySpace. But Vodafone, as part owner in Safaricom in Kenya, is simply exporting into West Africa the multiple platforms that Kenyans are already enjoying; and the primary aspect of any marketing strategy, particularly in a developing country, is cost. William A. Darkah, then head of enterprise operations for Vodafone Ghana, revealed on the BlackBerry Solutions launch date: "For the first time in the country, Vodafone prepaid customers can get daily unlimited browsing and electronic mails for only GH¢ 5.00."[29] This means that in Ghana at that time, for less than US$3.50 a day, one could send emails and browse the web through Vodafone.

Yet, rampant poverty makes even these relatively inexpensive technology devices prohibitive. The per capita income of Ghana is approximately US$1,500 annually, translating to US$4.15 per person per day. Many of the poorest people just in Accra alone, who don't make that much income, resort to selling every kind of foodstuff and household goods on the streets of the city as "hawkers" to make a living. In a market like Ghana with widespread poverty, "low cost" is relative, rendering the average Ghanaian not able to afford this new BlackBerry. One level above the street hawkers are those who have small business stalls on the roadways, perhaps selling a few household goods. To reach the *average* Ghanaian consumer, telecoms will engage these small street-level vendors to promote their technology products. These stationary vendors with stalls might have a red and white Vodafone sidewalk-advertising tripod in front, or a Vodafone sign painted on what amounts to their makeshift wooden shacks (Figure 3.1). How much do these poor vendors receive for this direct advertising? Multibillion dollar transnational corporations such as Vodafone, to compete, must engage *all* levels of the population of a developing country, even some of the poorest.

By engaging even the lowest level of the economy, multibillion dollar telecom corporations maximize their profit potential in developing countries such as Ghana. In Figure 3.1, one sees the "Step by Step Enterprises" vendor whose roadside-business sign includes the Zain logo, with an adjacent sign for MTN, and a Vodafone standup road sign that has fallen over on the

Figure 3.1 Accra street vendor's stall advertising three major telecom companies (Author's photo).

road. In this way poor Ghanaian vendors, to survive, advertise three of the chief telecom companies. Contrasting this Accra roadside-business scenario with one of the biggest giveaway promotions by a telecom company—Vodafone's "One Million Dollar Grand Prize"— vividly demonstrates how cosmopolitan ideology underpins transnational capital even in poor countries. Vodaphone's customer giveaway consisted of a four-bedroom fully furnished home in Trasacco Valley, one of the biggest upscale suburban developments just outside of Accra. The million-dollar award included a Mitsubishi Pajero SUV vehicle with "a complimentary driver for three months," and of course, one year of free high-speed Vodafone broadband Internet connection plus a landline. The upscale Western-standard lifestyle promoted by this Vodafone giveaway contest is an example of the postmodern lifestyle accompanying Africa's neoliberal privatization and globalization in the era of late capitalism. Concomitantly, it evidences the continuity of the absolute disparity in wealth between the privileged few and the abject poverty of the Ghanaian masses.

Vodafone is actually one of the newer telecom companies in Ghana that has emerged with a strong competitive market share. Vodafone Ghana is the latest addition to the worldwide Vodafone Group Plc, headquartered in Newbury, United Kingdom. It operates in over 30 countries, including several African countries, the Middle East, Asia, and the United States (including the ownership of 45 percent of Verizon Wireless). Its focus is in hardware and infrastructure, and as of 2010 had yet to involve itself in the pop culture industry of Ghana like the other major telecom companies. It had, instead, focused on buying out the former government-owned shares of Ghana's communications market. According to its own company profile on its website, Vodafone considers itself to be "the world's leading mobile telecom company" particularly since "the successful acquisition of 70% shares in Ghana Telecommunications Company (GT), and its OneTouch subsidiary for $900 million dollars."[30] The Ghanaian government had already abdicated its ownership and responsibility for communications development in the country when it privatized Ghana Telecommunications Company (GT), subcontracting it to the Norwegian company Telenor as early as 1996. But Vodafone's acquisition of the controlling interests of GT from the Ghanaian government represents a virtual relinquishing of control over future developments and, therefore, profits in the booming worldwide technology and media sector. Therefore, much of the profits of the telecom industry will leave Ghana in this era of neoliberal multinational global capitalism.

However, it is MTN that has claimed to be "the market leader in the increasingly competitive mobile telecommunication industry in Ghana." They are ubiquitous in Ghana, particularly because they have chosen, in

contrast to Vodafone, to submerge itself in Ghanaian popular culture and the hiplife music scene, linking its market brand to the sponsorship of television shows, hiplife music artists, and the Ghana Music Awards itself. Due to this saturation in the pop culture industry in Ghana, MTN's yellow logo loomed ubiquitously large in my fieldwork. Its slogan associated with its yellow logo, "Everywhere You Go," is partially generated from the fact that it was one of the earlier telecoms in Ghana under the name of Spacefon. MTN's choice to take a strong popular culture marketing strategy is lodged in its focus on Africa and the Middle East as its target markets. MTN's saturation in music and popular culture is extremely effective, on a continent where "the arts" are a way of life, traditionally integral to the socialization process itself.[31]

MTN Group Limited is a company that started in South Africa in 1994 and has expanded to 21 countries in Africa and the Middle East. It is divided into its three operating regions: South Africa and East Africa, West Africa and Central Africa, and Middle East and North Africa. It claimed more than 116 million subscribers within its market for 2010, and prides itself on involving the company in African social initiatives where it does business. The Ghana Investment Promotion Centre has recognized these MTN efforts by voting it "The #1 company in Ghana.

MTN has become the model telecom company for involvement in Ghana's popular hiplife music. It has historically sponsored music events such as the prestigious Ghana Music Awards (GMAs) that I discuss below. However, to emphasize how influential Ghanaian popular music is in the competitive telecommunications market, a major "coup" happened in 2012 when Vodfone became the major sponsor of the GMAs, replacing MTN after a decade of sponsorship. The MTN Ghana Music Awards became the Vodaphone Ghana Music Awards. There is fierce competition for Ghana's youth market and hiplife music is at the center of the corporate competition. However, MTN sponsors many popular television shows both in Ghana and throughout Africa that, in turn, connects its youth markets. For example, MTN Ghana sponsors TV3's "Spotlight Show," an entertainment-in-review talk show that explores the music scene in Accra and the country, while engaging the latest technology of viewer call-ins, tweets, and texts via MTN networks. At the time of this writing, MTN was also exploring mobile TV service in Ghana, positioning itself for the android capabilities of smartphone technology.

MTN has become known in particular for sponsoring live hiplife/reggae music performances, including the famous Shaggy Show in 2003, featuring the Jamaican reggae singer Shaggy and Ghanaian raga artist Batman Samini. Samini became an MTN music endorser, representing the company throughout Africa, including being a mentor to contestants on the MTN-sponsored

Project Fame West Africa, the continent's answer to the US *American Idol* talent show. MTN also sponsors the annual Joy 99.7 FM's "Nite of the All Stars" concert, showcasing most of the top-selling hiplife artists (see Chapter 2, Figure 2.3). This involvement with hiplife music has extended to Okyeame Kwame becoming its second music endorser, and his making of a MTN Ghana TV commercial that won the "Best Television Advert" award. Hiplife music artists are garnering the clout, like their US hip-hop counterparts, to exploit and to be exploited by transnational corporate capital. All of my interviewees pointed to one exploitative aspect of Ghana's increasing artist-corporate relationships: the clause in their contracts that states that the artist cannot appear on a music event sponsored by another telecom company. In a country as small as Ghana, with most popular culture events sponsored by competing telecom companies, this stipulating contractual clause severely limits agency in artists' career development.

Exploring Okyeame Kwame's relationship with MTN exposes the entangled and complex contractual liaisons between hiplife artists and telecommunications corporations. Although Kwame was also a spokesperson for Coca Cola, he was more associated with the African telecom giant due to MTN's popular visibility in Ghana. At the time of this writing, the Rap Doctor's Facebook homepage featured his 2010 MTN-sponsored tour, "OK in Your Zone." Simultaneously as health ambassador for the Ghanaian government (Chapter 2), Kwame combines his own One Mic Entertainment, the Okyeame Kwame Foundation, and MTN to take Hepatitis B screenings and education to several regions of the country. At the same time, by including other hiplife artists in the tour, Kwame promotes the entire hiplife music industry. On his "OK in Your Zone" music tour he also featured veterans such as Samini, Richie, Kwabena, and Obour, as well as then relative newcomers such as Iwan, Mimi, Eazzy, Bradez, and others. His savvy entrepreneurship is apparent by having the tour simultaneously promote his new album "The Clinic" and MTN as a company, all while helping to improve the health of the country. The official tour poster indelibly stamps MTN and Okyeame Kwame as being in the same zone, with the ideological implication that their zone is "your zone." Artist and corporate philanthropy merge to bring awareness to a persistent African health problem, which, in turn, ameliorates some of the exploitative aspects of the artist-corporate relationship.

Savvy hiplife artists such as Okyeame Kwame are using their celebrity status to create agency for hiplife music, his generation, and Ghana through relationships with corporations such as MTN; but this determined youth agency does not preclude the convolutions that result from these artist-corporate liaisons in the era of late capitalism. As Okyeame Kwame was getting ready to perform at the Milo Marathon in Dansoman, another corporate-sponsored

pop culture event (Chapter 2), he revealed some behind-the-scenes senti-
ments about his relationship with MTN. "It's about the ideas we are bring-
ing, and how we're telling them. They [MTN] are trying to keep us shining.
They let me and Samini sit in at meetings, and we give our opinions. But, of
course, they could do more."[32] Although MTN claims to forge "meaningful
partnerships and pro-active community involvement," the "more" to which
Kwame refers goes far beyond what so-called socially conscious transnational
corporations such as MTN are currently doing regarding their "long-term
achievable sustainable contributions" to the communities within their profit-
able African markets.[33]

Even with MTN's self-perceived "meaningful relationships," there are
accusations of lack of sensitivity and anti-Ghanaian small business practices
by MTN and other telecom companies. A news article on the GhanaWeb.
com site entitled "Major Telecommunication Companies Cheating Ghanaian
Contractors" exposed a spurious business practice by the major three telecoms,
including MTN: contracting for the construction of its telecommunication
tower masts to 419 contactors, who in turn subcontract to local Ghanaian
businesses at a fraction of their paid fee ("a third of the whole contract sum").
The final fees reaching the local builders make "it very difficult to complete
the work," thereby continuing the often-hurled indictment that local Africans
are incompetent in improving their own infrastructure, even when aided by
foreign investment.[34] This latter sentiment came in several vitriolic blog com-
ments in response to the online article, completely ignoring the issue of a cor-
porate setup for failure.

In addition, the news article exposes the revealing fact that when
these small Ghanaian companies do manage to finish the job, often
"they are never paid, thus putting them in a very difficult financial situa-
tion." Reportedly, when the aggrieved small businesses complain directly
to MTN, Vodafone, and Zain, they get no response. The article also
accuses these Ghanaian telecom giants of putting Ghanaian front men
at the helm of the original 419 contractors "to avoid paying certain fees
to Government," while at the same time exposing the workers construct-
ing the towers to safety risks that they "would never get away with...in
their own country, but they keep abusing our people everyday." Ultimately
the article blames the Ghanaian government for "failing our people" with
no protection given to local small businesses or its workers.[35] Often what
looks like philanthropy by major corporate entities masks exploitative
abuses of local Africans for the goal of profits to stockholders. Hiplife art-
ists' acts of agency become small counter-hegemonic drops in the ocean of
corporate abuses.

Tigo is another Ghanaian telecom company that is operated by
Millicom Ghana Limited. As the cell phone service that I personally use

when in the country, I remember the day that I bought my Tigo service: in August of 2008, one of my Ghanaian university students, Afriye Adomako, took my fiancé Gene and me to get a mobile phone. I had no idea of the choices that I had or how the international GSM (Global System for Mobile Communications) service worked. I just knew that the Fulbright orientation that I had received in Washington, DC emphasized that I needed a GSM compatible phone and that the service in Africa would be "spotty." I actually bought a GSM phone before I left for Ghana, only to find out that my British telephone number that came with it was prohibitive to Ghanaians—it would cost them long-distance rates every time they talked to me. When Afriye took us to buy a "local" phone at a small phone outlet in Madina, near the Legon campus, I simply told the saleswoman that I needed a phone with a Ghana number. Becoming a part of the Tigo service was as simple as she selling me a Nokia phone with a Tigo SIM (subscriber identity module) card in it.

As a newly arrived foreigner, I didn't even realize that I was going into a Tigo store, or even what Tigo was; it was simply a store that sold cell phones and I accepted what I was given. However, I was very aware that to have the ability to call anywhere in the world at the touch of a button from anywhere in the country was a huge technological leap from my first communication experiences in Ghana in 1976: The one time I called home during that year, I had to make an appointment in Accra at the central telephone headquarters a week ahead of time to place a long-distance call to the United States. And when I finally had my long-distance phone conversation to the United States a week later, all I remember was there was so much static that I had to scream to have an effective conversation. During my 32-year absence, mobile cell phones had become an absolute necessity, and a foreigner is usually dependent on an African friend, as I was, to negotiate one's important initial purchases like a mobile phone that becomes one's lifeline.

Millicom Ghana Limited (Tigo) was actually the first Mobile cellular network to incorporate in sub-Saharan Africa in March 1990, and began its operations in 1992. It is a part of Millicom International Cellular that operates in 16 countries across Asia, Latin America, and Africa, where they first started in Sénégal and Chad before moving into Ghana as Mobitel/Buzz. Although it is behind MTN, Vodafone, and Zain in size and subscribers, Tigo is a strong competitor, having increased subscribers 66 percent between 2006 and 2007. During my research, the telecom company also boasted one of the few women in upper management, Anita Erskine as corporate affairs manager, who was often the company spokesperson. She steered various Tigo corporate sectors, including its "social responsibility" projects. In Africa, a corporation's social responsibility is not only a "nice thing" to do, but also becomes crucial

to survival in African markets where multinationals don't want to appear totally insensitive to ubiquitous social needs while pursuing its profit motive. Each company finds pet projects among the myriad socioeconomic problems in urban and rural Africa. Tigo has carved out its social responsibility niche in the sector of education with its 2010 announcement of renovations of "32 deprived schools in Greater Accra" in districts such as Nima, where hiplifers VIP and their base support reside.[36]

Like most savvy global companies doing business in Ghana, Tigo uses hiplife music and culture to sell its products. Tigo's "Express Yourself" sound byte plays into the postmodern trend of unique individualism that subverts notions of group class and ethnic solidarity. In 2008, they sponsored several hiplife-oriented TV shows such as "Open for Discussion" on TV3 that featured artists such as Tic Tac. They also ran their "Be Heard" TV adverting campaign that promoted use of Tigo to download one's favorite ringtone. The first frame of the TV advertisement shows a Ghanaian youth who answers his phone and hears hiplife music being played by two older Ghanaians, presumably some of the youngster's relatives who are dancing and partying to the youth music. The male youth who answered the phone looks incredulously in to the camera, as he can't believe his ears that his older uncles are partying to hiplife music. Telecom companies use the popularity of hiplife music, as it transcends the generational divide, to sell their products to customers of all ages. Tigo's "Be Heard" campaign sells the Ghanaian public the contemporary concept that each person can have a unique cell phone ringtone, no matter one's age, even in the collective poverty that most find themselves.

Besides infrastructure upgrades, telecom companies all position themselves in a very competitive Ghanaian market through an appeal to global youth cosmopolitanism with a local style that is often facilitated by hiplife music. Quayson identifies Tigo as "the most fascinating [of the Ghanaian cell phone companies] because of the ways in which their advertising subtly reformulates the local into an instantiation of a transnational and scrupulously non-local signification." He perceives a nontraditional Pan-Africanism in their advertising strategy that allows their company to enter several African markets without the specificity of locality, including the "multicultural mix" of South Asian (East Indian, Arabic, Persian, etc.) populations living in Africa. Quayson analyzes that Tigo's Pan-Africanism "pertains to an image of black youth that allows it to be assimilated to various categories of fashion that are (a) not easily localizable, and (b) not limited to an exclusively black ethnic identity."[37] Tigo, as one of the oldest telecom companies in Africa, has had the time to construct a variety of marketing campaigns that utilize the multicultural complexities of sociocultural reality on the continent.

Zain, as an international telecommunications company based in the Middle East, was the newest addition to the telecom scramble in Ghana at the time of my research, making a loud entrance into the market during my 2008 fieldwork. Since then, it was bought by Bharti Airtel, an Indian telecommunications company that operates in over 20 countries as well as Africa. However, since Zain was the company operating during my fieldwork, I will focus on them as example of "corporate recolonialization." Nigerian tech guru Oluniyi D. Ajao explains, "Zain had already done their homework very well and launched a very sophisticated network" including "the first 3.5G network."[38] Zain was the first to give MTN serious competition at all levels of infrastructure and marketing, and as Ajao analyzed in 2009, "Perhaps it is an endorsement of the quality offered by Zain that makes it the fastest growing network in Ghana today."[39] Indeed, Zain did enter the market with an aggressive advertising campaign that couldn't be missed in Accra, creating billboards and banners with the youth-oriented "The Zain 026 Experience."

In Figure 3.2 one sees one of Zain's strategically placed billboards right near the main highway leading out of Tete Quarshie Circle, where the prestigious South African-owned Accra shopping mall is situated, toward the upscale trendy district of East Legon. In the billboard image one sees the hoodie-clad young black female holding her mobile phone, with seven males in different colored tee shirts with the numbers 1–7 on their backs. The message is that Zain's "026" experience allows one to chose one's

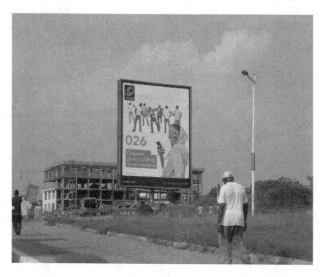

Figure 3.2 Zain billboard showing youth-oriented lifestyle (Author's photo).

own personal cell phone number that follows the 026 Zain network prefix, thereby promoting the perception of personal choice as central to the cosmopolitan postmodern lifestyle. The youths are not wearing Ghanaian traditional clothes (which some Ghanaian youths continue to do); instead they don hip-hop ubiquitous jeans and hoodies as style markers for global youths who value "individual choice." At the same time the billboard's urban context illustrates Ghana's industrial "progress" through many construction projects that rarely benefit the average citizen, often serving only as a reminder of what he/she *cannot* afford. Indeed, the average Ghanaian cannot manage to pay for a vehicle, and therefore transportation is either by *tro-tro* (low-cost people's van) or walking, as the man does in the foreground. A lopsided Tigo banner to the left of the construction site pales symbolically in comparison to the new greater-financed Zain advertisement campaign.

Zain (K.S.C.) began in 1983 in Kuwait as that region's first mobile operator. They expanded to Bahrain, Jordan, Iraq, Saudi Arabia, and eventually to Sudan on the African continent. By 2007, they began their "ACE" strategy that included "accelerating the growth in Africa, creating Zain Africa BV, and in 2008 reported a gross income of US$6 billion." In March 2010, within 16 months after entering the Ghanaian market, Philip Sowah, Ghanaian country manager for Zain Ghana, introduced its "Zap" mobile commerce service with advertising that read, "Use mobile phones like a mobile wallet to pay for goods and services and conduct banking services regardless of the type of handset you use."[40] With this new technology, Zain became one of the leaders in the smartphone industry in Ghana, after it had already successfully launched Zap in Kenya, Malawi, Niger, Sierra Leone, Tanzania, and Uganda. Sowah noted at the Accra launching, "Once again, Zain is creating a wonderful world where customers can move about freely with their mobile phones transacting on goods and services."[41] Zain's marketing sound byte is "It's a wonderful world": cheery corporate slogans, created as a part of neoliberal global trade agreements, help create the cosmopolitan individualism that is the antithesis of Africa's traditional communalism.

The era of neoliberal global trade in the telecommunications business in Africa became apparent when in June 2010, an Indian telecom company, Bharti Airtel, significantly increased Zain's assets when it bought Zain Africa from the Kuwait parent company. The US$9 billion sale made Bharti Airtel the fifth largest cell phone company by subscribers. Bharti, in turn, is 32 percent owned by Singapore Telecommunications Ltd., who had already unsuccessfully tried to enter the African market by attempting to buy into MTN. Bharti Airtel now enjoys the market, once owned by Zain in Ghana, only three short years after Zain entered Ghana in 2008. Africa has become

a premium market for telecommunications technology in the information age for Asian and Middle Eastern business interests.

But what is most important to my hiplife research is how Zain, as the original new telecom, utilized the youth subculture to capture the attention of the Ghanaian public to initiate business in the country in November 2008. Entering with a ubiquitously publicized hip-hop concert billed as "The Zain 026 Experience," the concert, held at the large Ohene 'Djan Stadium in Accra, was headlined by American hip-hop artists Wyclef Jean and Eve with R&B artist Mario, along with Ghanaian hiplife artists Kwaw Kese, Obrafuor, and Tinny, as well as Nigerian hip-hoper 2Face. The concert, I conjectured at the time, would be an opportunity to see a transnational high-profile hip-hop concert with American, Ghanaian, and Nigerian artists working together to represent the GHHN.

As it turned out, Zain's introductory concert represented a major statement about ineffective corporate and hip-hop collusion. What became the apparent problem from the very beginning was the ticket prices: starting at 20GHC (20 Ghana Cedis) at the low end, tickets increased to 100GHC VIP tickets, leaving most of Zain's would-be patrons outside the gates in the parking lot having their own party or trying to scam their way into the stadium. The venue was only about one-third filled due to these exorbitantly high ticket prices by Ghanaian standards, with the public receiving an initial signal from Zain, as the new telecom, that they had to have money to participate in the global culture that it represented. The following is an account of the November 22, 2008 concert.

Arriving at the stadium box office an hour after the advertised start time, with no long line of ticket buyers at the window, presaged "The Zain 026 Experience." However, the usual hawkers of Fan Milk, groundnuts, and plastic-pouch drinking water, trying to make a cedi, were in big numbers in the parking lot. Joining them were scalpers selling supposedly "counterfeit" tickets, or so the ticket seller at the window told me. Adia Whittaker, a visiting American friend and researcher, accompanied me, and we purchased 50 GHC "Golden Circle" tickets that was supposed to get us into mid-range semi-VIP seating area, which turned out to be a quarter of a mile from the stage. We entered the stadium at 6:30 p.m., with less than 1,000 people in the 40,000-seat Ohene 'Djan Stadium. I realized that either this concert was going to start very late, or Zain was going to loose a lot of money. It turned out to be both. Although more concertgoers did arrive later, the total audience attendance in no way filled the huge sports stadium. And what's more, the first act didn't begin until 9:00 p.m., four hours after the advertised start time.

The Zain 026 Experience will be indelibly marked in my mind because the producers were totally oblivious as to how to produce a hip-hop concert

anywhere, let alone in Africa. Glass barriers not only cordoned off tiered-price seating, but they also lined the entire field completely separating us from the artists. These barriers added to the sense of distance from the stage positioned at the far end of the soccer field. As a concession to the audience's distance, two large projection screens framed the stage area. But the projected images were of such poor quality that they did not facilitate viewing. Adding to these significant problems was the poor sound quality: the music was muffled and hardly recognizable from where we were seated. Ghanaian audience members all round me were complaining about the money they had spent, yet couldn't enjoy the music because the venue was too large for the sound system that the producers provided.

Zain's concert fiasco revealed capitalist insensitivity at its worst, leaving the artists with the dilemma of how to salvage the obvious disrespect to them and their loyal fans, which each attempted in his own way. Obrafour opened the concert with four female dancers in shorts and t-shirt on the stage, with little effectiveness. Two of the next Ghanaian artists tried to close the gap between performers and audience by leaving the stage and coming out onto the field, traveling to the different audience sections behind the glass barriers. Tinny was the best at bridging the constructed obstacle, and despite the 20-foot barriers he created an effective call-and-response aesthetic that is at the foundation of hip-hop. As soon as he entered the stage, he immediately jumped down onto the ground with his cordless mic, followed by his crew and film documenters, rapping while traveling to each audience section. The people were enthusiastic, appreciating his attempt to directly connect with them to create the expected synergy. Kwaw Kese, wearing his trademark Palestinian *keffiyeh* headdress, decided to bypass the distant stage altogether, and was brought out on a donkey, parading around the grounds as if he was royalty. His shtick was not as effective as Tinny's straightforward "rocking" the crowd, and he eventually mounted the stage to finish his performance.

My Zain concert experience ended with the last of the African warm-up performances. Nigeria's 2Face closed out the first half of the event, with his deejay filling up his extended pre-entrance time with a "back-in-the day" mix, while using flaming sticks like a Polynesian hotel performer. It was extremely difficult for the artists to achieve typical hip-hop performance energy within the venue setup, making the event a disappointment with only glimmers of artistic triumph. After hours of waiting for a show with few high moments, Adia and I left before the American headline hip-hop acts. After being at the stadium six hours for a show scheduled for a start time of 5:00 p.m., we projected that Wyclef, as the main attraction, would not perform until 2:00 a.m., making it difficult to get a taxi to return to the Legon campus in the wee hours of the morning.

The audience members were young Ghanaians and white expatriates—all hip-hop enthusiasts, representing the GHHN. Most of the Ghanaian females wore straightened hair and weaves, skinny jeans with glittery tops and heels. Inside the stadium, you could have been in black Los Angeles. Visually, the only way you knew you were in Africa were the food hawkers with trays on their heads, some of whom wore traditional cloth. The Western dress style of hip-hop was everywhere evident, making the concept of the GHHN visible—the American contemporary look, dominating the surface identity image, while the music itself provided a localized Ghanaian/African soundscape as substance.

The following day, I got a post-performance debriefing form Reggie Rockstone that validated my own assessment of the concert. He said, "The Zain *026* Experience turned out to be The Zain *02-Shit* Experience. That's what people are calling it in Accra after the disaster of the Wyclef-headlined concert." Rockstone told me that Wyclef had "succeeded" that night by climbing on top of one of the barriers and delivering his songs to the audience perched on the glass structures meant to separate him form the people. Having six previous acts to study the situation before his finale performance, he had strategized his approach by the end of the concert and salvaged the event. Two years later, when I reminded Reggie about the infamous concert, he reflected,

> Clef witnessed it himself. Those barriers! It was straight like from South Africa and shit! You had people holding bars and like looking in [to try and see something]. Clef was like, "Yo, open the gates. Let the people go." I don't know how he pulled that concert off. But he came through because he wanted to reach the people.[42]

The insensitive class issues of the ticket prices aside, the Zain concert was indeed an example of corporate exploitation of hip-hop culture to sell its business image, and in the process demonstrating a lack of understanding of the culture or how to successfully produce it *artistically*, not to mention a total lack of respect for the youth culture they were attempting to use as a marketing tool.

Even while hip-hop artists necessarily engage with big business, their own artistic collaborations go beyond corporate control, enacting resistance to commercial takeover of their culture. Wyclef Jean's impact on the Ghanaian hiplife scene did not stop with Zain's hiring him to headline their concert. Hip-hop counter-hegemonic style—flippin' the script—triumphed with Rockstone drafting Wyclef as a featured artist into his home studio the next day to record on a new track called "Glad," along with 2Face and Kwaw Kese. Donating his services free of charge, Wyclef Jean bridged the

Black Atlantic, signifying how internationally famous hip-hop artists of the GHHN can aid less-known African hip-hop artists, and thereby renewing the arc of mutual inspiration. Resistive mutual artistic acknowledgment and collaborations often happen inspite of transnational corporate-sponsored concerts. But that collaborative support depends upon the artists involved. Reggie revealed,

> When the big wigs come out, they get star struck. When Jay-Z came here [in 2007], we got into it. Usually the [African-American] brothers don't get it about Africa. When they come to Africa, they need to perform for free [to help us out]. A brother like Wyclef, he gets it. He comes from Haiti.[43]

Superstar American artists who do "get it" create significant counter-hegemonic collaborations that transcend corporate-sector manipulations. Wyclef's recording on Reggie's "Glad" became the opening track on his 2010 *Reggiestration* album. Along with its music video, this collaboration furthers the careers of African hip-hop artists such as Reggie Rockstone, who are indigenizing hip-hop while continuing to connect to the GHHN.

Global hip-hop has become a complex combination of American pop culture hegemony, marginalized local indigeneity, and the generational marker of the Africanist rebellious trickster "bad boy" as cultural link. One line in Rockstone's verse in "Glad" recognizes continuing American dominance regarding *international* recognition: "Reggie Rockstone you ain't gon go far; how you gon get your music to America."

American hip-hop hegemony is visually apparent in Figure 3.3 as the Zain concert poster: Wyclef looms largest, flanked by Eve and Mario, with the four African artists as the smallest image to the right and left of the Americans. Corporate-sponsored transnational hip-hop concerts, such as the "Zain 026 Experience," represent the global multinational business that the international youth culture has become, yet as capitalist bedfellows hip-hop and corporate multinationals are often clashing cultures. Zain, as a Middle Eastern-managed mobile telecom company then trying to conquer Africa, reveals corporate opportunism regarding its capitalist partner (hip-hop and hiplife) and its constituency (youth audience) when its motivation is only about exploiting the culture for financial gain, without genuine respect for the art. Global telecoms pushing Africa into international commerce are vital in the merging of capital with popular culture; and black music's centrality in that model is increasing exponentially with hip-hop's entry into the market. Respectful understanding of the youth subculture becomes all the more crucial.

Lastly, Ghana's telecommunications sector would not be complete without an examination of an anomaly in the country's telecom competition— Glo Mobile Ghana, owned by the Nigerian-based Globacom Limited that

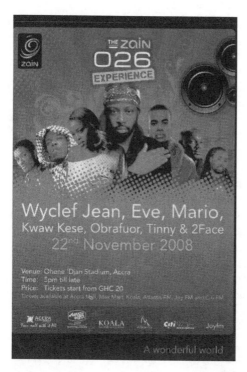

Figure 3.3 "The Zain 026 Experience" poster showing a hierarchy of American and Ghanaian/African artists.

started in 2003. Glo's marketing campaign is visible all over Accra; in fact, when I entered the Kotoka International Airport in early September 2010, the first advertisement that I saw was a larger-than-life size poster of Reggie Rockstone on a colorful Glo poster, welcoming me to Ghana. However, the incongruity lies in the fact that even with a ubiquitous urban presence, since Glo won a competitive contract from the Ghanaian National Communications Authority (NCA) in July 2008, Glo Mobile Ghana had not yet launched its cell phone service by the end of that same year.

As the sixth telecom company licensed in Ghana, Glo is the only company under private ownership by an African. Otunba Michael Adenuga is a wealthy Nigerian entrepreneur who owns the Mike Adenuga (MA) Group, consisting of Globacom, Conoil, Consolidated Oil, and Equatorial Trust Bank, among others, all operating out of Nigeria. Glo Mobile Ghana is Adenuga's attempt to expand his market throughout West Africa, which, besides Nigeria, already includes Gambia, Benin, and Côte d'Ivoire. The company has not only engaged in a strong pop culture-oriented marketing

campaign in Ghana by using many hiplife, highlife, and gospel music artists, but it also originally excelled in building effective telecommunications infrastructure. According to the Telecom Paper website, "[Ghana's] NCA picked Glo Mobile as the preferred bidder because of the superiority of its technical presentation, pedigree and extensive roll-out plan."[44]

Yet those rollout plans for actual service had yet to materialize as of late 2010 due to a series of suspicious setbacks. Nigeria boasts of indigenous ownership, albeit private, of Globacom as its leading telecom provider. Yet in Ghana, the numerous setbacks include "encroachment on the frequency allocated to it by the NCA, repeated sabotage of its billboards, and the delay in securing approval for the swift deployment of its infrastructure such as base stations."[45] After instilling pride in Ghanaians with their popular music artists so prominently displayed throughout Accra (see Figure 3.4), there was immense local disappointment at the delay in Glo's anticipated service to the country. There have been allegations of sabotage from within the industry, particularly because Glo Mobile Ghana would have an infrastructure advantage because of its "submarine cable (Glo-1) that links West Africa to the U.K."[46]

I have included Glo Mobile Ghana in this analysis of Ghana's influential telecom sector because of its respectful insider-use of hiplife artists in their

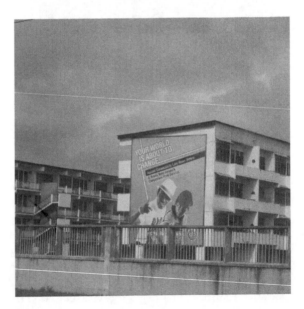

Figure 3.4 Glo poster on Accra Housing Project with hiplife artists Tinny and Edem, and slogan "Your World is About to Change."

marketing campaign, contracting and paying the artists before Glo's telecom service had even started. Although the company projected a January 19, 2012, launch date,[47] a significant point about Glo's predicament has been that hiplife artists are *aware* of the complex business dealings, in which the telecom companies are involved, and that these form the larger scheme of twenty-first-century commerce in Africa. Rockstone reflected this understanding when he revealed:

> As in most places, but particularly in Africa, many a deal will get cut; things we will never hear about, know about; that's just what it is. With the question of Glo coming in, there's a whole story that is so muddy. Thinking of how bad they're treating him, he, Mike Adenuga, should have packed up and left. But it goes back to the type of deal that got cut.[48]

As Africa tries to make its transition from being an exploited *resource* for other global markets to becoming a significant *player*, itself, in global commerce, many obstacles emerge, both culturally internal and economically external, the latter of which is largely based on so-called neoliberal trade reforms that have been imposed upon the continent.

This is an important moment in the information technology revolution on the African continent because it not only allows Ghanaian hiplife artists to build an international audience base, but it also replicates previous power relations. I agree with Carmody's ethical interrogation of the beneficial and detrimental aspects of what he calls the "global mobile phone value chain."

> I seek to interrogate the hypothesis of transformation by examining the ways in which Africa is integrated into the global mobile phone value chain, and the uses to which this technology is put on the continent. While mobile phones are having significant and sometimes welfare-enhancing impacts, their use is also embedded in existing relations of social support, resource extraction, and conflict.[49]

I would add that the telecoms are embedded in the reality of unequal power relations in global finance policies, which I explore below. Carmody reveals that colonial power relations are "merely being partially modified" as they become "reinscribed by the information revolution that has swept over the continent."[50] One must interrogate the idea that the telecom multinationals are a part of a neocolonialist regime, particularly when faced with the case of Adenuga's dilemma in establishing his Glo Mobile Ghana enterprise among the other foreign telecom companies already established in Ghana. In this era of late capitalism, hiplife music becomes implicated in issues imbedded

in the global economic restructuring taking place at the beginning of the new millennium, of which Ghanaian telecom companies such as Vodafone, MTN, Tigo, Zain, and Globacom are a significant and visible part.

Mobile telephones and the Internet facilitate the information age with their social networking capabilities and their democratizing of international marketing through platforms such as YouTube. The so-called Arab Spring of youth-led uprisings in North Africa and the Middle East facilitated by this technology, as well as hip-hop music itself, is but one crucial example. Artists and community groups participating in this "virtual democracy," such as hiplife artists seeking to garner global attention, complicate the long-standing arguments about social inequalities and global hierarchies that these new technologies also represent. These complexities are what prompt development geographer Carmody to ask whether these current dynamics of globalization, spanning the personal, the nation-state, and international capital, amount to a "recolonization or renaissance" in Africa? One cannot answer this question without an interrogation of the place of the World Bank and the IMF within these complexities.

AFRICA'S STRUCTURAL ADJUSTMENT POLICIES AND BUSINESS AS USUAL?

Neoliberalism is a relatively new term for a centuries-old global issue: free trade within the world's center-periphery paradigm of power. Today Asian countries' entry into this global hierarchy complicates what was exclusively European and American hegemony since the nineteenth century. Like "hegemony"—ideological, sociocultural, and political dominance—"neoliberalism" is not merely economic in scope, but also social and moral. According to Elizabeth Martinez and Arnoldo García, "Around the world, neo-liberalism has been imposed by powerful financial institutions like the International Monetary Fund, the World Bank, and the Inter-American Development Bank...the capitalist crisis over the last 25 years, with its shrinking profit rates, inspired the corporate elite to revive economic liberalism. That's what makes it 'neo' or new."[51]

Neoliberalism's rhetoric of conformity to market forces, created by the most powerful international financial institutions, also engenders social conformity in all sectors affected by those contrived market forces. The million-dollar giveaway prize by Vodafone, mentioned earlier, is an example of the attempt by a transnational telecom giant to create hegemonic conformity to a personal lifestyle that is far beyond the reach of the majority of the population of Ghana, as one of the world's poorest nations. Promulgating the belief that the average hardworking Ghanaian will be able to attain *that* standard of living is ludicrous, making transparent the goal of

increasing the disparity between the rich and poor that underpins the neo-liberal policy of free trade and its lifestyle value of materialism. Sociocultural ideology undergirds public policy; therefore neoliberal *social* values ride the coattails of its global *economic* dictates.

However, not all theorists emphasize global economic control imbedded within neoliberalism. Anthropologist Aihwa Ong focuses on "governing activities" that "are recast as nonpolitical and nonideological problems that need technical solutions." Ong analyzes the technical emphasis within neoliberalism as "a new relationship between government and knowledge,...focusing on the active, interventionist aspect of neoliberalism in non-Western contexts, where *neoliberalism as exception* articulates sovereign rule and regimes of citizenship."[52] She uses Foucault in abstracting contemporary "neoliberal rationality" that she contends, "informs action by many regimes and furnishes the concepts that inform the government of free individuals who are then induced to self-manage according to market principles of discipline, efficiency and competitiveness."[53] If only neat explanations of how neoliberalism, like this, allowed *all* so-called free citizens of democratic societies to actually take advantage of these market principles.

Ong's geographic region is Southeast Asia that experienced colonial regimes as did Africa, as well as postcolonial governments that were equally as exploitative as in many African countries. In addition, Ong explains two basic tenets of neoliberalism as a political philosophy: "a) a claim that the market is better than the state at distributing public resources and b) a return to a "primitive form of individualism: an individualism which is 'competitive,' 'possessive,' and construed often in terms of the doctrine of 'consumer sovereignty.'"[54] However, if neoliberal policies of trade truly brought so-called technical solutions and consumer sovereignty, there should be a visible rise in the rewards of ethical personal achievement that would result in an increase of the middle class in neocolonial societies, such as Ghana, where neoliberal trade policies have been imposed by new corporate relationships with local governments. However, if Ghana is any example, the small rise in the middle class does not balance the huge profits being reaped by the multinational corporations in cahoots with the state.

Journalist Naomi Klein is particularly articulate about neoliberalism's insidious techniques endeavoring to create a world where all societies and economies conform to a unitary model.

> When we debate this model, we are not discussing the merits of trading goods and services across borders but the effects of profound corporatization around the world; the ways in which "the commons" is being transformed and rearranged—but backed, privatized, deregulated—all in the name of participating and competing in the global trading system. What is being

designed at the WTO [World Trade Organization] is not rules for trade but a template for one-size-fits-all government, a king of "McRule." And it's this template that is under dispute.[55]

She makes it clear that the age-old global system of trade is not in question, but rather the problem of forced uniformity to Western corporate templates with attendant value systems that undermine local production and exchange that have worked for centuries. These neocolonial tactics have been in the making, in fact, since the latter part of the twentieth century, replacing direct colonial rule. The Bretton Woods institutions are the World Bank and the IMF, established in the United States in July 1944 in Bretton Woods, New Hampshire by 43 countries. These powerful financial institutions were instituted in a postwar global environment to establish an "economic order based on notions of consensual decision-making and cooperation in the realm of trade and economic relations" among the allied forces that were triumphant in World War II.[56] Therefore, these institutions have been regulating the flow of commerce and monetary policies since the era of colonialism. Great Britain, as one of the primary countries involved with establishing the so-called Bretton Woods institutions, is obviously familiar with the Ghanaian economy since that colonial power developed and exploited it for over 70 years. From Nkrumah's administration until today, the United Kingdom has been involved in various forms of intrusion into the Ghanaian economy.

World Bank and IMF involvement in Africa's fiscal policies intensified in the 1980s with its Structural Adjustment Program that created the controversial Structural Adjustment Policies (SAPs). SAPs have generally had the supposedly unintended consequence of increasing poverty, as opposed to abating it: (1) devaluing local currencies against the dollar, (2) lifting import and export restrictions, (3) forced balancing of national budgets, and (4) removing price controls and state subsidies. The leverage that these institutions have over poor African countries to accept these often-divisive regulatory policies is, of course, Africa's need for financial loans and aid in debt repayment. As one of the advocacy groups opposed to the World Bank and IMF's policies, The Whirled Bank Group, reveals:

> Balancing national budgets can be done by raising taxes, which the IMF frowns upon, or by cutting government spending, which it definitely recommends. As a result, SAPs often result in deep cuts in programmes like education, health and social care, and the removal of subsidies designed to control the price of basics such as food and milk. So SAPs hurt the poor most, because they depend heavily on these services and subsidies.[57]

Over the last 30 years, I have personally witnessed how SAPs' implementation in Ghana has had these deleterious effects on the population.

Adoption by African heads of states of World Bank policies, and SAPs in particular, has been a double-edged sword. During my visits to Ghana, I have recognized that even those Ghanaian presidents who rejected IMF policies, through corruption in their own administrations, created economic environments with the same effects that critics accuse SAPs of creating. For example, in 1976 Colonel Ignatius Acheampong, who had overthrown the IMF-friendly Busia government in 1972, was head of state in Ghana. Acheampong's National Redemption Council "adopted measures aimed at legitimizing his illegal seizure of political power...by reversing the Busia government's devaluation of the currency" that, in turn, raised the cedi's value by 21.4 percent. The result was that the price of foodstuffs and consumer goods were equally as high as they were under the IMF policies of the Busia government.[58] I, along with many Ghanaians, suffered long cues for simple consumer items. Preferring poverty under one's own leaders' corruption, the majority of Ghanaians remained vehemently against its governments' alignment with the World Bank and IMF.

For decades after independence, an anti-World Bank attitude represented Ghanaians' national socioeconomic will until the reign of Flt. Lt. Jerry "J. J." Rawlings that began with his coup against Acheampong in 1979. Political Science Professor and Attorney Kwame Boafo-Arthur assesses Ghanaian politics regarding national involvement with the Bretton Woods institutions until Rawlings: "Thus Rawlings's predecessors either went to the IMF and lost political power, or for fear of losing power refused to accept IMF conditionalities but ended losing power all the same."[59] According to Boafo-Arthur, Rawlings's Provisional National Defense Council (PNDC) pulled off an "economic miracle" through implementation of SAPs, which was a "paradigmatic U-turn" after Rawlings's "initial socialist posturing." Quoting Gyimah-Boadi, Boafo-Arthur assesses Rawlings's "success" as relative, due to the fact that "the PNDC relied on an array of non-democratic and authoritarian political practices in combination with neo-corporatist arrangements to gird its rule."[60] Shipley assess the critical shift during the Rawlings administration thusly:

> Rawlings's leadership continued as he shifted from military leader to democratic president, even as the state moved away from the ideals of state-centered socialism towards privatization. The rise of a small, viable middle class was accompanied by increasing economic polarization. In the process a growing mass of urban youth have been relegated to unemployment, urban displacement, and self-described ghettoization.[61]

This argument is what hiplife emcee Trigmatic complains about regarding his Osu neighborhood in Accra (Chapter 1), where youth are fed up with a lack of employment and opportunities. These "neo-corporatist arrangements" are the hegemonic new world order that the World Bank began implementing in the 1980s. They now constitute the omnipresent neoliberal ideology that underpins SAPs that are difficult to reject, let alone escape.

Similar socioeconomic dynamics are found in East Africa. While benefitting only a few in East Africa, Ntarangwi makes it clear which segment of the population had advantages due to SAPs:

> Not all people in East Africa were regularly affected by SAPs and other programs pushed by the IMF and World Bank under neoliberalism. Local elites, for instance, benefited from the failure of the state as they cashed in on cheap imports and were also employed and involved in civil society following the proliferation of nongovernmental organizations (NGOs).[62]

Ntarangwi goes on to quote one of Africa's important literary figures and humanists, Chinua Achebe. In his famous address, "Africa is People," Achebe emphasized the invidious effects of neoliberal policies on the continent's real people with real lives and problems, as opposed to journalistic statistics. In his address to the World Bank Group in 1998, Achebe made a pointed humanist statement that often gets overlooked when dealing with global economic policies concerning poverty and health conditions: "You are developing new drugs and feeding them to a bunch of laboratory guinea pigs and hoping for the best. I have news for you. Africa is not fiction. Africa is people, real people. Have you thought of that?"[63] This kind of microlevel understanding of real people coping with the realities of change and the lack of it in Africa becomes essential for comprehending the vicissitudes of neocolonialism today.

In these neoliberal times, privatization of vital social services such as health and communications become a part of the IMF's rhetorical intentions to reduce poverty. Yet, Ntarangwi reminds us, "As a policy for economic change in Africa, privatization represents a radical departure from the previous arrangement where the government was the central player in public policy."[64] Today, neoliberal culture and economic privatization has become the dominant discourse; so much so that African governments have been forced to abdicate their authority over vital social services such as health, that were once their exclusive purview. In today's privatization of health, poor Ghanaians must pay a fee for service to see a doctor. Indeed, some hiplife artists use their artistic and cultural power within Ghana to supplement what the government does not provide for the masses of its people. Okyeame Kwame's "OK in Your Zone" tour (Chapter 2), with its Hepatitis

B education and screenings, offered free health screenings while uplifting the people's spirits through his hiplife music.

After independence, many of the most astute African revolutionaries, who had led Africa's valiant liberation struggles, resisted their former colonial masters' economic domination. Nyerere in Tanzania instituted his Arusha Declaration, "which urged his counterparts in Africa to withdraw from the world's economic system dominated by the West."[65] In Ghana, Nkrumah rejected IMF and World Bank policies that "prescribed non-inflationary borrowing and drastically reduced government spending."[66] He did so in favor of his government-led development programs such as the Akosombo Dam and the Kaiser Aluminum plant in Tema. Nkrumah was not against foreign investment, but he implemented policies that would ensure continued Ghanaian control in those economic ventures. The World Bank and IMF's economic stipulations for loans were not acceptable under Nkrumah's conception of the newly independent Ghana and his model for African unity. Today, government control has been replaced by corporate privatization, like the major telecom companies that provide virtually all of the communications services in Ghana.

Lack of local government control in these neoliberal trade times is what Klein and international protesters rail against in the large protest demonstrations that we witness on the local news during G8 Trade Summits: "Hundreds of thousands are taking to the streets outside trade meetings not because they are against trade itself but because the real need for trade and investment is systematically being used to erode the very principles of self-government. 'Govern our way or be left out completely' seems to be what passes for multilateralism in the neo-liberal age."[67] This uncontrolled economic privatization scenario is the hub of today's neocolonialism in Africa.

Being one of the first African leaders to utilize the concept of "neocolonialism," Ghana's Kwame Nkrumah was acutely aware of the potential for this new form of colonialism. As Leong Yew analyzes, "Underneath all these various meanings of neocolonialism is a tacit understanding that colonialism should be seen as something more than the form of occupation and control of territories by a Western metropole."[68] Today colonialism does not come in the form of military force or administrative structures run by foreigners, but by late-capitalist corporate ownership of the state's fundamental economic sectors that are operated by foreign interests. Simultaneously, counterproductive ideological perceptions of the world infiltrate the society along with these new business structures.

Taken as a whole, the telecom companies of Ghana are particularly neocolonial because the country's entire communications system is out of Ghanaian control; along with foreign ownership of ICTs comes

exclusive purview over fundamental information-centered markets central to twenty-first-century political economy. Nkrumah astutely perceived these ever-changing methods of a "Manichean system of dependency and exploitation"[69] when he declared:

> Neo-colonialism is…the worst form of imperialism. For those who practise it, it means power without responsibility and for those who suffer from it, it means exploitation without redress. In the days of old-fashioned colonialism, the imperial power had at least to explain and justify at home the actions it was taking abroad. In the colony those who served the ruling power could at least look to its protection against any violent move by their opponents. With neo-colonialism neither is the case.[70]

Nkrumah's prescient assessment of the potential for a dire future for Africa, if its newly independent countries were not vigilant, predicted the unregulated greed that has become global late capitalism on the continent. The neoliberal ideology that undergirds the new world economic order increases the ranks of the poor, even as it promotes the rhetoric of reducing poverty such as the UN's New Millennial Goals. Today's corporate recolonialization has unleashed an insidious opponent to local empowerment that has expanded from old European colonial powers to Asia, the Middle East, and even more affluent parts of Africa itself. These are complex factors of the global and national economic contexts in which hiplife artists in Ghana, who want to "blow up" internationally, find themselves.

AFRICA'S POP MUSIC INDUSTRY AND THE GHANA MUSIC AWARDS

Even with hegemonic corporate takeover of Ghana's previous economic authority, hiplife music has benefited from major American and South African pop culture and music corporations currently proliferating across Africa. For example, Mimi's appearance on "Big Brother Africa" jump-started her Afro-Pop music career, while the South African-based Endemol International produced the TV program as the biggest producers of reality television in Africa. Also, Tic Tac's appearance and endorsement of Viacom's MTV Base Africa's 2005 launching in Ghana was a boon to his continental reputation. These are but two of the many examples of hiplife artists' African connection to the international pop culture industry (see Chapter 1).

The world's biggest recording music companies are now moving into Africa to capitalize on its relatively untapped market. In the process, Africa's pop music artists, who have remained in the peripheral "world music" marketing category for decades, have the potential of becoming a part of the billion-dollar platform of international pop music. Sony Music Entertainment,

the corporate conglomerate for record labels such as Arista, Columbia, Epic, RCA, and Sony Music Latin, is a perfect example of American investment on the African continent. Sony utilized the 2010 World Cup soccer games, played on the continent in South Africa for the first time, to negotiate a contract to become the official music supplier for the games. While the world's attention was on Africa for a positive sporting event, rather than the stereotypic civil wars, fleeing refugees, and draught and famine news syndrome,[71] Sony launched a record compilation of some of Africa's major music artists called *Hello Africa*. The compilation album was released May 31, 2010, with a byline that read: "Popular hit tracks by contemporary superstar African artists from all over the continent inspired by the 2010 FIFA World Cup—a World Cup but with Africa as the theatre and South Africa the stage!"

Several of the hiplife artists explored in Chapter 1 were signed to Sony's corporate partner for Africa, Rockstar 4000, which produced the seminal *Hello Africa* compilation. Batman Samini, Tic Tac, and D-Black, as well as the Ghana-based Lynx Entertainment artists Richie, Asem, Eazzy, and OJ Blaq, were signed to Rockstar 4000, Africa's first pan-African 360 Music and Entertainment Company. Rockstar 4000 has an exclusive pan-African partnership with Sony Music Entertainment Africa. These corporate business links mean that hiplife artists will be distributed globally. A GhanaWeb.Com news release announced that Sony would be distributing these artists' music and video catalogues to "hundreds of digital storefronts that include digital music services like iTune, Amazon MP3, Napster, eMusic, Rhapsody, YouTube, MySpace Music, Juno Download, and Turntable Lab."[72] These marketing strategies emphasize the importance of mobile phone carriers in the new digital age of music delivery through these platforms. Rockstar 4000 revealed that Ghanaian musicians would also be distributed via "Verizon Wireless, Sprint, AT&T, T-Mobile, and Nokia via Sony's partnership with the San Francisco-based digital distributor IODA." The Lynx Entertainment artists used their moment of increased visibility by recording "Africa's Moment" for inclusion on the album that was heard internationally in conjunction with the World Cup, "inspiring millions of fans to rise up in support of Ghana's highly rated national football team— the Black Stars."[73] Ghanaian hiplife artists use every opportunity presented to promote themselves and their country, which are conceptually linked in the international market.

Rockstar 4000's pursuit of African music artists to its label doesn't end with Ghana, but includes Uganda, Zambia, Tanzania, and Nigeria, as a part of a continent-wide objective to team R&B and hip-hop-oriented musicians, all to take African pop music to a new level of global recognition. One8 is a new music group developed by Sony Music and Rockstar 4000 that includes eight African music artists representing the continent:

2Face Indibia (Nigeria), Alikiba (Tanzania), Amani (Kenya), Fally Ipupa (DRC), 4X4 (Ghana), Movaizhalene (Gabon), Navio (Uganda), and JK (Zambia). While cultural border crossings and African pop music collaborations are not new, record-company induced collaborations, such as One8, challenge the participating artists, brought together by corporate marketing goals to find an underpinning Africanist aesthetic musically and lyrically that works for them *and* the international audience they seek. As 2Face analyzes, "Most of the collaborations we have had over time have been self instigated. This is a new kind of opportunity for us all to collaborate for Africa. It is a big break for me because I will be able to reach out to millions of my fans outside Nigeria."[74] But, this group of eight African musicians is teamed with famed US R&B singer R. Kelly. American pop music dominance again insinuates itself into an African music marketing strategy, as Sony and Rockstar 4000 corporate heads gamble that R. Kelly's fame will inure to their chosen African artists who are assessed as ready for global exposure.

The African One8 group, united with the popular, but controversial, black American superstar R. Kelly, represents a major experiment for developing the earning potential for African pop music, including Ghanaian hiplife. Rockstar 4000 released a press statement that promoted the project thusly: "One8 is destined for greatness, shattering perceptions about African music as it builds networks and excitement across the pan-African music landscape and across the world."[75] This network building will be accomplished through worldwide digital platforms of Internet social networking and mobile phones, facilitating a cosmopolitan lifestyle that offers the illusion of empowerment. Rockstar 4000 and Sony Entertainment embed their cosmopolitan sociocultural values underlying their neoliberal marketing strategy for their overall economic agenda:

> One8 is not only just another all-star lineup, but is a progressive, digital media driven project. It's driven by the passion of the artists to not only allow their fans access around the clock, but to give them the freedom to escape from their every day challenges and empowering their fans to be whatever they want to be through the power of music and the digital world—connecting them across cities, borders and continents.[76]

With software and distributing Internet platforms such as the deals with iTunes, Amazon MP3, Napster, YouTube, and MySpace Music, these multinational music companies' inroads into Africa promises to expand these artists' international visibility while augmenting their own corporate profits through a new market. In fact, One8 toured the United States at the end of 2010 and recorded a CD and music video in Chicago, while being

digitally connected with their fans 24 hours a day on Facebook, Twitter, Flickr, and YouTube via computers and cells phones. Mobile digital technology is no longer an *adjunct* to traditional marketing, but rather has become *central* to late capitalism's marketing strategies in the postmodern cosmopolitan era.

Although Africa is far behind the rest of the world in popular culture industries, South Africa and Nigeria, as the wealthiest and most populous nations respectively, are playing a significant role in the expansion of Africa's industry. South Africa's pioneering of e-music videos with Channel O, under the corporate title of M-Net, jump-started music video telecasting on the continent. Hip-hop became a primary music genre of the station, once the music genre was legalized the same year of the downfall of apartheid. The near-simultaneous lifting of the ban on rap music and the advent of Channel O's hip-hop videos was, of course, no coincidence. F. W. de Klerk's apartheid regime would not have benefitted from an often brutally honest music genre like hip-hop with which to contend. The postapartheid South African pop culture industry has proliferated over the last 17 years in films and television, promoting music with all-Africa talent competitions, where some Ghanaian artists have distinguished themselves. Nigeria's large population of nearly 155 million (seven times greater than Ghana),[77] along with its internationally noted Nollywood film industry and state-of-the art music recording studios in Lagos, has distinguished itself on the continent in music sales and pop culture infrastructure. However, when viewed from an international perspective,

> there has been limited commercialization of African music in domestic and foreign markets. Consequently, Africa's share in global trade of music products remains marginal at less than 1 percent of world exports. Much of what hinders the development of the African music industry is lack of infrastructure to support the growth of a vibrant music industry, investment and entrepreneurial skill in the music industry, and limited capital. A consequence of this weak market is the absence of the big conglomerate record labels in most countries.[78]

This latter point is why Sony and Rockstar 4000's project with the One8 group was a strategic move. The African continent is like a sleeping giant that is waking up, and with its "profusion of talent...and the richness of cultural traditions"[79] and diversity, I argue, it will eventually become a force with which to be reckoned.

The US media conglomerate Viacom, now CBS Corporation, is most responsible for the proliferation of American popular culture throughout the world and Africa with its MTV brand. Viacom had acquired the controlling shares in MTV Europe as early as 1991, but did not establish MTV Base in

Africa until 2005, creating its milestone one hundredth world channel. As its website boasts, "MTV base is a pan-African music TV channel serving 48 countries in sub-Saharan Africa." In its initial news release for its launching, Viacom said that its new African channel would "reflect the tastes and interests of African youth via a combination of African and international music videos and locally produced content, complemented by MTV's UK and US long-form programming such as 'MTV Cribs' and 'Making the Video'."[80] The content of MTV's well-known US-generated programs globally project the cosmopolitan lifestyle of "hip wealth" to the world. The combined message of "MTV Cribs" and "Making the Video" is: aspire to the "good life" like your favorite American rock star by learning how to brand and market yourself. Hence, a video like Mimi's "Tattoo," which positions her in an upscale-looking domestic love relationship (Chapter 1), replicates a ubiquitous global Western lifestyle, with a few local African twists.

Media savvy African youth were initially skeptical as to the effects of the introduction of Western-oriented MTV programming on the continent. Comments like the following appeared on South Africa's leading pop culture marketing and media news resource, Biz Community.Com:

> MTV base = Americanization + bland boring Afropop. We have already been watching MTV Europe after ten years, and the addition of MTV base won't change a thing. MTV base will either become another outlet for overbearing American pop culture ("The Real World" and "Jackass," etc.) or it will be a bland washed up version of what Americans think African music is like...Either way we both lose and I would rather watch MTV Euro where the music is bearable or Channel O were WE get some airplay.[81]

These kinds of viewer blog comments demonstrate an initial reception to MTV Base Africa that did not naively accept its representations of Western-oriented youth culture programmed onto Africa, challenging it to become more relevant and sophisticated about Africa's own pop music and cultures.

Perhaps MTV Africa got the message, and in 2008 launched the MAMAs—MTV Africa Music Awards—in Nigeria. It did so with none other than Zain as a corporate partner, just as the Middle Eastern telecom company was making its initial inroads into Africa. Hence, global pop culture conglomerates such as Viacom and transnational telecommunications companies such as Zain are in cahoots in what Carmody calls the "hypothesis of transformation," where Africa "advances" technologically and culturally through the reinscription of previous colonial-like power relations in the guise of corporate-free enterprise.

The MAMAs were launched in November 2008 at the Velodrome venue in Nigeria's capital Abuja, as a two-hour television spectacular that

combined performances by top African and international artists in the midst of award presentations. "Hip-Life" was listed as one of the continent's competitive musical categories, along with Reggae, Afro-Pop, Hip-Hop, Soul, Funk, Dancehall, and Zouk. Game, a Los-Angeles-based rapper, was the US guest star with Kwaw Kese and Samini representing the Ghanaian hiplife genre. By 2010, the growing awards ceremony moved to Eko Exhibition Hall in Lagos, as the economic center of Nigeria. Because Bharti Airtel had bought Zain early in 2010, Airtel became the new corporate headline sponsor. Perceived as always needing an American hip-hop artist, the 2010 award ceremony was headlined by hip-hop singer T-Pain and was hosted by Eve, who has gained a reputation as the US *female* rapper-actor for Africa.

Performed live on December 11, the 2010 MAMAs was then televised a week later on December 18 on MTV Base. To further address the African relevancy issue, as well as the geographic size and diversity of the continent, MTV Networks Africa created "The Road to MAMA," ancillary events in three locations on the continent—DRC, South Africa, and Dar es Salaam, Tanzania. In the end, the Lagos state government recognized the significance of MTV Networks Africa and the MAMAs by making some municipal infrastructure improvements. The Lagos state commissioner for information and strategy, Opeyemi Bamidele, officially commented:

> MTV's global celebration of African music and youth culture has brought significant inward investment into the state and is a brilliant opportunity for us to reinforce to the international community that we have the facilities, expertise, and infrastructure to deliver world-class events equal or better to anything that Africa has to offer.[82]

Globally visible events such as MTV's MAMAs become venues for proving Africa's worth to the world. This need to provide evidence of contemporary Africa's value, particularly to transnational corporations and other nation-states, is often employed to the advantage of transnationals seeking to do business in Africa by negotiating lopsided deals that cause the state to abdicate vital social-sector authority to profit-seeking corporations. But local control over the business of popular culture could be one counter-hegemonic method, I argue, to ameliorate foreign influence over defining the sociocultural context of African music, and more importantly reaping a disproportionate amount of the resulting monetary profit.

For Ghanaian hiplife music, there's no more influential local business regarding its continuing definition, increasing recognition, and resulting music sales, than the Ghana Music Awards. Produced by Charter House, a "one-stop production house" that includes an advertising department,

events production such as the Ghana Music Awards (GMAs), and a television-producing unit. Besides the GMAs, Charter House also produces the Miss Malaika Ghana Pageant and the end-of-the-year Ghana Rocks concert that features Ghanaian musicians in Ghana and abroad. During my 2010 fieldwork, Public Relations Manger Juno Turkson verified the place of the GMAs in relation to Charter House: "Charter House has been in existence for about 10 years now, since 2000. One of our biggest events, which we are synonymous with, is the Ghana Music Awards. It was a landmark program for us."[83]

In fact, Charter House started doing business at a time when hiplife music was emerging commercially as an important music genre with its second generation of artists. Nii Ayite Hammond, head of production at Charter House, discussed the two entities' development; he also acknowledged the generational issue of hiplife youth having to prove themselves to their elders in Ghana (Chapter 2),

> Hiplife is definitely growing, and Charter House has contributed to the growth of that genre, because we all established at the same time. The company was established around the time that hiplife was growing. For the birth of any new thing, there's always difficulty in trying to crawl before you walk. You have the elderly ones who trample over you along the line. So, there were actually not many places that they [hiplife artists] had in terms of expression.[84]

Hammond also emphasizes his concern for an organic development of new music forms from an insider's understanding of local sociocultural dynamics.

> One of the television programs we [Charter House] did was called "Agoro," a local quiz show that had entertainment as a part of it. Because it was a primetime Saturday program, it became a platform that was used to promote hiplife music, for it to become acceptable in the minds of people. It was a strong platform for it to grow. So, as of now it [hiplife] has grown and it is creating a lot of jobs for the youth.[85]

This emic perspective is one that a foreign business conglomerate can rarely attain, a reason international business interests in Africa hire indigenous local managers and "front men" to be the Ghanaian public face of the company, particularly when they sponsor many of the local popular culture events. However, the realities of business in the second decade of the new millennium is that the Ghana Music Awards, for example, was actually "MTN Ghana Music Awards" And now the "Vodafone Ghana Music Awards." The ubiquitous presence of the primary telecommunicatons companies in

Ghanaian popular culture is nowhere more evident than in the sponsorship of the Ghana Music Awards, with their ultimate control represented by their name in the title of the entire event.

However, the Charter House makes a concerted effort to create an equitable selection process that includes input from the entire country. Their website instructs that the selection process is structured to account for both the public's tastes, as well as industry professionals' choices as stakeholders in the music. They hold a series of interactive "forums" that occur in three geographic zones that correspond to the official regions of the country: northern zone, held in Kumasi, is comprised of Ashanti, Northern, Upper, East and West Brong Ahafo; the western zone, held in Takoradi, comprises the Western and Central Regions; and the southern zone, held in Accra, comprises Greater Accra, Eastern, and Volta Region. Given the cultural and economic dominance of Accra, these forums are important to create a sense of inclusion of the entire country; but nonetheless these efforts toward equity do not quell public accusations of an Accra-artist bias.

Although a music award ceremony that honors *all* Ghanaian music genres, the Ghana Music Awards has achieved a reputation of professionalism that has specifically increased the respect of hiplife as a new Ghanaian music form. Out of their regional forums, the Categorization and Nominations Committee generates a final list of nominees that is published in the major newspapers for popular votes. MTN, which was the corporate sponsor for nearly ten years, also benefitted from the voting by being the only telecom network to receive texted votes to a special code. Final tally becomes a combination of the people's choices along with the selection and planning committee members' votes for the same published nominees. The final tabulation is done by the international audit and tax corporation KPMG and announced at the gala awards ceremony held in April each year. Locally controlled, albeit with telecom corporate money, the Ghana Music Awards is professionally produced with a strong cultural insider perspective that has matured with hiplife music, and has been partially responsible for the genre's increased recognition nationally and throughout Africa.

Big business, therefore, is both a facilitator and a threat to the hiplife movement in Ghana. On the one hand, hiplife corporate sponsorship has advanced many artists' careers as well as the infrastructure of Ghana's developing music industry. On the other hand, multinational corporate control, particularly by Ghana's telecom companies, is far too great and posses a threat to hiplife's ultimate autonomy to be counter-hegemonic in its artistic and social purposes. According to the cultural hegemony paradigm, grassroots music movements such as hip-hop are usually incorporated and diluted to the point of becoming mainstream, thereby usurping its ability to promote more artistic and cultural *choices* for its audience in favor of

establishing a particular "hiplife persona" that becomes the "commodity of spectacle."

The contrived commodity itself begins to colonize all social life with the "new" political economy. As Debord told us decades ago, "The fetisism of the commodity" is the tool of socioeconomic control that "attains its ultimate fulfillment in the spectacle." But the real threat is that the created spectacle comes to be regarded "as the epitome of reality." This is particularly insidious in a poor country like Ghana. *Complicity with* and/or *resistance to* this reality altering aspect of the spectacle become the socioeconomic bookends with which music artists are faced. Most oscillate between the two because, as Rockstone says, "We gotta eat." In the next chapter, I turn to how hiplife artists negotiate the fine line between complicity and resistance, redefining the cultural hegemony paradigm.

"THE GAME": HIPLIFE'S COUNTER-HEGEMONIC DISCOURSE

THE PURPOSE OF THIS CHAPTER IS TO ELUCIDATE THE OTHER side of the cultural hegemony paradigm: opposition or counter-hegemony by subcultures that engage various resistive strategies to dominant ideologies and structural controls. Before exploring specific hiplife projects of agency that attempt to counteract the effects of big-business neocolonial hegemony in Ghana, I investigate the causal structure that creates hegemony in the first place. Again, Cultural Studies theory is helpful in plummeting the formation of social, cultural, political, and economic dominance that rules through the replication of a particular social ideology dictating cultural values, rather than through aggressive force. Cultural hegemony occurs by creating a tacit complicity, even when it may be counterproductive to marginalized groups within a given society. Hebidge, using Stuart Hall, explains:

> The term hegemony refers to a situation in which a provisional alliance of certain social groups can exert "total social authority" over other subordinate groups, not simply by coercion or by the direct imposition of ruling ideas, but by "winning and shaping consent" so that the power of the dominant classes appears both legitimate and natural.[1]

In Ghana, transnational corporations such as the telecom companies, local popular culture business entities such as Charter House (Chapter 3), and the state itself indeed form shifting "provisional alliances" that exert "ruling ideas," such as the global cosmopolitan lifestyle, which ultimately "wins and shapes consent" from the majority of the population, particularly youths. Indeed, Ghanaian youth culture, represented by hiplife music, is

crucial to creating a sense of the cosmopolitan lifestyle perceived as "legitimate and natural." For example, the imaging of youth culture represented in the "Zain 026 Experience" billboard (Chapter 3, Figure 3.2) represents values such as "personal choice" over one's mobile phone number, which presumably has one's favorite hiplife ringtone downloaded for a fee. This is a corporate practice with an underlying sociocultural message that ultimately becomes hegemonic in tandem with other ubiquitous neoliberal signs.

The insidious nature of the hegemonic discourse is constituted by the fact that it "wins and shapes consent" that few question because of its omnipresence. Even the older generation's initial objections to the "foreign influence" of dress style, change in morality, and the lack of respect for local traditions, are eventually assuaged by the ubiquity of the new values system. Although African values of communalism and respect for elders don't fade completely, they are significantly undermined. This shift in social ideology is facilitated, of course, by increased global business injecting necessary foreign exchange into a developing country's struggling economy.

Hegemony must be maintained also by certain cultural and psychological methodologies. Hebidge theorized early on about hegemony's tactics:

> Hegemony can only be maintained so long as the dominate classes "succeed in framing all competing definitions within their range," so that subordinate groups are, if not controlled, then at least contained within an ideological space which does not seem at all "ideological": which appears instead to be permanent and "natural," to lie outside history, to be beyond particular interests.[2]

One can understand global cosmopolitanism becoming the hegemonic discourse in the economic and cultural centers that generated it, such as Western Europe and the United States. However, for this hegemonic individualistic cosmopolitan lifestyle to take root in a society where the average person makes less than US$4 a day and resides in a rural area with agrarian subsistence living testifies to the allure of twenty-first-century late capitalism. This is the essential change that I have witnessed in Ghana over the last 35 years, where technology, business, and popular culture have been able to "frame all competing definitions" of what is "natural." Many rural citizens have always desired to move to the urban center of Accra to increase their earning potential; however, the rate of adoption of attendant hegemonic values is what has increased exponentially. This new imposed ideology establishes how the average Ghanaian citizen views the future to which she or he should aspire, and demonstrates the ability for hegemonic discourse to frame itself "outside of ideology" and "outside of a history" that Nkrumah warned against as the "worst form of imperialism" (Chapter 3).

COUNTER-HEGEMONY: "THE GAME" THAT MUST BE PLAYED

South African Media Studies scholar Adam Haupt's *Stealing Empire: P2P, Intellectual Property and Hip-Hop Subversion* (2008) is helpful in exploring the possibility of pop music agency in the face of such insidious hegemonic forces posed by global capital. Immediately, he addresses the center of my own quest: "The key question I pose is whether transnational corporations have appropriated aspects of youth, race, gender, creativity, cultural expression and technology for their own enrichment—much to the detriment of civil society."[3] As I demonstrated in Chapter 3, there can be little doubt that even as the multinationals provide a boost to the entrepreneurial goals of a few young hiplife artists and engage in relatively small social responsibility campaigns, their profits and exploitative tactics far supersede those minimal efforts. The question then becomes, what are the possibilities of counter-hegemonic projects that balance what Haupt's calls the new "Empire"?[4]:

> I consider the possibilities of responding to Empire and resisting corporate globalization through strategies that employ some of the same decentralised, network-based techniques that benefit global corporate entities... The agency of subjects in relation to Empire is explored via specific cultural practices, like P2P file-sharing or hip-hop activism.[5]

The use of creative skills and counter-hegemonic intent by hiplife artists engaging in hip-hop activism is what I explore in this chapter, offering several projects of resistance and critiques of "Empire." These projects are constituted both at the artistic level in hiplife music as well as at the community level in social activism, aided by hiplife artists' newfound fame within global pop culture.

Although Haupt lodges transnational corporate hegemony in the international "legal instruments of coercion" such as NATO (North Atlantic Treaty Organization) and the World Trade Organization's agreements of GATT (General Agreement on Tariffs and Trade) and TRIPS (Trade-Related Aspects of Intellectual Property Rights), he also analyzes hegemony's ideological coercion in "the production of norms."[6] Moreover, he emphasizes the nature of hegemony to *incorporate* all entities within its reach through the production of "natural" social norms; therefore it is the marginalized subcultures' convincing *inclusion* that permits "the possibility for conceptualizing agency within the operation of this form of power."[7] As Haupt contends, "The extent to which counter-culture or subculture is co-opted by dominant corporate media, assess[es] the extent to which Empire can be challenged from within its operation."[8]

Youth subcultures negotiate ways of coping with inevitable societal change. As a result, hiplife music is complicit with transnational hegemonic capital and its ideological discourse, but not completely. Ghanaian hiplife youths have had to negotiate a particularly thin line between the subcultural tenets of "keeping it real" while trying to "get paid" within the hegemonic "ideological space" that their music is helping to create. As I mentioned before, Reggie Rockstone framed the dilemma succinctly: "There's a fine line between not totally giving it all out for the commercial, and maintaining your consistency, you know what I mean. It's deep! But you gotta eat, and at the same time you still gotta mix."[9] Although I used this quote in Chapter 1 as a part of a longer Rockstone statement, I revisit it here to emphasize multiple meanings. When faced with the "selling out" factor, consistency, to which Rockstone alludes, becomes one's own self-perception as an artist and human being. "Mixing," in Rockstone's ideology, contains several levels of meaning, including perceived necessary musical collaborations for commercial success discussed in Chapter 1; but more importantly, here, "mixing" also alludes to a musician's involvement with corporate structures in "the game" of the music business itself, especially if one wants to "eat." Practicality is thus defined by the "natural" hegemonic ideology that subsumes all "competing definitions" of what is natural, including indigenous values that have existed for centuries. As Shipley notes:

> In a nation-state which many Ghanaians perceive as increasingly polarized, providing decreasing economic possibilities for the masses, hiplife produces potential for international economic success. The social processes of studio production allow artists to objectify the symbols and practices of public moral being and reconfigure themselves as successful social actors through parody and critique.[10]

The economic bottom line and the limited access to resources for upward mobility in class-polarized societies such as Ghana produces what Shipley terms an "aesthetic of the entrepreneur," as well as reinforces the trickster figure so popular in transatlantic black cultures.

In his *Power and Performance: Ethnographic Explorations through Proverbial Wisdom and Theater in Shaba, Zaire* (1990), anthropologist Johannes Fabian built his entire ethnography about Zairean theatre around a proverb that he heard during his fieldwork: *Le pouvoir se mange entier* (Power is eaten whole). He notes, "In the Luba languages of Democratic Republic of the Congo (Zaire) 'to eat' is frequently used to denote access to power,"[11] understanding the African philosophical concept of eating and the stomach region of the body as a source of power, spiritual as well as physical. Reggie Rockstone's statement about the entrepreneurial reality of hiplife artists illuminates the

dilemma of the hegemony/counter-hegemony paradigm for hiplife music in Ghana.

Hence, what are the possibilities of resistance within the obvious all-encompassing neoliberal ideology and transnational corporate structures? Cultural Studies theorists conjecture one form of counter-hegemony as agency adopted by youth subcultures to subvert the hegemonic discourse in which they must participate. According to Hebidge, hegemony is forced to *incorporate* subversive practices such as hiplife music that can often revise the meanings of global cosmopolitan style. Panji Anoff explains hip-hop agency as it connects with traditional African values in the marketing of particular hiplife artists:

> When you successfully package the general essence of anybody, the process of marketing and promoting them then is self-fulfilling. It's not as straight-forward as it sounds, but some of it does come from the original hip-hop principle of "keeping it real." Keeping it real [becomes a necessity] because [initially] they didn't have the conventional channels to market and promote themselves. They [used to] market and promote themselves by the propagation of their own existence.
>
> If you think about it, that principle is almost identical to what you have in the village; where if you look at the village system, how does news spread about one artist from one village to the other if there is no radio, and there are no posters, and there are no billboards? So, I believe that is the model. Everyday we hear of a global village, but it really does not make sense, except in terms of art, and in terms of trying to center an artist's career around his/her existence. Then we are going back to those basic principles [of simple village-like promotion].[12]

Panji's "village marketing" analysis, as a way of keeping the organic promotion of artists necessitates an engagement with particular hiplife musicians who are not necessarily duped by the reigning hegemonic discourse—artists who are considered hiplife iconoclasts such as King Ayisoba and Wanlov Kuborlor (Emmanuel Owusu Bonsu)—and who are instead bringing a more African indigenous identity to hiplife, whether traditional African (Ayisoba) or urban pidgin-speaking underclass (Wanlov Kuborlor).[13]

Panji is particularly insightful about the hegemony of Western cultural thought on the societal context in which hiplife is situated in Ghana, and about the importance of artists such as King Ayisoba (Chapter 2) in countering that hegemony. "He [Ayisoba] is very conscious of the ancient spirit that he represents, and it's important to understand that it is timeless. I mean, we confuse modernity with timelessness, and we assume that in the Western culture, which has come to swap us, there is not enough time in the day to say hello to each other, and that that is the way forward."[14] Because

Ghana, as a nation, is increasing multinational corporate presence as the way to future progress, what we witness, even in the relatively small market of Ghanaian hiplife, is the "swapping" of artists' images and talents for profit in ways that are continually increasing. How hiplife artists negotiate corporate vicissitudes will establish the future of hiplife music as a social movement.

Thus, I argue that *incorporation* of the often counter-hegemonic popular music of Ghanaian youths is a crucial means to naturalizing and maintaining hegemony in a culture where music has always been a socializing tool. However, artists such as King Ayisoba, maintain an allegiance to an African humanist identity, what Ntarangwi calls "an Africa that is vernacular and traditional." These kinds of hiplife artists use their celebrity to actually decode and critique Western hegemony's effect on Africa. In the process, they become a counter-hegemonic "Trojan Horse" in the incorporation process of neocolonial corporate power. Ntarangwi sees similar counter-hegemonic effects in East Africa: "By building on indigenous structures, hip hop is transforming and revitalizing the lives, perceptions and cultures of East African youth by creating a new avenue for communication and offering unprecedented tools for education, empowerment, activism, and entertainment."[15]

However, hiplife, like most pop music, exists within what Cultural Studies scholar Lawrence Grossberg calls a "revolution [that] is only a simulacrum." Today, what passes for revolutionary counter-hegemonic acts are in actuality a legal semblance of the real thing. Grossberg's analysis of rock-and-roll music equally applies to hiplife today: "Rock and roll practice is a form of resistance for generations with no faith in revolution."[16] Although repetitions of *coup d'états* are often associated with Africa's fledgling polities, Ghana remains relatively stable; hiplife's musical contribution to entrepreneurial projects that are currently proliferating in the country facilitates that stability. Hence, Ghanaian hiplife is situated perfectly within Grossberg's paradigm where

> if the response of hegemony to resistance is through practices of incorporation, then the power of rock and roll lies in its practice of "excorporation," operating at and reproducing the boundary between youth culture and the dominant culture. Rock and roll reverses the hegemonic practices of incorporation—by which practices claiming a certain externality are relocated within the context of hegemonic relations.[17]

Musical simulacrum symbolically challenges the hegemonic order, as opposed to an actual political coup, and is, I argue, part of the efficacy of complicity with neoliberal global enterprise, simulating itself as twenty-first-century

"progress."[18] Panji again analyzes Ghanaians in this regard: "We don't see it [Western values] as a flaw, we don't see it as a chink in the armor; we don't try and understand what the implications of it are."[19] In Ghana, lack of deconstruction of Western values is particularly due to the fact that a Western education is viewed as the civilizing and humanizing turning point in a Ghanaian's life, "making anything," as Panji argues, "that is linked to an African's education as defendable." The educated African is, thus, set apart, allowing him or her to participate in a seemingly meaningful connection with the international community guided by neoliberalism. Panji continues:

> Because educated Ghanaians tend to be successful because of their educa-
> tion, they can't really afford to think about whether what they are defending
> is right or wrong, because that is how they survive. It is their only means of
> remaining ahead. No careful analysis is made of anything, because all you
> know is this man went to school and now he has power.[20]

In Ghana, hip-hop became the popular culture manifestation of the glori-
fication of Western education and values. Its initial imitative adoption by Ghanaian youths in the 1980s and early 1990s was, ironically, part of the pedestal on which Western culture and fluency in the English language, albeit vernacular, were positioned. *Class* becomes relative in the circulation of the "low-art" designation of African American popular culture (the mar-
ginality of culture). Importantly, what I call hip-hop's "Trojan Horse effect" was ever-present, and the latent counter-hegemonic potential of hip-hop was also part of the initial attraction to the culture for Ghanaian youths want-
ing a sociopolitical voice (the marginality of youth). The counter-hegemonic potential within hiplife music was exactly what made it possible for savvy artists such as Okyeame Kwame to use their formal education to decon-
struct the very foundation on which that education is based.

Haupt positions these seeming sociocultural contradictions associated with hip-hop within the context of youth subcultures in battle with power-
ful hegemonic "Empire."

> Hip-Hop, as a subculture, is therefore engaged in a struggle over the sign in
> its attempts to challenge mainstream representations of black subjects. But
> these challenges are not merely offered via the content of rap lyrics. Instead,
> the "challenge to hegemony" is displayed at the "profoundly superficial level of
> appearances": This is at the level of signs, and is expressed obliquely in style.[21]

As I explained in Chapter 2, style signification in hiplife youth culture is lodged in a generational assertion that challenges Ghanaian social norms, while simultaneously reinforcing the reification of Western culture.

Given hip-hop's and hiplife's inclusion within multinational corporate capital even with their counter-hegemonic practices, allows one to comprehend the countervailing forces operating within contemporary late capitalism. I argue that hegemonic *cooptation* of youth cultural production like hiplife by corporate and governmental agencies in cahoots with each other, offer astute, aware practitioners of that production counter-hegemonic opportunities. Haupt, using Hardt and Negri, agrees:

> Empire is vulnerable from any point and that revolutionary possibilities can only take the form of a constituent counterpower that emerges from within Empire. Therefore the very means that consolidate Empire's decentralized power can be used to challenge it from within its operation."[22]

I turn now to how "counterpower" is possible in Ghana's hiplife movement, and how it is, in fact, consciously used by one of its astute practitioners known as Obour.

OBOUR'S HIPLIFE "GHANA FIRST" CAMPAIGN AND "THE GAME"

Obour, born Bice Osei Kufuor in the Ashanti region, is an important hiplife artist who represents all three aspects of hiplife that I have been exploring in this text: indigeneity, youth agency, and counter-hegemony. Obour is a second-generation hiplife artist in his mid-thirties who is a prominent political activist promoting youth agency and the counter-hegemonic potential of globalized hip-hop culture. Learning the traditional Ashanti *atumpan* drums as a child was a part of Obour's socialization, playing them in the Juaso-Ashanti Akyem chief's palace. Like Okyeame Kwame's use of *kete* drums in his 2008 performance of "Woso" (Chapter2), Ashanti *atumpan* drumming requires mastering complex syncopated rhythms that are used for transmission of the wisdom of the culture through proverbs. Obour attributes his *atumpan* training as a source of his lyrical and rhythmic sense as a hiplife artist, validating again the links within the Africanist aesthetic throughout the Black Atlantic.

Obour's music career began to develop during his college years, because his personal discipline allowed him to negotiate both the worlds of music and academia with aplomb. His London-based cousin, J. Amano, began producing him with his own Soul Records label, and Obour's first album *Atentenben* won three awards at the 2002 Ghana Music Awards. His second album *Dondo* contained the hit tract "Nana Obour," which won the "Best Video" award at both the Ghana Music Awards and Ghana Music Awards

UK in 2003. Perceiving himself as one of the guardians of hiplife music and culture, in 2005 Obour's Family Tree Entertainment Production company combined a celebration of his own work as an artist with the commemoration of ten years of the hiplife movement in Ghana at the International Conference Centre in Accra. Moreover, in August 2011, he became the president of the Musicians Union of Ghana (MUSIGA), and had formerly been the union's national youth organizer. His election to this prominent position of Ghana's music sector makes Obour the youngest MUSIGA president ever. With his early 2000 accolades and his self-proclaimed proprietary role in hiplife subculture, I place Obour as one of the leaders of the second generation of hiplife musicians.

What particularly distinguishes Obour is his utilization of hiplife music for various social campaigns that have benefitted the country socially, culturally, and politically. Some of his more visible projects have been the promotion of reading and literacy, road and highway safety (a big problem in a country with few traffic rules), empowerment of Ghanaian women and girls through education, promoting youths' participation in electoral politics through his Youth for Presidency campaign, trees for climate change, and education of Ghanaians about the importance of peace and unity as a nation during the 2008 elections, his "Ghana First Peace Train." Obour's social activism, under his Youth Icon organization, promotes collaborations with various social and governmental agencies to implement what he calls his "campaigns" to make a difference.

Obour has become so visible and effective nationally with his social campaigns that the government of Ghana gave him the National Honors' Grand Medal. He became the youngest recipient of this national award that was given to him for his contributions to the advancement of the country through his music and social crusades. Obour perceives these two aspects of his career—his music and social campaigns—as being responsible for his receiving the prestigious award.

> The citation for my award was like, according to the letter, "You've been nominated for a national honor grand metal for your contribution to Ghanaian music and using music to positively cause social change." I would account for it as an award for past campaigns that I have done like my reading and my Route 50. Prior to Route 50 road safety campaign you wouldn't have seen a Ghanaian driving with a seat belt on; but my campaign hammering on such issues like seat belts, and if you drink don't drive were worth it. It was an extremely popular campaign on TV constantly for like two years.
>
> Apart from that, when it comes to contributions to music, personally I'm a musician. I have organized several world tours with Ghanaian music, and I think all that promotes Ghana and Ghanaian music. So the nation, upon

reviewing some of these things I have been doing, maybe thought it right to honor—even my Youth for Presidency campaign. I got the award at the peak of that campaign, where I was whipping up sentiments of young people in politics, in elections, in voting, and all that. I believe that both went into it, both my music and my social campaigns.[23]

Bice Osei Kufuor's assumed emcee name, Obour, represents the utilization of the concept of agency. The name Obour, meaning "stone," comes from his grandfather Nana Kwesi Obour, from whom it is said that Obour inherited his traits of strength and determination. Obour's lyrics in his "Fontomfrom" tract proclaims his stonelike strength against injustice in a traditional proverbial manner:

Obour no obaa edwamanfoɔ yɛkye no a yɛsi no obour
Tetehɔ no Nananom edikanfo bepɛ gya ɛgye
obour ɔwɔ pampamsrada mene kosua na mmom w'amene bour
Wɔbour mmom na ehene poma na poma nhene bour

Lizards that crawl on walls are stoned by kids;
Huge animals that stay too long on trees are stoned
Me I am. A knife is sharpened on the stone.
The police officer catches thieves; he does not take rent payments.

In this verse from "Fontomfrom," Obour declares that like the stone he becomes a weapon against physical and social elements that harm people. He further emphasizes in the last line that those who are sworn to keep the peace, like policemen, should not collect bribes, an obvious condemnation of rampant corruption in Ghanaian civil service. Obour views his role as hiplife artist as a tool, or stone, to eliminate harmful aspects of Ghanaian society. From his perspective, certain characteristics of his ancestral inheritance empower him to assume the role of rectifier of harmful elements resulting from an unchallenged social order.

As a self-imposed guardian of hiplife music, Obour created an anchoring project that was a defining moment in the culture with his 2006 album *Best of The Lifes: Highlife Meets Hiplife,* which explored the foundation of hiplife within highlife music (see Chapter 1). The entire album was a collaboration with veteran highlife musician A. B. Crenstil, a major player in Ghanaian pop music since the 1960s. Crentsil's career developed as a respected member of the highlife groups Sweet Talks and the Ahenfo Band, and particularly for promoting guitar-based highlife music, while also supporting himself as an electrician. The album cover of *Best of The Lifes* visually represents the two distinct generations of Ghana's music: Crentsil with a wide grin from underneath a sprawling straw hat,

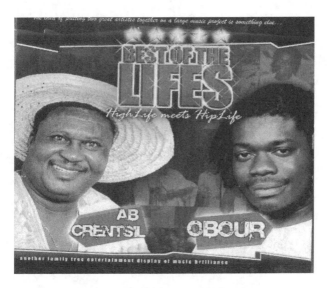

Figure 4.1 *Obour's Best of the Lifes: Highlife Meets Hiplife* album cover.

along side the dreadlocked, tee shirted Obour, with a closed-mouth smile (Figure 4.1).

Although their two self-presentations show distinctive generational differences, the album's music makes a definitive statement about hiplife's strong allegiance to highlife as its parental music form. On the video of the album track "Adjoa," the two artists also make clear their generational style differences: Obour appears in the hip-hop style markers of baggy sweat pants and t-shirt with backward turned cap (Chapter 2), while Crenstil wears a tuxedo and bow tie. But the music and the dance represented in the video transcends generation, with both artists enjoying the West African guitar-based melodic highlife rhythms undergirding rapped and sung verses. The choreography of the young video backup dancers, who joyously weave around Crentsil and Obour, visually demonstrate how the two generations merge through dance to the same exuberant music: the choreography incorporates simple highlife social dance steps to intricate torso isolations of Congo soukous, and from daredevil breakdance acrobatics to furious West African traditional steps, all blending into an African and African diaspora party that knows no boundaries of culture or generation.

The cultural intertwining of hiplife and highlife is the statement that Obour ultimately makes with this album, proving that hiplife, as it developed since the mid-1990s, stood on the shoulders of the *habitus* of the century-old music of highlife. Obour admits that some hiplife tracks are

nearly indistinguishable from the highlife sound. In categorizing "Adjoa" he analyzes:

> By the old definition of hiplife, I would call that song hiplife; but actually I should call that song highlife, if you define it by rhythm. Because the rhythm was strictly a highlife rhythm that I took and added modern-day hip-hop punches to it. You know, making it more appealing, changing the tones to make it sound more youth appealing. And then I rap on it; so, the rap is known as a youth culture, as hip-hop, as hiplife; So that's why I call that song a fusion of hiplife and highlife, the way I was representing the hiplife on that album.[24]

He reveals the *need* to add rap lyrics to attract the youth-dominated Ghanaian music scene. But in the process of attracting young people through the hip-hop element of rap, he easily compels them into the world of highlife music, because they are linked by the same aesthetic.

Obour's recognition of the linked Africanist aesthetic undergirds his understanding of how the two "lifes" continue to blend in various ways through past and present phases of hiplife music. As elucidated in Chapter 1, he has analyzed five distinct phases of hiplife that combine hip-hop and highlife in various musical admixtures that correspond to the three distinct generations of hiplife musicians (Figure 1.1). From rapping in indigenous languages to a hip-hop beat to strong highlife rhythms with local dialects to the current GH Rap that fuses English and Twi, hip-hop and highlife intermingle as the indigenizing process continues. Moreover, the indigenizing process is directly linked to the counter-hegemonic project as *cultural* tool to "flip the script." Once commercial incorporation becomes the dominant social dynamic, the counter-hegemonic agenda of hip-hop as a subculture elicits methods, such as indigeneity, to defy the very mainstreaming procedure in which it has been complicit.

Beyond surreptitious *artistic* practices, direct social activism is an obvious counter-hegemonic procedure. One of Obour's more prominent social activist campaigns, during my 2008 fieldwork, was the Ghana First Peace Train. During November and December of that election year, he organized a music tour that appeared in all ten regions of Ghana to promote a peaceful electoral process. Given the recent political violence in Kenya and Democratic Republic of the Congo at the time, the world's attention was on Ghana to see if it was possible to have fair and civil elections in Africa. Presidential campaigning took place primarily between two candidates: Nana Addo Dankwa Akufo-Addo of the NPP and Dr. John Evans Atta Mills of the NDC. Several reports of youth violence at campaign rallies surfaced while I was in the country, and public admonitions for peace by clergy, government

officials, and public spokespersons were broadcast daily on Ghanaian television. As a part of the national effort for peaceful elections, Obour's Ghana First Peace Train was a highly visible campaign, adding a youth component to the national efforts.

The Ghana First Peace Train was a traveling group of young hiplife, reggae, gospel and R&B musicians who performed, marched, and addressed large audiences promoting peace during the 2008 Ghanaian presidential elections.[25] The overwhelming message was to put Ghana as their country *before* any one particular political party. So even though Obour is Ashanti and the NPP is associated in general with the Akan group, he did not endorse them, instead remaining neutral in his campaign to put the country above either party. He warned youths against being used as pawns in the political electoral game, where poor young boys, in particular, are often paid by party officials to disrupt rallies of the opposition during campaign season, and to cause havoc at precincts during the actual voting process. Obour received national attention for his diplomatic efforts through the use of hiplife music, and the efforts of the youths became associated with peaceful elections, while boosting the youth music's public image.

The campaign was successful in great part due to Ghanaian youths' identification with hiplife music's artists that are promoted by big business interests. Yet, hiplife musicians involved with the Ghana First Peace Train used their celebrity to further their collective interest in a civil transition of political administrations. In this way the hegemonic order and counter-hegemonic projects, at strategic points, work in tandem for all concerned.

Obour not only utilized the national music tour as a part of his campaign, but also created a music video called "Ghana First" that was frequently shown on television to reach more people to reinforce the message. Understanding the power of music to unify and heal, Obour wrote "Ghana First" and organized tens of Ghanaian musicians to perform on the video, all promoting the message of national unity. The video's group shots were purposefully filmed in front of the Black Star Monument in the historic Independence Square that symbolizes the meaning of Ghana's sovereignty from British colonialism under Kwame Nkrumah. This site is also where the fiftieth anniversary commemoration of independent Ghana had just taken place a year before in 2007. In the music video, a long line of Ghanaian youths swayed and sang the refrain: "Ghana First: We love peace, unity, and harmony; Ghana First: unity, we are one family." A youth-oriented music video became the medium to demonstrate the power of the nation's youths to remind Ghana of its legacy as the first country to lead the continent into the era of independence. Hiplife and Ghanaian pop music was

at the center of a discourse of a moral citizenry and Ghana's historical role in Africa.

To model this historic national unity Obour was strategic in his choice of artists across music genres, as well as those associated with the different regions of Ghana: R&B artists Isaac Showboy, Jane, and Chemphe appeared; Lenny Akpadie and Ohemaa Mercy signified gospel; while Kwaw Kese and 5 Five represented hiplife; Reggy Zippy upheld the raga music side; and Irene grounded the "Ghana First" song with highlife. Obour finished the video with Sherifa Gunu (Chapter 1) and King Ayisoba (Chapter 2), two artists from the Northern and Upper regions respectively. Ayisoba ended the entire song with his signature "kai, kai, kai," turning Obour's message back to an indigenous root. The song's broad-ranging pop music and equitable regional representation created symbolic unity for national consumption of the message: the country's advancement that depends upon unity supersedes petty rivalries.

As a nationally visible hiplife musician, Obour vividly demonstrates the power of youths as an actual majority of the population in Ghana. At the end of the 2008 presidential elections, he assessed the youth element in the effectiveness of the Ghana First Peace Train project:

> At the close of the event, I made Ghanaians pledge together with me that we would all enter this election peacefully. There were loads of icons that people respect—musicians who especially the youths respect. And when all of us are talking in this tone, I believe strongly that it goes a long way. And it did go a long way to affect the tenor and the incident-free nature of the elections that we just had. I think our campaign really, really worked to the extent that this has been done more peacefully than in past elections.[26]

Obour has made his mission to empower young people by giving them a voice through hiplife music. His manifesto on his former 2008 website highlighted his challenge to the *lack* of voice given to the youth in traditional Ghanaian society, and it reads like a patriotic constitution for young people, peppered with a healthy dose of his signature iconoclasm:

> You and I brothers and sisters represent the raw manpower base of our dear nation and in fact the heartbeat and energies of mother Ghana. Yet anytime we endeavor in our rightful youthful spirit to take up top challenges, be it in politics or social life, we are excused with age. Fellow youth our national constitution gives credence to this line of thought, making it impossible for the youth to contest the highest office of the land.
>
> The time has come for us to stand united and join hands, hearts and souls to champion a noble cause of positively engaging the youth in key national issues. My brothers and sisters, they always refer to us as leaders of tomorrow and yet they don't want us to be a crucial part of today.

Through his umbrella organization, Youth Icons, Obour attempts to change the paradigm of African youths' traditional silence in deference to their elders. Obour calls the youths of Ghana to participate in their government, and in fact, "flip the script" about age in Africa. His political charge inures to hiplife music because of his artistic and social visibility.

THE DISCOURSE OF SELF-CRITIQUE IN HIPLIFE

Obour's counter-hegemonic efforts happen artistically as well. His 2010 song "Wahala" complains that increased business ventures in Ghana is not creating more money for the average Ghanaian citizen. As one line in the song asks in pidgin, "Where the Money Go Dey?" At a point when transnational corporate success is thriving in Ghana, this is an important counter-hegemonic question generated from the hiplife music movement. His counter-narrative includes hiplife music's own place in the game of business and politics. Similar to Nas' 2006 album *Hip-Hop Is Dead*, Obour's 2008 tract "The Game," featuring Okyeame Kwame and Richie, is an ultimate confrontation to hiplife music itself and its increased commercialization. On "The Game," R&B singer Richie begins by singing the chorus in English:

> Seem you searching for the answer
> cos wanna live happy ever after.
> We should never learn any chapter
> So we can write the story again
> Cos we killing the game.

Both artistic genres and social movements come of age when they are able to self-reflect and critique themselves. In "The Game," these hiplife musicians distance themselves enough from their artistic context to question where their music was going at the end of a decade of increased hiplife recognition and profitability. They warn that they should never run the risk of becoming stagnant ("We should never learn any chapter") thereby retaining the ability to challenge the system and "flip the script" ("So we can write the story again"). They also warn that today's hiplifers could be producing that which could bring about the death of "real" hiplife. In the song's music video, photos of hiplife artists float across the screen, juxtaposed with hiplife entrepreneurs sitting around a conference table where music deals are being made. The game of hip-hop and hiplife is constituted not only by its complicity with big business, but also by its ability to maintain counter-hegemonic social resistance.

The verses by Okyeame Kwame and Obour enumerate the failings of hiplife music as it evolved in the world of Ghanaian business. In Kwame's Twi first verse, he acknowledges the fact that hiplife record sales had been

steadily dropping, which, for him, implicitly meant that it was not fulfilling its original purpose.

> Yɛ fail, yɛn nyinna yɛ faili
> Hip life yɛ nsohwɛ anka yɛ faili
> Yɛ traili nti na ama yɛ waili
> Yɛ yaa na ye yie a nɛ efri diɛn nti

> We have failed, we have all failed
> If hip life were an exam, we would have failed
> We have trailed that is why we are wailing
> If we have tried and it isn't working,
> then what is the cause?

Then Obour emphasizes this point with the next Twi verse:

> Diɛn nti na efi sɛ neɛ
> Mi nɛ wɔ di kai hunu waen di
> Esi kaen ni oaten twenɔ
> Yɛ ahbɔho baen
> Y'angye kwaen, y'a
> Ade gyaen, Maho pae baako fuɔ mbɔ ɔmaen
> Mene momienu na
> Nyinaa koa ho na hip life ayɛ tan

> Why is it that you and I who started it all, saw who?
> Fought first, being hated, pulled hard, we couldn't protect it,
> We couldn't claim our space,
> we performed woefully,
> and made it burst open,
> one man does not build a nation.
> The two of us all have made hip life nasty.

Here, instead of blaming *all* hiplife artists in general for what he perceives as the declining state of affairs for hiplife, Obour instead places the blame on Okyeame Kwame and himself, as two of the pioneers of hiplife. As Terry Ofosu interprets:

> Obour means to say that the hiplife pioneers, who fought through [initial] hatred, became too individualistic and therefore could not protect hiplife. This is because artistes who had hits were always ready to pay payola, while those who didn't have hits complained bitterly, which means their [artistic] front was divided."[27]

The realities of the business of hiplife affected both the successful and unsuccessful rappers, creating disunity in hiplife as a social youth movement. The

culture of Ghanaian bribery as national way of life *and* the focused indi-
vidualism underpinning neoliberalism's transnational corporate enterprise
are analyzed as the cause of the potential death of hiplife, even as they are
making some artists famous and wealthy. This is exactly the cultural junc-
ture that Nas was elucidating in 2006 for American hip-hop. Hip-hop and
hiplife have given youths a counter-hegemonic voice while enabling their
gainful employment, partly because the music has involved itself in capital-
ism's global ideology of self-aggrandizement.

New York-based Ghanaian musician Blitz the Ambassador, first explored
in the Introduction, builds his career on a similar rejection of the commer-
cialization of hip-hop music that he feels not only "kills the game," but more
importantly also kills the music. Radio in Ghana (and the United States) is
a promoter and a "murderer" of the youth music culture developing out of
their own lived experiences. Blitz strikes back on his *Stereotype* CD with his
track called "Kill the Radio."

> I got introduced to radio in Ghana, and learned what I know about hip-hop
> through it. But commercial radio is the number one culprit, absolutely mis-
> construing the culture. I have to be the antithesis to radio. When they [com-
> mercial radio] hear me, I am not the norm. If the culture is going to survive, it
> cannot depend upon commercial radio. Radio represents *programming*—not
> the culture.[28]

In Blitz's video of "Kill the Radio," he and his band play their music live on
a New York street corner where the culture was originally generated, while a
male figure in a black suit and tie, with a boom box radio for his head, walks
into the scene imposing himself. Blitz interprets:

> The video is a metaphor, which includes the corner where the art still is hap-
> pening. When the record labels and commercial radio get through with them,
> the artists can come back to the hood, broke, where they started. The image
> [of the guy in a black suit and tie with a head for a radio] came way before
> the record. The radio represents the corporate structure—payola—pay for
> play—a terrible structure that kills artists and the art.[29]

This is exactly what Obour and Okyeame Kwame are railing against back
in Ghana. Whether in Africa or the United States, the same global capitalist
structure dominates the organizational mechanisms by which music is trans-
ferred from the creative artists to the world through a particular standardiza-
tion. Obour and Okyeame Kwame's "The Game" records the juncture of
the conscious coming-of-age of Ghanaian hiplife, where the "success" of
hiplife artists ironically creates awareness of the dilemma in which they find
themselves. Toward the end of the track, Richie sings about the existential

difficulty inherent in this familiar place that many artists in the music business find themselves:

> It's been a long time we've been wrong
> We turn our backs to what's going on
> Cos the game is so hard and we're staying strong
> We keep the music playing.

To end the diatribe on a positive note, Obour tells us, "Hiplife's never gonna die, Hiplife's still alive, opposition go shy, Resurrectors!" He reminds us that if the movement is ultimately based on a solid need for counter-hegemonic youth voicings, hiplife will live on. Moreover, the corporate and political entities that implicitly stand in opposition to the music's original sociocultural purpose will pale in comparison to its artistic "Resurrectors" emerging and flourishing because they speak, unlike the traditional Akan *Akyeame*, for the people themselves and not the elite.

Because hip-hop, at its foundation, is counter-hegemonic, it inevitably comes in conflict with the hegemonic order that appropriates it as a part of a co-optation process for the system's perpetuation. Herein lies "the game" in which pop music of any sort finds itself, particularly one that is founded on opposition to not just social, but also political and economic, norms, like hiplife in Ghana. As Haupt reminds us, "Hip-Hop, as a subculture, is therefore engaged in a struggle over the sign in its attempts to challenge mainstream representations of black subjects." Even black subjects involved with hip-hop in a *black* society such as Ghana find themselves challenging hegemony for their own existential survival.

The normalization of social and ideological devices that work against the best interest of the majority is part of the consensus-building process of hegemony created by transnational corporate power. This is particularly obvious in developing nation-states, such as Ghana, trying to situate itself in the neoliberal world order. Obour says, "We couldn't protect it; We couldn't claim our space," in recognition of the struggle in which hiplife music found itself 15 years into the game. Yet, he gives hiplife hope with its potential "Resurrectors" that may be emerging in today's third generation of the music.

CONCLUSIONS

This book is about hiplife music and culture of Ghana and its indigenization process of received globalized hip-hop that has empowered a new generation of young Ghanaians, even as that process has become mired in neoliberal transnational capital. I have argued that indigeneity is inextricably linked to both generational empowerment and hegemonic corporate power.

Localization of dominant US pop culture facilitates economic and ideological hegemony by transnationals such as telecommunications companies, as they make inroads into new developing markets such as Ghana. Because youths are prime targets in late capitalism's globality, pop culture forms such as hiplife are particularly vulnerable to manipulations, even as young people find new sociocultural authority within traditional societies where they previously had none.

Hip-hop's globalization implicitly presents a rebellious youth culture challenging the status quo in its new received locality, mapping onto each discrete location the tenet of "flippin' the script" and confronting longstanding sociocultural norms of each country's lived experience. The "glocal," or the interaction of local habitus with global imported products and attendant ideology, is one lens through which we can understand hip-hop's internationalization. I have explored how this process has grounded itself in Ghana, West Africa through (1) cultural indigeneity, (2) youth agency, and (3) complicity with and resistance to the hegemonic multinational global corporate enterprise. As popular music and culture, in general, became increasingly central to transnational big business since the second half of the twentieth century when hip-hop evolved out of the postindustrial 1970s, youth music was particularly poised to interact with the exigencies of late capitalism. Aesthetically, the indigenization process often empowers the local culture, reinforcing its traditions and its own contributions to world popular culture; but at the same time homegrown social norms that youths deem antiquated are explicitly challenged.

The case of Ghana reveals that the marginality of class is relative to each global situation, as many hiplife artists are actually from the Ghanaian middle class with significant tertiary education rather than the stereotypic ghettocentric image promulgated by US hip-hop. Yet these relatively well-off Ghanaian emcees cannot ignore their context of rampant national poverty and the exploitation of their primary youth constituency. Hip-hop's globalization into Africa situates it implicitly within "gangsta" situations, saturated with the scramble for state power and global commerce that go far beyond American ghetto neighborhood gang violence. Local corruption and the neocolonialist agenda that continues through unimpeded free trade by multinational corporations supported by the World Bank and the IMF spawn these African exploitative circumstances.

At the same time, the *cultural* priorities underpinning the aesthetic of hip-hop is viewed as having their origin in Africa. Therefore, importing hip-hop in Ghana was a process of re-indigenizing a diasporic polyrhythmic double-entendre, proverbial aesthetic that had left their shores centuries ago with the transatlantic slave trade. The long-term indigenization process of hip-hop's entrenchment in Ghana, from the late 1980s imitative phase through the adaptive mid-1990s, to the current indigenizing phase since the

early 2000s, established a distinct youth empowerment movement that has changed the dynamics of the society. Hip-hop cultural artifacts, like music videos and films, initially deemed "foreign" and shown in the 1980s Accra video centers, over time were transformed into indigenous hiplife by youths' understanding of the Africanist aesthetic in the diasporan connection.

The indigenization process has, in fact, strengthened the cultural links imbedded in black Atlantic music forms that disintegrates the local/foreign dichotomy. "While embedded within older formal structures of oral circulation," argues Shipley, "hiplife is understood in local terms as marking social newness, its performative elements mapping out new configurations of public speaking and moral value."[30] Ntarangwi acknowledges this same process in Uganda.

> By combining the local tradition of rapping associated in praise singing with the dance-oriented Jamaican beats, many Ugandan musicians have bridged an otherwise polarized music scene that once projected two different music traditions—the local and the foreign.[31]

The high value placed on music and dance is ubiquitous throughout Africa and its diaspora, facilitating the connections that eventually create what I have been calling "the arc of mutual inspiration," and what poet Kamau Brathwaite refers to as "bridges of sound."[32] Indeed, music and dance in similar recontextualized cultures from Africa to the Caribbean to the United States becomes the undeniable cultural links that bridge time and space, and that inspire continual cross-fertilization that transcends the hip-hop "origins" question.

It is significant that hip-hop, as a contemporary phase of the cultural links across Africa and its diaspora—the arc of mutual inspiration—has occurred among youths. Previous musical connections of jazz and R&B have occurred among an older segment of the population. With forms like hiplife, Africa's cultural trait of age-deference (also prevalent in other parts of the world) comes under scrutiny and is often defied. Television and music producer Iso Paley's assessment of how the entire Ghanaian music scene has shifted distinctively toward the youth, as opposed to previous eras of popular music, is an important insight (Chapter 2). And with youth-oriented music comes shifting cultural style markers. From the early Accra *sakura* style to the current-day style markers that span the baggy jeans, dreadlocks, and pimp/playa suited attire, hip-hop culture provoked and disturbed the Ghanaian status quo of elders.

I have also argued that hiplife music owes its roots as much to Ghana's own highlife pop music as it does to globalized hip-hop. Highlife can be traced to the early ballroom orchestra sound of the late nineteenth-century

coastal Central Region Fantes shifting to Accra as the capital of the colonial Gold Coast. From Caribbean maritime trade influences of calypso music to US ragtime jazz and vaudeville influences in the Gold Coast concert party theatre, Ghana incorporated several previous "foreign" inspirations to create highlife popular music, which, in turn, influenced all of West Africa. That same openness to blending cultures—the global and the local—plays a significant role in the indigenization process of twenty-first-century hiplife. Transitional highlife artist Ghedu-Blay Ambolley, with his propensity for Fante spoken word within his sung verses, became a precursor to Ghanaian style rap in indigenous languages before Reggie Rockstone, as hiplife's "Godfather," gave "permission" to Ghanaian emcees to rap in Twi and other indigenous languages. During its first 15 years of existence that this text chronicles, hiplife's innovations are shown to develop upon the previous rhythmic and melodic approaches to musical organization of highlife combining with hip-hop beats through five distinct phases of the youth music. Collaborative hiplife albums such as *Best of The Lifes*, with the contrast in hiplife emcee Obour's and highlife singer A. B. Crentsil's distinctive generational styles (explored above), are indicative of not only the generational music shift in Ghana, but also of building upon a solid indigenous musical foundation. Hiplife continues to morph within certain boundaries established by tradition and innovation—between the past (highlife) and the present (hip-hop). In this era of globalization, one thing is clear to hip-hop producers, such as Cedric Muhammad:

> The influence that all of us in the United States have had over the Hip-Hop culture and industry is rapidly ending. It will be replaced in many ways by the creative energy coming from regions of the world like Central and South America and Africa, whose socio-economic conditions in many ways are closer to the original essence of Hip-Hop as it manifested in New York City neighborhoods in the 1970s.[33]

Moreover, I have explored hiplife in Ghana within a globalizing economy where popular culture constitutes significant power in international commerce. The relationship between pop culture and big business becomes even more complex in the era of neoliberal policies impinging on poor West African countries such as Ghana. Technology being particularly integral to this phase of global late capitalism, it is no coincidence that Ghana's telecommunication companies dominate its socioeconomic landscape. Telecom corporations such as MTN, Zain, Tigo, and Vodafone have various relationships with hiplife artists that help promote their careers, while using the artists' pop culture visibility in Ghana to sell their mobile phone technologies in the country. I have argued that these companies using hiplife artists'

celebrity, and turning them into their spokespersons, as well as the corporations' promotion of their relatively small social responsibility programs, do not compensate for their ideological manipulations over the society, let alone their large profits generated from this poor country. Transnational corporate hegemony, however, is often resisted through many of the same artists' counter-hegemonic projects. Herein lies "the game" of capitalism and global pop culture that reveals itself in Ghanaian hiplife.

The counter-hegemonic practices by hiplife artists can be positioned within a Foucauldian understanding of power relations. "Power relations are not something that is bad in itself, that we have to break free of." Instead, Foucault revealed that "a society can [not] exist without power relations, if by that one means the strategies by which individuals try to direct and control the conduct of others."[34] The problem with hegemonic power, Foucault identified, is the inability of *all* social actors "to acquire the rules of law, the management techniques, and also the morality, the ethos, the practice of the self, that will allow us to play these games of power with as little domination as possible."[35] Savvy hiplife artists, such as Obour and Okyeame Kwame, attempt to influence the rules of law and the management techniques, as well as the national morality, to elevate the ethos of the power game in Ghana, when many of their fans and general constituency cannot.

Foucault also spoke more directly to my subject of pop music itself. He discussed "rock music" (one can substitute rap) as "an integral part of the life of many people" in the sense of it being "a cultural initiator: to like rock, to like certain kinds of rock rather than another, is also a way of life, a manner of reacting; it is a whole set of tastes and attitudes." And like Debord, he analyzed pop music "as a spectacle," in that "listening to it is an event...that...produces itself on stage...through which the listener affirms himself."[36] Foucault's perspective on pop music positions rap and hiplife music in real social processes, recalling what jazz drummer Max Roach pronounced about hip hop: "What makes hip hop so revolutionary is that it lives in the world, not just the world of music."

The social processes of hip-hop in the United States and hiplife in Ghana, lodged in the real world, alludes to larger purposes of popular music globally as repositories of social history. As George Lipsitz notes:

> ...[P]opular music [is] social history, as an archive of past and present realities and future possibilities, as one place where we may hear footsteps in the dark. I argue that historical changes that are only remotely registered in history books, newspapers, or the pronouncements of politicians can appear in vivid relief and full complexity within products of the popular music industry—if we learn how to read them correctly.[37]

My intention has been to offer an analysis of the hiplife movement in Ghana as a contribution to the canon of analyses that "reads" popular music—in this case hiplife as an indigenization of hip-hop—in many of its complexities, furthering our understanding of past and present sociohistorical processes. Ghanaian pop music history, viewed from highlife music evolving out of early European contact through the colonial period, chronicles an indigenization process of Western cultural influences for over a century. Hiplife becomes only a contemporary example of a long-term sociocultural process that has occurred in Ghana historically.

African American hip-hop entrepreneur Cedric Muhammad places Africa at the center of hip-hop's continued pop culture dominance through technology.

> Another major factor at work, which I believe, will eventually move the throne of the industry elsewhere is the rapid economic development of Africa and its cultural diversity. As technological, economic, and physical infrastructure is built in Africa, and as income levels rise, the ability to monetize creative works (make money from them) and offerings tied to music will grow so fast it will make your head spin.[38]

I, too, believe that Africa's dominance in global pop culture is possible because it is the source of the Africanist aesthetic that underpins world popular music and dance forms. The power of this aesthetic cannot be underestimated, and when it is augmented by increased economics and growth of infrastructure, the continent could become a formidable force. Africa's rise from an unrecognized, misunderstood "dark" continent could happen through its youthful popular music. However, I warn that neoliberal policies fueling popular culture implicitly continue and augment the class disparity so rampant throughout Africa.

Perhaps Ghana's poverty will remind hiplife artists to "keep it real" as they aspire to attain continental and global prominence while promoting this distinctive new Ghanaian music. Hiplife music will continue to change aesthetically, but hopefully will remain grounded in its own sociocultural circumstances. Obour says it best: "So we more or less need to study what hiplife is now and probably give it a new working definition. Maybe [it should be defined as] a youthful musical revolution that more or less has part of Ghanaian culture, Ghanaian dialect, mixed with the hip-hop culture."[39]

Hiplife's "youthful musical revolution," as its original intent, is crucial to its survival as it "blows up" around the world.

NOTES

INTRODUCTION: "EVERY HOOD HAS ITS OWN STYLE"

1. Saidiya Hartman, *Lose Your Mother: Journey along the Atlantic Slave Route* (New York: Ferrar, Straus and Giroux, 2007), 6.
2. Ibid., 7.
3. Jesse Weaver Shipley, "Aesthetic of the Entrepreneur: Afro-Cosmopolitan Rap and Moral Circulation in Accra, Ghana," *Anthropological Quarterly* 82, no. 3, Summer (2009): 643–644.
4. Ibid., 661.
5. I would like to thank the Fulbright Scholars Program, particularly the Council for International Exchange of Scholars for executing my 2008 Fulbright grant in Ghana that yielded this research. I also would like to thank the Bureau of Educational and Cultural Affairs of the US Department of State as the governmental arm that allocates the funding for these important international educational exchange grants.
6. S. Craig Watkins opens his *Representing: Hip Hop Culture and the Production of Black Cinema* (Chicago, IL: University of Chicago Press, 1998), ix.
7. Bruce Ziff and Pratima V. Rao, eds., *Borrowed Power: Essays on Cultural Appropriation* (New Brunswick, NJ: Rutgers University Press, 1997), 1.
8. Ibid., 5.
9. Ghana still has several important active gold mines even after centuries of the former Gold Coast that was plundered of this much sought-after natural resource.
10. Dr. Nkrumah also earned a theology degree from Lincoln Theological Seminary in 1942, and received MA degrees in education and philosophy from the University of Pennsylvania in 1942 and 1943.
11. Shipley, "Aesthetic of the Entrepreneur," 645.
12. Kwame Anthony Appiah, *In My Father's House: Africa in the Philosophy of Culture* (New York: Oxford University Press, 1992), 175.
13. Kevin K. Gaines, *American Africans in Ghana: Black Expatriates and the Civil Rights Era* (Chapel Hill: University of North Carolina Press, 2006), 5.
14. A couple of texts on Ghana's history would provide the curious a detailed historical record. For an examination of precolonial times through the

1980s Rawlings military rule see F. K. Buah, *A History of Ghana, Revised and Updated* (Oxford: Macmillan Education, 1998). A more recent historical account from independence to the Kufuor presidency is J. G. Amamoo, *Ghana: 20 Years of Independence* (Accra: Jafint. Ent., 2007).

15. Ishmael Mensah, "Marketing Ghana as a Mecca for the African-American Tourist," June 10, 2004,http://www.modernghana.com/news/114445/1/marketing-ghana-as-a-mecca-for-the-africanamerica.html.

16. Michael Scherer, "Obama's Statement at Cape Coast Castle," *Time.com*, July 11, 2009. http://swampland.blogs.time.com/2009/07/11/obamas-statement-at-cape-coast-castle/.

17. Blitz the Ambassador (Samuel Bazawula), Telephone Interview, September 24, 2009.

18. Ta-Nehisi Paul Coates, "Ghana's New Money," *Time.com*, August 21, 2006. http://www.time.com/time/magazine/article/0,9171,1229122,00.html.

19. Interestingly enough, the style of "sakura" shaven heads is not that foreign to Ghanaians, as the Ashanti, one of the main ethnic groups, traditionally have shaven heads among the men, and very closely cut hair for the women. The shaven heads among the *sakura* boys of Accra, however, did not fit the traditional cultural usage, and therefore they were criticized. "Flippin' the script" becomes relative.

20. Shipley, "Aesthetic of the Entrepreneur," 646.

21. John Collins, Personal Interview, University of Ghana, Legon, September 23, 2008.

22. Shipley, "Aesthetic of the Entrepreneur," 646.

23. Ibid.

24. Terry Bright Ofosu, "Dance Contests in Ghana" (MA Thesis, School of Performing Arts, University of Ghana, Legon, June 1993), 23.

25. Ibid., 27.

26. Ofosu says in his thesis, "In the early 80s a group of promoters came together to organize 'Ceazer 83/84' a 'Breakdance' contest at Black Ceazers Palace [in the Osu district of Accra]. This contest was won by Reginald Ossei [Reggie Rockstone]..." (25). Rockstone was originally a part of a breakdance collectively known as "the Gravity Rockers."

27. Reggie Rockstone, Personal Interview, Accra, Ghana, November 23, 2008.

28. Ibid.

29. Ibid.

30. Reggie Rockstone, Personal Interview, Accra, Ghana, September 29, 2010.

31. Diamond mining in Akwatia continues until today. For a recent study of the diamond mining industry there see Kaakpema Yelpaala, "Mining, Sustainable Development, and Health in Ghana: The Akwatia Case-Study," 2003.http://www.watsoninstitute.org/ge/watson_scholars/Mining.pdf.

32. Reggie Rockstone, Personal Interview, Accra, Ghana, September 29, 2010.

33. Ibid.

34. Reggie Rockstone, Personal Interview, Accra, Ghana, November 23, 2008.

35. Ibid.

36. Reggie Rockstone, Personal Interview, Accra, Ghana, September 29, 2010.

37. Abraham Ohene Djan, Personal Interview, OM Studios, Accra, Ghana, September 24, 2010.

38. Lord Kenya recorded in Ayana Vellisia Jackson, "Full Circle: A Survey of Hip Hop in Ghana." Accessed October 14, 2010. http://www.avjphotography.com/AVJ_hiplifeessay.htm.

39. Tony Mitchell, *Global Noise: Rap and Hip-Hop Outside the USA* (Middletown, CN: Wesleyan University Press, 2001), 1–2.

40. In October 2008 at the 8th Annual Waga Hip Hop Festival in Ouagadougou, Burkina Faso King Ayisoba was the only Ghanaian featured in this regional Francophone hip-hop festival. He performed in this costume and represented a bridge between the contemporary hip-hop style and an ancient African persona. He is at the far end of the roots indigenizing process going on in hiplife.

1 "MAKING AN AFRICAN OUT OF THE COMPUTER": GLOBALIZATION AND INDIGENIZATION IN HIPLIFE

1. Catherine M. Cole, *Ghana's Concert Party Theatre* (Bloomington: Indiana University Press, 2001), 20.

2. Ibid., 21.

3. Michael Wanguhu, *Hip-Hop Colony* (Chatsworth, CA: Emerge Media Group, LLC., 2007), DVD documentary.

4. Cole, *Ghana's Concert Party Theatre*, 21.

5. Ronald Robertson, "Glocalization: Time-Space and Homogeneity-Heterogeneity," in Mike Featherstone, Scott Lash, and Roland Robertson, eds., *Global Modernities* (London: Sage Publication, 1995). See also my exploration of the "glocal" in relation to hip-hop in *The Africanist Aesthetic in Global Hip-Hop* (New York: Palgrave Macmillan, 2007), 64–66. Also, for an explanation of Pierre Bourdieu's concept of *habitus* in relation to hip-hop, see 55–57.

6. Pierre Bourdieu, *Outline of a Theory of Practice*, trans. Richard Nice (New York: Cambridge University Press, 1977), 86.

7. Alastair Pennycook and Tony Mitchell, "Hip Hop as Dusty Foot Philosophy," in H. Samy Alim, Awad Ibrahim, and Alastair Pennycook, eds., *Global Linguistic Flows: Hip Hop Cultures, Youth Identities, and the Politics of Language* (New York: Routledge, 2009), 28.

8. Zine Magubane, "Globalization and Gangster Rap: Hip Hop in the Post-Apartheid City," in Dipannita Basu and Sidney J. Lemelle, eds., *The Vinyl Ain't Final: Hip Hop and the Globalization of Black Popular Culture* (London: Pluto Press, 2006), 210.

9. Ibid.

10. Daara J quoted in Pennycook and Mitchell, "Hip Hop as Dusty Foot Philosophy," 32. See also similar sentiments critiquing American materialism and violence by Tanzanian hip-hop youth in Sidney J. Lemelle, "'Ni Wapi Tunakwenda': Hip Hop Culture and the Children of Arusha," in Dipannita Basu and Sidney J. Lemmelle, eds., *The Vinyl Ain't Final: Hip Hop and the Globalization of Black Popular Culture* (London: Pluto Press, 2006), 230–254.

11. Pennycook and Mitchell, "Hip Hop as Dusty Foot Philosophy," 32.

12. See a specific example of rap-like practices among the Ekiti Yoruba in Halifu Osumare, *The Africanist Aesthetics in Global Hip-Hop: Power Moves* (New York: Palgrave Macmillan, 2007), 33–35.

13. Daara J Interview, March 3, 2005, quoted in Pennycook and Mitchell, "Hip Hop as Dusty Foot Philosophy," 32.

14. Tope Omoniyi, "So I Choose to Do Am Naija Style," in Alim, Ibrahim, and Pennycook, eds., *Global Linguistic Flows*, 176–1777.

15. Pennycook and Mitchell, "Hip Hop as Dusty Foot Philosophy," 25.

16. Osumare, *The Africanist Aesthetic in Global Hip-Hop*, see for example Chapter 1, "Phat Beats, Dope Rhymes, and Def Moves," 33–35, where I explore the Ekiti Yoruba's *alamo* rhythmic speech and its relation to the rap aesthetic.

17. Osumare, *The Africanist Aesthetic in Global Hip-Hop*, 70. In addition, Ghanaians in general identify with African Americans' antiracist struggles. Although race manifests differently throughout most of Africa and unequal power among ethnicities plays a much larger role in their lives, European dominances culturally and economically pushes the racial dimension on the continent.

18. For a good exploration of "authenticity in relation to race and culture" see R. A. T. Judy, "On the Question of Nigga Authenticity," 105–118; and Robin D. G. Kelley, "Looking for the 'Real' Nigga: Social Scientists Construct the Ghetto," 119–136, both in Murray Forman and Mark Anthony Neal, eds., *That's the Joint! The Hip-Hop Studies Reader* (New York: Routledge, 2004). Although these essays on authenticity issues in the United States are constructed around race, they have implications ultimately for authenticity issues about the origins of hip-hop on the African continent or Bronx, New York.

19. Obour, Personal Interview, December 12, 2008.

20. Reggie Rockstone, Personal Interview, September 8, 2010.

21. Andy Bennett, *Popular Music and Youth Culture* (New York: St. Martin's Press, 2000), 55. Bennett uses James Lull's *Media, Communication, Culture: A Global Approach* (Cambridge: Polity Press, 1995) to address American pop music hegemony in relation to local cultures.

22. See Jannis Androutsopoulos, "Language and the Three Spheres of Hip Hop," in Alim, Ibrahim, and Pennycook, eds., *Global Linguistic Flows*, 43–62.

23. Omoniyi, "So I Choose to Do Am Naija Style," 128.

24. Magubane, "Globalization and Gangster Rap," 215. Magubane quotes, Hugh Dellios, "Multilingual S. Africa Talking up a New Dialect." *Chicago Tribune*, February 9, 1998. http://articles.chicagotribune.com/1998-02-09/news/9802090172_1_lingo-soweto-languages.

25. Jane E. Goodman and Paul A. Silverstein, *Bourdieu in Algeria: Colonial Politics, Ethnographic Practices, Theoretical Developments* (Lincoln: University of Nebraska Press, 2009), 216.

26. John Collins, *West African Pop Roots* (Philadelphia, PA: Temple University Press, 1992), 18, calls this early brass-band music "konkomba music."

27. Panji Anoff, Personal Interview, Alliance Francais in Accra, October 10, 2008. He is also the founder of the annual Accra High Vibes Festival of live band-oriented hiplife music.

28. Jesse Weaver Shipley, "Aesthetic of the Entrepreneur: Afro-Cosmopolitan Rap and Moral Circulation in Accra, Ghana," *Anthropological Quarterly* 82, no. 3 (Summer 2009): 659.

29. Ibid.

30. Collins, *West African Pop Roots*, notes that the early dance orchestras that started in the first decade of the twentieth century, such as the Excelsior Orchestra in Accra and the Accra Rhythmic Orchestra, had faded out by World War II. The smaller jazz combos, such as the Tempos, eventually directed by E. T. Mensah, transitioned onto the scene around 1945. "It was the Tempos' style of highlife that became all the rage; by the early 1950s the band started touring West Africa and recording for Decca... It was during the 1950s that E. T. was acclaimed the king of highlife throughout West Africa..." 24.

31. Ibid., 24 and 25.

32. Ibid., 24.

33. Regarding highlife music as social commentary, it should be noted that Collins acknowledges the musical form's part in the independence movement as led by Kwame Nkrumah in the 1950s. He discusses E. K. Nyame as innovator in bringing indigenous music and language to the early theatrical form of the Ghanaian concert party. His guitar band was a favorite of Nkrumah, accompanying him on many state visits. "Many of E. K.'s songs and plays supported Nkrumah and the independence movement." (38–39).

34. Shipley, "Aesthetic of the Entrepreneur," 645.

35. Saidiya Hartman, *Lose Your Mother: Journey along the Atlantic Slave Route* (New York: Farrar, Straus and Giroux, 2007), 155.

36. See for example John Miller Chernoff, *African Rhythm and African Sensibility: Aesthetics and Social Action in African Musical Idioms* (Chicago, IL: University of Chicago Press, 1979), for a seminal treatise on the relationship of African music structure as social practice.

37. One of the recorded slave rebellions in colonial America spawning the black codes that banned drumming by slaves is the Stono Rebellion in South Carolina in 1739. For an account of the rebellion and the subsequent laws it generated see Lynne Fauley Emery, *Black Dance in the United States from 1619 to Today*, 2nd revised ed. (Hightstown, NJ: Dance Horizon Book, 1988, 1972), 82–83.

38. Gyedu-Blay Ambolley, Personal Interview, Accra, Ghana, November 22, 2008.

39. B. B. Menson, Personal Interview, November 15, 2008.

40. Bayo Holsey, *Routes of Remembrance: Refashioning the Slave Trade in Ghana* (Chicago, IL: The University of Chicago Press, 2008), 51.

41. Ibid., 47.

42. Ibid., 48.

43. Gyedu-Blay Ambolley, "Abrentsie," *Partytime Revisited*, Simigwa Records, 1988.

44. Gyedu-Blay Ambolley, Personal Interview, Accra, Ghana, November 22, 2008,

45. Terry Ofosu, Personal Interview, University of Ghana, Legon, September 27, 2010.

46. Reggie Rockstone, Personal Interview, Accra, Ghana, September 8, 2010.

47. Shipley, "Aesthetic of the Entrepreneur," 650.

48. Ibid., 651.

49. Panji Anoff, Personal Interview, Accra, Ghana, September 15, 2010.

50. *Homegrown: Hiplife in Ghana*. Independent film, directed by Eli Jacobs-Fantauzzi. Clenched Fist Productions in Association with BDN Productions, 2008.

51. "VIP, Happy FM Rock Nima with Salafest Jams," Peace FM Online, September 20, 2010, htt://showbiz.peacefmonline.com/news /201009/83711.php.

52. George Clifford Owusu, "VIP Album Launch A Hit," Modern Ghana News, February 19, 2010. http:///www.modernghana.com/music/11326/3vip-album-launch-a-hit.html.

53. Michael Eric Dyson, *Know What I Mean? Reflections on Hip Hop* (New York: Basic Civitas Books, 2007), 43.

54. Biography of Obrafuor, Ghana Base Music. Accessed October 26, 2010. http://music.thinkghana.com/artist/Obrafuor/.

55. Mwenda Ntarangwi, *East African Hip Hop: Youth Culture and Globalization* (Urbana: University of Illinois Press, 2009), 14.

56. The video of "Kwame Nkrumah" by Obrafuor can be found on YouTube at: http://www.youtube.com/watch?v=2qGgUBQhd_E.

57. Adam Haupt, *Stealing Empire: P2P, Intellectual Property and Hip-Hop Subversion* (Cape Town, South Africa: HSRC Press), 2008, 183.

58. Iso Paley, Personal Interview, TV3 Studios, Accra, Ghana, September 18, 2008.

59. Ibid.

60. Tricia Rose, *The Hip Hop Wars: What We Talk About When We Talk About Hip Hop—And Why It Matters* (New York: Basic Civitas Books), 2008, 35. Rose has long been touted to be the very first to publish a *scholarly* hip-hop text. See her *Black Noise: Rap Music and Black Culture in Contemporary America* (Hanover, CN: Wesleyan University Press, 1994).

61. Chale, "Kwaw Kese-Museke African Artistes," July 7, 2006. http://www .museke.com/en/KwaKese. Accessed October 27, 2010.

62. "Music Africa: Afro Fest Bababo Stage Youth Zone." Accessed October 28, 2010. http://www.musicafrica.org/stage_baobab_youth.htm.

63. Juliet Yaa Asantewa Asante, "Samini—Marriage is the Last Thing on my Mind," *Entertainment Today* 4 (2007): 23.

64. Panji Anoff, Telephone Interview, September 16, 2010.

65. "Batman Samini," Ghana Base Music, accessed October 26, 2010. http://music.thinkghana.com/artist/samini/.

66. Rose, *The Hip Hop Wars*, 77.

67. Manthia Diawara, "Toward a Regional Imaginary in Africa," in Fredric Jameson and Masao Miyoshi, eds., *The Cultures of Globalization* (Durham, NC: Duke University Press, 1998), 103.

68. Terry Ofosu, Email Communication, October 28, 2010.

69. Omoniyi, "So i Choose to Do Am Naija Style," 129–130.

70. Terry Ofosu, Email Communication, October 28, 2010.

71. Ofosu, Email Communication, October 28, 2010.

72. Sarkodie, Personal Interview, Tema, September 19, 2010

73. Akon's father, famed Senegalese traditional drummer Mor Thiam, is a good friend and colleague of mine. He told me that over the years as Akon was growing up in the United States, he made sure that he sent him back to Dakar during summer vacations, so that he would continue to speak Wolof, his first language, as well as to remain aware and a part of his traditional culture.

74. For a telling account of underdevelopment of Africa as a market for pop music by an industry insider, see Cedric Muhammad, "Africa, The Next Throne of Hip-Hop," All HipHop, May 18, 2010. http://www.allhiphop.com/stories/editorial/arrchive/1010/05/18.2222.

75. "Dr. Duncan of Adom FM," Ghana Web, November 4, 2004. http://ghanaweb.com/GhanaHomePage/audio/artikel.php?ID=191666#. Accessed November 1, 2010.

76. Sarkodie, Personal Interview, Tema, September 19, 2010.

77. Ibid.

78. Trigmatic, Personal Interview, Accra, Ghana, September 20, 2010.

79. Ibid.

80. The jama song that made it big on the Ghana charts in 2010 was Nana Boroo's "Aha Yede" (This Place is Fun) track that appeared on his *Young Executive* album.

81. Trigmatic, Personal Interview, Accra, Ghana, September 20, 2010

82. Reggie Rockstone, Personal Interview, Accra, Ghana, September 8, 2010. Regarding class, language, and the hiplife generation, he revealed: "This is the only [African] country where if you speak bad English—if you're Ghanaian and you can't speak good English—they actually use that to cut you off, as far as your progress. It will come up, like, 'Oh, he can't speak English'. Right down to the president: President [Atta Mills] made a little bungle in a speech. He was trying to say 'economy' and he said 'ecomony.' In the whole country there were jokes for weeks. Kids had that shit on their ringtones. You've heard this remix by Little Wayne 'amele, amele?' They had remixed Little Wayne and had it going 'ecomony, ecomony'," [mocking the President's English mishap].

83. For one of the classic studies on the effects of having minority sta-
tus regarding unequal opportunities and its psychological effects in
the American public schools see John U. Ogbu, *Minority Status and
Schooling: A Comparative Study of Immigrant and Involuntary Minorities*
(New York: Garland, 1991), as well as Edgar G. Epps, *African American
Education: Race, Community, Inequality and Achievement* (Boston, MA:
JAI, 2002). For an examination of the perceived cultural aspects of
"race" in higher education see, Sarah Susannah Willie, *Acting Black:
College, Identity, and the Performance of Race* (New York: Routledge,
2003).

84. Trigmatic, Personal Interview, Accra, September 20, 2010.

85. See Osumare, *The Africanist Aesthetic in Global Hip-Hop*, particularly 3
and 62–63.

86. Ato Quayson, "Signs of the Times: Discourse Ecologies and Street Life on
Oxford St., Accra," *City & Society* 22, no, 1: 72. He further explains the
nexus-like nature of Oxford Street. "The name Oxford Street is partly an
improvisation and a chimerical projection of popular desire, for it is not
the real name of the street under discussion and does not appear on any
official maps of the city. Rather it is part of a much longer road, officially
called Cantonments Road." He goes on to say that it was "popularized
after the return to the country of diasporic Ghanaians especially from
London following the end of military rule and the restoration of multi-
party democracy in 1992,"

87. Ibid.

88. Shipley, "Aesthetic of the Entrepreneur," 633.

89. Mimi, Personal Interview, Accra, Ghana, September 22, 2010.

90. Ntarangwi, *East African Hip Hop*, 49.

91. One female historical warrior-figure, as an example, was Yaa Asantewaa.
She was the Queen Mother of the Edweso subgroup of the Ashanti dur-
ing the Gold Coast era of Ghana when the British were trying to colonize
the country by conquering the Ashanti. She assumed the leadership of
the Ashanti during the Asante-British war of 1900 when no male chiefs
stepped forward to assume the role. Although the British were ultimately
militarily successful, she was noted as a supreme military strategist. In her
famous speech to gather Ashanti forces she is quoted as saying: "Is it true
that the bravery of the Ashanti is no more? I cannot believe it. It cannot
be! I must say this, if you the men of Ashanti will not go forward, then we
will. We the women will."

92. John Collins, Personal Interview, University of Ghana, Legon,
September 23, 2008.

93. Mimi, Personal Interview, Accra, Ghana, September 22, 2010.

94. Ntarangwi, *East African Hip Hop*, 4.

95. Rose, *Black Noise*, 147.

96. Interesting enough, Mimi's record label, Movingui Records, is a part of
a conglomerate of businesses that includes Movingui Kitchens that sells

upscale kitchen designs to rich upper-class Ghanaians. As a consummate businesswoman, she also owns Mobingui Investments.

97. Ibid.

98. For an astute analysis of the concept of "nigga" as a form of performative identity, see Davarian L. Baldwin, "Black Empires, White Desires," in Forman and Neal, eds., *That's the Joint!*,159–176. Balwin warns, "The project of uncovering the racially hybrid subjectivity of the nigga is halted when the nigga is flaunted as the only 'real' black identity," 166. I argue the same limiting aspects in having to perform "the saucy girl."

99. Cheryl L. Keyes, "Empowering Self, Making Choices, Creating Spaces: Black Female Identity via Rap Music Performance," in Forman and Neal, eds., *That's the Joint!*, 269.

100. Joan Morgan, "Functional Feminism," in Forman and Neal, eds., *That's the Joint!*, 281.

101. Mzbel and Reggie Rockstone, "Late Night Celebrity Show," TV3, Accra, Ghana, September 27, 2010.

102. Ntarangwi, *East African Hip Hop*, 49. For the classic text on gender and performativity, see Judith Butler, *Gender Trouble: Feminism and the Subversion of Identity* (London: Routledge, 1990).

103. Akosua Adomako and Awo Asiedu, Personal Interview, University of Ghana, Legon, September 14, 2010.

104. Akofa Anyidoho and Nana Dansowaa Kena-Amoah, "Let's Have More Positive Lyrics About Women," *Daily Graphic,* August 30, 2008, 20.

105. Ibid.

106. Mimi, Personal Interview, Accra, Ghana, September 22, 2010.

107. Ibid.

108. Shipley, "Aesthetic of the Entrepreneur," 662.

109. Ntarangwi, 4. See Arjun Appadurai, *Modernity at Large: Cultural Dimensions of Globalization* (Minneapolis: University of Minnesota, Press, 1996).

110. Olly Wilson. "Significance of the Relationship Between Afro-American Music and West African Music," *Black Perspective in Music* (Spring, 1974), 234. African American musicologist Olly Wilson builds upon Kwabena Nketia and other Africanist musicologists, such as Richard Waterman (1952) and Alan Merriam (1958) who first established geographic musical regions in Africa. Wilson ventures to delineate a "black-music cultural sphere" that encompasses West Africa, South America, and North America, presaging Paul Gilroy's "black Atlantic" musically by 20 years.

111. Osumare, The Africanist Aesthetic in Global Hip-Hop, 46.

112. James Snead, "Repetition as a Figure of Black Culture," 1990: 222, quoted in Susan Vogel, "Digesting the West," *Africa Explores: 20th Century African Art* (New York: Center for African Art, 1991), 19.

113. Osumare, *The Africanist Aesthetic in Global Hip-Hop*, 46–47.

114. Rose, *Black Noise*, 39.

2 EMPOWERING THE YOUNG: HIPLIFE'S
YOUTH AGENCY

1. Halifu Osumare, *The Africanist Aesthetic in Global Hip-Hop: Power Moves* (New York: Palgrave Macmillan, 2007), 68.
2. Ibid., 69.
3. One example of the power of youth and the place of globalized hip-hop in social change is the so-called Arab Spring, a revolutionary wave of demonstrations, protests, and outright armed rebellions throughout North Africa and the Middle East. Starting in December 2010 in Tunisia, this youth-driven movement for more democratic societies, quickly spread to Egypt, Libya, Syria, Bahrain, and Yemen. Many of the youths were informed by hip-hop and used its music to transmit the message of the despotic and oppressive regimes that had been ruling them for decades. Some of the more prominent emcees to emerge from this movement are Tunisia's El General and Egypt's Arabian Knightz, whose music tracks about the issues of the rebellion went viral on the Internet.
4. Mwenda Ntarangwi, *East African Hip Hop: Youth Culture & Globalization* (Urbana: University of Illinois Press, 2009), 3.
5. Jesse Weaver Shipley, "Aesthetic of the Entrepreneur: Afro-Cosmopolitan Rap and Moral Circulation in Accra, Ghana," *Anthropological Quarterly* 82, no. 3 (Summer 2009): 633.
6. Ibid., 659.
7. Tony Mitchell, "Another Root—Hip Hop Outside the USA," in Tony Mitchell, ed., *Global Noise: Rap and Hip Hop Outside the USA* (Middletown, CT: Wesleyan University Press, 2001), 4.
8. Osumare, *The Africanist Aesthetic in Global Hip-Hop*, 30–31.
9. Halifu Osumare, "Global Breakdancing and the Intercultural Body," *Dance Research Journal* 34, no. 2 (Winter 2002): 31.
10. Terry Ofosu, Personal Interview, University of Ghana, Legon, September 27, 2010.
11. Shipley, "Aesthetic of the Entrepreneur," 647.
12. Manthia Diawara, "Home Cosmopolitan," *In Search of Africa* (Cambridge, MA: Harvard University Press, 1998), 247, 250, and 252.
13. Halifu Osumare, "Motherland Hip-Hop: Connective Marginality and African American Youth Culture in Senegal and Kenya," In Mamadou Diouf and Ifeoma Kiddoe Nwankwo, eds., *Rhythms of the Afro-Atlantic World: Rituals and Remembrances* (Ann Arbor, MI: The University of Michigan Press, 2010), 174–175.
14. Regarding Nkrumah's use of popular music, as John Collins notes (41), "When he [Nkrumah] became Prime Minister, [E. K. Nyame's] Akan Trio accompanied him to many state functions." Nyame was a staunch supporter and Nkrumah liked highlife music and its use of the popular theatrical form of concert parties; John Collins, *West African Pop Roots* (Philadelphia, PA: Temple University Press, 1992).

15. "Ghana People 2010." *2010 CIA World Factbook and Other Sources*. Accessed November 10, 2010. http://www.theodora.com/wfbcurrent /ghana/ghana_people.html.

16. Ken Gelder, "Introduction to Part Two," in Ken Gelder and Sarah Thornton, eds., *The Subcultures Reader* (London: Routledge, 1997), 83.

17. Bayo Holsey, *Routes of Remembrance: Refashioning the Slave Trade in Ghana* (Chicago, IL: The University of Chicago Press, 2008), 49.

18. Ibid. The respectability argument by Holsey is taken from Evelyn Higginbotham, "The Politics of Respectability," *Righteous Discontent: The Women's Movement in the Black Baptist Church, 1880–1920* (Cambridge, MA: Harvard University Press, 1993). In so doing, Holsey poses an alternative view of black assimilation and correlates the strategies of both Ghanaians and African Americans as attempting to counter the inferiority discourse of the late nineteenth century and early twentieth centuries.

19. Ibid., 51.

20. Panji Anoff, Personal Interview, Dworwulu, Accra, September 15, 2010.

21. John Clarke, Stuart Hall, Tony Jefferson, and Brian Roberts, "Subcultures, Cultures and Class," in Ken Gelder and Sarah Thornton, eds., *The Subcultures Reader* (London: Routledge, 1997), 101.

22. Panji Anoff, Personal Interview, Dworwulu, Accra, September 15, 2010.

23. Dick Hebdige, "Subculture: The Meaning of Style," in Ken Gelder and Sarah Thornton, eds., *The Subcultures Reader* (London: Routledge, 1997), 130. Originally published in *Subculture: The Meaning of Style* (London: Methuen, 1979).

24. Panji Anoff, Personal Interview, Dworwulu, Accra, September 15, 2010.

25. Joe Austin and Michael Nevin Willard, "Introduction," in John Austin and Michael Nevin Willard, eds., *Generations of Youth: Youth Cultures and History in Twentieth Century America* (New York: New York University Press 1998), 6.

26. Adam Haupt, *Stealing Empire: P2P, Intellectual Property and Hip-Hop Subversion* (Cape Town, South Africa: Human Sciences Research Council, 2008), 188.

27. Iso Paley, Personal Interview, TV3 Studios, Accra, Ghana, September 18, 2008.

28. Ibid.

29. Ibid.

30. Nii Ayite Hammond, Personal Interview, Charter House in Accra, September 23, 2010.

31. Austin and Willard, *Generations of Youth*, 1.

32. Jamie Claude, "King Ayisoba," Museke African Artistes, October 10, 2006. http://www.museke.com/en/KingAyisoba. Accessed November 13, 2010.

33. Panji Anoff, Personal Interview, Ouagadougou, Burkina Faso, October 18, 2008.

34. For an explanation of *nommo* in relation to rap, see Osumare, *The Africanist Aesthetic in Global Hip-Hop*, 31–36.

35. "Frafra People; Ghana: Profile," National Geographic. http://www
.nationalgeographic.com/geographyofwealth/frafra-profile.html. Accessed
November 13, 2010.
36. I would like to thank Panji Anoff for his colloquial translations.
37. See my analysis of French hip-hop and the *anlieues* in Osumare, *Africanist
Aesthetic in Global Hip-Hop*, 84–91
38. Ali Diallo, Personal Interview, Ouagadougou, Burkina Faso, October 18,
2008.
39. Kwame Anthony Appiah, *In my Father's House: Africa in the Philosophy of
Culture* (New York: Oxford University Press, 1992), 175.
40. Okyeame Kwame, Ghanabase.com. http://music.thinkghana.com/artist
/okyeamekwame/. Accessed January, 2009.
41. "GhanaBase Music Meets Okyeame Kwame," March 15, 2007. http://www
.ghanabase.com/interviews/2007/775.asp?artistnews=okyeamekwame.
Accessed November 15, 2010.
42. Ntarangwi, *East African Hip Hop*, ix.
43. Ibid.
44. Ibid.
45. "GhanaBase Music Meets Okyeame Kwame, Ghana Base Music," March 15,
2007. http://music.thinkghana.com/interviews/200703/34121.php.
46. Okyeame Kwame, Personal Interview, Accra, November 2, 2008.
47. According to Rap Basement at http://www.rapbasement.com/hip-hop
/genres/crunk-music.html: The crunk genre originated in the early 1990s
but did not become mainstream until the early 2000s. The first notable
crunk single is commonly believed to be "Tear Da Club Up '97" by Three
Six Mafia, debuting in 1997 and reaching #29 on the US rap charts.
48. Shipley, "Aesthetic of the Entrepreneur," 660–661.
49. Brenda Dixon Gottschild lists "high-affect juxtaposition" as one of
the primary aspect of African-based performance. She illuminates, in
Digging the Africanist Presence in American Performance (Westport, CT:
Greenwood Press, 1996), 14, that "mood, attitude, or movement breaks
that omit the transitions, connective links valued in the European aca-
demic aesthetic, are the keynote of this principle... The result may be
surprise, irony, comedy, innuendo, double entendre, and finally, exhilara-
tion." Okyeame Kwame's performance that night was, in fact, wrought
with double entendre, innuendo, and it definitely ended in exhilaration.
50. Shipley, "Aesthetic of the Entrepreneur," 634.
51. Ibid. 642.
52. Ibid. Here Shipley quotes the rapper Sidney who recognizes the impor-
tance of local resonance with lyrics for success in competitive hiplife
marketplace.
53. Osumare, *The Africanist Aesthetic in Global Hip-Hop*, 36.
54. Okyeame Kwame, Personal Interview, Accra, Ghana, November 29,
2008.
55. Kwesi Yankah, *Speaking for the Chief: Okyeame and the Politics of Akan
Royal Oratory* (Bloomington: Indiana University Press, 1995), 10.

56. Ibid., 13.

57. Ibid., 14.

58. Okyeame Kwame. Facebook Homepage. http://www.facebook.com /pages/Okyeame-Kwame/23344505854.

59. Achille Mbembe, "The New Africans: Between Nativism and Cosmopolitanism," in Peter Geschiere, Birgit Meyer, and Peter Pels, eds., *Readings in Modernity in Africa* (London: International Institute; Bloomington: In Association with Indiana University Press), 2008.

60. These life expectancy figures were from 2000 data retrieved from See World Life Expectancy Chart at About.Com: Geography, 110. http://geography. about.com/library/weekly/aa042000b.htm.

61. Okyeame Kwame, Personal Interview, Keep Fit Club, Dansoman, September 25, 2010.

62. Ntarangwi, *East African Hip Hop*, 11.

3 "SOCIETY OF THE SPECTACLE": HIPLIFE AND CORPORATE RECOLONIALIZATION

1. Catherine M. Cole, *Ghana's Concert Party Theatre* (Bloomington: Indiana University Press, 2001), 19.

2. Halifu Osumare, *The Africanist Aesthetic in Global Hip-Hop: Power Moves* (New York: Palgrave Macmillan, 2007), 150–166.

3. Jesse Weaver Shipley, "Aesthetic of the Entrepreneur: Afro-Cosmopolitan Rap and Moral Circulation in Accra, Ghana," *Anthropological Quarterly* 82, no. 3 (Summer 2009), states that the popular image of the Kuffuor's NPP party was important in the corporate privatizing transition in Ghana: "While not accurate in terms of policy, in the popular imagination, the 2000 transition was seen as a crucial shift from an old state-centered approach to free-market-oriented governance" (640).

4. Victor S. Navasky, "Rebranding Africa," *The New York Times*, Op-Ed, July 10, 2009.

5. Shipley, "Aesthetic of the Entrepreneur," 633.

6. Peter Geschiere, Birgit Meyer, and Peter Pels, "Introduction," in Peter Geschiere, Birgit Meyer, and Peter Pels, eds., *Readings in Modernity in Africa* (London: International African Institute; In association with Bloomington: Indiana University Press, 2008), 1.

7. Ibid.

8. Achille Mbembe, "The New Africans," in Geschiere, Meyer, and Pels, eds., *Readings in Modernity in Africa*, 107.

9. Ibid., 110.

10. Pnina Werbner, *Anthropology and the New Cosmopolitanism: Rooted, Feminist and Vernacular Perspectives* (Oxford: Berg, 2008), 2.

11. Ibid.

12. Ibid.

13. Guy Debord, *Society of the Spectacle* (London: Rebel Press, 1970), 19.

14. Ibid. Debord goes on to say, "With the Industrial Revolution's manufactural division of labour and mass production for a global market, the commodity finally became fully visible as a power that was colonizing all social life, It was at that point that political economy established itself as the dominate science, and as the science of domination" (21).

15. Ibid.

16. Throughout this chapter, I use the term "postmodern." My meaning of this debatable term is similar to Frederick Jameson's explanation of postmodernism in *Postmodernism, or, The Cultural Logic of Late Capitalism* (Durham, NC: Duke University Press, 1992), where capitalism since the 1960s utilizes popular culture in a wholly different way than in the first half of the twentieth century. This new economic order is able to hold sway over the replication of cultural tenets *because* it is viewed as the natural order of social life. Other meanings such as that of postrationality and a new expression of thought itself that has been forwarded by Jean-François Lyotard in *The Postmodern Condition* (1984) and *Moralitiés Postmodernes* (1993) can also be subsumed in my meaning. For an exhaustive analysis of postmodernism in relation to hip-hop, see Russell Potter, *Spectacular Vernaculars, and Spectacular Vernaculars: Hip-Hop and the Politic of Postmodernism* (Albany: State University of New York Press, 1995).

17. Ato Quayson, "Signs of the Times: Discourse Ecologies and Street Life on Oxford St., Accra." *City & Society* 22, no. 1: 72.

18. Pádraig Carmody, *Globalization in Africa: Recolonization or Renaissance?* (Boulder, CO: Lynne Reinner Publishers, 2010), 110. He quotes M. Castells, *End of the Millennium* (Malden, MA: Blackwell, 1998), 95.

19. "Cellular/Mobile Network," Ghana Web.Com. Accessed November 28, 2010.http://www.ghanaweb.com/GhanaHomePage/communication /mobile.php.

20. "Telephones and Communications," Ghana Web.Com. http://www .ghanaweb.com/GhanaHomePage/communication/. "Cell Phone Usage Worldwide, by Country." http://www.infoplease.com/ipa/A0933605. html. Accessed November 28, 2010.

21. Panji Anoff, Personal Interview, Dworwulu, Accra, September 15, 2010.

22. For example, Carmody, *Globalization in Africa*, says, "Black Star TV has spurred an investment to assemble mobile phones that can receive the service by a Korean Manufacturer in Ghana" (113).

23. One example of Asian capital investment in Ghana is the new State House commissioned by the Kufuor government. It was built by the East Indian company Shapoorji Pallonji for US$37million. However, today it is rarely used by the current Mills administration.

24. Carmody, *Globalization in Africa*, 4.

25. Ibid., 4–5.

26. The obvious question becomes, how does the coltan discovery in the Democratic Republic of the Congo play into the current civil war in that country and its effects on neighboring countries. According to the website *Cellular-News* (http://www.cellular-news.com/coltan/), "A recent report

by the UN has claimed that all the parties involved in the local civil war have been involved in the mining and sale of coltan. One report suggested that the neighboring Rwandan army made US $250 million from selling coltan in less than 18 months, despite there being no coltan in Rwanda to mine. The military forces of Uganda and Burundi are also implicated in smuggling coltan out of Congo for resale in Belgium." The exploitations of colonialism have regrouped into neocolonial dynamics in the global ICT market.

27. Henry Jenkins, *Converge Culture: Where Old and New Media Collide* (New York: New York University Press, 2006), 11. Jenkins quoted from Ithel de Sola Pool, *Technologies of Freedom: On Free Speech in an Electronic Age* (Cambridge, MA: Harvard University Press, 1983), 23.

28. Panji Anoff, Personal Interview, Dworwulu, Accra, September 15, 2010.

29. "Vodafone Launches Blackberry in Ghana," Ghana Web, September 18, 2010. Accessed, November 29, 2010. http://www.ghanaweb.com /GhanaHomePage/NewsArchive/artikel.php?ID=19067.

30. Vodafone Company Profile. Accessed November 28, 2010. http://www .vodafone.comgh/Aboput-Us/Vodafone-Ghana.aspx.

31. Ghana's early twentieth-century concert parties, as a popular entertainment that traveled throughout the urban and rural areas with its dance, music, and minstrel-like morality tales, is a prime example of the centrality of expressive culture in relation to African societies.

32. Okyeame Kwame, Personal Interview, Keep Fit Club, Dansoman, September 25, 2010.

33. MTN Group, "Our Community." Accessed November 30, 2010. http:// www.mtn.com/Sustainability/2010/Our%20Community/Default. aspx.

34. "Major Telecommunication Companies Cheating Ghanaian Contractors," GhanaWeb.Com." Accessed November 30, 2010. http://www.ghanaweb. com/GhanaHomePage/features/artikel.php?ID=178199.

35. Ibid.

36. "Tigo to Renovate 32 Deprived Schools in Greater Accra," March 18, 2010. Peace FM Online. Accessed December 1, 2010. http://news.peacefmonline .com/education/201003/40343.php.

37. Quayson, "Signs of the Times."

38. Oluniyi D. Ajao, "Vodafone, Zain, MTN, Tigo, Glo Mobile and Their Competition in Ghana," July 22, 2009. Ajao Personal Blog. Accessed December 1, 2010. http://www.davidajao.com/blog/2009/07/22/vodafone- zain-tigo-mtn-glo-ghana/.

39. Ibid.

40. "Zain Launches Award Winning Mobile Commerce Service 'Zap' in Ghana," Business Intelligence Middle East, March 17, 2010. Accessed December 1, 2010. http://www.bi-me.com/main.php?id=45207&t=1.

41. Ibid.

42. Reggie Rockstone, Phone Interview, September 8, 2010.

43. Reggie Rockstone, Phone Interview, November 23, 2008.

44. "Glo Mobile Wins Ghana's Sixth Mobile License," TelecomPaper, June 16, 2008. Accessed December 2, 2010. http://www.telecompaper.com/news /glo-mobile-wins-ghanas-sixth-mobile-licence.

45. For the allegations of sabotage, see Oluniyi Ajao, "Glo Mobile to Leave Ghana?," May 24, 2010. Accessed December 2, 2010. http://www .davidajao.com/blog/2010/05/24/glo-mobile-to-leave-ghana/. Ajao quotes the government-owned *Daily Graphic News* as a source of some of these allegations where Glo's signage and light boxes were vandalized near tele- com competitors advertisements that were untouched.

46. Ajao, "Vodafone, Zain, MTN, Tigo, Glo Mobile and their Competition in Ghana."

47. "Nigeria: Glo Mobile Ghana Gets Launch Date," AllAfrica.com, December 27, 2011. Accessed December 31, 2011. http://allafrica.com /stories/201112270875.html. The article states, "Globacom will on January 19, 2012, formally begin commercial operations on its network in Ghana." It also reads that "the company would pre-empt the launch by holding a series of 'activities' designed to ensure that Glo Mobile's superior services' get the launch attention they deserve."

48. Reggie Rockstone, Phone Interview, September 8, 2010.

49. Carmody, *Globalization in Africa,* 109.

50. Ibid., 111.

51. Elizabeth Martinez and Arnoldo García, "What is 'Neo-Liberalism?' quoted in 'Neoliberalism: Origins, Theory, Definition'." Accessed December 2, 2010. http://web.inter.nl.net/users/Paul.Treanor/liberalism. html.

52. Aihwa Ong, *Neoliberalism as Exception: Mutations in Citizenship and Sovereignty* (Durham, NC: Duke University Press, 2006), 3.

53. Ibid.

54. Ibid., 11.

55. Naomi Klein, *Fences and Windows: Dispatches from the Front Lines of the Globalization Debate* (New York: Picador [St. Martin's Press], 2002), 78.

56. "What Are the Bretton Woods Institutions?" Bretton Woods Project. Accessed December 4, 2010. http://www.brettonwoodsproject.org/item. shtml?x=320747.

57. "Structural Adjustment Program," The Whirled Bank Group. Accessed December 3, 2010. http://www.whirledbank.org/development/sap.html.

58. Kwame Boafo-Arthur, "Structural Adjustment Programs (SAPS) in Ghana: Interrogating PNDC's Implementation," *West Africa Review* 1, no. 1 (1999). Accessed September 5, 2010 http://www.africaknowledgeproject.org/index. php/war/article/view/396.

59. Ibid.

60. Ibid.

61. Shipley, "Aesthetic of the Entrepreneur," 646.

62. Mwenda Ntarangwi, *East African Hip Hop: Youth Culture & Globalization* (Urbana: University of Illinois Press, 2009), 91.

63. Chinua Achebe quoted in Ntarangwi, *Hip Hop in East Africa,* 91.

64. Ntarangwi, *Hip Hop in East Africa*, 87.
65. Ibid.
66. Boafo-Arthur, "Structural Adjustment Programs (SAPS) in Ghana."
67. Klein, *Fences and Windows*, 79.
68. Leong Yew, "Political Discourse: Theories of Colonialism and Postcolonialism," a part of lectures of the University Scholars Programme, National University of Singapore. Accessed December 2, 2010. http://www.postcolonialweb.org/poldiscourse/neocolonialism1.html.
69. Ibid.
70. Kwame Nkrumah, *Neo-Colonialism: The Last Stage of Imperialism* (London: Thomas Nelson and Sons, 1965), xi.
71. See Charlyne Hunter-Gault, *New News Out of Africa: Uncovering Africa's Renaissance* (New York: Oxford University Press, 2006), which argues for a counter-narrative to Africa's "dark continent" stereotype. She argues, "Rather, this little book is an attempt to share the motivations that led me to Africa and to illuminate some of the examples that speak to what I call 'new news' out of Africa" (x).
72. "Four Ghanaian Artists Sign to Rockstar 4000," GhanaWeb.Com. Accessed October 29, 2010. http://www.ghanaweb.com/GhanaHomePage/NewsArchive/artikel.php?ID=184493.
73. Ibid.
74. Oluwaseyi Ogunbameru, "XTRA: One8 Unites Africa." Accessed November 11, 2010. http://234next.com/csp/cms/sites/Next/Home/5638601146/xtra_one8_unites_africa.csp.
75. "The Birth of a Music Revolution in Africa." Accessed October 29, 2010. http://www.ghanaweb.com/GhanaHomePage/NewsArchive/artikel.php?ID=195552.
76. Ibid.
77. Ghana's female Afro-Pop singer, Mimi, whom I discuss extensively in Chapter 1, tours throughout Africa, and had this to say about the difference between the Nigerian and Ghanaian music scene in terms of population and sales: "Nigeria has the same problem as us regarding payola; but it's better than us because they buy a lot of albums, and their population is bigger. The whole of Ghana is like one city in Nigeria. It's huge. So at least if they do that [demand bribes] to you, the CD will go, it will pay off. Because Ghana is small, how much can you expect to sell? I'm not looking for popularity and just fame for nothing. What is fame without money?"
78. Geoffrey P. Hull, Thomas Hutchison, and Richard Strasser, *The Music Business and Recording Industry: Delivering Music in the 21 Century* (New York: Routledge, 2011), 313–314.
79. Ibid., 313.
80. "MTV to Launch MTV Base in Africa," BizCommunity.Com: Daily Ad Industry News. October 25, 2004. http://www.biz-community.com.
81. Blog Comment to "MTV to Launch MTV Base in Africa," May 22, 2005. BizCommunity.Com: Daily Ad Industry News. http://www.biz-community.com.

82. "Lagos State Government & MTV Networks Africa Partner to Deliver
 the MTV Africa Music Awards with Airtel," MAMA MTV Base 2010:
 MAMA Hot News. Accessed December 7, 2010. http://www.Mam
 .mtvbase.com/newsArticle.aspx?iNewsID=13.
83. Juno Turkson, Personal Interview, Charter House Headquarters, Accra,
 September 23, 2010.
84. Nii Ayite Hammond, Personal Interview, Charter House Headquarters,
 Accra, September 23, 2010.
85. Ibid.

4 "THE GAME": HIPLIFE'S COUNTER-HEGEMONIC DISCOURSE

1. Dick Hebdige, "From Culture to Hegemony," In Dimon During, ed.,
 The Cultural Studies Reader (London: Routledge, 1999), 366. Hebidge
 quotes Stuart Hall, "Culture, the Media, and the 'Ideological Effect,'"
 In J. Curran, M. Gurevitch, and J. Woollacott, *Mass Communication and
 Society* (London: Edward Arnold, 1991), 315–348.
2. Ibid.
3. Adam Haupt, *Stealing Empire: P2P, Intellectual Property and Hip-Hop
 Subversion* (Cape Town, South Africa: Human Sciences Research Council,
 2008), xv.
4. Haupt defines empire "as [a] form of supranational cooperation between
 the US and the former imperial powers of Western Europe that allows
 them to act in ways that benefit them economically, militarily, culturally
 and politically" (1). He particularly emphasizes the postmodern aspects of
 "media as an ideological state apparatus" in this new kind of empire.
5. Haupt, *Stealing Empire*, xv–xvi.
6. The WTO created GATT in 1995 and represented the biggest reform of
 international trade since World War II. TRIPS has even more implications
 for the intellectual property rights contained in music production. As the
 WTO website notes, "Ideas and knowledge are an increasingly important
 part of trade. Most of the value of new medicines and other high technol-
 ogy products lies in the amount of invention, innovation, research, design
 and testing involved. Films, music recordings, books, computer software
 and on-line services are bought and sold because of the information and
 creativity they contain." Understanding the WTO: Intellectual Property:
 Protection and enforcement. Accessed August 5, 2011. http://www.wto.
 org/english/thewto_E/whatis_E/tif_E/agrm7_E.htm.
7. Haupt, *Stealing Empire*, xviii–xix.
8. Ibid., xix.
9. Reggie Rockstone, Personal Interview, Accra, Ghana, September 8, 2010.
10. Jesse Weaver Shipley, "Aesthetic of the Entrepreneur: Afro-Cosmopolitan
 Rap and Moral Circulation in Accra, Ghana," *Anthropological Quarterly*
 82, no. 3 (Summer 2009): 652.

11. Johannes Fabian, *Power and Performance: Ethnographic Explorations through Proverbial Wisdom and Theater in Shaba, Zaire.* Madison: University of Wisconsin Press, 1990, 24. "Eating," from an African philosophical perspective, has great currency throughout the continent. For example, Congo *nkisi* wooden figures have a container carved into the stomach region where herbal medicine is placed for the consecration of the figure's spiritual purpose.

12. Panji Anoff, Personal Interview, Dworzulu, Accra, September 15, 2010.

13. Wanlov Kuborl was born Emmanuel Owusu Bonsu in Romania and raised in Ghana. "Kuborlor" means "bush person" in Ghanaian pidgin, and he raps in Twi, English, and pidgin. He calls his style "Kuborlor" music fusing hip-hop, reggae, Afrobeat, Afro-Pop, and hiplife. See http://www.museke.com/en/Wanlov.

14. Panji Anoff, Personal Interview, Dworzulu, Accra, September 15, 2010.

15. Mwenda Ntarangwi, *East African Hip Hop: Youth Culture & Globalization* (Urbana: University of Illinois Press, 2009), 27.

16. Lawrence Grossberg, "Another Boring Day in Paradise: Rock and Roll and the Empowerment of Everyday Life," in Ken Gelder and Sarah Thornton, eds., *The Subcultures Reader* (London: Routledge, 1997), 481. The original article appeared in 1984 in *Popular Music* 4: 225–258.

17. Ibid.

18. For an important critique of the European ideology of "progress" see Dona Richards, "European Mythology: The Ideology of 'Progress'," In Molefi Kete Asante and Abdulai S. Vandi, eds., *Contemporary Black Thought* (Beverly Hills, CA: Sage Publications, 1980), 59–79.

19. Panji Anoff, Personal Interview, Dworzulu, Accra, September 15, 2010.

20. Ibid.

21. Haupt, *Stealing Empire*, 185.

22. Ibid.

23. Obour, Personal Interview, East Legon, December 12, 2008.

24. Ibid.

25. Obour explained that his Ghana First Peace Train was actually a project that copartnered with another organization with the same purpose: "I first had a campaign called the One Ghana Peace Project. Along the line, a team of musicians came together to organize the Ghana First Peace Train. So, these are two individual projects, but since both had 'peace' as a theme, and since I was a musician, along the line there were places the two could collaborate, and I brought them together. But the One Ghana Peace Project, I started it." Personal Interview, East Legon, December 12, 2008.

26. Ibid.

27. Terry Ofosu, Personal Interview, September 25, 2010.

28. Blitz the Ambassador, Phone Interview, September 24, 2009.

29. Ibid.

30. Shipley, "Aesthetic of the Entrepreneur," 660.

31. Ntarangwi, *East African Hip Hop*, 27.

32. Carolyn Cooper, *Sound Clash: Jamaican Dancehall Culture at Large* (New York: Palgrave Macmillan, 2004), 231. Cooper analyzes that Brathwaite "evokes the substrate cultural ties that connect Africans on the continent to those who have survived the dismembering Middle Passage. The paradoxical construct 'bridges of sound' conjoins the ephemerality of aural sensations with the technological solidity of the built environment."

33. Cedric Muhammad, "Africa, The Next Throne of Hip-Hop," AllHipHop.Com. http://allhiphop.com/stories/editorial/archive/2010/05 /18/22225694.aspx. Accessed May 20, 2010. Muhammad was the former manager of New York's Wu Tang Clan, and interacted with many of the record company executives responsible for worldwide distribution of hip-hop music.

34. Michel Foucault, *Ethics: Subjectivity and Truth,* edited by Paul Rabinow and translated by Robert Hurley from *The Essential Works of Michel Foucault, 1954–1984, Vol. 1* (New York: The New Press, 1994), 298.

35. Ibid. Foucault does not define "power games" in the usual sense: "When I say 'game,' I mean a set of rules by which truth is produced. It is not a game in the sense of an amusement; it is a set of procedures that lead to a certain result, which, on the basis of its principles and rules of procedure, may be considered valid or invalid, winning or losing" (297).

36. Michel Foucault, *Politics, Philosophy, Culture: Interviews and Other Writings, 1977–1984,* edited by Lawrence D. Kritzman and translated by Alan Sheridan (New York: Routledge, 1988), 316.

37. George Lipsitz, *Footsteps in the Dark: The Hidden Histories of Popular Music* (Minneapolis: University of Minnesota Press, 2007), xv.

38. Muhammad, "Africa, The Next Throne of Hip-Hop."

39. Obour, Personal Interview, East Legon, December 12, 2008.

BIBLIOGRAPHY

BOOKS AND ESSAYS

Amamoo, J. G. *Ghana: 20 Years of Independence*. Accra: Jafint. Ent., 2007.

Androutsopoulos, Jannis. "Language and the Three Spheres of Hip Hop." In H. Samy Alim, Awad Ibrahim, and Alastair Pennycook, eds., *Global Linguistic Flows: Hip Hop Cultures, Youth Identities and the Politics of Language*, 43–62. New York: Routledge, 2009.

Appadurai, Arjun. *Modernity at Large: Cultural Dimensions of Globalization*. Minneapolis: University of Minnesota, Press, 1996.

Appiah, Kwame Anthony. *In my Father's House: Africa in the Philosophy of Culture*. New York: Oxford University Press, 1992.

Austin, Joe, and Michael Nevin Willard, eds., *Generations of Youth: Youth Cultures and History in Twentieth Century America*. New York: New York University Press, 1998.

Baldwin, Davarian L. "Black Empires, White Desires." In Murray Forman and Mark Anthony Neal, eds., *That's the Joint! The Hip-Hop Studies Reader*, 159–176. New York: Routledge, 2004.

Bennett, Andy. *Popular Music and Youth Culture*. New York: St. Martin's Press, 2000.

Boafo-Arthur, Kwame. "Structural Adjustment Programs (SAPS) in Ghana: Interrogating PNDC's Implementation." *West Africa Review* 1, no. 1 (1999). Accessed September 5, 2010. http://www.africaknowledgeproject.org/index.php/war/article/view/396.

Bourdieu, Pierre. *Outline of a Theory of Practice*. Translated by Richard Nice. New York: Cambridge University Press, 1977.

Buah, F. K. *A History of Ghana, Revised and Updated*. Oxford: Macmillan Education, 1998.

Butler, Judith. *Gender Trouble: Feminism and the Subversion of Identity*. London: Routledge, 1990.

Carmody, Pádraig. *Globalization in Africa: Recolonization or Renaissance?* Boulder, CO: Lynne Reinner Publishers, 2010.

Castells, M. *End of the Millennium*. Malden, MA: Blackwell, 1998.

Chernoff, John Miller. *African Rhythm and African Sensibility: Aesthetics and Social Action in African Musical Idioms*. Chicago, IL: University of Chicago Press, 1979.

Clarke, John, Stuart Hall, Tony Jefferson, and Brian Roberts. "Subcultures, Cultures and Class." In Ken Gelder and Sarah Thornton, eds., *The Subcultures Reader*, 100–111. London: Routledge, 1997.

Cole, Catherine M. *Ghana's Concert Party Theatre*. Bloomington, IN: Indiana University Press, 2001.

Collins, John. *West African Pop Roots*. Philadelphia, PA: Temple University Press, 1992.

Cooper, Carolyn. *Sound Clash: Jamaican Dancehall Culture at Large*. New York: Palgrave Macmillan, 2004.

Debord, Guy. *Society of the Spectacle*. London: Rebel Press, 1970.

Diawara, Manthia. "Toward a Regional Imaginary in Africa." In Fredric Jameson and Masao Miyoshi, eds., *The Cultures of Globalization*, 103–124. Durham, NC: Duke University Press, 1998.

———. *In Search of Africa*. Cambridge, MA: Harvard University Press, 1998.

Dyson, Michael Eric. *Know What I Mean? Reflections on Hip Hop*. New York: Basic Civitas Books, 2007.

Emery, Lynne Fauley. *Black Dance in the United States from 1619 to Today*. 2nd revised ed. Hightstown, NJ: Dance Horizon Book, 1988, 1972.

Epps, Edgar G. *African American Education: Race, Community, Inequality and Achievement*. Boston, MA: JAI, 2002.

Fabian, Johannes. *Power and Performance: Ethnographic Explorations through Proverbial Wisdom and Theater in Shaba, Zaire*. Madison: University of Wisconsin Press, 1990.

Foucault, Michel. *Ethics: Subjectivity and Truth*. Edited by Paul Rabinow and translated by Robert Hurley from *The Essential Works of Michel Foucault, 1954–1984, Vol. 1*. New York: The New Press, 1994.

———. *Politics, Philosophy, Culture: Interviews and Other Writings, 1977–1984*. Edited by Lawerence D. Kritzman and translated by Alan Sheridan. New York: Routledge, 1988.

Forman, Murray. *The 'Hood Comes First: Race, Space, and Place in Rap and Hip-Hop*. Middletown, CT: Wesleyan University Press, 2002.

Gaines, Kevin K. *American Africans in Ghana: Black Expatriates and the Civil Rights Era*. Chapel Hill: University of North Carolina Press, 2006.

Gelder, Ken. "Introduction to Part Two." In Ken Gelder and Sarah Thornton, eds., *The Subcultures Reader*, 83–89. London: Routledge, 1997.

Geschiere, Peter, Birgit Meyer, and Peter Pels, eds., *Readings in Modernity in Africa*. London: International African Institute; In association with Bloomington: Indiana University Press, 2008.

Gilroy, Paul. *The Black Atlantic: Modernity and Double Consciousness*. Cambridge, MA: Harvard University Press, 1993.

Goodman, Jane E., and Paul A. Silverstein. *Bourdieu in Algeria: Colonial Politics, Ethnographic Practices, Theoretical Developments*. Lincoln: University of Nebraska Press, 2009.

Gottschild, Brenda Dixon. *Digging the Africanist Presence in American Performance*. Westport, CT: Greenwood Press, 1996.

Grossberg, Lawrence. "Another Boring Day in Paradise: Rock and Roll and the Empowerment of Everyday Life." In Ken Gelder and Sarah Thornton, eds., *The Subcultures Reader*, 477–493. London: Routledge, 1997.

Hall, Stuart. "Culture, The Media, and the 'Ideological Effect.'" In J. Curran, M. Gurevitch, and J. Woollacott, eds., *Mass Communication and Society*, 315–348. London: Edward Arnold.

Hardt, M. and A. Negri. *Empire*. London and Cambridge, MA: Harvard University Press, 2000.

Hartman, Saidiya. *Lose Your Mother: Journey along the Atlantic Slave Route*. New York: Ferrar, Straus, and Giroux, 2007.

Haupt, Adam. *Stealing Empire: P2P, Intellectual Property and Hip-Hop Subversion*. Cape Town, South Africa: Human Sciences Research Council Press, 2008.

Hebdige, Dick. "From Culture to Hegemony." In Dimon During, ed., *The Cultural Studies Reader*, 357–367. London: Routledge, 1999.

———. "Subculture: The Meaning of Style." In Ken Gelder and Sarah Thornton, eds., *The Subcultures Reader*, 130–142. London: Routledge, 1997. Originally published in *Subculture: The Meaning of Style*. London: Methuen, 1979.

Higginbotham, Evelyn. *Righteous Discontent: The Women's Movement in the Black Baptist Church, 1880–1920*. Cambridge, MA: Harvard University Press, 1993.

Holsey, Bayo. *Routes of Remembrance: Refashioning the Slave Trade in Ghana*. Chicago, IL: University of Chicago Press, 2008.

Hull, Geoffrey P., Thomas Hutchison, and Richard Strasser. *The Music Business and Recording Industry: Delivering Music in the 21 Century*. New York: Routledge, 2011.

Hunter-Gault, Charlyne. *New News Out of Africa: Uncovering Africa's Renaissance*. New York: Oxford University Press, 2006.

James Lull. *Media, Communication, Culture: A Global Approach*. Cambridge: Polity Press, 1995.

Jameson, Frederick. *Postmodernism, or, The Cultural Logic of Late Capitalism*. Durham, NC: Duke University Press, 1992.

Jenkins, Henry. *Converge Culture: Where Old and New Media Collide*. New York: New York University Press, 2006.

Judy, R. A. T. "On the Question of Nigga Authenticity." In Murray Forman and Mark Anthony Neal, eds., *That's the Joint! The Hip-Hop Studies Reader*, 105–118. New York: Routledge, 2004.

Kelley, Robin D. G. "Looking for the 'Real' Nigga: Social Scientists Construct the Ghetto." In Murray Forman and Mark Anthony Neal, eds., *That's the Joint! The Hip-Hop Studies Reader*, 119–136. New York: Routledge, 2004.

Klein, Naomi. *Fences and Windows: Dispatches from the Front Lines of the Globalization Debate*. New York: Picador (St. Martin's Press), 2002.

Lawless, Elaine J. "Claiming Inversion: Lesbian Constructions of Female Identity as Claims of Authority." *Journal of American Folklore* 11 no. 429 (1998): 3–22.

Lemelle, Sidney J. "'Ni Wapi Tunakwenda': Hip Hop Culture and the Children of Arusha." In Dipannita Basu and Sidney J. Lemmelle, eds., *The Vinyl Ain't Final: Hip Hop and the Globalization of Black Popular Culture*, 230–254. London: Pluto Press, 2006.

Lipsitz, George. *Footsteps in the Dark: The Hidden Histories of Popular Music.* Minneapolis: University of Minnesota Press, 2007.

Lull, James. *Media, Communication, Culture: A Global Approach.* Cambridge: Polity Press, 1995.

Lyotard, Jean-François. *Moralitiés Postmodernes.* Paris: Galilée, 1993.

———. *The Postmodern Condition.* Minneapolis: University of Minnesota Press, 1984.

Magubane, Zine. "Globalization and Gangster Rap: Hip Hop in the Post-Apartheid City." In Dipannita Basu and Sidney J. Lemmelle, eds., *The Vinyl Ain't Final: Hip Hop and the Globalization of Black Popular Culture,* 208–229. London: Pluto Press, 2006.

Mbembe, Achille. "The New Africans: Between Nativism and Cosmopolitanism." In Peter Geschiere, Birgit Meyer, and Peter Pels, eds., *Readings in Modernity in Africa,* 107–111. London: International Institute; Bloomington: In Association with Indiana University Press, 2008.

Mitchell, Tony. *Global Noise: Rap and Hip-Hop Outside the USA.* Middletown, CT: Wesleyan University Press, 2001.

Nkrumah, Kwame. *Neo-Colonialism: The Last Stage of Imperialism.* London: Thomas Nelson and Sons, 1965.

Ntarangwi, Mwenda. *East African Hip Hop: Youth Culture and Globalization.* Urbana: University of Illinois Press, 2009.

Ofosu, Terry Bright. "Dance Contests in Ghana." MA Thesis, School of Performing Arts, University of Ghana, Legon, June 1993.

Ogbu, John U. *Minority Status and Schooling: A Comparative Study of Immigrant and Involuntary Minorities.* New York: Garland, 1991.

Omoniyi, Tope. "So I Choose to Do Am Naija Style." In Samy Alim, Awad Ibrahim, and Alastair Pennycook, eds., *Global Linguistic Flows,* 176–177. New York: Routledge, 2008.

Ong, Aihwa. *Neoliberalism as Exception: Mutations in Citizenship and Sovereignty.* Durham, NC: Duke University Press, 2006.

Osumare, Halifu. "Motherland Hip-Hop: Connective Marginality and African American Youth Culture in Senegal and Kenya." In Mamadou Diouf and Ifeoma Kiddoe Nwankwo, eds., *Rhythms of the Afro-Atlantic World: Rituals and Remembrances,* 161–177. Ann Arbor, MI: The University of Michigan Press, 2010.

———. *The Africanist Aesthetic in Global Hip-Hop: Power Moves.* New York: Palgrave Macmillan, 2007.

———. "Global Breakdancing and the Intercultural Body." *Dance Research Journal* 34, no. 2 (Winter 2002): 30–45.

Pennycook, Alastair, and Tony Mitchell. "Hip Hop as Dusty Foot Philosophy." In H. Samy Alim, Awad Ibrahim, and Alastair Pennycook, eds., *Global Linguistic Flows: Hip Hop Cultures, Youth Identities, and the Politics of Language.* New York: Routledge, 2009.

Pool, de Sola. *Technologies of Freedom: On Free Speech in an Electronic Age.* Cambridge, MA: Harvard University Press, 1983.

Potter, Russell. *Spectacular Vernaculars, and Spectacular Vernaculars: Hip-Hop and the Politic of Postmodernism.* Albany: State University of New York Press, 1995.

Quayson, Ato. "Signs of the Times: Discourse Ecologies and Street Life on Oxford St., Accra." *City & Society* 22, no. 1: 72–96.

Richards, Dona. "European Mythology: The Ideology of 'Progress'." In Molefi Kete Asante and Abdulai S. Vandi, eds., *Contemporary Black Thought*, 59–79. Beverly Hills, CA: Sage Publications, 1980.

Roach, Joseph R. *Cities of the Dead: Circum-Atlantic Performance.* New York: Columbia University Press, 1996.

Robertson, Ronald. "Glocalization: Time-Space and Homogeneity-Heterogeneity." In Mike Featherstone, Scott Lash, and Roland Robertson, eds., *Global Modernities*, 25–44. London: Sage Publication, 1995.

Rose, Tricia. *The Hip Hop Wars: What We Talk about when We Talk about Hip Hop—And Why It Matters.* New York: Basic Civitas Books, 2008.

———. *Black Noise: Rap Music and Black Culture in Contemporary America.* Hanover, CT: Wesleyan University Press, 1994.

Shipley, Jesse Weaver. "Aesthetic of the Entrepreneur: Afro-Cosmopolitan Rap and Moral Circulation in Accra, Ghana." *Anthropological Quarterly* 82, no. 3 (Summer 2009): 633–678.

Watkins, S. Craig. *Representing: Hip Hop Culture and the Production of Black Cinema.* Chicago, IL: University of Chicago Press.

Werbner, Pnina. *Anthropology and the New Cosmopolitanism: Rooted, Feminist and Vernacular Perspectives.* Oxford: Berg, 2008.

Willie, Sarah Susannah. *Acting Black: College, Identity, and the Performance of Race.* New York: Routledge, 2003.

Wilson, Olly. "Significance of the Relationship Between Afro-American Music and West African Music." *Black Perspective in Music* (Spring, 1974): 234–243.

Yankah, Kwesi. *Speaking for the Chief: Okyeame and the Politics of Akan Royal Oratory.* Bloomington, IN: Indiana University Press, 1995.

Ziff, Bruce, and Pratima V. Rao, eds., *Borrowed Power: Essays on Cultural Appropriation.* New Brunswick, NJ: Rutgers University Press, 1997.

INTERNET ARTICLES

Ajao, Oluniyi. "Glo Mobile to Leave Ghana?" Oluniyi Ajao Blog. May 24, 2010. Accessed December 2, 2010. http://www.davidajao.com/blog/2010/05/24/glo-mobile-to-leave-ghana/.

———. "Vodafone, Zain, MTN, Tigo, Glo Mobile and Their Competition in Ghana." Oluniyi Ajao Blog. July 22, 2009. Accessed November 28, 2010. http://www.davidajao.com/blog/2009/07/22/vodafone-zain-tigo-mtn-glo-ghana/.

"Batman Samini." Ghana Base Music. Accessed October 26, 2010. http://music.thinkghana.com/artist/samini/.

Biography of Obrafour. Ghana Base Music. Accessed October 26, 2010. http://music.thinkghana.com/artist/obrafour/.

"Cellular/Mobile Network." GhanaWeb.com. Accessed November 28, 2010. http://www.ghanaweb.com/GhanaHomePage/communication/mobile.php.

"Cell Phone Usage Worldwide, by Country." Accessed November 28, 2010. http://www.infoplease.com/ipa/A0933605.html.

Chale. "Kwaw Kese-Museke African Artistes." July 7, 2006. Accessed October 27, 2010. http://www.museke.com/en/KwaKese.

Claude, Jamie. "King Ayisoba." Museke African Artistes. October 10, 2006. http://www.museke.com/en/KingAyisoba. Accessed November 13, 2010.

Coates, Ta-Nehisi Paul. "Ghana's New Money." Time.com. August 21, 2006. http://www.time.com/time/magazine/article/0,9171,1229122,00.html.

"Dr. Duncan of Adom FM." Ghana Web. November 4, 2004. Accessed November 1, 2010. http://ghanaweb.com/GhanaHomePage/audio/artikel.php?ID=191666#.

"Four Ghanaian Artists Sign to Rockstar 4000." GhanaWeb.Com. Accessed October 29, 2010. http://www.ghanaweb.com/GhanaHomePage/NewsArchive/artikel.php?ID=184493.

"Frafra People; Ghana: Profile." National Geographic. Accessed November 13, 2010. http://www.nationalgeographic.com/geographyofwealth/frafra-profile.html.

"GhanaBase Music Meets Okyeame Kwame." Ghanabase.com. March 15, 2007. Accessed November 15, 2010. http://www.ghanabase.com/interviews/2007/775.asp?artistnews=okyeamekwame.

"Ghana People 2010." 2010 CIA World Factbook and Other Sources. Accessed November 10, 2010. http://www.theodora.com/wfbcurrent/ghana/ghana_people.html.

"Glo Mobile Wins Ghana's Sixth Mobile License." TelecomPaper. June 16, 2008. Accessed December 2, 2010. http://www.telecompaper.com/news/glo-mobile-wins-ghanas-sixth-mobile-licence.

Jackson, Ayana Vellisia. "Full Circle: A Survey of Hip Hop in Ghana." Accessed October 14, 2010. http://www.avjphotography.com/AVJ_hiplifeessay.htm.

"Lagos State Government & MTV Networks Africa Partner to Deliver the MTV Africa Music Awards with Airtel." MAMA MTV Base 2010: MAMA Hot News. 2010. Accessed December 7, 2010. http://www.Mam.mtvbase.com/newsArticle.aspx?iNewsID=13.

"Major Telecommunication Companies Cheating Ghanaian Contractors." GhanaWeb.Com. Accessed November 30, 2010. http://www.ghanaweb.com/GhanaHomePage/features/artikel.php?ID=178199.

Martinez, Elizabeth, and Arnoldo García. "What is 'Neo-Liberalism?' quoted in 'Neoliberalism: Origins, Theory, Definition'." Accessed December 2, 2010. http://web.inter.nl.net/users/Paul.Treanor/liberalism.html.

Mensah, Ishmael. "Marketing Ghana as a Mecca for the African-American Tourist." June 10, 2004. http://www.modernghana.com/news/114445/1/marketing-ghana-as-a-mecca-for-the-african-america.html.

MTN Group. "Our Community." Accessed November 30, 2010. http://www.mtn.com/Sustainability/2010/Our%20Community/Default.aspx.

"MTV to Launch MTV Base in Africa." BizCommunity.Com: Daily Ad Industry News. October 25, 2004. Accessed December 7, 2010. http://www.biz-community.com.

"MTV to Launch MTV Base in Africa." Blog Comment. May 22, 2005. BizCommunity.Com: Daily Ad Industry News. Accessed December 7, 2010. http://www.biz-community.com.

Muhammad, Cedric. "Africa, The Next Throne of Hip-Hop." AllHipHop. Com. Accessed May 20, 2010. http://allhiphop.com/stories/editorial/archive/2010/05/18/22225694.aspx.

Music Africa: Afro Fest Bababo Stage Youth Zone. Accessed October 28, 2010. http://www.musicafrica.org/stage_baobab_youth.htm.

"Nigeria: Glo Mobile Ghana Gets Launch Date." AllAfrica.com. December 27, 2011. Accessed December 31, 2011. http://allafrica.com/stories/201112270875.html.

"Okyeame Kwame." Ghanabase.com. Accessed January 15, 2009. http://music.thinkghana.com/artist/okyeamekwame/.

Oluniyi D. Ajao. "Vodafone, Zain, MTN, Tigo, Glo Mobile and Their Competition in Ghana." July 22, 2009. Ajao Personal Blog. Accessed December 1, 2010. http://www.davidajao.com/blog/2009/07/22/vodafone-zain-tigo-mtn-glo-ghana/.

Oluwaseyi Ogunbameru. "XTRA: One8 Unites Africa." Accessed November 11, 2010. http://234next.com/csp/cms/sites/Next/Home/5638601146/xtra_one8_unites_africa.csp.

Owusu, George Clifford. "VIP Album Launch A Hit." Modern Ghana News, February 19, 2010. http:///www.modernghana.com/music/11326/3vip-album-launch-a-hit.html.

Scherer, Michael. "Obama's Statement at Cape Coast Castle." Time.com, July 11, 2009. http://swampland.blogs.time.com/2009/07/11/obamas-statement-at-cape-coast-castle/.

"Structural Adjustment Program." The Whirled Bank Group. Accessed December 3, 2010. http://www.whirledbank.org/development/sap.html.

"Telephones and Communications." GhanaWeb.Com. Accessed December 3, 2010. http://www.ghanaweb.com/GhanaHomePage/communication/.

"The Birth of a Music Revolution in Africa." Accessed October 29, 2010. http://www.ghanaweb.com/GhanaHomePage/NewsArchive/artikel.php?ID=195552.

"Tigo to Renovate 32 Deprived Schools in Greater Accra." March 18, 2010. Peace FM Online. Accessed December 1, 2010. http://news.peacefmonline.com/education/201003/40343.php.

"Understanding the WTO—Intellectual Property: Protection and Enforcement." Accessed August 5, 2011. http://www.wto.org/english/thewto_e/whatis_e/tif_e/agrm7_e.htm.

"VIP, Happy FM Rock Nima with Salafest Jams." Peace FM Online. September 20, 2010. http://showbiz.peacefmonline.com/news/201009/83711.php.

Vodafone Company Profile. Accessed November 28, 2010. http://www.vodafone.comgh/AboputUs/Vodafone-Ghana.aspx.

"Vodafone Launches Blackberry in Ghana." Ghana Web. September 18, 2010. Accessed November 29, 2010. http://www.ghanaweb.com/GhanaHomePage/NewsArchive/artikel.php?ID=19067.

"What Are the Bretton Woods Institutions?" Bretton Woods Project. Accessed December 4, 2010. http://www.brettonwoodsproject.org/item.shtml?x=320747.

Yelpaala, Kaakpema. "Mining, Sustainable Development, and Health in Ghana: The Akwatia Case-Study." March 2004. http://www.watsoninstitute.org/ge/watson_scholars/Mining.pdf.

Yew, Leong. "Political Discourse: Theories of Colonialism and Postcolonialism." A part of lectures of the University Scholars Programme, National University of Singapore. Accessed December 2, 2010. http://www.postcolonialweb.org /poldiscourse/neocolonialism1.html.

"Zain Launches Award Winning Mobile Commerce Service 'Zap' in Ghana." Business Intelligence Middle East. March 17, 2010. Accessed December 1, 2010. http://www.bi-me.com/main.php?id=45207&t=1.

DISCOGRAPHY AND VIDEOGRAPHY

Ambolley, Gyedu-Blay. "Abrentsie." *Partytime Revisited*. Simigwa Records, 1988.
Boroo, Nana. "Aha Yede" (This Place is Fun). *Young Executive*, 2010.
Jacobs-Fantauzzi, Eli. Director. *Homegrown: Hiplife in Ghana*. Film documentary. Clenched Fist Productions in Association with BDN Productions, 2008.
Mimi. "Tattoo." *Music in Me*. Movingui Records, 2008.
Obour. "Fontomfrom". *Fontomfrom*. Family Tree Entertainment, 2009.
———. "The Game." *Fontomfrom*. Family Tree Enteratinment, 2009.
Obour and A.B. Crentsil. "Adjoa." *The Best of the Lifes: Hiplife Meets Hiplife*. Family Tree Entertainment, 2006.
Obrafour. "Kwame Nkrumah." *Pae Mu Ka*. OM Studios, 1999.
Okyeame Kwame. "Woso." *M'anwensem*. One Mic Entertainment, 2008.
Rockstone, Reggie. "Glad." *Reggiestration*. Rockstone's Office, 2010.
———. "Ese Woara." *Reggiestration*. Rockstone's Office, 2010.
Tic Tac. "Kangaroo." *Accra Connection*. TN Records, 2006.
Wanguhu, Michael. Director. *Hip-Hop Colony*. Film documentary. Chatsworth, CA: Emerge Media Group, LLC, 2007.

INTERVIEWS

Adomako, Akosua, and Awo Asiedu. Personal Interview. University of Ghana, Legon. September 14, 2010.
Ambolley, Gyedu-Blay. Personal Interview. Accra, Ghana. November 22, 2008.
Anoff, Panji. Telephone Interview. September 16, 2010.
———. Personal Interview. Dworwulu, Accra. September 15, 2010.
———. Personal Interview. Ouagadougou, Burkina Faso. October 18, 2008.
———. Personal Interview. Alliance Francais in Accra. October 10, 2008.
Blitz the Ambassador (Samuel Bazawula). Telephone Interview. September 24, 2009.
Collins, John. Personal Interview. University of Ghana, Legon. September 23, 2008.
Diallo, Ali. Personal Interview. Ouagadougou, Burkina Faso. October 18, 2008.
Djan, Abraham Ohene. Personal Interview. OM Studios, Accra Ghana. September 24, 2010.
Hammond, Nii Ayite. Personal Interview. Charter House in Accra. September 23, 2010.

Menson, B. B. Personal Interview. November 15, 2008.

Mimi. Personal Interview. Accra, Ghana. September 22, 2010.

Obour. Personal Interview. East Legon. December 12, 2008.

Ofosu, Terry. Email Communication. October 28, 2010.

———. Personal Interview. University of Ghana, Legon. September 27, 2010.

Ohene Djan, Abraham. Personal Interview. OM Studios, Accra. September 24, 2010.

Kwame, Okyeame. Personal Interview. Keep Fit Club, Dansoman. September 25, 2010.

———. Personal Interview. International Convention Center, Accra. November 28, 2008.

Paley, Iso. Personal Interview. TV3 Studios, Accra, Ghana. September 18, 2008.

Rockstone, Reggie. Personal Interview. Accra, Ghana. September 29, 2010.

———. Personal Interview. Accra, Ghana. September 8, 2010.

———. Personal Interview. November 23, 2008.

Sarkodie. Personal Interview. Tema. September 19, 2010.

Trigmatic. Personal Interview. Frankie's Restaurant, Accra. September 20, 2010.

Turkson, Juno. Personal Interview. Charter House, Accra. September 23, 2010.

NEWS ARTICLES

Anyidoho, Akofa, and Nana Dansowaa Kena-Amoah. "Let's Have More Positive Lyrics about Women." *Daily Graphic.* August 30, 2008.

Asante, Juliet Yaa Asantewa. "Samini—Marriage Is the Last Thing on My Mind." *Entertainment Today* 4 (2007).

Dellios, Hugh. "Multilingual S. Africa Talking up a New Dialect." *Chicago Tribune*, February 9, 1998.

Navasky, Victor S. "Rebranding Africa." *The New York Times*, Op-Ed. July 10, 2009.

Index